Contents

Preface

The Concept for the first edition of OVEREXPOSURE: *Health Hazards in Photography* began a decade ago with a realization that very little information on the hazards inherent in handling photographic chemicals was readily available to the average practitioner. At the time, I was on the staff of The Friends of Photography and active in its publishing program. Then-executive director James Alinder and others on the staff readily agreed with me that the organization could make an important contribution to the field by producing a resource that would allow amateur, artistic or professional photographers to make informed choices about the materials they use in their work. I assumed the role of coordinator and editor for the OVEREXPOSURE project. The organization was awarded a "Services to the Field" grant from the Visual Arts Program of the National Endowment for the Arts to support research and publication of such a book.

To write the manuscript, The Friends was fortunate to find Susan Shaw, who had training in photography as well as experience in public health and environmental sciences. Through her understanding of these fields and her subsequent research, what had originally been contemplated as a sixty-page booklet became a major, critically acclaimed publication of more than three hundred pages.

When OVEREXPOSURE was released in 1983, it became clear immediately that the need we had perceived for the book did, in fact, exist. The modest press run sold out within a relatively short time. Countless orders have been received in recent years that unfortunately could not be filled, but the book has been available in public and university libraries throughout the country. In the first years following publication of OVEREXPOSURE—and continuing up to the present—not only did photographic chemistry and the processes utilized change substantially, but the depth of scientific knowledge about potential hazards and the precautions that should be taken increased as well. To simply reprint the book without incorporating new information was not seen as a viable or responsible option. Thus, when a commercial publisher, Allworth Press, expressed interest in the project, The Friends of Photography was pleased to transfer rights for this new edition. The organization has not, however, had direct involvement in either its research or its production.

To complement Susan Shaw's acknowledged expertise, Monona Rossol, a respected artist, chemist and industrial hygienist, has joined her as co-author.

While the general format of the book follows that of the original, the authors have made a great number of substantive changes in the content to reflect the most current levels of knowledge. The chapter covering the hazards and precautions related to color processes in photography has been enhanced significantly since that aspect of the medium has undergone a great deal of change since the first edition. Information about many other new chemicals has been added in other sections, as well, and the discussion of ventilation for darkrooms and studios has been substantially revised.

One entirely new chapter, "Photography and the Law," has been added to reflect the increased acceptance of the notion that all of us have the right to become informed about things that may affect our health and well-being. This chapter discusses both recently enacted "right-to-know" laws and the liability of schools and workplaces to inform and protect students and employees. The implications of these and other new Federal regulations are incorporated throughout.

Photographer John Pfahl's poignant letter in Chapter I underlines the importance of the information in OVEREXPOSURE. The ultimate choice of using or not using any process or chemical, of course, remains with the individual. With the resources contained here, photographers may make informed choices based on a full understanding of the hazards they might encounter, and individuals and institutions are given the knowledge necessary to make photographic practice a safer enterprise for all involved.

David Featherstone *San Francisco, June 1991*

Acknowledgements

Susan Shaw and Monona Rossol would like to thank Tad Crawford from Allworth Press for making this second edition possible. He gave us the opportunity to work together on this book again after almost nine years. At that time, Susan wrote the first edition and Monona served as an advisor. That collaboration began a relationship which resulted in Monona's founding of, Arts, Crafts, and Theater Safety (ACTS) with both authors sharing tasks on ACTS's Board of Directors, Susan founding the Marine Environmental Research Institute (MERI), the second edition of this book, and an enduring friendship.

Working on this book, we were reminded again that photographers are special people. Almost all those we asked offered freely of their time and expertise. Included among those to whom we are indebted: Bea Nettles, Chair of Photography Program, University of Illinois; noted photographers John Pfahl, Meridel Rubenstein, Robert Dawson, and Judy Natal; Joan Lyons, photographer, illustrator, and author; Mark Klett, Photography Collaboration, School of Art, Arizona University; Robert Hirsch, Associate Professor of Photography, Amarillo College, Texas; Jim Featherstone, Adjunct Assistant Professor, University of Toledo, Ohio; Gary Albright, Senior Conservator, Northeast Document Center; and Debbie Hess Norris, Assistant Director, Art Conservation Program, University of Delaware.

We also must thank Richard Weisgrau and Pat Caulfield of the American Society of Magazine Photographers; and New York photographer Michal Heron who helped us find our experts.

Technical people that provided invaluable help included: Nancy Clark, industrial hygienist and author; Ted Rickard, Ontario College of Art who helped with the Canadian regulations; Rudolph J. Jaeger, Consulting Toxicologist, Environmental Medicine, Incorporated; and Eva Karger, Manager, Health and Toxicological Information, and her colleagues at Polaroid Corporation who updated the Polaroid instant processes section of the book.

A few special people assisted with both editions of the book. These are: John Pfahl who helped with platinum and palladium printing, dye transfer and other processes in both editions and who wrote the Introduction to Chapter One; Joan Lyons and the other artists working at the Visual Studies Workshop in Rochester who commented on many processes; and David Featherstone who edited the first edition and wrote the preface to both. It was David who was the original liaison with The Friends of Photography, publisher of the first edi-

tion. Others from The Friends who helped with the first edition included James Alinder, Executive Director; and staff members Peter A. Andersen, Pam Feld and Claire Peeps.

People whose help on the first edition we also should not forget include:

* James P. Murphy, Susan Shaw's friend and medical editor;

* Catherine Eckdall, artist and printmaker;

* Granville Sewell, Ph.D., Columbia University School of Public Health, Division of Environmental Sciences, Susan Shaw's advisor who consistently encouraged her academic pursuits and inspired her to use her knowledge to make a difference in the world;

* Many physicians, scientists, industrial hygienists and health pro-fessionals who made valuable contributions to the research, especially (by their 1983 titles):
 William A. Burgess, Corporate Manager of Industrial Hygiene, Polaroid Corporation;
 Robert E. Stone, Ph.D., research scientist for the Chemical Information Unit of the New York State Department of Health;
 Thomas Cutter, P. E., consulting engineer;
 Leslie R. Andrews, Dr. P. H., C.I.H., Division of Environmental Sciences, Columbia University School of Public Health;
 Leo Orris, M. D., New York University Institute of Environmental Medicine; and
 Grant B. Romer, conservator at the George Eastman House in Rochester, New York.

* Among the many photographers who made major contributions to the first edition, we thank: James Hajicek, Assistant Professor of Photogra-phy at Arizona State University, Tempe; Don Leavitt and Marlis C. Schwieger, both based in New York City; Anne Brandeis, instructor at the New York Fashion Institute of Technology; Chris Rainier and John Sexton, both of Carmel, California; Robert Baker of Carmel, technical editor to Ansel Adams; and Robert Glenn Ketchum of Los Angeles.

* The National Endowment for the Arts for a public service grant which made the first edition possible.

Many friends and family members also provided invaluable encouragement throughout the project—too many to mention them all. But special thanks go to John Simpson Fairlie and Cynthia Stroud.

This incredibly long list of names will always cause us to remember how much we owe to so many.

Susan Shaw and **Monona Rossol** *August, 1991*

Introduction

The first edition of OVEREXPOSURE was a ground-breaker. It provided photographers with access to chemical data and safety information which was not readily available to them. In the nine years that followed, new laws made the information more available, but at the same time, rapid technical advances greatly increased the number of chemicals used in photography and the laws which regulate their use and disposal.

The second edition covers all the chemicals discussed in the first edition and many of the new ones. More importantly, this book can be used to meet many of the requirements of new occupational laws and regulations such as the Hazard Communication Standard or Right-to-Know laws. OVEREXPOSURE functions as a source of technical and regulatory information, a worker training manual, an aid in developing workplace checklists, and a source of additional help and safety supplies.

However technical the book may seem, Right-to-Know laws in both the U.S. and Canada require workers using photochemicals to understand most of this material, including basic toxicology and risk assessment in lay terminology. Self-employed photographers also need this knowledge to protect themselves. The material is necessarily challenging and some readers may have questions. For this reason, the authors may be contacted through the not-for-profit organization Arts, Crafts and Theater Safety (ACTS) hotline number:

(212) 777-0062

Writing this book is only part of our commitment to the photographic community. The other part is to provide a continuous source of health and safety information and services. We welcome hearing from you.

Susan Shaw and **Monona Rossol**

CHAPTER

Photographic Chemicals and Our Bodies

INTRODUCTION

1.000 This chapter is primarily a lay discussion of chemical risk assessment and toxicology. These subjects may seem dry and irrelevant, yet the key to avoiding health problems lies in understanding them. To personalize the subjects, the authors include the following open letter from well-known photographer John Pfahl.

I'm OK now, but I've had a lot of interesting trouble with my health because of my love of photography. Interesting, yes, but nothing I would really recommend.

I started taking and making pictures in the days when safety was not an issue and when the toxic properties of photo and art materials were not as widely known as they are today. I thought nothing of spending eight-hour days with my hands splashing in black-and-white print chemistry or of screen-printing my photographs with plastic inks, inhaling strong smelling solvents. I taught for years in a poorly venti-lated color-printing facility. I made color prints in a rental darkroom where the same chemistry-laden air was constantly being recirculated. After all, I had a strong constitution, good genes, a healthy childhood. My body could take anything. Besides, it always seemed that getting the end result was so crucial that I had to do anything to achieve it. My work gave meaning to my life. I could and should make sacrifices for it.

I started getting strange flu-like symptoms about fifteen years ago, but not necessarily during flu season. They would last a couple of weeks and then disappear again. They never seemed to be connected to a cause, but would appear at random intervals. As the years passed, however, the intervals got shorter and shorter until I found that I was spending months at a time feeling fatigued, achy, and dizzy. I went to doctors, of course, but when nothing ever showed up on any of the tests,

11

the bottom line was, "It's in your head." Fortunately, I was always able to continue making pictures. My passion for photography enabled me to overcome all obstacles.

Fate finally led me to an allergist who had experience with environmental illness and who was able to diagnose and treat me with success. I learned that exposure to toxins of various kinds over the years had severely compromised my immune system. I had developed sensitivities to almost everything. I could not photograph near busy highways without reacting to exhaust fumes. I had to leave restaurants that had been recently cleaned with disinfectants. Moldy environments would put me into bed for days. However, I finally knew what was wrong and what to do about it. By making major changes in my every-day environment, my diet, even the air I breathed and the water I drank, I started to reverse the process. Very slowly, my body began to lose its extreme sensitivities and many of the symptoms started to go away.

Then, in June of 1990, I felt a small lump in my neck and was diagnosed as having non-Hodgkin's lymphoma, a type of cancer that has been associated with exposure to toxins. Fortunately, it is also a type of cancer that responds well to modern chemotherapy. After six months of difficult treatments my disease is now in complete remission. Whether there is a direct link to my profligacy with photo chemistry will always be open to question, but I have my personal convictions on the matter.

I now know that at no point did I have to make a choice between my art and my health. If I had known and taken seriously the information to be found in this book I could have done my work without endangering my health. By making simple modifications in my work habits and in the environment of the laboratories I used, I could have saved myself a lot of aggravation.

I seriously debated with myself whether or not to share my health problems with you. I am usually more reticent about such matters. But, I think it is so extremely important for you, as a photographer, to read and heed the advice in this book, that I have related my experiences.

Photography can be an extraordinarily beautiful and significant form of human endeavor, but, at the same time, it can be very hazardous to your health. You should have the information necessary to protect yourself. — **John Pfahl,** 1991

LOOKING AT THE RISKS

1.001 Clearly, photographic chemicals pose a significant threat to health. But the seriousness of the threat is dependant on many factors and requires an understanding of some basic concepts such as: risk, hazard, degree of exposure, total body burden, and toxicity.

Risks and Hazards

A hazard is determined by a material's inherent chemical, biological or physical properties. Toxic developer powders, for example, are an inhalation hazard because they are finely divided dusts which can be inhaled easily into the lungs. A risk, on the other hand, is the probability of damage due to the hazard. Wearing respiratory protection or enclosing the chemical mixing process reduces the risk of inhaling the developer powders. Working safely with any photographic process involves taking precautions against the hazards of photographic materials in order to reduce the risk of illness or injury.

Degree of Exposure

The greater the exposure to a hazardous material, the greater the risk. In most cases, exposure is determined by individual work practices. Important factors include the amount of materials or chemicals used and the frequency and duration of exposure. For example, a photographer who does small-scale darkroom work only occasionally, using a half-gallon solution of developer for one-time use, has a much lower risk than one who does continuous darkroom work that requires mixing and handling of large amounts of developer and other chemicals over a longer period of time.

Duration of exposure is a special concern for photographers. Many work long hours in the darkroom, sometimes far in excess of eight hours, for weeks or months at a time while preparing for an exhibition, working on a book or completing similar projects involving a deadline. For this reason, photographers may be periodically at a higher risk of damaging their health than is a traditionally employed worker who works with similar materials only eight hours a day, year round. Moreover, many photographers work at home, often without adequate space, ventilation or other protective measures. Without careful planning, the home darkroom produces high levels of indoor pollution, thus exposing not only the photographer, but other family members as well, to toxic photographic chemicals on a continuous twenty-four hour basis.

Multiple Exposures

Health risks may be increased and complicated if one is exposed to two or more chemicals simultaneously. In this case, the effects may be either additive or synergistic. Additive effects are those in which the combined effect of two or more chemicals is equivalent to the sum of the effects of each agent on the body. This occurs most commonly when the chemicals effect the body in similar ways. An example would be inhaling glue solvents and drinking alcohol.

Synergistic

Synergistic effects occur when exposure to two or more chemicals produces effects greater than the sum of the effects of each agent. A

well-known synergism occurs when both alcohol and barbiturates are ingested. Multiple effects are particularly significant if the chemicals attack the same organ system of the body. This is of special concern to photographers because many of their chemicals affect the skin. They can either damage the skin itself or can be absorbed through it, causing dermatitis, ulcers, allergies or defatting skin tissues. As a result of these multiple insults, skin problems and allergies are seen frequently among photographers and printmakers.

The Total Body Burden

An additional factor in assessing health risks is the total body burden of a given chemical or material. This is the cumulative effect on the body of all the different exposures to that chemical from various sources. If the total body burden of a substance exceeds the body's adaptive capacity to eliminate or detoxify the material, the result may be injury, disease or even death. An example of this type of cumulative hazard is that of lead, to which we are exposed from numerous environmental sources, and which is used in several photographic toners. If the total body burden of lead from all sources becomes excessive, lead poisoning can result.

High Risk Individuals

Individual susceptibility is another important factor in determining risk. Certain individuals, because of biological or other physical factors, tend to be more susceptible to the harmful effects of chemicals. For example, smokers and heavy drinkers are more likely to suffer various types of body damage than nonsmokers and nondrinkers, Such individuals are considered to be members of a high-risk group.

At greatest risk are fetuses of exposed mothers and infants who are breast-feeding. Even minute amounts of some chemicals transmitted through the placenta or ingested with breast milk can cause harm. Children, particularly the very young, comprise another important high-risk group. Their incomplete biological development and small body weight make them susceptible to amounts of toxic materials that would not harm an adult. Children under the age of twelve should not be exposed to photographic chemicals, solvents or other toxic materials. Older children and individuals in other high-risk groups will need to take extra precautions in order to reduce health risks if they are exposed to these materials. These precautions are discussed in Chapter 2 and in subsequent chapters under specific processes.

Other high risk groups include immune-suppressed individuals and people with chronic diseases, especially diseases of the heart, lungs, kidneys and liver; the elderly; and allergic individuals, particularly asthmatics. In addition, many people have a high individual susceptibility to chemical allergies because of genetic factors or as a result of massive or prolonged exposures to chemicals that cause allergic sen-

sitization. Formaldehyde, turpentine and para-phenylenediamine developers are examples of chemicals that can cause allergic sensitization in some individuals. Others who may be at high risk are those who are under increased physical or emotional stress and, as a result, may be temporarily less resistant to chemical exposures.

Toxicity

Toxicity is the final factor determining the risk of using a given chemical. The toxicity of a material or substance is its ability to cause damage to the body. The higher the toxicity, the smaller the dose needed to cause injury. Most developers, for example, are highly toxic by ingestion, with ingestion of less than one tablespoon of compounds such as hydroquinone or pyrogallol possibly being fatal in adults. By comparison, the fixing agent, sodium thiosulfate (hypo) is much less toxic, having only a mild purging effect on the bowels if large amounts are ingested. The question of which photographic chemicals are toxic and to what degree is considered in detail in Chapter 4.

WHAT IS THE MEANING OF TOXIC?

1.002 There are several methods currently used to evaluate the toxicity of chemicals that will be referenced in this book. We will use the following.

Lethal Dose/Concentration 50

For those chemicals that are toxic by ingestion, toxicologists measure the oral "LD50," which is the lethal dose or amount of that substance required to kill fifty percent of a group of laboratory animals, usually rats. For substances that are toxic by inhalation, the "LC50," or lethal concentration required to kill fifty percent of a group of laboratory animals, is the most common toxicity standard.

These measures of toxicity also are used in labeling of consumer products including many photographic chemicals under the provisions of the Federal Hazardous Substances Act in the United States and the Hazardous Products Act in Canada (See Table 1-1).

TABLE 1-1 LABEL DEFINITIONS OF TOXICITY IN THE US AND CANADA

label designation	LD50	LC50
nontoxic	> 5.0 g/kg*	>20,000 ppm**
toxic	.05-5.0 g/kg	200-20,000 ppm
highly toxic	< .05 g/kg	<200 ppm

* grams per kilogram of the animal's body weight.
** Parts per million: parts of the substance in 1 million parts of air.

Threshold Limit Values

The most universally excepted standards to measure the relative toxicity of airborne pollutants are Threshold Limit Values (TLVs). These are set by the American Conference of Governmental Industrial Hygienists primarily on the basis of industrial workers' experience and animal research. The TLV-Time Weighted Average (TLV-TWA) is the airborne concentration of a substance to which most healthy adult workers can be exposed eight hours a day, forty hours a week without adverse effects. When TLVs are adopted into occupational safety and health laws they are called Permissible Exposure Limits (PELs) in the United States and Occupational Exposure Limits (OELs) in Canada.

TLVs will be used throughout this book to aid readers in comparing the toxicity of various chemicals. Although additional factors such as evaporation rate must be considered, chemicals with low TLVs are usually more toxic (see table 2-2). For more detailed discussion of TLVs, see 2.038.

TABLE 1-2 THRESHOLD LIMIT VALUES OF SOME COMMON SUBSTANCES

Substance	TLV-TWA*
carbon dioxide (greenhouse effect gas)	5000.0 ppm**
ethanol (grain alcohol)	1000.0 ppm
acetone (nail polish remover)	750.0 ppm
turpentine, toluene, xylene	100.0 ppm
ammonia	25.0 ppm
formaldehyde, fluorine, hydrogen peroxide	1.0 ppm
bromine, phosgene (chemical warfare gas)	.1 ppm

*Threshold Limit Value-Time Weighted Averages from the 1990/1991 American Conference of Governmental Industrial Hygienist's List.
** Parts per million: parts of the substance in 1 million parts of air.

However, TLVs are difficult to apply to darkroom situations because special air sampling equipment and laboratory analysis is needed to know if they are exceeded. In addition, TLVs only address inhalation of airborne concentrations of toxic substances. They cannot be used to determine safe levels of exposure by skin contact, skin absorption or ingestion.

For this reason, a more general system of relative toxicity ratings also will be used throughout this book.

Relative Toxicity Ratings

In this system, each chemical is rated for its toxicity by different routes of entry: skin contact, inhalation and ingestion. Keep in mind that chemicals not significantly toxic by one route of exposure may have a

high toxicity by other routes of exposure. In assessing the overall toxicity of any chemical or material, all forms of possible exposure need to be considered.

It also is important to remember that these relative toxicity ratings apply only to healthy adults, not to children or high risk individuals such as pregnant women or people with chronic heart disease, lung disease or a history of allergy.

The ability of chemicals to cause cancer or birth defects will be indicated in this book separately from its relative toxicity. Some chemicals of very low relative toxicity can cause cancer. The relative toxicity system uses four categories: highly toxic, moderately toxic, slightly toxic and not significantly toxic. These categories are defined as follows.

HIGHLY TOXIC

1.003 A chemical is highly toxic if it causes major damage or fatality resulting from a single large (acute) exposure. Examples of photographic chemicals that are highly toxic by skin contact include concentrated acids and alkalis, and highly corrosive compounds such as mercuric chloride and lead oxalate. Other examples in this group are phenols, many amine compounds and catechin, pyrogallol, amidol and paraphenylene diamine developers that can be absorbed through intact skin to cause systemic damage.

Examples of chemicals that are highly toxic by inhalation include phenol compounds, concentrated ammonia gas or poisonous gases such as hydrogen cyanide and hydrogen sulfide, which may be released as by-products of photographic processes.

By ingestion, all photographic developers with the exception of phenidone are highly toxic, and a single large (acute) exposure can be fatal. Concentrated acids or alkalis, other corrosive chemicals, toxic metal compounds and phenols are also highly toxic by ingestion.

A chemical also is highly toxic if it causes major injury resulting from repeated, long-term exposures to normal amounts of the material. Examples of this level of long-term (chronic) toxicity include injury to major organ systems resulting from repeated inhalation or skin absorption of chlorinated hydrocarbon solvents; possible reproductive effects following repeated exposures to cellosolves and their acetates; or systemic poisoning from chronic inhalation or ingestion of lead or mercury compounds.

A chemical also is considered highly toxic if it leads to a high frequency of severe and possibly life-threatening allergies from exposure to normal amounts of the material, such as severe asthma from inhalation of para-phenylenediamine developer powders; or platinosis with lung scarring and emphysema from inhalation of platinum salts.

MODERATELY TOXIC

1.004 It is very important not to misinterpret the word "moderate." Serious injury can result from moderately toxic materials under certain circumstances.

A material is moderately toxic if it causes minor damage resulting from a single exposure to normal amounts of the material. Examples of such damage include slight chemical burns from skin contact with sodium carbonate (soda ash) or iodine; or nose and throat irritation resulting from inhalation of the dusts of potassium sulfide or potassium persulfate.

A chemical is also moderately toxic if it results in a minor injury from repeated normal exposures to the material, such as dermatitis from chronic skin contact with most developers or with most organic solvents used in printmaking, conservation and restoration.

Moderately toxic chemicals may cause major injuries and sometimes fatalities from single or repeated exposures to massive amounts of the material. Examples of this type of injury include liver and kidney damage from repeated skin contact and absorption of toluene or xylene, aromatic hydrocarbons; or an acute blood disease (called methemoglobinemia) from inhalation of large amounts of the powders of developers such as hydroquinone, metol or elon, catechin, glycin and aminophenol; or possible fatality from the ingestion of large amounts of potassium bromide.

Finally, moderately toxic materials may lead to allergies in a large number of people exposed to the chemical. Examples include skin or respiratory allergies from exposure to formaldehyde, chromium compounds, gold chloride, most photographic developers and turpentine.

SLIGHTLY TOXIC

1.005 A material is slightly toxic if it causes minor injury that is readily reversible resulting from single or repeated exposures to normal amounts of the chemical. An example of such injury is minor skin irritation which disappears as soon as contact is discontinued which is produced by one of the least toxic developers (phenidone). Other examples include slight irritation of nose and throat from chronic inhalation of low concentrations of mild solvents such as ethyl alcohol or acetone.

Slightly toxic chemicals can cause more serious injury if massive exposures or overdoses occur, such as iron poisoning from ingestion of large amounts of ferrous sulfate, or gastrointestinal disorders from ingestion of several ounces of hypo, potassium ferrocyanide or tannic acid. In addition, slightly toxic chemicals may lead to allergies in a small minority of the people exposed to the material, such as skin allergies from contact with alum hardeners.

NOT SIGNIFICANTLY TOXIC

1.006 A material is not significantly toxic if it causes toxic effects only under highly unusual circumstances or by exposure to massive amounts. Examples of such relatively non-toxic chemicals include sodium thiosulfate (hypo), which is not significantly hazardous by skin contact; 3% hydrogen peroxide solutions, which are not significantly toxic by inhalation; and sodium nitrate (bleach) solutions, which are not significantly toxic by skin contact or inhalation.

HOW EXPOSURE OCCURS

SKIN CONTACT AND ABSORPTION

1.007 Many irritating chemicals, including corrosives, acids and alkalis, amines, aldehydes, organic solvents and others, can attack and destroy the protective barriers of the skin. Many solvents can cause drying or defatting of skin tissue and can damage the skin's ability to produce protective oils. Once the epidermal or outer layer of the skin is damaged, toxic materials can enter the body more readily. Chemicals can also enter the body through preexisting sores, cuts and abrasions on the skin. If these chemicals get into the bloodstream, they are then transported to other parts of the body, including the various organ systems, where they may do further damage.

In addition, many photographic developers, organic solvents and other chemicals can penetrate intact skin directly. These chemicals, if absorbed through the skin, may cause symptoms of systemic toxicity in one or more organs of the body. Skin absorption of highly toxic chemicals such as pure phenol can be rapidly fatal.

The skin around the eyes and the eyes themselves are especially susceptible to damage from irritating chemicals. The damage may occur as a result of corrosive liquid splashes or from contact with irritating vapors. See eye injury (1.018).

INHALATION

1.008 Inhalation is a common way in which chemicals, small particles and germs gain entry into the body. Many toxic substances including solvent vapors, aerosol mists, powders, dusts, gases and metal fumes can cause direct damage to the respiratory system itself, as well as damage to other parts of the body if they are taken into the bloodstream through the mucous membranes lining the respiratory tract.

The respiratory system has several defense mechanisms against toxic materials. First, the nose contains mucous membranes and hairs to trap large particles, and receptor cells that provide us with a sense of smell to warn us when chemicals are present. When we are exposed

to chemicals for too long, olfactory fatigue—the loss of the sense of smell—occurs, indicating that these cells are overloaded and are no longer effectively detecting chemicals.

The mucous linings of the trachea and bronchial tubes represent the next line of defense against dust and small particles. The mucous traps dusts and particles. Small hair-like projections called cilia sweep the mucous upward until it is coughed out or swallowed.

The small muscles surrounding the bronchioles (the small branches of the bronchi) function as a defense against irritating chemicals. Gases such as ammonia and sulfur dioxide can trigger these muscles to spasm and close off the bronchioles. This reaction—a sudden choking feeling—may be familiar to photographers who work in small, unventilated darkrooms or in areas where the fixing bath and other solutions are left out to evaporate and decompose into irritating gases or vapors. These gases, vapors and toxic dusts can injure the lung tissues directly, and may also enter the bloodstream through the thin membranes of the air-sacs (alveoli) at the end of the respiratory system.

Smoking greatly amplifies all the hazards of airborne chemical pollutants. For example, smoking inhibits the motions of the tiny, hair-like cilia that carry mucous and toxins out of the lungs. In addition, cigarette smoke contains large amounts of finely divided dust particles as well as tars and other irritating substances. Toxic chemicals tend to adhere to the surfaces of these particles, and are thus transported more deeply into the lungs, where they may cause permanent damage.

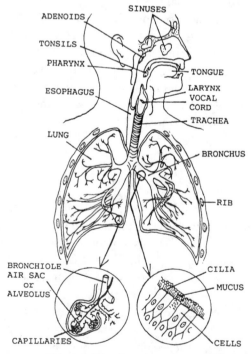

Fig. 1-1 The Respiratory System

Adapted from page 10 of *Occupational Lung Diseases*, American Lung Association, 1983.

INGESTION

1.009 Chemicals that are ingested, particularly corrosive ones, can have direct harmful effects on the tissues lining the mouth, throat and stomach wall. Toxic materials may also be absorbed into the bloodstream through the digestive tract, resulting in damage to the liver or other internal organs.

Deliberate or accidental ingestion of chemicals is still a frequent occurrence among children. Adults are more commonly poisoned by indirect means. For example, smoking, eating, drinking or applying make-up while working in the darkroom or studio, can increase the risk of accidental ingestion of small amounts of chemicals. Powdered chemicals and vapors tend to dissolve in drinks or collect on the surfaces of cigarettes and foods. Chemicals transferred to food from soiled hands and hand-to-mouth contact habits are other ways in which chemicals may accidentally be ingested.

The old practice of forming the point on a brush with the lips can result in serious ingestion hazards including possible poisoning from chronic ingestion of toxic dyes and pigments. Cases of accidental poisoning have also occurred from the pouring of chemicals into a nearby cup or glass that is later mistaken for a cup of coffee or other drink.

EFFECTS ON THE BODY

LOCAL VERSUS SYSTEMIC EFFECTS.

1.010 Chemicals used in photographic processes may affect the body in many ways. These effects can be local or systemic. Local effects cause irritation or injury at the immediate site of contact. Acids or strong alkalis splashed on the skin, for example, may cause burns or ulcerations.

Systemic effects occur when the chemical is absorbed by the body and causes damage in parts of the body far from the point of contact. Most solvents, for example, can cause effects on the brain (dizziness, nausea, etc.), although they are initially inhaled through the lungs or absorbed through the skin. In addition, many chemicals can affect more than one organ of the body at the same time. Potassium bromide, if absorbed or inhaled in amounts sufficient to cause poisoning, can damage both the skin, causing rashes, and the central nervous system (brain), causing depression, mental confusion and even hallucinations.

ACUTE VERSUS CHRONIC EFFECTS

1.011 Acute effects are serious illnesses resulting from single exposures to toxic chemicals by ingestion, inhalation or skin contact and absorption. Poisoning by ingestion is a classic example of this type of injury. Acute exposures may have three outcomes: complete recovery (if exposure is low enough), recovery with some level of disability (if exposure is higher), or death.

Although acute effects are usually observed immediately following the toxic exposure, acute illnesses can sometimes manifest themselves after a period of hours or even days following the exposure. An example of this type of delayed acute effect is the sudden and often fatal pulmonary edema that may occur eight to twelve hours following an exposure to high concentrations of the toxic gas, nitrogen dioxide, from nitric acid etching processes.

Chronic effects are usually caused by prolonged or repeated exposures to toxic chemicals, often in small amounts; and are characterized by a long latency period. An example of this type of illness is the chronic mercury poisoning found among daguerreotypists of the mid-nineteenth century, who were repeatedly exposed to the vapors of mercury.

Chronic effects more frequently encountered by photographers are chronic skin rashes or dermatitis from repeated contact with developer solutions, and chronic respiratory problems from repeated inhalation of acid vapors and irritant gases such as sulfur dioxide.

CANCER: A SPECIAL PROBLEM

1.012 Occupational Cancers are a special type of chronic illness. Chemicals which cause cancer are called carcinogens. Unlike ordinary toxic substances, the effects of carcinogens are not strictly dependent on dose. No level of exposure is considered safe. However, the lower the dose, the lower the risk of developing cancer. Occupational cancers typically occur 10 to 40 years after exposure. This period of time is referred to as a latency period.

The latency period makes it especially difficult to isolate a causative agent for cancer. Definite proof that a substance causes cancer in humans may require the study of hundreds or even thousands of people for many decades. It is easier to show that cancer is associated with certain populations. A recent study by the National Cancer Institute found an increased incidence of pancreatic cancer among press photographers than would normally expected. The cause of this increase is not known, but it raises concern about the many developing agents and color chemicals which are shown to cause cancer in test animals or mutations in cells or bacteria. By using these animal studies as a guide, scientists can extrapolate the risk for certain cancers to humans without waiting for a significant human body count.

Some substances such as some chromates (4.159, 4.175), benzidine dyes, certain chlorinated hydrocarbon solvents (4.249), and thiourea are known to cause cancer in humans. However, many substances used in photography have never been studied for their cancer-causing ability in humans or animals. Others may still be in the process of being evaluated.

In this book, the term "carcinogen" will be applied to all chemicals listed as such by the International Agency for Research on Cancer

(IARC) and the National Toxicology Program (NTP) in the United States, or to chemicals regulated in the workplace as carcinogens in either the United States or Canada. Those carcinogens for which there is also significant human evidence will be referred to as "human carcinogens."

Incomplete data related to carcinogenicity will also be reported if the authors consider it significant.

INJURY TO ORGAN SYSTEMS

1.013 THE SKIN. The skin is the largest and most directly accessible of all the organs. It is the third most fatty organ in the body, after the spinal cord and brain. Consequently it is particularly susceptible to attack by chemicals that can penetrate the outer layer or epidermis and cause the lipids (fatty tissues) in the skin to undergo various types of damage. Ultraviolet light, like certain chemicals, can penetrate the skin and cause uncontrolled cross-linking (forming undesirable bonds) between protein molecules as well as between lipids, a type of damage that results in loss of elasticity and in wrinkling. Chronic exposure to excessive amounts of ultraviolet light, such as the amounts generated by carbon arc lamps, may be a factor in the development of certain skin cancers over a prolonged period of time.

The skin is susceptible to other types of damage by a number of photographic chemicals. These include corrosives, solvents and other irritants, allergic sensitizers, chemicals that affect skin pigmentation and those that promote infections in skin tissues.

1.014 DIRECT IRRITATION. Chemicals that have a tendency to irritate and damage the skin directly are called primary skin irritants. These agents cause a type of inflammation of the skin known as irritant dermatitis, which is characterized by reddening, itching, blistering, thickening and flaking of the skin. Strong primary skin irritants such as concentrated acids, alkalis, amines, developers, chromium compounds, selenium compounds, silver nitrate, oxalates, permanganates and aldehydes (especially formaldehyde) can readily penetrate the epidermis and damage the underlying tissues after only a single exposure. Weaker primary irritants can cause dermatitis after prolonged or repeated exposures. These include diluted acids or alkalis, and most organic solvents. Many solvents, especially chlorinated hydrocarbons, can cause another type of damage by drying or defatting skin tissue, and removing its protective oils. Irritant dermatitis usually disappears when the exposure is stopped, but can become permanent if contact with primary irritants is prolonged.

1.015 SKIN ALLERGIES. Chemicals that can cause allergies in significant numbers of people are called sensitizers. Strong sensitizers used in photography that can cause skin allergies in susceptible people include form-

aldehyde, turpentine, gold and platinum salts and many developers such as metol, para-phenylenediamine and others. Numerous other chemicals are weaker sensitizers, capable of causing skin allergies in only a few, very susceptible individuals.

Allergic skin diseases are often called contact dermatitis or hypersensitivity dermatitis. Symptoms of these conditions can vary, but most often cause red and/or flaky patches, itching, and cracking of the skin. The condition may progress to sores and ulceration.

The initial exposure to a sensitizer does not provoke these symptoms. A sensitization period of seven to twenty-one days may be required for allergies to develop. Often, a person may be exposed to the chemical for months or years before the allergic reaction occurs. In fact, the longer one is exposed, the more likely it is that allergic sensitization will occur. Once sensitized, the body may react to small, sometimes even minute, amounts of the chemical. These reactions may occur at the time of exposure or within a day or two afterward. For example, skin contact may produce a rash during exposure, or a rash may develop a number of hours later. The body's ability to respond in this way is usually permanent and will occur whenever exposure reoccurs.

1.016 **SKIN CANCER.** Skin cancer, which usually takes from twenty to thirty years to develop, is not readily associated with most photographic chemicals. However, it may be caused by chronic exposure to carbon black (lamp black), a pigment used in many photographic printmaking processes, due to the presence of impurities in the carbon. In general, skin cancers, except melanomas, are considered less dangerous than other types of cancer, and are curable if detected early.

1.017 **OTHER SKIN DISEASES.** Repeated contact with photographic developers can cause lichen planus, an inflammatory skin disease characterized by tiny reddish papules that itch and can spread to form rough scaly patches on the hands. If exposure continues, these skin lesions can become eroded or ulcerated. There is also a potential for skin cancer to develop in lichen planus.

Changes in skin pigmentation, such as dark or light areas, can be caused by repeated exposure to some dyes, metal salts and chlorinated hydrocarbon solvents. Depigmentation of skin (and eyes) may occur after five years of repeated exposure to hydroquinone developer dusts.

Bacterial infections such as common acne and folliculitis can occur when the skin's oil glands, sweat glands, and hair follicles are blocked by oils, waxes and other materials. A special kind of acne called chloracne, a condition involving deeply pitted, blackened lesions and scarring of skin tissue, can be caused by skin contact, inhalation or ingestion of complex chlorinated hydrocarbons (such as PCBs and dioxin). All these skin conditions are easily prevented by avoiding

contact with causative agents and by washing often with soap and water.

Vitamin A and other dietary deficiencies also may be a factor in skin diseases and acne. Eating well and keeping in good general health also is recommended to prevent skin diseases.

THE EYES

1.018 Although our eyes are highly susceptible to damage, they have several defenses that help prevent injury. These include the eyelids and lashes, which keep large particles out of the eye; the conjunctiva, a membrane covering the eye and lining the inner surfaces and corners of the eyes; and tear ducts, which produce fluid to wash the surface of the eye and remove contaminants.

The eyes are sensitive to many chemicals used in photography and printmaking, as well as to physical injury from particulates (dusts) or from ultraviolet light. Damage can occur from splashing of corrosive liquids (acids and alkalis) or from their vapors. Contact with developer dusts or irritant gases such as ammonia, sulfur dioxide or formaldehyde can also result in serious injury to the eyes. Damage to the eyes may involve inflammation of the conjunctiva (known as conjunctivitis or pink eye), damage to the cornea, cataracts (opacity of the lens) and in-flammation of tear ducts.

Eye contact with aqueous ammonia solutions can result in severe irritation, and could lead to corneal ulceration and blindness. Contact with ammonia vapors or ammonia gas can also cause irritation and cor-rosive damage to the eyes.

Exposure of the eye to silver nitrate dust or liquid is corrosive and damaging to the eyes. Just as silver nitrate can produce a dark burn on the skin, so it can permanently darken the cornea and other eye tissues resulting in blindness.

Hydroquinone developer powders can also cause a specific type of eye injury. Following prolonged, repeated exposures to the dusts, brownish stains may appear on the conjunctiva. These may be fol-lowed by changes in the cornea that can result in loss of visual acuity. The early pigmentary stains are reversible, but the corneal changes tend to be progressive. After about five years of repeated exposure to the powder, depigmentation of eyes (and skin) may occur. Direct contami-nation of the eyes with hydroquinone powders causes immediate irri-tation and may result in corneal ulceration.

Wearing contact lenses in the presence of airborne gases, vapors and dusts can increase eye damage. Toxic chemicals can accumulate under the lenses, where they are pressed against the eyes. In addition, dusts from powdered chemicals can damage the lens plastic, causing pitting and subsequent scratching of the eyes. Gas permeable lenses tend to attract chemical vapors.

Photographers can protect their eyes against damage by wearing approved safety goggles during certain processes. The type of goggles that should be worn will vary according to the chemicals or processes involved. Goggles and other types of protective equipment are discussed in Chapter 2.

RESPIRATORY SYSTEM

1.019 The respiratory system is the primary route of entry for airborne chemicals into the body. Since photographic processes frequently involve the production of irritating gases and vapors, the respiratory system is especially vulnerable to injury from airborne contaminants. Many gases produced in photography are so irritating to respiratory tissues that a single exposure to even moderate amounts can cause injury. Example of highly irritating contaminants include sulfur dioxide, formaldehyde and ammonia; ozone and nitrogen oxides (from carbon arcs) and chlorine gas are also extremely irritating. Other less irritating chemicals that can severely damage the respiratory system include liquid vapors such as acetic acid, toluene, acetone, turpentine and other solvents, and caustic dusts such as sodium hydroxide, sodium carbonate, potassium dichromate and other corrosives.

1.020 **ACUTE RESPIRATORY DISEASE.** Chemicals can affect the respiratory system in many different ways. Irritant chemicals, for example can produce respiratory irritation in various parts of the respiratory system depending on their solubility in lung fluids and water. Highly soluble chemicals such as ammonia, sulfur dioxide, formaldehyde and the caustic dusts primarily injure the upper respiratory system because they dissolve quickly in the throat and large bronchi (or upper airways). These irritants cause immediate symptoms such as pain, hoarseness, sore throat, reddening and coughing. Only massive exposure to these chemicals will allow them to reach and damage the lower respiratory system.

Poorly soluble gases such as the nitrogen oxides, phosgene, and byproducts of carbon arc lamps and cigarette smoke are more hazardous than the soluble ones, because they can penetrate into the deeper parts of the lungs before dissolving. These gases and vapors have a burning effect on the more delicate tissues of the lower respiratory system, including the tiny air sacs, or alveoli, which tend to fill with fluid. Large exposures to these chemicals can cause pulmonary edema (fluid in the lungs). If the fluid fills a large area of the lungs, death may occur. Another possible complication is bacterial pneumonia, since fluid in the lungs provides an ideal growth medium for microorganisms.

Respiratory allergies represent another group of potentially acute respiratory diseases. An acute allergic response may affect the upper respiratory system, producing a hay fever-type syndrome, or it can af-

fect the lower respiratory system, causing asthma or alveolitis. Respiratory allergies, along with skin disorders, are common health problems among photographers and printmakers. Individuals with a history of respiratory allergies are especially susceptible.

A number of photographic chemicals can cause allergic reactivity in the tissues lining the respiratory tract. Severe respiratory allergies and bronchial asthma may be caused by inhalation of the dusts of paraphenylenediamine or aminophenol developers and other photochemicals. Photographers who do platinum printing may develop platinosis, a severe form of asthma, from inhalation of platinum salts. Printmakers may develop printer's asthma from inhalation of sprayed gum arabic resins.

Hypersensitivity pneumonia and pneumonitis are other, less common allergic responses that can be caused by exposure to certain dusts, fibers, bacteria and molds encountered by photographic conservators. These diseases are thought to result from an allergy to specific bacteria and molds. They can result, at worst, in scarring of lung tissues and permanent disability.

1.021 CHRONIC RESPIRATORY DISEASES. There are several chronic respiratory diseases which may result from exposure to photochemicals. Chronic bronchitis has been associated with repeated exposure to darkroom chemicals such as sulfur dioxide or to other lung irritants, even in small amounts. This disease is characterized by the excessive production of mucous, constriction of the bronchial tubes and recurrent coughing even on days when exposure does not occur.

Individuals who develop chronic bronchitis may also become very susceptible to respiratory infections, since the excess mucous is a breeding ground for bacteria and viruses. Victims may also have increased difficulty in breathing. Chronic bronchitis can also progress to emphysema if exposure to irritating chemicals continues. Emphysema is a severe chronic disease in which the fragile air sacs in the lungs, the alveoli, burst, producing pockets of "dead air" that are no longer available for breathing.

Cigarette smoke contains nitrogen oxides, aldehydes and other compounds which are lung irritants. Cigarette smoking can cause chronic bronchitis just as chemical irritants can, and the combined exposure may exacerbate an existing condition so that either chronic bronchitis or emphysema will progress more rapidly.

Cigarette smoking is also the most common cause of lung cancer because of repeated exposure to a class of chemicals—the polycyclic aromatic hydrocarbons—found in the "tars" of tobacco smoke. The risk of cancer is greatly increased when there is a simultaneous work-related exposure to cancer-causing chemicals. Chromate pigments such as lead chromate and zinc chromate used in printmaking processes are the only photographic materials that are known human lung carcino-

gens. Other chromium compounds commonly used in photography are suspected lung carcinogens. These include potassium dichromate, ammonium dichromate and chromic acid.

Respiratory allergies (see Acute Respiratory Diseases above) may manifest themselves as either acute or chronic illnesses depending on the severity of the exposure and the degree of sensitization of the individual.

CIRCULATORY SYSTEM

1.022 HEART. Several chemicals used in photographic processes can have a damaging effect on the heart. Inhalation of large amounts of many solvents can cause heart sensitization and even death ("glue sniffer's syndrome"). However, there are certain chemicals particularly noted for their effect on the heart. These include chlorinated hydrocarbons, fluorocarbons (spray propellants and film cleaners), toluene and carbon disulfide (a fumigant used in archival conservation).

Methylene chloride causes disturbances in the heart's rhythm. It also breaks down in the body to form carbon monoxide, and has caused fatal heart attacks. Methyl chloroform may cause heart sensitization to epinephrine, as well as arrhythmias (irregular heartbeat). Some Freons may also cause cardiac arrhythmias if inhaled at very high concentrations.

Chronic exposure to low levels of ozone, a toxic gas produced by carbon arc lamps and copy machines, can result in slowing of the heart and respiration rate. Individuals with lung damage are often very susceptible to a type of heart damage known as cor pulmonale, since scarring of the lungs causes the heart to work harder to pump blood through the narrowed vessels of the lungs. Thus, photographers and printmakers with chronic respiratory disease have an extra stress on their hearts, just as do people who are overweight, diabetic or smoke heavily.

1.023 BLOOD. One of the most important functions of the blood is to transport oxygen to the cells of the body. This is accomplished by the red blood cells, which carry hemoglobin. Some chemicals can interfere with the ability of hemoglobin to pick up and transport oxygen. One such chemical is carbon monoxide, a gas that is produced whenever there is incomplete combustion (for example, from carbon arc lamps or smoking cigarettes). Carbon monoxide readily combines with hemoglobin, forming a carboxyhemoglobin molecule that cannot be used for oxygen transport. This carboxyhemoglobin molecule is a cherry red color, and people with severe carbon monoxide poisoning have pink or cherry red faces and nails. Another source of carbon monoxide is from decomposition of the solvent, methylene chloride in the body.

Certain chemicals used in photography, including several developers and hydroxylamines used in color processing, can also interfere with the ability of hemoglobin to transport oxygen. These chemicals

oxidize the iron portion of the hemoglobin molecule to ferric iron, causing the acute blood disease methemoglobinemia. The principal sign of methemoglobinemia is cyanosis (bluish discoloration of the face, lips and nails) because the oxidized hemoglobin is incapable of transporting oxygen to the body tissues.

Other chemicals such as lead, benzene and naphthalene can disrupt the red blood cell membrane, resulting in hemolytic anemia. Lead entering the body can also cause anemia by preventing the formation of red blood cells. Benzene (benzol), an aromatic hydrocarbon solvent, can have a devastating effect on blood cells. Even in small amounts, benzene can destroy bone marrow, where new red blood cells, white blood cells and platelets are formed, causing aplastic anemia and leukemia, a type of blood cancer that is usually fatal. Ethylene oxide, a highly toxic fumigant gas, may also cause leukemia in humans. The toxicity of benzene and ethylene oxide is sufficient to warrant avoiding any exposure to them. Although benzene has been removed from consumer products for domestic use, until recently it was found in many paint and varnish removers used in printmaking processes. Benzene is present as a contaminant in gasoline or in some industrial solvent mixtures.

LIVER AND KIDNEYS

1.024 **LIVER.** Liver damage can be caused by many chemicals, including the developers para-phenylene diamine, catechin and pyrogallol, and solvents such as methyl cellosolve, toluene, xylene, chlorinated hydrocarbons and ethyl alcohol, as well as certain metal compounds including lead, cadmium, uranium, selenium and gold. Phenol and its compounds can also damage the liver. When the liver is damaged by overexposure to chemicals, it can no longer carry out its vital functions of metabolism and detoxification. This can result in injury to other parts of the body. Symptoms of liver damage may include jaundice (a yellowish or greenish tinge to the skin), tenderness and swelling of the liver, nausea, loss of appetite and fatigue. Hepatitis, or inflammation of the liver, is commonly thought of as a viral disease, but it can also be caused by toxic chemicals. If the exposure is discontinued the liver may regenerate and heal without permanent injury, unless the damage is very severe. Repeated exposures may result in cirrhosis, or scarring of the liver, which is irreversible.

1.025 **KIDNEYS.** Several types of kidney damage can be caused by exposure to chemicals used in photography and printmaking. Acute kidney disease can result from a loss of blood or from exposure to chemicals such as carbon monoxide or the common photographic developers that can interfere with hemoglobin and diminish the oxygen supply in the blood. When kidney tissues are starved for oxygen, they can no longer carry out their filtration and volume-regulating functions. This condition can

result in nonspecific symptoms such as high or low blood pressure, variation in sodium content of the blood and disturbances in the blood's acid-base balance.

A number of chemicals used in photography can damage the kidney tubules in particular, since the tubules may be exposed to large amounts of these substances during the removal of chemicals from the blood. This type of acute kidney damage may be severe enough to block urination and cause an accumulation of fluids and poisons in the blood, a condition known as uremia. Uremia can be caused by acute exposure to chemicals such as oxalic acid, turpentine, ethylene glycol, lead compounds, carbon disulfide and mercury. Symptoms of uremia include nausea, stomach irritation and liver damage; in severe cases uremia may result in coma and death.

A third type of acute kidney damage can be caused by chemicals or conditions (such as electrical shock) that result in the destruction of red blood cells or muscle tissue and release hemoglobin or the muscle protein myoglobin into the blood. These materials can clump to form a debris that causes blockage of the tubules, uremia and subsequent renal failure.

Chronic kidney disease can also be caused by a number of factors, including long-term chemical exposure and chronic conditions affecting the circulation. For example, high blood pressure can cause hardening of the kidney arteries, resulting in chronic impairment of kidney function. Long-term exposure to certain chemicals can cause chronic damage to kidney tubules, thus interfering with the filtration and reabsorption of substances in the bloodstream. Chemicals that can cause chronic kidney damage include several metal compounds (lead, cadmium, uranium and chromium), solvents (chlorinated hydrocarbons, cellosolves, carbon disulfide and turpentine), developers (catechin and pyrogallol), oxalic acid and oxalates.

In addition, a severe, immune-mediated type of chronic kidney disease (glomerular nephritis) can result from long-term exposure to common solvents such as petroleum distillates, aromatic hydrocarbons (toluene and xylene) and turpentine. This type of chronic kidney disorder is slowly progressive, and may have a latency period of up to twenty years with no warning signals, until it manifests as sudden, sometimes fatal kidney failure.

NERVOUS SYSTEM

1.026 The nervous system can be considered in two parts: the central nervous system, consisting of the brain and spinal cord; and the peripheral nervous system, consisting of the cranial nerves, the spinal nerves and the autonomic (involuntary) nervous system. Damage to the central nervous system is usually irreversible, whereas damage to the peripheral nerves can sometimes be reversed.

Some photographic chemicals, such as mercury and lead compounds, can affect both central and peripheral nervous systems. Chronic mercury poisoning can cause fine motor tremor of the muscles as well as severe psychological symptoms, indicating that injury to both central (brain) and peripheral nerves may occur. The psychological syndrome, called erethism, is often characterized by extreme irritability, depression, memory loss, confusion and explosive anger. This syndrome is depicted in the Mad Hatter in Lewis Carroll's *Alice in Wonderland,* whose character was in fact drawn from real hatters of the mid-nineteenth century who were exposed to mercuric nitrate and the vapors of mercury in the process of "carroting" felt hats.

Peripheral neuropathy, or inflammation of the nerves of the extremities, is a chronic nervous system disorder that can be caused by repeated exposures to either lead or mercury compounds. Chronic lead poisoning can result in "wrist drop" from paralysis of the nerves controlling the wrist muscles. Chronic mercury poisoning results in eventual paralysis of the extremities.

Certain chemicals can cause direct damage to the brain and central nervous system. These include the highly toxic gases hydrogen cyanide (produced by cyanide reducers in the presence of acid) and hydrogen sulfide (produced by sulfide toning solutions), which can directly poison the brain, causing loss of consciousness and rapid fatality. Brain damage can also occur indirectly, due to oxygen starvation from carbon monoxide poisoning. There is also evidence that a rare type of peripheral neuropathy may be associated with chronic, long-term exposure to cyanide compounds, even at relatively low levels of exposure. Other chemicals used in photography can damage the central nervous system in different ways. Massive exposure to bromide salts used as restrainers can cause bromide poisoning, characterized by severe psychoses and mental deterioration. Large amounts of sodium sulfite, a preservative in most developing solutions, can cause depression of the central nervous system. Potassium thiocyanate and sodium thiocyanate, used in color developers, can cause psychological symptoms similar to those caused by bromide poisoning if large amounts are ingested. Paraphenylenediamine developers, and other color chemicals such as tertiary-butylamine borane (TBAB), a fogging agent, and hydroxylamine sulfate, a neutralizing agent, can also cause central nervous system damage. Cellosolve (2-ethoxyethanol), a component of the bleach bath in some color processes, can cause narcosis and behavioral changes.

Essentially all solvents can cause depression of the central nervous system resulting in intoxication or narcosis. Acute symptoms of overexposure may include a feeling of being "high, " fatigue, dizziness, lack of coordination, mental confusion, sleepiness and nausea. Chronic low level exposures may produce symptoms that are mild or transient, even slight intoxication. However, a working lifetime of such exposures is

31

now known to cause a type of permanent brain damage whose symptoms include depression, irritability, sleep disturbances, short term memory loss, and motor coordination difficulties.

REPRODUCTIVE SYSTEM AND PREGNANCY

1.027 Certain chemicals used in photography can interfere with human reproduction in a number of ways and at a number of stages.

Reproductive effects. All of the solvents, including alcohol, will temporarily interfere with sexual function. Other solvents known to cause reproductive effects at low levels include the glycol ethers or cellosolves and their acetates. These are often used in photoresist (printmaking) materials and some color chemicals. They cause a number of adverse effects including atrophy of the testicles. Evidence exists that these effects are also seen in exposed workers.

Certain chemicals can affect the reproductive systems of both men and women, causing loss of sex drive, lowered fertility, genetic damage and problems in conceiving. For example, high levels of lead in the body can cause menstrual disorders, loss of sex drive, and possible sperm damage.

Studies of chemicals for their effects on both the male and female reproductive systems are not very adequate at this time. For this reason, it may be advisable for individuals of either sex who are planning a family to avoid undue exposure to photographic chemicals.

Effects on the pregnant woman. During pregnancy, certain metabolic changes occur that make women more susceptible to the damaging effects of a larger number of chemicals, particularly those which can injure the respiratory system or the circulatory system. Chemicals that affect these systems include most solvents, metal compounds, and gases such as sulfur dioxide, ammonia, hydrogen selenide and others. Carbon monoxide from carbon arcs can be especially harmful to the pregnant woman.

Toxic effects on the fetus. Chemicals that can have a direct toxic effect on the developing fetus are called embryotoxins. The heavy metals lead, cadmium and copper are examples of embryotoxic substances that can cross the placenta during pregnancy, causing stillbirths and miscarriages. Other examples of embryotoxins used in photographic processes include the organic solvents cellosolve, methyl cellosolve and their acetates, certain chlorinated hydrocarbons and the toxic gases carbon monoxide.

Birth defects. Some of the chemicals which are toxic to the fetus are also suspected teratogens. These substances may cause birth defects, even when present in very small amounts. These chemicals affect the fetus in the first trimester by interfering with organ development. Lead compounds used as photographic toners are examples of chemicals with teratogenic potential. Glycol ethers and hydroxylamine com-

pounds used in color processing are suspected teratogens since they produce birth defects in laboratory animals.

Mutations. Chemicals that can cause genetic damage are a special problem because even low levels of exposure may cause mutations. Mutagens (mutation-causing chemicals) can damage reproductive cells by altering the DNA structure (genetic information) in chromosomes. This type of damage can occur in both sexes, affecting egg as well as sperm cells. Exposure of the fetus to mutagens may result either in spontaneous abortions and in birth defects which can be passed to future generations. Chemicals used in photographic processes which are suspected mutagens include lead and its compounds, the chlorinated hydrocarbon trichloroethylene (TCE) used in printmaking, and ethylene oxide, a fumigant gas used in conservation.

Cancer. It is believed that some cancer-causing chemicals can have a carcinogenic effect on the children of women exposed to those substances during pregnancy. The classic example of this effect is the drug DES (diethylstilbesterole). This aspect of carcinogenicity is least studied of all.

Effects on the infant and child. Even the residues of toxic chemicals in the mother's milk can have a damaging effect on the breast-fed infant. Children, especially those under the age of twelve, are also highly susceptible to solvent vapors, toxic gases, metal dusts and corrosive substances. If the darkroom or studio is located in the home, family members, including children, may be subjected to these hazards on a continual basis unless living areas are completely separated from the work area, ventilation is adequate, and excellent hygiene is practiced.

Precautions. Black and white processing is not generally associated with reproductive hazards unless photographers also use certain metal-containing toners or intensifiers. With these exceptions, photographers using proper precautions should be able to work without substantial risk of reproductive effects. But for those doing color processing, printmaking or photographic conservation using organic solvents, color chemicals, heavy metals, dyes, pigments or fumigant gases, the risks of reproductive effects are considerably greater.

Determining the degree of these risks is difficult because the effects of most chemicals on the reproductive system, including most photographic chemicals, have not yet been adequately tested. There is concern that many chemicals do have adverse effects even at very low levels of exposure on both men and women.

Furthermore, the advisability of low level exposure to common chemicals, once thought to be relatively "harmless" to pregnant women, is now being reconsidered by scientists and physicians. Many physicians no longer recommend that pregnant women use alcohol, cigarettes, or even aspirin during pregnancy. Grain alcohol, once thought a relatively harmless substance, has recently been shown to

cause "fetal alcohol syndrome," a combination of birth defects and mental deficits. Some cases of "fetal alcohol syndrome" have been seen in mothers exposed to gasoline and glue solvents rather than alcohol. This suggests that other organic chemicals solvents may have similar effects.

Due to the increased susceptibility of a pregnant woman to many chemicals used in photographic processes, it is not possible at present to assume that she can work safely in a darkroom or studio if she works with solvents, dyes, heavy metals, toxic gases and other hazardous substances, even if precautions are taken. Since the first trimester (twelve weeks) of the pregnancy is often the most vulnerable stage, it is prudent to avoid all highly toxic chemicals throughout this period. Ideally, such chemicals should be avoided from the moment a pregnancy is planned (before conception) to the cessation of breast-feeding.

THE IMMUNE SYSTEM

1.028 It is now apparent that the immune system can also be affected adversely by chemical exposure. When toxic chemicals enter the body, the cells of the immune system, such as the white blood cells, also try to intervene to protect the body. Interaction between the immune system and chemicals can result in three main types of injury: 1) autoimmunity; 2) allergy and/or chemical hypersensitivity; and 3) immune suppression,.

Autoimmune diseases are disorders of immunologic regulation in which cells of the immune system become overly reactive (and destructive) to one's own body tissues. Gold salts can cause autoimmune diseases in certain individuals, and sensitization to color developers can result in lichen planus, a skin disease that is an immune-mediated, connective tissue disorder that is similar in many respects to autoimmune disease.

Allergies and chemical hypersensitivity can be caused by a number of photographic chemicals including formaldehyde, certain metal salts (platinum, mercury) and most developer chemicals.

Immunosuppression may involve defects in various compartments of immunity, or injury to a particular cell population such as T and B lymphocytes or the phagocytes (types of white cells). For example, heavy metals such as lead, cadmium, and mercury can suppress the immune system and impair the ability of an individual to resist bacterial and viral diseases.

Some developers, such as hydroquinone, catechol and phenol, are related to benzene and are suspected by some experts to be able to affect bone marrow to suppress production of blood cells which would impair the immune system.

2 Photography and the Law

2.001 A host of laws and regulations affect almost every aspect of our work. For example, fire, health, and safety laws affect how we design commercial and classroom studios and darkrooms. There also are laws affecting the use, storage, and disposal of professional and industrial photochemicals and, in some cases, some common household and hobby products as well.

These laws apply because many materials used in photography contain substances which now are known to be both toxic to people and hazardous to the environment. And due to increasing awareness of health and environment hazards, progressively stricter regulation and enforcement is inevitable.

Schools and universities that teach photography should be providing leadership in compliance with these laws. Instead, some of these institutions are operating in violation or in ignorance of these regulations themselves. Even sadder, they continue to send students out into the world who are ignorant of the laws designed to protect them on the job and which regulate their use and disposal of chemicals. And so, the cycle of non-compliance continues.

To break this cycle, there is a new law which mandates formal health and safety training for all employees, including teachers, who may use or be exposed to potentially toxic materials (see The Right-To-Know below). It is also imperative that schools transmit this training to their students or they risk legal actions for failing to meet their obligations to inform and protect their students.

If schools and businesses do not train and protect their employees willingly, governmental agencies, and sometimes the courts, can force

them to. This enforcement is necessary and beneficial, despite the bitter complaints we hear about restrictive Occupational Safety and Health Administration (OSHA) rules and excessive jury awards.

And certainly, enforcement works. One inspection, citation, or lawsuit has been observed to improve safety practices in an entire district overnight.

LAWS PROTECTING WORKERS

2.002　Both the United States and Canada have very complex regulations governing the relationship between employer and employee. However, whether the regulations are called the Occupational Safety and Health Act (OSHAct in the United States) or Occupational Health and Safety Act (OHSAct in Canada), their main purpose is very simple—to protect workers.

In the United States, the OSHA regulations general duty clause reads in part that "every employer covered by the Act shall furnish to his employees employment and a place of employment which are free from recognized hazards...." The Canadian OHSAct requires employers and supervisors to "take every precaution reasonable in the circumstances for the protection of a worker."

These brief general statements serve as the foundation for complex regulatory structures. Both Acts include rules about chemical exposures, noise, ladder safety, machinery guarding, and a host of subjects. Many of these rules apply to schools and photography-related businesses.

All of us should be aware of these rules. In my opinion, even high schools should not graduate students who are unacquainted with their rights in the workplace. If you are not familiar with these regulations, call your nearest Department of Labor and obtain a copy of the occupational safety and health general industry standards. Although they are not reader-friendly, become as familiar with them as possible.

THE RIGHT-TO-KNOW

2.003　Certain recently instituted regulations are proving particularly useful in pressing us to upgrade our health and safety practices. These are the so-called "right-to-know" laws.

In the United States, right-to-know laws were first passed by a number of individual states. Then a similar federal regulation called the OSHA Hazard Communication Standard (HAZCOM) was instituted. The result is that almost all employees in the United States now are covered by one or the other (sometimes both) of these laws. Even federal workers, so long exempt from OSHA regulations, come under this rule. There is a similar history in Canada with the resulting passage of

the federal Workplace Hazardous Materials Information System (WHMIS).

For the most part, both these laws require employers to provide written hazard communication programs, give workers access to complete inventories and data sheets for all potentially hazardous chemicals in the workplace, and require formal training of all employees who potentially are exposed to toxic chemicals.

Even an ordinary office worker comes under the rule if he or she works long hours with an ozone-producing copy machine. That worker must be told of the effects of ozone, shown what kind of ventilation is necessary to reduce it to acceptable limits, given access to a data sheet describing details of the toner's hazardous ingredients and instructed formally about what to do if the toner spills.

How much more, then, should the law be applied to photographers who use hazardous photochemicals, dyes, solvents, and so on. Yet many schools and photography-related businesses still do not comply with the new laws. These institutions should be aware that today, OSHA gives more citations for hazard communication violations than for any other rule infraction.

SPECIAL RIGHT-TO-KNOW FOR LABORATORIES

2.004 In the United States, some specialized photo labs may come under a separate right-to-know law designed especially for chemical laboratories. This special law defines a laboratory as one where " `laboratory use of hazardous chemicals' occurs. It is a workplace where relatively small quantities of hazardous chemicals are used on a non-production basis."

Some photo and film conservation and restoration labs may qualify. In general, the standard is a bit more complex and requires a higher degree of technical knowledge about chemicals among employees. Those who think they may come under this standard should contact their local OSHA office for a copy of the regulations and further information.

WHO'S COVERED?

2.005 Essentially, all employees* in the United States are covered by state, or federal hazard communication (right-to-know) laws. All employees in Canada are covered by the Workplace Hazardous Materials Information System (WHMIS). All employers in workplaces where hazardous materials are present, therefore, are required to develop programs and train their employees. (The employer is the person or entity that takes the deductions out of the paycheck.)

Self-employed photographers and teachers are not covered, but may be affected by the laws. For example, if you work as an indepen-

dent contractor working or teaching at a site where there are employees, all the products and materials you bring onto the premises must conform to the employer's right-to-know program labeling requirements. Your use of these products also must conform.

Teachers in the United States have a unique right-to-know obligation arising from the fact that they can be held legally liable for any harm classroom activities cause their students. To protect their liability, teachers should formally transmit to students right-to-know training about the dangers of classroom materials and processes. They also must enforce the safety rules and act as good examples of proper precautions.

(Precautionary training need not be done by elementary school teachers since they should not use photochemicals and other materials for which training would be required.)

* State and municipal employees in 23 states that do not have an accepted state OSHA plan are still exempt. However, many of these voluntarily comply in order to avoid jeopardizing their insurance coverage.

COMPLYING WITH THE RIGHT-TO-KNOW

2.006 To comply, call your local department of labor and ask them whether you must comply with a state/provincial or federal right to know. Then, ask for a copy of the law which applies to you and any available explanatory materials. Some of the government agencies have prepared well-written guidelines to take you through compliance step by step.

GENERAL RIGHT-TO-KNOW REQUIREMENTS

2.007 There are small differences between the United States and Canadian laws. For example, the definition of "hazardous" varies, and the Canadian law requires information in French. However, the two laws require employers to take similar steps toward compliance:

1. Inventory all workplace chemicals. Remember, even products such as bleach and cleaning materials may qualify as hazardous products. List everything. (This is an excellent time to cut down paper work by trimming your inventory. Dispose of old, unneeded or seldom-used products.)

2. Identify hazardous products in your inventory. Apply the definition of "hazardous" in the right-to-know law which applies to you.

3. Assemble Material Safety Data Sheets (MSDSs) on all hazardous products. Write to manufacturers, distributors, and importers of all products on hand for MSDSs. Require MSDSs as a condition of purchase for all new materials.

4. Check all product labels to be sure they comply with the law's labeling requirements. Products which do not comply must be relabeled or discarded.

5. Prepare and apply proper labels to all containers into which chemicals have been transferred. (Chemicals in unlabeled containers that are used up within one shift need not be labeled.) Rules for the types of information and warning symbols which conform to your right-to-know law can be obtained from your local department of labor.

6. Consult Material Safety Data Sheets to identify all operations which use or generate hazardous materials. Be aware that nonhazardous materials when chemically reacted, heated, or burned may produce toxic emissions which com under the law.

7. Make all lists of hazardous materials, Material Safety Data Sheets, and other required written materials available to employees. (The OSHA Hazard Communications Standard also requires a written Hazard Communications program which details all procedures.)

8. Implement a training program. See Training (2.029).

9. Check to see if you are responsible for additional state and provincial requirements. In the United States, the Supreme Court recently upheld (July 3, 1989) the right of states to enforce certain amendments to the federal right-to-know (HAZCOM) law.

THE INVENTORY

2.008 The first step in any program to control chemical hazards, is to make a complete inventory of all the products you use. The list also should include all ordinary consumer products—even if your right-to-know law does not require it. This is necessary because consumer products may be used on the job in greater amounts or in ways which are not typical. For example, a small tube of glue meant to be used a drop at a time may become hazardous when a full tube is used at once.

Be careful to include all soaps, cleansers, and maintenance products. Many of these now are known to contain toxic materials. Consumer artist's paints, tinting dyes, and pigments are often especially hazardous. In both the United States and Canada, artist's materials are exempt from the consumer paint lead laws and often contain lead, cadmium, and a host of toxic ingredients.

Reduce your inventory by discarding old materials for which ingredient information is no longer available. Throwing things away is often psychologically difficult for teachers and others who have spent years existing on tight budgets. However, it is a violation of the right-

to-know laws to have any materials in the workplace which are unlabeled, improperly labeled, or whose hazards and ingredients are unknown.

READING CONSUMER PRODUCT LABELS

2.009 To identify hazardous materials in your inventory, begin by reading product labels. However, do not assume that the label will warn of all the product's potential hazards. The truth is that the hazards of many of the ingredients in consumer products have never been fully studied, especially for chronic hazards.

Evaluating label information is further complicated by the fact that some photographic products are imported. By law, these products' labels are supposed to conform to standards in the United States or Canada. However, many improperly labeled products escape scrutiny and turn up in stores.

Even if the labeling meets standards, the label terminology may be difficult to interpret. The following United States and Canadian label terms illustrate the point:

2.010 **USE WITH ADEQUATE VENTILATION:** Many people think this means a window or door should be kept open while using the product. It actually indicates that the product contains a toxic substance which becomes airborne during the product's use and the ventilation should be sufficient to keep the airborne substance below levels considered acceptable for industrial use (see section on industrial Threshold Limit Values). Sufficient ventilation could vary from an ordinary exhaust fan to a specially designed local exhaust system depending on the amount of the material and how it is used.

In order to plan such ventilation, you must know exactly what substance the product gives off and at what rate. Ironically, this is often precisely the information the manufacturer excludes from the label.

2.011 **NONTOXIC.** Under the provisions of the United States Federal Hazardous Substances Act and the Canadian Federal Hazardous Products Act, toxic warnings are required only on products capable of causing acute (sudden onset) hazards. Products which can cause long-term hazards such as cancer, birth defects, allergies, chronic illnesses, and cumulative poisoning legally may be labeled "nontoxic".

To illustrate how grossly inadequate this labeling is, powdered asbestos could legally be labeled "nontoxic" under these laws. This is because the laws identify hazardous products by short-term tests which expose animals through skin and eye contact, inhalation, and ingestion (see LD^{50} and LC^{50}, 1.002). Two weeks after exposure, the animals are examined for harm. Since asbestos causes only long-term damage

(cancer, asbestosis), the animals will be unharmed in this period of time.

An amendment to the US Federal Hazardous Substances Act will change this inequity. The amendment requires chronic hazard labels for art materials. It will also allow the Consumer Product Safety Commission (CPSC) to ban all materials, which are required to carry either acute or chronic warnings, from grade six and under.

The new law became effective in November of 1990. Enforcement is still not very aggressive, but changes in art materials labeling can be expected soon. The CPSC has stated that once its chronic toxicity guidelines for enforcement of the new amendment are finished, they will be applied to all U.S. consumer products.

2.012 CHRONIC LABELING STANDARDS. The new law incorporates a toxicity standard for art materials developed in 1988 by the American Society of Testing and Materials which is identified as "ASTM D-4236." All art materials are now required to be evaluated by a toxicologist who will certify that the product meets this standard. All art material labels must include the statement "conforms to ASTM D-4236-88," must list any chronic hazards known to exist in the product and the ingredients which are responsible, must provide any warnings and precautionary advice necessary, and must include a telephone number at which the consumer can obtain further information about the chronic hazards.

When the CPSC finishes formalizing it's guidelines, all consumer products must be evaluated by a toxicologist who will certify that the product meets the CPSC guidelines. Presumably even photographic materials which are knowingly sold for household darkroom or school use will come under the new law. If the photochemical industry wishes to retain the general consumer market, they may have to do a considerable amount of relabeling.

The new law is an important step in providing consumers with better labeling. However, photographer's and artist's materials contain a great number of chemicals for which no chronic data exists. Among these, there may be many hazardous chemicals which still may be present in products without any warnings.

2.013 LABELS FOR INDUSTRIAL OR PROFESSIONAL USE ONLY. Products carrying this label are not supposed to be available to general consumers and should never be used by children or untrained adults. This label is meant to warns workers that they should be skilled in the use of the product and should have a Material Safety Data Sheet (see next section) as a guide to safe use of the product.

MATERIAL SAFETY DATA SHEETS

2.014 Material Safety Data Sheets are forms which provide information on a product's hazards, and the precautions required for its safe use in the

working environment. Material Safety Data Sheets are usually filled out by the product's maker and the quality of the information varies depending on the diligence and cooperativeness of the individual manufacturer. However, manufacturers are responsible to their respective government agencies for the accuracy of information they provide.

The Material Safety Data Sheets are essential starting points for the development of a data base for health and safety programs. They should not be considered complete sources of information on their own.

2.015 **WHO NEEDS THEM?** The Hazard Communications Standard, WHMIS, and right-to-know laws require that Material Safety Data Sheets be made available to all those who use or could be exposed to potentially hazardous products in the workplace. This would include not only the product's users, but those working near the material, those storing or distributing the material (in case of breakage), anyone exposed to airborne emissions from the products use, and so on.

All employers and administrators are required by law to obtain Material Safety Data Sheets and make them available to all employees. Teachers who are employees, must have access to Material Safety Data Sheets and should in turn make them available to all students old enough to understand them. Self-employed photographers should also obtain Material Safety Data Sheets for their protection as well.

In addition, all employers and administrators are responsible for training employees to interpret and use Material Safety Data Sheet information. See Training (2.029).

2.016 **HOW ARE THEY OBTAINED?** Material Safety Data Sheets can be obtained by writing to manufacturers, distributors, or importers of the product. Schools, businesses, and institutions can require Material Safety Data Sheets as a condition of purchase. If makers or suppliers do not respond to requests for Material Safety Data Sheets, send copies of your requests and other pertinent information to the agency responsible for enforcing your federal or local right-to-know law. These agencies usually get very good results.

Products for which there are no Material Safety Data Sheets or incomplete Material Safety Data Sheets must be removed from the workplace and replaced with products for which this information is available.

2.017 **WHERE SHOULD THEY BE KEPT?** Material Safety Data Sheets should be filed or displayed where the products are used and stored. For schools, experience has shown that the best procedure is to have a central file for all Material Safety Data Sheets and also to have smaller files in each classroom, shop, or work area which contains copies of the Material Safety Data Sheets used at that location.

Material Safety Data Sheet
May be used to comply with
OSHA's Hazard Communication Standard.
29 CFR 1910 1200 Standard must be
consulted for specific requirements

U.S. Department of Labor
Occupational Safety and Health Administration
(Non-Mandatory Form)
Form Approved
OMB No. 1218-0072

IDENTITY *(As Used on Label and List)*

Note: *Blank spaces are not permitted. If any item is not applicable, or no information is available, the space must be marked to indica'e that.*

Section I

Manufacturer's Name	Emergency Telephone Number
Address *(Number, Street, City, State, and ZIP Code)*	Telephone Number for Information
	Date Prepared
	Signature of Preparer *(optional)*

Section II — Hazardous Ingredients/Identity Information

Hazardous Components (Specific Chemical Identity; Common Name(s))	OSHA PEL	ACGIH TLV	Other Limits Recommended	% *(optional)*

Section III — Physical/Chemical Characteristics

Boiling Point		Specific Gravity (H_2O = 1)	
Vapor Pressure (mm Hg.)		Melting Point	
Vapor Density (AIR = 1)		Evaporation Rate (Butyl Acetate = 1)	
Solubility in Water			
Appearance and Odor			

Section IV — Fire and Explosion Hazard Data

		LEL	UEL
Flash Point (Method Used)	Flammable Limits		
Extinguishing Media			
Special Fire Fighting Procedures			
Unusual Fire and Explosion Hazards			

(Reproduce locally)

OSHA 174, Sept. 1985

Fig. 2-1 Material Safety Data Sheet (U.S.)

Section V — Reactivity Data

Stability	Unstable		Conditions to Avoid
	Stable		

Incompatibility (*Materials to Avoid*)

Hazardous Decomposition or Byproducts

Hazardous Polymerization	May Occur		Conditions to Avoid
	Will Not Occur		

Section VI — Health Hazard Data

Route(s) of Entry:	Inhalation?	Skin?	Ingestion?

Health Hazards (*Acute and Chronic*)

Carcinogenicity:	NTP?	IARC Monographs?	OSHA Regulated?

Signs and Symptoms of Exposure

Medical Conditions
Generally Aggravated by Exposure

Emergency and First Aid Procedures

Section VII — Precautions for Safe Handling and Use

Steps to Be Taken in Case Material Is Released or Spilled

Waste Disposal Method

Precautions to Be Taken in Handling and Storing

Other Precautions

Section VIII — Control Measures

Respiratory Protection (*Specify Type*)

Ventilation	Local Exhaust		Special
	Mechanical (*General*)		Other

Protective Gloves	Eye Protection

Other Protective Clothing or Equipment

Work/Hygienic Practices

✩ U S G P O 1986-491-529/45775

Fig. 2-1 Material Safety Data Sheet (continued)

Minimum Information Required on Canadian Material Safety Data Sheets for Controlled Products

Hazardous Ingredient Information

 I. Chemical identity and concentration
 a) of the product (if the product is a pure substance);
 b) of each controlled ingredient (if the product is a mixture);
 c) of any ingredient that the supplier/employer has reason to believe may be harmful; and
 d) of any ingredient whose toxic properties are unknown.
 2. The products CAS, UN and/or NA registration numbers.
 a) CAS=Chemical Abstracts Service Registration Number.
 b) UN=number assigned to hazardous materials in transit by the United Nations.
 c) NA=number assigned by Transport Canada and the United States Department of Transportation and for which a UN number has not been assigned.
 3. The LD^{50} and LC^{50} of the ingredient(s).
 a) LD^{50}=the dose (usually by ingestion) which kills half of the test animals in standard acute toxicity tests.
 a) LC^{50}=the airborne concentration which when inhaled kills half of the test animals in standard acute toxicity tests.

Preparation Information

 1. The name and telephone number of the group, department or person responsible for preparing the Material Safety Data Sheet.
 2. The date the Material Safety Data Sheet was prepared.

Product Information

 1. The name, address, and emergency telephone number of the product's manufacturer and, if different, the supplier.
 2. The product identifier (brand name, code or trade name, etc.)
 3. The use of the product.

Physical Data

 Physical state (gas, liquid, solid), odor and appearance, odor threshold (level in parts per million at which the odor becomes notice-able), specific gravity, vapor pressure, vapor density, evaporation rate, boiling point, freezing point, pH (degree of acidity or alkalinity), and co-efficient of water/oil distribution.

Fig. 2-2

Fire and Explosion Hazards

Conditions under which the substance becomes a flammable hazard, means of extinguishing a fire caused by the substance, flash point, upper flammable limit, lower flammable limit, auto-ignition temperature, hazardous combustion products, explosion data including sensitivity to mechanical impact and to static discharge.

Reactivity Data

1. Conditions under which the product is chemically unstable.
2. Name(s) of any substance with which the product is chemically unstable (will react hazardously).
3. Conditions of reactivity.
4. Hazardous decomposition products.

Toxicological Data

1. Route of entry (skin contact, inhalation, ingestion, eye contact).
2. Acute effects.
3. Chronic effects.
4. Exposure limits (Occupational Exposure Limits, Threshold Limit Values, etc.).
5. Irritancy.
6. Sensitization potential (ability to cause allergies).
7. Carcinogenicity.
8. Reproductive toxicity.
9. Teratogenicity (ability to cause birth defects).
10. Mutagenicity (ability to cause mutation).
11. Synergistic effects (names of substances which may enhance toxic effects).

Preventative Measures

1. Personal protective equipment needed.
2. Specific engineering controls required (e.g. ventilation).
3. Spill or leak procedures.
4. Waste disposal methods.
5. Handling procedures and equipment.
6. Storage requirements.
7. Special shipping information.

First Aid Measures

Specific first aid measures in event of skin/eye contact, inhalation or ingestion.

Fig. 2-2 (continued)

2.018 **WHAT DO THEY LOOK LIKE?** To begin with, the words "Material Safety Data Sheet" must be at the top. Some manufacturers resist sending Material Safety Data Sheets, sending instead sheets labeled "Product Data Sheet," "Hazard Data Sheet," or other improper titles. These information sheets do not satisfy the law's requirements.

Although Material Safety Data Sheets must contain the same basic information, the actual sheets may look very different. For example, some are computer generated and some are government forms. Figure 2-1 is a copy of the most recent United States Material Safety Data Sheet form (the OSHA 174 form). The Canadian forms require similar information (Figure 2-2); one important difference being that they require the chemical's odor threshold (OT) when known. This is a practical piece of information. For example if the Odor Threshold is higher than the Threshold Limit Value, workers know they are overexposed if they can smell the substance.

2.019 **INFORMATION REQUIRED ON MATERIAL SAFETY DATA SHEETS.** All of the information on the form in Figures 2-1 and 2-2 should be on a Material Safety Data Sheet. In general, Material Safety Data Sheets should identify the product chemically (with the exception of trade secret products), identify any toxic ingredients, list its physical properties, its fire and explosion data, its acute and chronic health hazards, its reactivity (conditions which could cause the product to react or decompose dangerously), tell how to clean up large spills and dispose of the material, identify the types of first aid and protective equipment needed to use it safely, and discuss any special hazards the product might have.

2.020 **HOW TO READ MATERIAL SAFETY DATA SHEETS.** It would take a small book to explain how to read a Material Safety Data Sheet and define all the terms you are likely to encounter. Fortunately there already are many small books and pamphlets on this subject. Your local department of labor, and many other organizations publish such items. You should obtain some of these materials and append them to your written right-to-know program to be used as training aids. (See Bibliography, References for Chapters 1 through 4.)

There are some common problems which are associated with photographic Material Safety Data Sheets that should be addressed here. (Remember that some Material Safety Data Sheets are not divided into the sections below, but all the information should be present somewhere in the Material Safety Data Sheet.)

2.021 **SECTION I** — The Material Safety Data Sheet must have the manufacturer's name, address, and emergency telephone number at the top. It is the company whose name is on the Material Safety Data Sheet that is responsible for providing you with information and help.

Some manufacturers send out other companies' Material Safety Data Sheets. This improper procedure occurs because some small manufacturers use other companies' raw materials and either mix them to make their product or simply relabel them.

The Material Safety Data Sheet also must be written with the intended use of the product in mind. For example, if a product is meant to be sprayed and the Material Safety Data Sheet only reflects the hazards of the material in liquid form, the Material Safety Data Sheet is improper for the use intended.

Some suppliers send old, outdated Material Safety Data Sheets. Check the date of preparation. If there is no preparation date or if the Material Safety Data Sheet is several years old, demand a more recent one. In Canada, three-year-old Material Safety Data Sheets are automatically invalid.

2.022 **SECTION II—HAZARDOUS INGREDIENTS.** The definition of a "hazardous ingredient" varies in different state, provincial, and federal laws. But the OSHA Hazard Communication Standard definition is most frequently used. OSHA considers as hazardous, any chemical which is a physical hazard (flammable, unstable, etc.) or a health hazard. Health hazard is further defined to mean any "chemical for which there is statistically significant evidence based on at least one study..."

This means that a chemical must be listed if there is even one proper animal study indicating a potential problem. On the other hand, manufacturers may decline to list many chemicals which have never been studied at all. Some of these also may be health hazards.

Some photographic chemical manufacturers decline to list any of their ingredients because they claim their products are proprietary or trade secrets. Users should be aware that there are legal criteria for claiming trade secret status. If you receive a Material Safety Data Sheet for a trade secret product, call your department of labor to find out if these criteria were met. For example, in many states, a trade secret product must be registered with the state health department or Department of Labor.

Uninformative Material Safety Data Sheets with most of the blanks left empty may be sent. Insist that Material Safety Data Sheets be complete. Even when the product is not very hazardous, the blanks should be filled with information showing that this is the case.

Proper identification of an ingredient should include: chemical name, chemical family, synonyms, and common name(s). Good Material Safety Data Sheets also include the "CAS" number. "CAS" stands for the Chemical Abstracts Service, an organization that indexes information about chemicals. The CAS number enables users to look up information about the chemical in many sources.

Exposure limits should also be listed if they exist. For example: ACGIH-Threshold Limit Values, OSHA-Permissible Exposure Limits,

and Canadian Occupational Exposure Limits (2.038). Sometimes manufacturers will also list their own recommended limits if no others exist for the material.

The percentage of each ingredient in materials that are mixtures is optional, but many manufacturers supply them.

2.023 **SECTION III—PHYSICAL/CHEMICAL CHARACTERISTICS.** Boiling point, evaporation rate, and other properties of the material are listed here. The description of appearance and odor can be compared to the look and smell of your product to verify that you have the right Material Safety Data Sheet.

2.024 **SECTION IV—FIRE AND EXPLOSION HAZARD DATA.** Flash point and other data are listed here along with information about the proper fire extinguisher to use and any special fire hazard properties of the material. This section should be consulted when planning emergency procedures.

2.025 **SECTION V—REACTIVITY DATA.** Photographers who experiment with their media should pay special attention to the section on reactivity. This section describes how stable the material is, under what conditions it can react dangerously, and materials with which it is incompatible. If you do not understand this section, do not experiment.

2.026 **SECTION VI—HEALTH HAZARD DATA.** Toxicological information about the product is summarized here. You may need to use one of the resources listed in the Appendix to look up some of the terminology or abbreviations. Remember that this data is only a summary. Further investigation is often needed.

Cancer information which should be included on United States Material Safety Data Sheets includes whether the material is considered a cancer agent by either the National Toxicology Program (NTP), the International Agency for Research on Cancer (IARC), or OSHA. If any of these agencies consider the material to be carcinogenic, it should be treated as such. This system will also be used in this book.

2.027 **SECTION VII—PRECAUTIONS FOR SAFE HANDLING AND USE.** Use the information in this section to plan storing and handling of the material. Waste disposal information is usually not detailed because so many different local, state, provincial, and federal regulations exist. Check regulations that apply to your location.

2.028 **SECTION VIII—CONTROL MEASURES.** Proper respiratory protection, ventilation, and other precautions should be described here. Consult the section in this book on ventilation and respiratory protection for more detailed information.

TRAINING

2.029 Since right-to-know laws already are in effect, all employees in both the United States and Canada already should have received their training. Additional training should take place whenever new employees are hired or new materials or processes introduced. Some state and provincial laws require yearly training as well.

 The amount of time the training should take is not specified. This is because the law intends the training requirements to be performance oriented—that is, the employees must actually understand whatever information they need to recognize the hazards of their specific jobs and how to work safely. Often, short quizzes are used to verify that the employees have understood the presentation.

 The material taught should consist of basic industrial hygiene which has been adapted for the lay person. Industrial hygiene is the science of protecting worker's health through control of the work environment.

 Training for photographers and teachers can usually be accomplished in a full day. The information which must be communicated includes:

1. The details of the hazard communication program that the employer is implementing, including an explanation of the labeling system, the Material Safety Data Sheets and how employees can obtain and use hazard information.

2. The physical and health hazards of the chemicals in the work area. This should include an explanation of physical hazards such as fire and explosions, and health hazards such as how the chemical enters the body and the effects of exposure.

3. How employees can protect themselves. This should include information on safe work practices, emergency procedures, use of personal protective equipment that the employer provides, and explanation of the ventilation system and other engineering controls that reduce exposure.

4. How the employer and employees can detect the presence of hazardous chemicals in the work area. This should include training about environmental and medical monitoring conducted by the employer, use of monitoring devices, the visual appearance and odor of chemicals, and any other detection or warning methods.

REQUIRED TRAINING PROGRAM MATERIAL

2.030 Employers are expected to communicate certain concepts to their employees if they are to meet training requirements for the right-to-know

laws. First they need materials from their Department of Labor about the specific requirements of the law which applies to them. Next, they need technical information about health and safety hazards. Much of this book can be used for this part of the training program. The program should include the basic toxicology principles covered in Chapter One, the general precautions in Chapter Three and all the material in this chapter. It is especially important that training programs for photographers provide an in-depth understanding of inhalation hazards and Threshold Limit Values covered below.

INHALATION HAZARDS

2.031 Health-damaging chemicals can enter our body by inhalation, skin contact and ingestion. Exposure by skin contact usually can be prevented by wearing gloves, using tongs to handle materials, and the like. Ingestion can be prevented by good work habits and by not eating, smoking, or drinking in the workplace. Precautions against inhalation are more complex.

To prevent inhalation of airborne chemicals, it is first necessary to understand the nature of airborne contaminants such as gases, vapors, mists, fumes, and dust.

2.032 **GASES.** Gases vary greatly in toxicity. They can be irritating, acidic, caustic, poisonous, and so on. Some gases also have dangerous physical properties such as flammability or reactivity. Toxic gases which may be encountered in photography include: sulfur dioxide from decomposition of sulfites in baths, acetic acid, and formaldehyde from offgassing of some formaldehyde-preserved solutions.

Some gases are not toxic. An inert gas such as argon or neon used in some lighting bulbs is an example. Such gases are dangerous only when present in such large quantities that they reduce the amount of oxygen in the air to levels insufficient to support life. These gases are called asphyxiants.

Freons, still used in spray cans to dust prints, are gasses of very low toxicity, although some Freons are associated with heart problems at high concentrations. See Table 2-1 (2.038) for toxicity of darkroom air contaminants.

Scientists define gas as "a formless fluid" that can "expand to fill the space that contains it." We can picture this fluid as many molecules moving rapidly and randomly in space. Air, for example, is a mixture of different gases—that is different kinds of molecules. Even though each different gas has a different molecular weight, the heavier gases will never settle out because the rapid molecular movement will cause them to remain mixed. In other words, once gases are mixed, they tend to stay mixed.

In almost all cases, gases created during photoprocessing are mixed with air as they are released. This means that they also will not sink even if they are heavier than air. Instead they will "expand into the space that contains them." In most cases the gas will diffuse evenly throughout the space—the darkroom—in time.

When the gas escapes from the room or is exhausted from the room by ventilation, expansion of the gas continues (theoretically) forever. It is this expansion, for example, that causes spray-can propellants to reach the stratospheric ozone layer.

Under certain conditions, gases will not freely mix with air. For example, gases may layer out or take a long time to mix with air in locations where there is little air movement—such as in storage areas. In this case, gases that are heavier than air will sink to the floor. Large volume gas releases will also behave this way.

2.033 **VAPORS.** Toxic vapors created in photography include organic chemical vapors from solvent-containing products such as some color developers and film cleaners. Vapors, like gases, may vary greatly in toxicity, flammability and reactivity.

Vapors are the gaseous form of liquids. For example, water vapor is created when water evaporates—that is, releases vapor molecules into the air. Once released into the air, vapors behave like gases and expand into space. However, at high concentrations they will recondense into liquids. This is what happens when it rains.

There is a common misconception that substances do not vaporize until they reach their "vaporization point"—that is their boiling point. Although greater amounts of vapor are produced at higher temperatures, most materials begin to vaporize as soon as they are liquid.

Even some solids convert to a vapor form at room temperature. Solids that do this are said to "sublime." Mothballs are an example of a chemical solid which sublimes.

2.034 **MISTS.** Mists are tiny liquid droplets in the air. Any liquid, water, oil, or solvent, can be misted or aerosolized. Some mists, such as paint spray and air brush mists, also contain solid material. Paint mist can float on air currents for a time. Then the liquid portion of the droplet will vaporize—convert to a vapor—and the solid part of the paint will settle as a dust.

The finer the size of the mist droplets, the more deeply the mist can be inhaled and the more likely it is to harm delicate lung tissues. In general, a mist of a substance is more toxic than the vapor of the same substance at the same concentration. This results from the fact that when inhaled, the droplets deliver the mist in little concentrated spots to the respiratory system's tissues. Vapors, on the other hand, are more evenly distributed in the respiratory tract, and some vapor will be expired on exhalation.

2.035 **FUMES.** Fumes are very tiny particles usually created in high heat operations such as welding, soldering, or foundry work. They are formed when hot vapors cool rapidly and condense into fine particles. For example, rare earth metals such as cerium and lanthanum fume when carbon arcs are burning.

Fume particles are so small (0.01 to 0.5 microns in diameter)* that they tend to remain airborne for long periods of time. Eventually, however, they will settle to contaminate dust in the workplace, in the ventilation ducts, in your hair or clothing, or wherever air currents carry them. Although fume particles are too small to be seen by the naked eye, they sometimes can be perceived as a bluish haze rising like cigarette smoke from carbon arcs or welding operations.

Fuming tends to increase the toxicity of a substance because the small particle size enables it to be inhaled deeply into the lungs. In addition to many metals, some organic chemicals, plastics, and silica will fume. Smoke from burning organic materials including cigarettes also contain fume-sized particles.

Laymen commonly use this term to mean any kind of emission from chemical processes. In this book, however, only the scientific definition will be used.

2.036 **DUSTS.** Dusts are formed when solid materials are broken down into small particles by natural or mechanical forces. Sanding and sawing are examples of mechanical forces which produce dusts. Powdered dry photochemicals contain dust-sized particles.

The finer the dust, the deeper it can be inhaled and the more toxic it will be. Respirable dusts—those which can be inhaled deeply into the lungs—are too small to be seen with the naked eye (0.5 to 10 microns in diameter).

2.037 **SMOKE.** Smoke is formed from burning organic matter. Burning wood and hot wire-cutting plastics are two smoke-producing activities. Smoke is usually a mixture of many gases, vapors, and fumes. For example, cigarette smoke contains over four thousand chemicals, including carbon monoxide gas, benzene vapor, and fume-sized particles of tar.

* A micron is a metric system unit of measurement equaling one millionth of a meter. There are about 25,640 microns in an inch. Respirable fume and dust particles are in the range of 0.01 to 10 microns in diameter. Such particles are too small to be seen by the naked eye.

EXPOSURE STANDARDS

2.038 Exposure to airborne chemicals in the workplace is regulated in the United States and Canada. The United States limits are called OSHA Permissible Exposure Limits (PELs). The Canadian limits are called

Occupational Exposure Limits (OELs). Although the levels at which various chemicals are regulated may differ occasionally, both country's regulations are based on a concept called the Threshold Limit Values (TLVs). The Permissible Exposure Limit and Occupational Exposure Limit for most substances are identical to the Threshold Limit Value. Threshold Limit Values are airborne substance standards set by the American Conference of Governmental Industrial Hygienists (ACGIH). Copies of the Threshold Limit Values can be obtained from the ACGIH (see address in Bibliography).

Threshold Limit Values are designed to protect the majority of healthy adult workers from adverse effects. There are three types:

1. Threshold Limit Value-Time Weighted Average. Threshold Limit Value-Time Weighted Averages are airborne concentrations of substances averaged over eight hours. They are meant to protect from adverse effects those workers who are exposed to substances at this concentration over the normal eight-hour day and a forty-hour work week.

2. Threshold Limit Value-Short Term Exposure Limit. Threshold Limit Value-Short-Term Exposure Limits are fifteen minute average concentrations that should not be exceeded at any time during a work day.

3. Threshold Limit Value-Ceiling. Threshold Limit Value-Ceilings are concentrations that should not be exceeded during any part of the workday exposure.

Threshold Limit Values should not be considered absolute guarantees of protection. Threshold Limit Values previously thought adequate have repeatedly been revised as medical tests have become more sophisticated, and as long-term exposure studies reveal chronic diseases previously undetected.

At best, Threshold Limit Values are meant to protect most, but not all, healthy adult workers. They do not apply to children, people with chronic illnesses, and other high risk individuals.

Threshold Limit Value-Time Weighted Averages also do not apply to people who work longer than eight hours a day. This is especially true of people who live and work in the same environment, such as photographers with home darkrooms. In these cases, very high exposures have been noted, since the individual is likely to be exposed to contaminants twenty-four hours a day. With no respite during which the body can detoxify, even low concentrations of contaminants become significant.

Expensive and complicated air-sampling and analysis are usually required to prove that Threshold Limit Values are exceeded. For this reason, Threshold Limit Values are primarily useful to photographers as proof that a substance is considered toxic, and that measures should

be taken to limit exposure to substances with Threshold Limit Values.

Photographers should also be aware that many substances known to be toxic have no Threshold Limit Values. In some cases the reason for this that there is insufficient data to quantify the risk from exposure.

When additional factors, such as evaporation rate, are considered, photographers also can use Threshold Limit Values to compare the toxicity of various chemicals. Threshold Limit Values cannot be used as direct comparisons of toxicity because they are each set to protect workers from a chemical's dominant effect such as eye irritation, cancer, or nerve damage. However in general, the smaller the Threshold Limit Value, the more toxic the substance.

Gases and vapors with Threshold Limit Value-Time Weighted Averages 100 parts per million (ppm) or lower can be considered highly toxic. Table 1 lists the Threshold Limit Value-Time Weighted Averages of some gaseous and vapor air contaminants.

Dusts are not commonly created in photoprocessing except during weighing of dry chemicals. In general, dusts whose Threshold Limit Value-Time Weighted Averages are set at ten milligrams per cubic meter (mg/m3) are considered only nuisance dusts. Particulates with Threshold Limit Value-Time Weighted Averages smaller than 10 mg/m3 are more toxic. For example, the TLV-TWA for hydroquinone is 2 mg/m3. Table 2 lists some Threshold Limit Values for photochemical dusts.

TABLE 2-1 THRESHOLD LIMIT VALUE-TIME WEIGHTED AVERAGES* OF SUBSTANCES USED IN PHOTOGRAPHY (in order of increasing toxicity)

gas or vapor	darkroom or studio source	ppm**
Freons (e.g. # 12 & 13)	"dust off" aerosol products	1000.
butane	propellant for some aerosol products	800.
xylene	many printmaking resists and developers	100.
n-hexane	rubber cement and thinner solvent	50.
ammonia	diazo copiers	25.
acetic acid	stop bath	10.
hydrogen sulfide	emitted by sulfide-containing toners	10.
cellosolve & its acetate	some color systems, photo resists, etc.	5.
catechol (catechin)	a photodeveloping chemical	5.
sulfur dioxide	emitted by sulfite-containing baths	2.
formaldehyde	preservative-some color processing chemicals	1.
bromine	daguerreotype accelerator	0.1

* Threshold Limit Value-Time Weighted Averages from 1991 ACGIH list.
** ppm = parts per million.

TABLE 2-2 THRESHOLD LIMIT VALUES-TIME WEIGHTED AVERAGES* OF PHOTOCHEMICAL DUSTS (in order of increasing toxicity)

dust or mist	milligrams per cubic meter	
nuisance dusts: dusts with no significant hazards such as	10.	(total dust)
chalk (calcium carbonate)	10.	" "
sodium bicarbonate (baking soda)	10.	" "
sodium bisulfite	5.	" "
sodium metasulfite	5.	" "
hydroquinone	2.	" "
uranium compounds	0.2	(as U)
para-phenylenediamine	0.1	(total dust)
chromic acid	0.05	(as Cr)
mercury compounds (inorganic)	0.05	(as Hg)
platinum salts (soluble)	0.002	(as Pt)

* Threshold Limit Value-Time Weighted Averages from the 1991 ACGIH list.

Credit: Most of the material in this chapter was adapted for photography from *The Artist's Complete Health and Safety Guide*, Allworth Press, 1990.

3

Safety in the Darkroom and Studio

SETTING UP A SAFE WORKSPACE

3.001 There is a popular notion today that photographers should be able to set up a darkroom or studio just about anywhere, provided they have enough ingenuity and a few basic resources. After all, early photographers worked in covered wagons, and Alfred Stieglitz reportedly did his printing under equally primitive circumstances, using a table draped with a floor-length cloth for a darkroom. This approach to photography, however romantically appealing, is inadequate today. Early photographers worked under such primitive conditions by necessity, unaware of the health risks involved in prolonged or repeated exposures to toxic materials. Today, much more is known about the hazards of photographic chemicals. The fact that potentially toxic materials are being used should be a major consideration in determining the proper location for a darkroom or studio, as well as an impetus to develop safe work practices.

HOME DARKROOM PROBLEMS

3.002 Many photographers have their darkrooms at home, and printmakers often work out of home studios. This can be hazardous. First, because exposure to toxic chemicals may be extended over long periods of time, and second because other family members may be similarly exposed. For example, if living areas have a faint odor of photochemicals or solvents, the family's exposure is occurring twenty-four hours a day. Even without odor, continuous exposure to chemicals below the odor threshold and to dusts may be occurring. In these cases, even very low levels of indoor pollution become very significant.

Home studios also may be located in inappropriate rooms. Common locations for home darkrooms or studios are bathrooms and kitchens. In kitchens, photography and printmaking dusts and vapors may contaminate food. Bathrooms are usually small, heavily trafficked areas where contamination of surfaces with chemicals can easily result in exposure by skin contact. Enclosed rooms such as closets may not provide sufficient space and usually cannot be provided with proper ventilation.

In fact, rooms in an ordinary home or apartment usually are not sufficiently ventilated for photographic processes. Good ventilation (see Ventilation 3.032) must be provided before considering home work. Dilution ventilation is adequate for hobbyists doing occasional black and white processing. More hazardous procedures such as toning, intensifying, and color processing should not be done at home unless special local exhaust ventilation is installed.

In addition, all the rest of the general safety precautions listed in this chapter apply to home darkrooms. If small children are present in the home, or if living and working areas cannot be totally separated, it is not advisable to work at home. Those who cannot afford their own darkrooms or studios may want to consider leasing a location where several photographers share the costs.

CHOOSING A LOCATION

3.003 The following basic physical requirements should be considered when determining the suitability of a particular location.

RUNNING WATER. There should be a source of readily accessible running water, not only for processing purposes, but for washing after work, for cleaning up spills, and for flushing the skin or eyes with large amounts of water if chemical splashes occur.

EASY ACCESS TO OUTSIDE AIR FOR VENTILATION. Windows or easily penetrated outside walls may be needed in order to install ventilation. Basements, laundry rooms or large closets are usually unsuitable since these locations often do not have windows and may have inside or cement walls.

SUFFICIENT DISTANCE FROM OTHER LIVING SPACES. Venting your toxic air contaminants into other tenants' apartments or lofts may not only cause conflicts, but runs counter to most local air pollution and/or health department codes. Some regulations require air contaminants to be vented above the roof of the building. If this is the case, an upper floor location would be advantageous.

ACCESS TO WASTE DISPOSAL. Research the sewage regulations and waste pick-up rules at the proposed location. Studios whose drains lead to septic systems present almost impossible waste and clean up problems, since many chemicals can poison the system. Most communities do not permit solvents to be flushed down drains and some local laws prohibit flushing of photochemicals. Failure to comply with waste disposal laws may result in exceedingly large fines. General guidelines for proper disposal of toxic wastes are discussed below (3.021).

SUITABLE CHEMICAL STORAGE FACILITIES. Research local codes regarding storage of chemicals. For example, many areas have laws regulating the amount of flammable solvents that can be stored. Some communities require inventories of chemicals be given to local fire marshals.

ELECTRICAL SAFETY. The workspace needs to be large enough to separate wet and dry areas so that electrical outlets can be located in dry areas only. Ground fault interrupters should be installed on each outlet. The darkroom or studio needs to have enough electrical wiring to carry the required load. Kodak book K-13, Photolab Design, contains extensive guidelines and diagrams on proper locations and layouts for various photographic processes within a workspace (see Bibliography). This publication may be of assistance.

EMERGENCY EXITS. All darkrooms and studios should have at least two exits in case of fire or medical emergencies. The emergency exit could be a gasketted light-tight door or a breakaway panel.

ESSENTIAL PROTECTIVE EQUIPMENT

3.004 Darkrooms and photographic printmaking studios or workshops should have the following safety equipment:

3.005 **FIRE EXTINGUISHERS.** These need to be approved according to the materials that are used and the type of fire they can cause. For example, Class A fires caused by ordinary combustibles such as wood, paper or textiles require a water-based extinguisher; Class B fires caused by solvents and other flammable materials require a dry chemical or carbon dioxide type extinguisher, as do Class C, or electrical fires. Class D fires caused by combustible metals require a dry powder-type fire extinguisher. For photography and photographic printmaking materials, a combination A-B-C type fire extinguisher is recommended.

The fire extinguisher(s) should be easily accessible, placed near exits, and anyone working in the darkroom or studio should know how to operate them. Ideally, hands-on training sessions should be attended by all those who might be called on to use the extinguisher in an emergency. In some communities, local fire departments will provide this

training. Fire extinguishers should also be checked annually to ensure that they are fully charged and working properly.

3.006 EMERGENCY EYEWASH FOUNTAINS & DELUGE SHOWERS. For emergencies in which large amounts of corrosive acids, alkalis, solvents or other irritants are splashed or spilled on the skin or into the eyes, deluge showers and eyewash fountains are required to prevent severe injury by delivering quantities of water to affected areas.

On the job, eye washes should be capable of delivering 15 minutes of continuous washing, and must be located in the darkroom or studio. If deluge showers are required, they must be within 25 feet of places where corrosive chemicals are handled. The equipment should meet the requirements of American National Standards Institute (ANSI) Standard Z 358.1-1981. Workers must be formally trained in emergency procedures.

If standard equipment is unaffordable for individual home photographers, an alternative type of eyewash fountain can be fashioned out of about six inches of flexible rubber tubing attached to a cold-water faucet in the immediate vicinity of the workspace. An ordinary shower located in the same part of the house can serve as a deluge shower. These substandard solutions should only be used if the home studio photographers work is restricted to premixed black and white chemistry, and no glacial acetic acid or equally corrosive chemicals are present. (Remember, these suggestions for home photographers will not satisfy workplace regulations.)

3.007 SPRINKLER SYSTEMS. If flammable materials are used, an automatic sprinkler system should be installed in the darkroom or studio. Even if these materials are not used, fire extinguishers and smoke detectors are essential precautions against fire and should be present in the workspace.

3.008 SMOKE DETECTORS. Smoke detectors save lives. Photoelectric-type detectors are recommended, since they are more sensitive to smoldering fires than the ionization-type units (and they are better for the environment). Smoke detectors can be especially important if the studio or darkroom is in the home.

3.009 FIRE BLANKETS. Fire blankets should be accessible to anyone in or near the work area. In the event that clothing catches on fire, a fire blanket can be used to smother the flames.

3.010 FIRST AID KIT. A standard industrial first aid kit purchased from any reliable safety supply company should be available. It should be clearly visible from all areas of the work space (see 3.056). For home darkrooms, include materials for assisting children who accidentally ingest materials, such as syrup of Ipecac.

3.011. LIST OF EMERGENCY TELEPHONE NUMBERS. A list of emergency telephone numbers should be posted in a convenient place next to the telephone and should include the local fire department, hospital, doctor, ambulance service, poison control center and police. In addition, post the twenty-four hour emergency numbers from the photographic manufacturer's Material Safety Data Sheets for immediate information about their products (see 3.013).

SUBSTITUTIONS: CHOOSING SAFER MATERIALS

3.012 The substitution of safer for more toxic materials is one of the first rules of safety. Substitution is the simplest way to decrease the risk of health effects from exposure to photographic chemicals or from accidents. By comparing the toxicity ratings of various chemicals, the least toxic materials can be used for a particular purpose.

For example, among the common black and white developers, several are highly toxic and should be avoided if at all possible. These included diaminophenol hydrochloride (amidol), para-phenylene diamine, catechin (catechol), pyrogallic acid and chlorquinol. The least toxic developer by skin contact is phenidone; others such as monomethyl para-aminophenol sulfate (metol) are moderately toxic. Therefore, if phenidone can be substituted for a highly toxic developer such as amidol or para-phenylene diamine, the safety factor will be increased.

If it is desirable to use the more toxic materials for aesthetic reasons, then photographers should familiarize themselves with the hazards of those materials and take all precautions for handling them safely. For some individuals, the choice of developer may not be a question of aesthetic trade-off, but of physical necessity. Once skin rashes or allergies become a problem, it may be necessary for some people to switch to a phenidone developer in order to continue working at all.

Substitution of safer materials is even more important when solvents or solvent mixtures are used. The least toxic solvents include denatured alcohol, acetone and isopropyl alcohol, while the most toxic solvents are the aromatic hydrocarbons, chlorinated hydrocarbons, cellosolves and the cellosolve acetates. Most other solvents are moderately toxic. Therefore, any time a solvent such as acetone or mineral spirits can be substituted for aromatic hydrocarbons, health risks are decreased. In some cases, the selection of an alternative material may involve the substitution of one hazard for another. For example, acetone is less toxic, but more flammable than most other solvents. Thus, in choosing acetone, the risk of fire is increased. This is still an acceptable alternative, however, since protection against fire hazards can be achieved much more easily than protection against the toxic effects of solvents.

Certain photographic materials should be avoided altogether be-

cause they are so highly toxic that they cannot be used safely, even if all proper precautions are taken. Alkali cyanide salts used as photographic reducers are an example of this extreme hazard. Other materials, such as carbon tetrachloride, should be avoided because they are known or suspected human carcinogens. Materials that should not be used, and their possible substitutes, are listed in Table 3-1.

TABLE 3-1 "DO NOT USE" PHOTOGRAPHIC MATERIALS

MATERIAL	USE	POSSIBLE SUBSTITUTE
Metal compounds:		
chromic acid (4.037)	bromoil bleach	copper sulfate (4.081)
lead acetate (4.088)	cyanotype toner	tannic acid (4.049)
lead nitrate (4.089)	salted paper toner	gold chloride (4.087) potassium chloride
lead oxalate (4.090)	platinum toner	potassium phosphate (4.061)
mercury (vapor) (4.093)	Daguerreotype	iodine (4.121) (Becquerel method)
mercury chloride (4.091)	intensifiers	chromium intensifiers(5.026)
& mercuric iodide (4.092)	& preservatives	thymol (4.028)
uranium nitrate (4.108)	intensifier, platinum toner; salted paper	silver nitrate (4.104] gold chloride (4.087)
Oxidizing agents		
potassium cyanide (4.124)	reducers	potassium ferricyanide (4.101)
& sodium cyanide (4.133)	& intensifiers	chromium intensifiers (5.026)
Solvents		
benzene (4.245)	lacquer thinner, general cleaning	benzine (4.274) mineral spirits (4.275) with 10% toluene (4.246) added
carbon tetrachloride (4.241)	lacquer thinner, general cleaning	same as above
dioxane (4.278)	movie film cleaner	mineral spirits (4.275)*
gasoline (4.273)	printmaking solvent	mineral spirits (4.275) or kerosene (4.276)
trichloroethylene (4.250)	printmaking solvent	presensitized plates (9.018) water-soluble resists (9.018)
Conservation fumigants		
carbon disulfide (4.277) ethylene oxide, propylene oxide, Vikane, methyl bromide, & other restricted use pesticides (10.003)		Individuals not certified to use these fumigants should use thymol (4.028) or o-phenyl-phenol (4.029)
Miscellaneous chemicals		
phenol (4.027)	preservative & fungicide	thymol (4.028) or o-phenyl-phenol (4.029)
carbon arc lamps (3.030)	printmaking	sunlight, sunlamps, quartz & halide lamps, photo floods (3.030)

*Mineral spirits for this purpose should be good quality and highly refined or it will leave a residue on evaporation.

SOURCES OF INFORMATION

3.013 This book, combined with Material Safety Data Sheets and other right-to-know resources listed in the Appendix should provide readers with a very complete source of general hazard information on materials currently used in photography and photoprintmaking. However, new chemicals and processes are frequently introduced, photographers often experiment with materials, and information about the toxicology of photochemicals changes almost daily as new research is released. For these reasons, readers need access to sources of up-to-date technical information.

Access to the authors of this book as well as answers to technical inquiries and general occupational safety and health information can be obtained without charge by calling or writing:

> Arts, Crafts and Theater Safety, Inc. (ACTS)
> 181 Thompson St., #23
> New York, NY 10012 212-777-0062

Canadians may obtain information answers to questions about art and photography hazards as well as referrals to sources of general occupational safety and health information from ACTS (above) or from:

> Ontario Crafts Council Resource Centre
> 346 Dundas Street West
> Toronto, Ontario M5T 1G5 416-977-3551

Emergency numbers for photochemical manufacturers should be listed on their Material Safety Data Sheets. These numbers should be posted by your telephone in case of emergencies. Kodak and Ilford operate twenty-four hour "hotlines" to provide immediate information on photographic chemicals and their hazards for their customers. These numbers are:

> Ilford: (800) 842-9660 Kodak: (716) 722-5151

The occupational safety and health department of Local Departments of Labor, which are listed in the government pages of the telephone book, also can be good sources of information in both the United States and Canada.

STORAGE, HANDLING AND HOUSEKEEPING

3.014 The hazards of most materials used in photography and photo printmaking can be significantly reduced by correct handling. This includes taking proper precautions during mixing, processing, storage and housekeeping procedures.

Darkrooms require a high standard of housekeeping since many photographic processes are carried out in the dark. This means that the

room should be uncluttered and easy to keep clean. Floor storage and trip hazards should be eliminated. Wet and dry areas should be clearly separated.

Cleaning up the darkroom or studio regularly after work prevents needless exposure to toxic materials. This is especially important in home darkrooms, where living areas can become con-taminated. Good housekeeping also reduces the risk of accidents and fires.

Housekeeping includes frequent and proper disposal of chemical wastes. All waste materials, including exhausted chemical solutions, solvents, used film or paper, rags and other items, should be disposed of in a manner that will not pollute the environment (see 3.021).

Procedures for storage and handling are dictated by the hazards of the materials. The two basic types of hazardous materials used in photographic processes are toxic chemicals, such as poisonous sub-stances and corrosive acids and alkalis; and flammable or combustible materials, including most organic solvents. These categories of mate-rials are discussed separately below. Most of the organic solvents are both flammable and toxic, however, so both precautions need to be considered.

STORAGE AND HANDLING OF TOXIC MATERIALS

3.015 The following guidelines provide general rules for storing and handling potentially toxic or corrosive photographic materials. Specific precau-tions are given for handling liquids, powders and gases.

• For small-scale processing, chemicals should be stored in a locked, ventilated cabinet or in a locked, ventilated darkroom. Those who pro-cess large amounts of photographic materials should have a well-or-ganized chemical storeroom.

• Labels on all containers should meet requirements of the applicable right-to-know law (see 2.007). Always fully label containers into which chemicals have been transferred.

• Eliminate all chemicals with incomplete, defaced or missing labels. Replace a missing label only if the contents of a container are definitely known.

• Chemicals should be ordered in nonbreakable containers whenever possible. Use metal or plastic containers, not glass. Do not use bottles, milk cartons or other containers that might look like other substances or tempt children.

• Always store containers of acids and other corrosive liquids on the lowest shelves in order to minimize splashes of liquid to eyes and face in case of accidental breakage. Do not store chemicals on the floor.

• Do not store chemicals that may react with each other in the same area. Most darkrooms need several small cabinets in which to isolate reactive chemicals. For example, segregate solvents from acids and nitric acid from other acids. Consult the "reactivity" section of a chemical's Material Safety Data Sheet and/or chemical texts for classes of chemicals with which it should not be stored or mixed.

• Keep all containers closed, even when working, to prevent the escape of toxic vapors from liquids and toxic dusts from powders. Cover processing trays between printing sessions (or discard used solutions) to reduce exposure to toxic decomposition gases such as sulfur dioxide.

• Do not eat, smoke, drink, apply make-up or do any personal hygiene procedure in the storeroom, darkroom or studio. Contamination of food or accidental ingestion of small amounts of substances from hand-to-mouth contact from these activities has been documented. Smoking around chemicals is especially dangerous, since this allows dust and chemicals on the hands to get into the mouth or to be burned with the cigarette and inhaled.

• Wear special clothes such as smocks and aprons in the darkroom or studio and leave them in the workplace. Wash work clothes and towels frequently, separately from other clothing. This prevents the transportation of toxic materials into the home or living areas.

• Use the "buddy system." Never work alone or without someone within earshot who can help you if there is an accident.

• In case of spills or accidental skin contact with irritating chemicals, wash the affected skin immediately with plenty of water. If the chemicals are corrosive, use the deluge shower and call out for help. If chemicals are splashed in the eyes, call out for help, get to the eye wash fountain and rinse the eyes for at least fifteen minutes. Have your "buddy" call a physician while you continue rinsing.

• Wash hands carefully with soap and water after working with photographic chemicals, before eating and during work breaks. Never use solvents to clean the hands. If soap and water are not sufficient, use a mildly acidic cleanser such as pHisoderm® (available at safety equipment and surgical supply stores) and then wash with soap and water.

3.016 SPECIAL PRECAUTIONS FOR POWDERS

• Transfer powders that create dusts with spoons, scoops or similar implements. Do not dump or shake powders, since this raises chemical dust into the air.

• To prevent inhalation, handle powders in wet form whenever possible. That is, make up large batches of various solutions whenever possible, rather than several small batches, in order to minimize exposure to the powders.

• Wear a respirator which is approved for toxic dusts when transferring or handling large amounts of powders, unless you are working in a local exhaust hood. See respirators (3.042).

• Mix powders in a local exhaust hood or use a "glove box" specially designed for this purpose. A "glove box" can be fashioned from any medium-sized cardboard box with a sheet of glass or clear plastic covering the top and holes cut out on each side. The openings should be large enough for hands to reach inside the box. Chemical gloves should be worn when mixing powders in the box. Coat the inside of the box with shellac so that it can be cleaned easily. (See figure 3-1.)

Fig 3-1

• Clean up powder spills promptly with wet paper towels or water. If the powder is purchased in a paper bag or sack, store the partially used bag in a metal or plastic container that can be sealed.

3.017 SPECIAL PRECAUTIONS FOR LIQUIDS

• Avoid skin contact with toxic or corrosive liquids, such as developer solutions, concentrated alkalis and acids and all organic solvents. Never put bare hands into processing baths, but use tongs instead. In

some cases, chemical gloves and barrier creams may be needed to prevent skin contact during the mixing of highly toxic or corrosive chemicals. Obtain technical information from manufacturers on the various types of gloves and creams that are available, because they are each designed to be effective only against specific contaminants. See Chemical Gloves (3.045).

• Clean up spills of toxic and corrosive liquids immediately to reduce evaporation. Use spill control materials such as amorphous silicates, or spill-control pillows designed to absorb toxic liquids. These items can be ordered from any reputable safety supply company. After use, these materials can be placed in special hazardous waste disposal bags and disposed of accordance with local regulations.

• Protect the eyes by wearing safety goggles when handling chemical solutions, particularly corrosive liquids that can splash and cause eye damage. Do not share goggles and keep them clean so that they do not bring soil or chemicals into contact with the face. Be careful not to adjust or handle the goggles with contaminated gloves or hands.

3.018 SPECIAL PRECAUTIONS FOR GASES

• Practice good housekeeping to reduce exposure to highly toxic gases such as sulfur dioxide from the developer or fixing bath, or hydrogen sulfide from sepia (sulfide) toners. Processing trays, especially acid and fixing baths, should be filled only when actually in use and covered between printing sessions. It is better to discard used solutions rather than to allow them to sit and evaporate. Wipe up spills immediately to prevent evaporation and contamination of the workroom air.

• Make sure there is adequate ventilation in the room (3.032). If adequate ventilation cannot be achieved, wear an approved respirator with a proper cartridge (acid gas, ammonia, organic vapor, formaldehyde, etc.) matched to the particular contaminant. See Respirators (3.042).

• Take care not to mix photographic chemicals inappropriately to avoid producing toxic gases accidentally. Refer to chart Toxic Gases and Their Common Sources (4.140).

STORAGE AND HANDLING OF FLAMMABLE AND COMBUSTIBLE MATERIALS

3.019 Most of the organic solvents (4.236) commonly used in color processing, photographic printmaking, retouching, conservation and restoration and other processes are flammable or combustible liquids which

require special storage and handling. In addition to the solvents themselves, flammable or combustible solid materials such as solvent-soaked rags, paper or sawdust can ignite spontaneously in air, especially in the presence of heat, creating flash fire hazards in the studio. An even greater fire hazard are materials such as cellulose nitrate films that are explosive or can spontaneously ignite when exposed to air.

One class of solvents, the chlorinated hydrocarbons, are not usually flammable. Sources of heat and flame still should not be used in their presence, however, because they dissociate into highly toxic gases such as phosgene. Some of the solvents in this class (e.g. trichloroethylene) are considered flammable if heated.

Solvents sold as consumer products are regulated in the U.S. under the Federal Hazardous Substances Act (FHSA) and in Canada under the Federal Hazardous Products Act (FHPA). These acts define "flammable liquids" as those whose flash point is under 100°F (38°C) and "combustible liquids" as those with flash points of 100°F (38°C) or above.

The National Fire Protection Association's (NFPA) definitions of flammability are much more complex. For example, IA and IB solvents have their flash points below normal room temperature, and thus can cause flash fires under normal conditions. Class IC liquids are fire hazards only on hot days or if near a source of heat. See table 3-2.

TABLE 3-2 FLAMMABLE AND COMBUSTIBLE LIQUIDS USED IN PHOTOGRAPHIC PROCESSES

U.S. NATIONAL FIRE PROTECTION ASSOCIATION	U.S. FEDERAL HAZARDOUS SUBSTANCES ACT CANADIAN FEDERAL HAZARDOUS PRODUCTS ACT
CLASS **FLAMMABLE LIQUIDS**	**EXTREMELY FLAMMABLE**
IA (Flash Point < 73°F, Boiling Point < 100°F) ethyl ether aerosol sprays labeled "flammable" (4.283)	(Flash Point < 20°F) acetone benzene ethyl ether gasoline methyl ethyl ketone
IB (Flash Point < 73°F, Boiling Point > 100°F) acetone (4.263) benzine (4.274) benzene(4.245) butyl acetate (4.258) ethyl acetate (4.259) ethyl alcohol (4.241) gasoline (4.273) isopropyl alcohol (4.240) methyl alcohol (4.239) methyl ethyl ketone (4.262) toluene (4.246)	FLAMMABLE (Flash Point 20°F - 100°F) benzine butyl acetate ethyl acetate ethyl alcohol isoamyl acetate isopropyl alcohol methyl alcohol toluene xylene xylene

IC	(Flash Point > 73° F, Boiling Point < 100° F) Flammable if heated, or on a hot day isoamyl acetate (4.257) xylene (4.247)	
CLASS II	**COMBUSTIBLE LIQUIDS** (Flash Point > 100° F, Boiling Point < 140° F) methyl cellosolve (4.265) naphtha (high flash)	**COMBUSTIBLE LIQUIDS** (Flash Point 100°F - 150°F) butyl cellosolve cellosolve methyl cellosolve naphtha (high flash)
IIIA	(Flash Point > 140° F, Boiling Point < 200° F) butyl cellosolve (4.267)	
IIIB	(Flash Point > 200° F) cellosolve (4.268) ethylene glycol (4.270) propylene glycol (4.270)	**NOT A COMBUSTIBLE HAZARDOUS SUBSTANCE** (Flash Point >150°F) ethylene glycol propylene glycol

Even relatively small amounts of flammable and combustible liquids (such as the few gallons that might be found in any printmaking or restoration studio) must be stored and handled according to state/ provincial and local fire regulations. For example, in New York City a fire permit is needed to store or use more than five gallons of Class I and II liquids (flammable and combustible) combined. A metal storage cabinet designed in accordance with OSHA and NFPA standards can be used to store up to 60 gallons of flammable and combustible liquids (combined).

Photographers should also be certain that they are not violating the rules of their fire insurance carriers. Some home policies are null and void if over a few gallons of solvents are stored in the home, or if a small business is operated at home.

PRECAUTIONS FOR PREVENTION OF FIRES

3.020 The following precautions provide basic guidelines to help prevent fires caused by flammable and combustible materials used in photographic processes.

• Do not smoke or permit smoking in any darkroom or studio containing flammable or combustible liquids. The vapors of flammable liquids can travel to other parts of the work area and to surrounding areas, creating fire hazards in the general vicinity of the studio as well.

• Flammable liquids should be kept in metal safety cans with springloaded caps, never in glass or plastic bottles. Keep the cans

clearly labeled, and store them in an approved cabinet when not in use. All containers of flammable and combustible liquids should be kept covered to prevent evaporation into the workroom air.

• Clean up spills of flammable liquids immediately, using either spill-control materials such as amorphous silicates or spill-control pillows to absorb the liquids. These materials can then be disposed of in special hazardous waste disposal bags according to local regulations. These bags and solvent absorbents can be obtained from safety equipment suppliers. See clean up procedures (3.021) and safety equipment sources (3.048). Do not use sawdust for clean-up procedures since the some solvent-soaked dusts can spontaneously combust and start a flash fire in the studio.

• When dispensing solvents from large metal drums, use approved transfer pumps or drum faucets. When pouring flammable liquids from large metal drums into metal containers, make sure the drum is grounded (connected to a line to a ground) and the two containers are "bonded." Bonding is done by connecting the drum and the container with a braided wire with metal clips on each end. These procedures are required to prevent static electricity from igniting the flammable vapors.

• Make sure all electrical equipment is in good condition, and grounded. Fans used in local exhaust ventilation systems should have explosion-proof motors and nonsparking or non-ferrous blades. Do not use space heaters unless they are approved for use in the presence of flammable materials.

• Waste liquids and rags or paper soaked with flammable or combustible liquids should be stored in special wide-mouth, metal waste disposal cans with self-closing lids, and disposed of daily accordance with local regulations.

• Materials that can undergo spontaneous combustion should be kept in sealed containers to exclude all air. If this is not possible, keep these materials in containers that are well ventilated, to prevent a build-up of heat.

• Nitrate films require special storage and handling precautions. These films should be disposed of according to local fire codes. See hazards and precautions of cellulose nitrate films in Chapter 9.

• Do not store flammable or combustible materials near exits or escape routes from the darkroom or studio.

• Keep a combination A-B-C type fire extinguisher on hand for emergency use.

SAFE DISPOSAL OF HAZARDOUS WASTES

3.021 Today, disposal of chemicals is strictly regulated. Failure to comply with many of these regulations can result in extraordinarily large fines. Even worse, permanent environmental damage may result.

In the U.S., the federal Clean Water Act (CWA) limits discharge of environmentally hazardous pollutants. The CWA's limitations are imposed on local sewerage authorities who, in turn, sets limits on local facilities to insure that its discharge limits are not exceeded. For example, the CWA limit on silver discharge is 5 parts per million (ppm). A local sewerage authority, however, may impose a more severe limit on its customers since its effluent must always meet the 5 ppm limit.

In addition, even stricter limits may be used because treatment facilities differ in their method and capacity treatment. And photographers located in areas in which septic systems are used will have different rules still.

Chemicals put in ordinary trash are also regulated. Rules vary from municipality to municipality. Different rules apply to chemicals taken to rural land fills. Even the discharge of chemicals into the air from ventilation systems is regulated.

To find out which regulations apply to your own particular situation, you must begin at the local level. For this reason, there are no hard and fast rules that can apply to all situations. However, the following are basic rules for the clean-up and disposal of waste materials produced in photographic processes.

• Never dump large quantities of photographic chemicals. For disposal of larger quantities, consult local environmental protection regulations. If you regularly create color and black and white waste chemicals, contact the manufacturer of your photochemicals for technical data on disposal (see Bibliography).

• Dispose of small quantities of waste into drains with proper procedures if local regulations permit. For example, small quantities may be generated by processing once or twice a week, using a half-gallon each of developer, stop, fix and hypo clear, and perhaps a quart of toner. Flush individual solutions down the drain with copious amounts of water. A quart or so of spent solution discharged daily into the drain, allowing the water to run for several minutes afterward, is generally acceptable in most areas.

• Some chemicals must be disposed of by commercial hazardous waste companies or delivered to a community hazardous waste collection program. (Free or low cost community hazardous waste programs are usually available to individuals who generate small amounts of hobby or household waste chemicals. These services are not available to com-

mercial photographers.) Examples of chemicals which should be handled by waste disposal companies or household waste programs include selenium toners, bleaches containing sodium or potassium dichromate, ferricyanide or ferrocyanide, zinc-containing chemicals, and large amounts of silver-contaminated fixers.

• Fixer wastes usually contain silver in concentrations of thousands of parts per million which is far in excess of the 5 ppm federal CWA limit. Large operators may want to consider setting up a silver recovery system. Small operators may wish to pool wastes to make silver recovery an option (see 3.024).

• Materials which cannot be discharged by permit to the sewer are considered "hazardous waste." Schools or businesses in the U.S. that generate more than a few gallons of waste a month usually are required to file as a "hazardous waste generator" in either the "small" or "very small quantity generator" category. Determination of the category to which you belong depends on both the amount and the toxicity of waste generated. Call the Environmental Protection Agency at 1-800-424-9346 for information about your category.

• Teachers in public schools and universities should not find disposal difficult. Schools already should have instituted regular waste disposal services. Photography teachers should be able to coordinate their waste disposal with that of the science, art, maintenance, and other waste generating departments.

• If the darkroom drain leads to a septic system instead of a municipal sewer, do not attempt to discharge even small quantities of the more toxic chemicals, such as certain bleaches or cyanide compounds. These can destroy the bacterial culture in the tank or slowly leach into ground water. The smaller the septic system, the more vulnerable it is to damage. Darkroom work on such systems should be restricted to very small-scale activities. Photochemical manufacturers often have information about which chemicals can be safely disposed of in septic systems. However, check first with local authorities. Some waste chemicals may have to be picked up by commercial waste disposal companies.

• If you must contract with a commercial hazardous waste disposal company, follow their rules regarding collection and containerization waste. For example, never mix different waste chemicals prior to collection unless instructed to do so.

• Never discharge photographic chemicals into storm sewers, streams, ponds or other natural bodies of water. This practice is illegal and will have adverse effects on most life forms.

• Very small amounts of organic solvents, according to the Environmental Protection Agency, can be disposed of by allowing them to evaporate in a safe area such as a local exhaust system (3.035) or an outdoor location where people or animals will not be exposed.

• For disposal of large amounts of organic solvents, contact your community waste disposal program or a commercial waste disposal company (see above).

SPECIAL PRECAUTIONS FOR CLEAN UP AND DISPOSAL OF LIQUIDS

3.022 • Very large spills of toxic chemicals which cannot be contained (e.g., which get into the ground or water) must be reported to the local environmental protection authorities.

• Prepare for spills in advance. Stock spill control materials appropriate for the materials you use. Common materials include diatomaceous earth, vermiculite, activated charcoal, clay, kitty litter or amorphous silicate. Commercial spill-control "pillows" or units are even more efficient. The pillows are dropped in the spill. They absorb the liquid absorbed which can then be evaporated in a safe location (e.g., an exhaust hood), or the pillows can be placed in hazardous waste disposal bags and picked up by waste disposal companies (see 3.021). Spill control pillows and hazardous waste disposal bags are available from safety equipment suppliers. See safety equipment sources (3.048).

• Do not use paper towels or sawdust to soak up spills of flammable liquids, since this can create a fire and evaporation hazard,

• Clean up spills of hazardous liquids such as acids, alkalis, developer solutions or solvents can be done by soaking up the liquid with a damp sponge and wiping down the area several times may be adequate.

• Wear safety gloves for cleaning up spills. For large spills of highly toxic substances, wear an approved respirator and any protective clothing needed to guard against hazards while cleaning up.

• Neutralization techniques are useful for cleaning up acid and alkali spills. For example, sulfuric, acetic and hydrochloric acids can be neutralized by adding sodium bicarbonate powder. Alkalis such as caustic soda, sodium hydroxide, ammonia and some developer solutions can be neutralized with citric acid or dilute acetic acid. Do not attempt neutralization unless you understand the reactions which are occurring and a thoroughly familiar with the laboratory techniques involved. For example, never neutralize highly concentrated solutions of acids

and alkalis (dilute them first). Never neutralize spent developer solutions containing sodium sulfite preservative with acetic acid, since this mixture can produce highly toxic sulfur dioxide gas.

• Some neutralized chemicals still are considered toxic waste. For example, neutralized nitric acid is a metallic nitrate salt which still may not be accepted in some sewer systems.

• If disposal of neutralized acids and alkali is allowed, pour individual chemicals slowly down the sink with plenty of cold water. Let the water run for several minutes afterward to flush the chemical along the drain. When pouring out acid solutions, make sure there is adequate ventilation to prevent inhalation of toxic vapors and gases.

• Use special procedures for some chemicals. Follow the manufacturer's instructions carefully, and flush with plenty of water for several minutes afterward.

• Never pour water-insoluble liquids or flammable solvents down the drain. They may collect there and evaporate to contaminate the air of the darkroom or studio or explode in the sewer line.

• Waste solvents for re-cycling should be collected and stored in metal safety cans with spring-loaded caps to prevent evaporation into workroom air.

SPECIAL PRECAUTIONS FOR
CLEAN UP AND DISPOSAL OF SOLIDS

3.023 • Clean up spills of dusts and powders with wet methods such as using damp paper towels, sponges, or mops. Spilled powders can also be hosed down with water if there is a floor drain. Never sweep, because it will stir up the dusts and contaminate the air. If vacuum cleaners are used, they should have special high efficiency filters (HEPA) if the powders are very fine, and they must have explosion-proof motors if the dusts are flammable.

• Finish the darkroom floor with a sealer that will prevent dusts and powders from collecting in cracks and pores.

• Dispose of dusts and powders in sealed plastic bags or other closed containers.

• Dispose of glass bottles, broken glass and other sharp-edged objects in a separate, well-marked waste container, in order to prevent injury to refuse collectors.

• Full or partly full bottles of chemical solutions should not be thrown away with ordinary trash, because the compactors used by collection services may burst the bottles and splash toxic chemicals on anyone who is nearby.

• Do not throw chemical-laden negatives or prints into the waste bin without first rinsing them. Make sure these materials are enclosed in a sealed container or plastic bag before they are discarded. Rinse out bottles and other chemical containers before discarding them. These forms of contaminated darkroom waste can be hazardous to refuse collectors.

• Do not leave chemical-laden bottles or other containers at the local dump without consulting your local health department or waste management board for information on regulations (see 3.021).

SILVER RECOVERY SYSTEMS

3.024 Chemical recovery and regeneration are practical techniques that can help to reduce hazardous darkroom wastes. Silver recovery, although scarcely profitable on a small-scale basis, should be considered for its environmental advantages.

Small-scale recovery devices are now available to photographers. The two most common methods are the metallic replacement and the electrolytic cell method.

METALLIC REPLACEMENT. This method passes solutions containing silver through a column of steel wool or iron powder. When the silver contacts the iron, the iron dissolves and the silver deposits where the iron was located. When the unit has taken up all the silver it will hold, it is returned to the manufacturer, who supplies a new cartridge and pays for the silver. This method has the following advantages and disadvantages.

Advantages	Disadvantages
economical	not reusable-recurring cost
easy to use	requires monitoring
no electrical hook up	high shipping & refining costs
will remove silver to < 5ppm	unrefined silver may be
can remove silver from wash water	"hazardous waste"
	iron deposits may block drains
	may require holding vessels

THE ELECTROLYTIC CELL. In this method an electric current is passed through the solution of complexed silver thiosulfate and silver ions by means of a carbon anode and a stainless steel cathode.

Advantages	**Disadvantages**
collected silver is 92-98% pure	high initial cost—10 times
shipping and refining costs low	replacement method
cathodes are reusable	requires electrical connection
easy to monitor	residual silver in fixers may
drains won't be blocked	be >5ppm
	may require a holding vessel

There are other methods in addition to these. Each method has advantages and disadvantages. The choice must be made on the individual photographers needs and the type of chemistry used. A supplier of ion exchange cartridges is:

Environmental Products International,
PO Box 492, 340 School Street,
Craig, CO 81625　　　(303) 824-3294

Some companies which offer electrolytic units include:

CPAC, Inc., Leicester, NY 14481 (716) 382-3223, (800) 477-1417
Drew Resource Corp., Berkeley, CA 94710 (415) 527-7100, (201) 344-0201
Rotex Silver Recovery Corp., Springfield, OH 45501 (513) 322-0189
Siltech Corp., 4025 Spencer St., Suite 201, Torrance, CA 90503 (213) 371-5355

Another option is to contact a silver reclamation company to pick up the exhausted hypo and recover the silver for you. If several photographers are sharing a darkroom, or belong to a photography workshop or similar group, it might be worthwhile to collect the used hypo baths in a central unit for silver recovery.

ACCIDENTS

3.025　Accidents can occur to photographers as a result of fatigue, carelessness, inexperience, time pressures and many other factors. Lack of proper safeguards and maintenance of photographic equipment, and the use of defective equipment are other sources of accidents.

PHYSICAL AND CHEMICAL ACCIDENTS

3.026　Physical accidents commonly occur from the mishandling of equipment in location or studio photography. These may include dropping heavy equipment on a foot or touching a high-intensity quartz bulb with bare hands, causing it to explode when turned on. Lifting heavy equipment improperly can result in back sprains or more serious back injuries. Physical accidents can also occur in the darkroom, where the condition of darkness itself increases physical and chemical hazards. In the workroom, cuts can occur while operating paper trimmers and burns can result from contact with print dryers.

Chemical accidents often occur while mixing or pouring chemicals, due to liquid splashes that damage skin or eyes. Accidental powder spills can raise toxic or flammable dusts in the air, creating inhalation or fire hazards. Wet floors, especially in the mixing areas, may result in slips or falls. Solvent exposure at high concentrations can cause narcosis, often resulting in a loss of coordination and judgement which, in turn, can increase the risk of accidents.

The potential for accidents of all types is greatly increased when unrealistic work schedules cause photographers to work too many hours. This practice is especially egregious in schools when production of work is valued above learning safe and proper work habits.

PRECAUTIONS AGAINST ACCIDENTS

3.027 • Learn safe lifting limits and how to lift equipment properly. This is particularly important when lifting objects such as larger view cameras, strobe lights or any item over thirty pounds. The lifting method most generally recommended is to keep the back straight and bend the knees to pick up an object, rather than keeping the knees straight and bending over to lift it. Be especially careful when lifting heavy equipment in and out of automobiles, since this is when many back injuries occur.

• Never touch a high-powered light bulb, especially a quartz halogen bulb, with bare hands. Skin oils and acids can cause the bulb to explode when turned on, hurling shattered glass on anyone nearby. Always use gloves when handling any type of photographic lighting equipment.

• Be familiar with the operation of all equipment, its hazards and precautions for preventing accidents. This is especially important for darkroom equipment such as paper trimmers or print dryers, which are often used in relative darkness.

• Know the hazards of all chemicals being used, as well as the proper precautions for their safe use, before mixing and handling them in a darkroom or studio.

• Avoid overexposure to solvents, since they can cause fatigue and loss of judgement and coordination.

• Avoid becoming overtired; this can lead to poor judgement that results in accidents.

• Mop or wipe up liquid spills on the floor of the darkroom to avoid chemical exposures by inhalation, and to prevent accidental falls.

- Make sure there is an emergency eyewash and shower (or adequate alternative) in the immediate vicinity of your darkroom or studio in case an accidental splashing of a corrosive liquid results in skin or eye injury. (3.006).

- Never work alone or at least without someone within ear shot who can respond if there is trouble.

LIGHTING AND ELECTRICAL HAZARDS

3.028 Photographers who work in studios or in indoor locations are continuously exposed to artificial, incandescent lighting from various types of electric lamps with a tungsten filament. These may include high-intensity photoflood lamps or quartz halogen, xenon, and halide lamps, as well as powerful strobe lights that flash at intervals and reach peak intensities well over the intensity of the constant tungsten source. Working under the direct glare of these lights can result in chronic eye strain (asthenopia), eye discomfort, headaches and nausea.

Working in the relative darkness of the darkroom can introduce the same type of chronic eye strain and discomfort. For many applications, a darkroom need not be "dark," since it is the color, not the intensity of light that is important. Many safelights are available that provide good light levels.

Faulty electrical wiring or improperly grounded electrical equipment can be a source of fire, burns or electrical shock. Burns may vary in severity from first-degree or superficial skin damage to third-degree burns involving extensive tissue destruction. With second or third degree burns, if the damage covers a large area of the body, there is danger of shock and even death.

Electrical shock can occur in small, cramped darkrooms, where wet and dry areas are overlapping, and particularly if floors are wet from spills. If electrical equipment in the darkroom is not properly grounded, or if electrical outlets are overloaded, a fire hazard exists. Electrical shock can cause burns, as well as unconsciousness resulting from either paralysis of the respiratory center, heart fibrillation or both. A severe shock can be fatal.

PRECAUTIONS FOR LIGHTING AND ELECTRICAL HAZARDS

3.029 • Avoid direct glare from any type of lighting if at all possible. If high-intensity lights or strobe lights are used, tinted sunglasses with polarizing lenses should be worn to cut down direct glare to the eyes.

- Wear protective clothing and safety gloves when handling photographic lighting equipment. Wear heavy gloves for handling hot lights.

• Make sure all electrical equipment is grounded. If there is a three-prong plug, it should be plugged into a three-pronged receptacle. If an adapter is used, attach the adapter wire to a known ground.

• Purchase ground fault interrupters (GFIs) for each outlet and plug equipment into the GFI. This way any faulty equipment, short, or water problem will stop the current to the equipment immediately.

• Make sure the darkroom is large enough so that the wet and dry areas are separate. Electrical outlets should not be located near wet processes. Never leave liquid spills on the floor or on surfaces where they might create electrical hazards.

• Be familiar with proper first aid treatment for burns and electrical shock.

CARBON ARC LAMPS AND OTHER ULTRAVIOLET HAZARDS

3.030 Carbon arc lamps and light sources can still be found in darkrooms or studios that use outdated equipment. This lamp was a major hazard in the past. The carbon arc, unlike other modern light sources, produces actinic light by combustion, and this burning creates highly toxic by-products. The carbon electrodes contain a central core of rare earth metals of the cerium group, carbon, tar and pitch surrounded by a copper coating. Combustion of these materials produces carbon monoxide, ozone, nitrogen oxides and rare earth metal fumes. These gases and fumes are all highly toxic by inhalation. Hazardous amounts of these substances can be inhaled without noticeable discomfort. Chronic effects from repeated exposures to carbon arcs may include emphysema and severe pulmonary fibrosis or scarring of lungs.

In addition, carbon arcs produce excessive amounts of ultraviolet light that can cause severe sunburn and eye damage. Other types of lights used in photographic processes, such as sunlamps, metal halide lamps or quartz lamps, also emit ultraviolet radiation.

PRECAUTIONS FOR LIGHT SOURCES

3.031 Replace carbon arc lamps. Use sunlight, a sunlamp, xenon, quartz halogen lamp or other light source instead. If carbon arcs must be used, they must be directly vented to the outside with local exhaust ventilation. If the light is not enclosed, welding goggles or hand-held shields with shade number 14 (American National Standards Institute goggles for carbon arc welding) should be used to shield the eyes. Paint walls in the darkroom with zinc1 oxide paint to reduce reflected ultraviolet radiation.

VENTILATION

3.032 For photographic processes, "adequate ventilation" does not mean simply opening a window or door. Nor does it mean having a fan blowing air around within the room or installing an air conditioning unit (which only cools the air) in a window.

These approaches are not adequate, and may actually make matters worse. In order to provide appropriate ventilation, it is necessary to understand the uses of different types of ventilation. There are two broad categories of ventilation: 1) comfort ventilation to keep people in modern buildings comfortable; and 2) industrial ventilation to keep photographers and others who work with chemicals healthy.

Comfort ventilation provides sufficient air movement and fresh air to avoid buildup of humidity, heat, and indoor air pollutants in buildings. This usually is accomplished by either natural or recirculating ventilation systems.

Natural ventilation takes advantage of rising warm air and prevailing winds to cause the air in buildings to circulate and exchange with outside air. Often chimney-like flues are constructed behind walls to draw out warm air. Such systems are found mostly in older buildings where high ceilings and open spaces enhance the system. Some older buildings also employ "univents" installed in rooms on outside walls. These units draw in some outside air through louvers in the wall, mix it with room air, and heat and expel the mixture.

Recirculating ventilation systems use fans or blowers to circulate air through ducts from room to room throughout the building. On each recirculating cycle, some fresh air from outside is added and some recirculated air is exhausted. The amount of fresh air added usually varies, depending on how tightly insulated the building is and the vagaries of the particular ventilation system or its operator.

People feel ill when insufficient amounts of fresh air are added to comfort ventilation systems. People in these buildings may complain of eye irritation, headaches, nausea, and other symptoms. Taken together, these sometimes are called the "sick building syndrome" or the "tight building syndrome."

Comfort systems have difficulty even providing comfort. Clearly, none of these systems can adequately control air pollution created by photographic processes.

Industrial Ventilation, Photo processes which produce airborne toxic substances should only be done in areas provided with industrial ventilation. There are two types of industrial ventilation: 1) general or dilution ventilation, and 2) local exhaust ventilation.

GENERAL OR DILUTION VENTILATION

3.033 General or dilution ventilation does exactly what its name implies. It dilutes or mixes contaminated workplace air with large volumes of clean air to reduce the amounts of contaminants to acceptable levels. Then the diluted mixture is exhausted (drawn by fans or other devices) from the workplace. Dilution systems usually consist of fresh air inlets (often having fans and systems for heating or cooling the air), and outlets (exhaust fans).

Although often cheap and easy to install, dilution ventilation has limits. For example, only vapors or gases of low toxicity or very small amounts of moderately toxic vapors or gases are removed sufficiently by dilution ventilation. Never use dilution ventilation to remove either highly toxic materials or any materials in the form of particles such as dusts or mists.

Dilution ventilation can be used for simple black and white developing because the emissions from the process are gases and vapors in low concentrations. To be successful, however, air inlets and outlets should be positioned to assure that air flow moves in the desired direction (see Figure 3-2), that the whole room is ventilated (no dead air spaces), that expelled air cannot return via an inlet, and that there is plenty of air available to replace the exhausted air. If replacement air is obtained from the outside, it also will have to be heated or cooled before it enters the room.

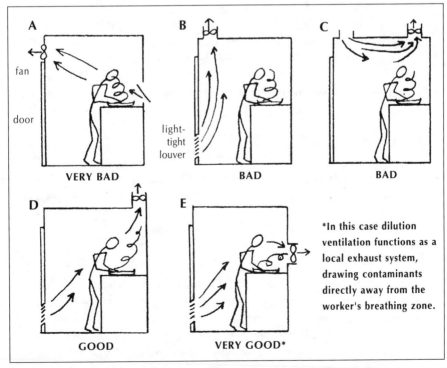

Fig. 3-2

In special cases, the exhaust fan can be positioned very close to the work station (see Figure 3-2, drawing E). In this way it acts like a local exhaust (3.035). Do not use this system with aerosol cans, spray painting, airbrush operations, or with flammable materials unless the fan is explosion-proof. Before installing this system, be sure your local regulations and building codes permit the use of this system for toxic substance control.

DILUTION VENTILATION RATES are often estimated by the air change per hour (AC/Hr) method. Some photochemical manufacturers recommend between ten to fifteen air changes per hour for ordinary black and white processing darkrooms. A major drawback of this method of estimation is that it does not differentiate between very large rooms or very small rooms. Obviously, 10 air changes per hour in a large room will provide much more dilution of contaminants than 10 air changes per hour in a small room, assuming that the same amount of contaminants are produced in each room. For this reason, the number of air changes should be adjusted for the room size. For large darkrooms, 10 air changes per hour may be sufficient. For very small individual darkrooms, at least 20 air changes per hour may be required.

By the same token, a room with a high concentration of airborne contaminants will obviously need more fresh air than a room with a low concentration of contaminants. A large gang darkroom where many people are producing air contaminants will also need a higher number of air changes.

The advantage of this method is that it is simple to apply. For example, determining the power of the fan required for these systems is simple to calculate using the following formula:

The fans capacity in cubic feet per minute = ft^3/min = CFM The room's volume in cubic feet (height x length x width) = ft^3 Air changes per hour = (AC/Hr)

$$\frac{(\text{room volume in } ft^3) \times (\text{number of AC/Hr})}{60 \text{ minutes/hour}} = CFM$$

For a darkroom that is 10 by 20 feet with a 10 foot ceiling which requires about 15 air exchanges per hour, the fan's capacity should be:

$$\frac{10 \times 20 \times 10 \times 15}{60} = 500 \text{ CFM}$$

This formula assumes that the fan's performance is absolutely unhindered. This is true only if the fan encounters no resistances such as some negative pressure in the room or an opposing breeze. For example, some air resistance is encountered even if a fan blows directly to the outside air through a window or other opening. For this reason, fans should be selected which are capable of moving air against pressure. Most window exhaust fans should be able to deliver the re-

quired CFM against 1/4 or 1/2 inch static pressure. Manufacturers should be able to provide this data on their fans performance specified static pressures.

If the fan must blow the air through a duct or a light trap, the resistance of the duct or trap must be compensated for in the calculations. In fact, an ordinary exhaust fan may not be able to overcome such resistance. You may need the assistance of an engineer or industrial hygienist to help you make these determinations.

GUIDELINES FOR GENERAL VENTILATION

3.034 • The system should bring fresh air to the breathing zone and draw contaminated air away from the worker (Figure 3-2). For this reason, overhead exhaust fans often are not recommended.
• Air inlets and outlets should be sufficiently far apart so that the contaminated air being exhausted does not reenter through the air inlet.
• There must be a source of replacement air which is sufficient to make-up the amount exhausted by the fan without creating negative pressure in the room.
• Fresh or replacement air should reach all parts of the studio without creating uncomfortable drafts.
• The replacement air may have to be cooled or heated to a comfortable temperature.
• The exhaust fan should have the capacity to meet the required ventilation rate for the work space. (See calculations above.)
• If significant amounts of flammable solvents are being used, make sure that there is an approved, explosion-proof fan.
• Make sure that the ventilation system does not exhaust toxic contaminants from the darkroom or studio into the areas where it is unwanted such as the living or working spaces of neighbors.
• Check periodically to see that the components of the ventilation system are working properly.

LOCAL EXHAUST VENTILATION

3.035 Local exhaust ventilation is the best means by which materials of high toxicity and materials which are particles—dusts, fumes, and mists—are removed from the workplace. Table 3-3 lists processes which require local exhaust ventilation. Local exhaust ventilation captures the contaminants at their source rather than after they have escaped into the room air. For this reason, local ventilation systems remove smaller amounts of air than dilution systems. They accomplish this by use of a hood which draws in air and which encloses or is positioned very close to the source of the contamination, ductwork to carry away the captured air, possibly an air-cleaner or filter or purify the air before it is released outside, and a fan to pull air through the system.

3.036 **HOODS.** Hoods not only must collect the contaminant, they must do so while drawing the contaminated air away from the worker's breathing zone. For this reason, kitchen-type overhead canopy hoods are not recommended since they will draw gases coming from the processing baths past the worker's face and into the hood. Normally, hoods for dusts or powders (heavy particles) require a higher capture velocity (faster air flow) than those collecting vapors and gases.

There are several types of hoods that are useful for photographic purposes. These include:

The table slot (see Figures 3-3 and 3-4). This system has a slot drawing in air which runs around the outside edge of the table. It is ideal for gang darkroom work because it provides exhaust for the processing baths for workers positioned anywhere around the table.

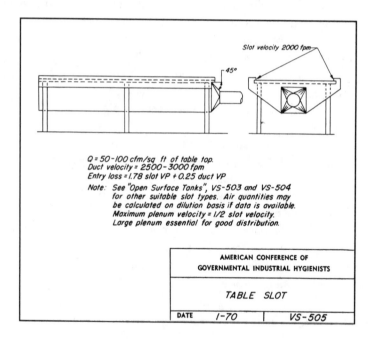

Slot velocity 2000 fpm

45°

$Q = 50 - 100$ cfm/sq ft of table top.
Duct velocity = $2500 - 3000$ fpm
Entry loss = 1.78 slot VP + 0.25 duct VP
Note: See "Open Surface Tanks", VS-503 and VS-504 for other suitable slot types. Air quantities may be calculated on dilution basis if data is available. Maximum plenum velocity = $1/2$ slot velocity. Large plenum essential for good distribution.

| AMERICAN CONFERENCE OF |
| GOVERNMENTAL INDUSTRIAL HYGIENISTS |

TABLE SLOT

| DATE | 1-70 | | VS-505 |

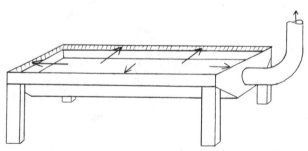

Fig. 3-3 & Fig. 3-4

Reprinted by permission from *Industrial Ventilation, A Manual of Recommended Practice, 20th Edition.*

The slot hood (see Figure 3-5). This system draws gases and vapors across a work surface, away from the worker. Slot hoods are good for many kinds of sink or bench work, including photo developing, silk-screen printing, and air brushing. They are rather expensive because experts are needed to design and build them properly, but they provide a shop with surfaces on which most photographic processes can be safely carried out. Side shields to protect the work area from cross drafts will increase the efficiency of slot hoods.

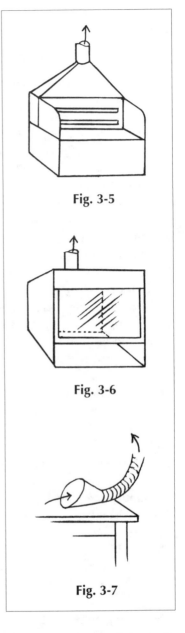

Fig. 3-5

Chemistry Fume hoods (see Figure 3-6). These are purchased "off the shelf" from safety supply and ventilation companies. In order to obtain the proper hood and accessories, the supplier must be told precisely what processes and chemicals you intend to use in the hood. These hoods are excellent for very hazardous processes such as weighing and mixing dry chemicals, diluting strong acids, and so on. There are some chemistry fume hoods on the market which "purify air" and return it to the room. These are not proper equipment for photographic processes.

Fig. 3-6

Movable exhaust systems (see Figure 3-7). Also called "elephant trunk" systems, these flexible duct and hood arrangements are designed to remove fumes, gases, and vapors from processes such as small table top processes which use solvents or solvent-containing products. Movable exhausts also can be equipped with pulley systems or mechanical arms designed to move hoods to almost any position.

Fig. 3-7

Special-collecting systems. Many pieces of equipment can be purchased with collecting hoods built into them. Included are automatic photo processors, diazo copiers, projection lights, carbon arcs, and other heat sources, and more. Always ask sales people about ventilation options. They usually do not volunteer this information because they fear they may jeopardize sales by calling attention to the toxic nature of the emissions and/or the need to install the equipment near access to outside air. Many photo processors have built in systems terminating in a flexible duct which must be exhausted to the outside. Some diazo copiers have self-contained systems which absorb ammonia gas on replaceable chemical absorbent filters.

TABLE 3-3 PHOTOGRAPHIC PROCESSES AND MATERIALS
REQUIRING LOCAL EXHAUST VENTILATION

Black and white special processes
hypo-alum toners requiring heat (5.035)
sulfide toning (5.035)
selenium-sulfide toning (5.035)
chromium intensifiers combining potassium dichromate and hydrochloric acid
 in the bleach solution (5.026)
chromic acid bleaches (5.030)
reduction using rapid fixer, with citric acid added to ammonium thiosulfate
 (5.030)
airbrushing or spraying on retouching lacquers, lacquer thinners or retouch-
 ing dyes (5.059)

Color processes
all color processing (especially Cibachrome) (6.001-6.010)
airbrushing or spraying on retouching dyes or retouching solvents (6.011)
hand-coloring using lacquer-based spray paints or water-based sprays (6.016)
retouching with dye bleaches containing highly volatile chlorine compounds (6.011)

Daguerreotype (7.002)
Becquerel method; heating the halogen sensitizer (chlorine, bromine, iodine)

Kallitype (Van Dyke) (8.012)
spraying on the silver nitrate sensitizer

Woodburytype (9.013)
making the intaglio mold with acrylic resins

Photoetching (9.018)
using solvent-based resists and resist products (KPR)
preparation of etching solutions and etching process

Photolithography (9.023)
using solvent-based emulsions, lacquer developers and related materials

Photosilkscreening (9.028)
using commercial stencil removers or screen cleaners

Photoceramics (9.033)
direct methods using solvent-based photoresist materials (KPR) kiln firing

Kwik-Printing (9.038)
airbrushing or spraying on Kwik-Print colors

Conservation and restoration (10.001)
spray-deacidification using denatured alcohol as the spray vehicle
using a thymol cabinet for fumigation
using naphthalene or para-dichlorobenzene in fumigation units
spraying on lacquers or lacquer thinners

3.037 **DUCTS AND FANS.** Local exhaust systems that exhaust flammable solvents will require special explosion-proof fans if the fan motor is inside the duct and thus in the path of the solvent vapors. If the fan motor is outside the duct and is belt-driven, then the blades should be made of a non-sparking material such as aluminum and the belt should be enclosed. All fan parts should be electrically grounded, and should conform to standards of the National Board of Fire Underwriters and the National Fire Protection Association. Ducts should be made of corrosion and fire-resistant materials and should not have sharp changes of direction, since this can cause a loss of air velocity that would have to be overcome with a more powerful fan. Industrial ventilation manufacturers can supply proper ducting needed.

3.038 **SPRAY BOOTHS.** This system is useful to any photographer who also uses aerosol or paint sprays, solvent-containing lacquers or adhesives, or airbrush inks. Spray booths also can double as a place to weigh and mix dry chemicals and for other hazardous processes such as plastic resin casting and solvent cleaning processes.

Spray booths from small table models to walk-in-sized or larger can be purchased or designed to fit the requirements of a particular studio. The spray booth, its ducts and fans, and the area surrounding the booth must be made safe from explosion and fire hazards if significant amounts of solvents or solvent-containing materials are used. (See Figure 3-8.)

Fig 3-8

ALTERNATIVES TO LOCAL EXHAUST SYSTEMS

3.039 In actual practice, an ideal local exhaust system sometimes is too expensive or impractical for an individual photographer. In these cases alternative systems may be the only solution.

For photographers who are doing only occasional processing and are working in small darkrooms, a modified canopy-type exhaust hood with sides, placed against a wall, may suffice (see Figure 3-9). An ad-

equate source of replacement air also is essential. A traditional canopy hood takes advantage of the fact that hot gases rise. They can be used effectively for other studio processes such as over hot plate oil tables, dye baths, wax and glue pots, stove ranges, and the like.

Fig 3-9

For printmakers and others who do not need a light-tight environment, a similar alternative system can be achieved by use of a window exhaust fan (see Figure 3-2, drawing D). Adding screens or walls around the workspace in front of the fan can increase the efficiency of this system.

For mixing or handling powdered materials, the glove box (Figure 3-1) can be used. Some photographers have improved this system by attaching the hose of a vacuum cleaner to the back partition. This creates negative pressure in the box and collects any dust created. The vacuum's filter, however will not collect extremely fine particles. For this reason, the vacuum should be placed out a window or some other location where these particles can be exhausted to the outside.

Ineffective ventilation alternatives which should not be used include bathroom-type ceiling exhaust fans, various "air-purifiers," window air-conditioning units and other air-conditioning systems.

GUIDELINES FOR LOCAL EXHAUST SYSTEMS

3.040 Some of the rules to consider when choosing a local exhaust system include:

a. Place the work into or as close to the hood as possible. If a hood is more than several inches away it may not draw contaminants into it.

b. Make sure the air flow is great enough to capture the contaminant. Keep in mind that dusts are heavy particles and require higher velocity air flow for capture than lighter vapors and gases.

c. Make sure that contaminated air flows away from your face, not past it.

d. Make sure that the exhausted air cannot re-enter the shop through make-up air inlets, doors, windows, or other openings. e. Make sure enough make-up air is provided to keep the system operating efficiently.

PLANNING VENTILATION

3.041 Planning ventilation systems for large schools, studios, and shops usually requires experts for each phase of work. You should carefully apprise these experts of your special needs before they begin their work. First, an industrial hygienist should evaluate the processes you plan to do and recommend specific ventilation systems. Next a professional engineer experienced in industrial ventilation design both dilution and local exhaust ventilation systems. In addition, a heating, ventilating, and air conditioning (HVAC) engineer may be needed to integrate the new ventilation systems into existing ones, or to upgrade comfort ventilation systems. Once the experts have designed the systems, employ an appropriate contractor to install it. Be particularly careful to choose qualified experts. Engineering and contracting errors can result in very expensive and time-consuming problems.

Planning ventilation for small shops and individual studios is much less complicated. A good reference called Ventilation: A Practical Guide (Available from CSA, 5 Beekman St., New York, NY 10038) provides basic ventilation principles and calculations. Mechanically inclined artists should be able to use this manual to design and install simple systems.

Photographers should be leery of salesmen touting products which appear to solve ventilation problems cheaply by purifying contaminated air and returning it to the workplace. Some of these devices are not only useless in most studios, but they actually can be harmful.

After a ventilation system has been installed, it should be checked to see that it is operating properly. If an engineer, industrial hygienist, or contractor worked on the job, he or she should make the initial check and recommend any changes necessary to meet design specifications. If experts were not consulted, you may decide to consult one at this stage. Even without the advice of an expert, some common-sense observations can be made:

1. Can you see the system pulling dusts and mists into it? If not, you might use incense smoke or soap bubbles to check the system visually. When released in the area where the hood should be collecting, the smoke or bubbles should be drawn quickly and completely into the system.

2. Can you smell any gases or vapors? Sometimes placing inexpensive perfume near a hood can demonstrate a system's ability to collect vapors or it can show that exhausted air is returning to the workplace (or some other place where it should not be).

3. Do people working with the system complain of eye, nose, or throat irritation or have other symptoms?

89

4. Is the fan so noisy and irritating that people would rather endure the pollution than turn it on? Fans should not be loud, and experts should be expected to work on the system until it is satisfactory.

Use these observations continually to see that the system continues working properly. Maintenance schedules for changing filters, cleaning ducts, changing fan belts and the like also should be worked out and kept faithfully.

PERSONAL PROTECTIVE EQUIPMENT

3.042 **RESPIRATORY PROTECTION.** Adequate ventilation, not respirators, should be the primary means of controlling airborne toxic substances. United States Occupational Safety and Health Administration (OSHA) regulations restrict use of respiratory protection except: when a hazardous process is used only very occasionally (less than thirty times a year); or while ventilation is being installed, maintained, or repaired; where engineering controls result in only a negligible reduction in exposure; during emergencies; or for entry into atmospheres of unknown composition. Most Canadian provincial regulations allow more liberal use of respiratory protection.

All respirators, filters, and other components should meet the standards of The National Institute for Occupational Safety and Health (NIOSH). Both the United States and Canadian governments accept these standards. All approved respirators and components will carry the initials "NIOSH" and an approval number. Only NIOSH-approved products should be used.

It is important to choose precisely the right type of protection for a particular task. Wearing the wrong type of respirator, a surgical mask (which is designed as protection against biological hazards, not chemical ones), or a damp handkerchief, actually may make the situation worse.

There are three basic respirator types: air-supplying, air-purifying, and powered air-purifying.

AIR-SUPPLYING RESPIRATORS bring fresh air to the wearer usually by means of pressurized gas cylinders or air compressors. They are the only respirators which can be used in oxygen-deprived atmospheres. They also are complex and expensive systems requiring special training for those using them.

POWERED AIR-PURIFYING RESPIRATORS provide wearers with air which has been pumped (usually by a small unit attached to the wearer's belt) through filters or cartridges. This filtered air is supplied under slight pressure to a mask or shield over the wearer's face. These are usually priced somewhere between the other two types of respirators.

AIR-PURIFYING RESPIRATORS use the wearer's breath to draw air through filters or chemical cartridges in order to purify it before it is inhaled. Most air-purifying respirators are priced in a range that artists will find practical. Photographers are likely to find the following types of air-purifying respirators most useful:

1) Disposable or single-use types which often look like paper dust masks and are thrown away after use;

2) Half-face types which cover the mouth, nose, and chin, and have replaceable filters and cartridges; and

3) Full-face types which look like old-fashioned gas masks and have a replaceable canister.

Learning to select and use respirators properly is not as easy as it looks. For this reason, United States employers are required by OSHA (the Occupational Safety and Health Administration) to institute written programs for all workplaces where respirators are used. At present, Canadian regulations are not as strict, but many regulations for specific chemicals require written respirator programs. Among these substances are several used by artists and conservators including silica, lead, and ethylene oxide.

Written respirator programs should be instituted in schools, universities, businesses, museums, and all institutions whose personnel use respirators. If students are allowed to use respirators, the program should be extended to include them. Although students are not covered under occupational laws, the school's liability will be jeopardized if students do not receive equal or better protection than staff.

The formal program requirements include fit testing to assure that contaminated air does not leak in, institution of proper procedures for cleaning, disinfecting, and storing, plus provisions for periodic inspection and repair of respirators, and for formal training of people in the use and limitations of respirators. Also included are recommendations for medical screening for users. Medical tests or questionnaires are needed to identify users who have physical conditions which make wearing respirators dangerous. For example, heart or lung problems may be worsened by the additional breathing stress created by a respirator.

Fit testing is needed to identify those people who should not wear a respirator because its facepiece will not form a good seal against their skin allowing contaminants to bypass the filters. Some reasons respirators will not fit include having a face shape or size that does not conform to the respirator, the presence of facial hair (such as beards and sideburns or even a few hours growth of facial hair), facial scars, broken nose, and missing dentures. Fit testing should be done annu-

ally in order to catch changes in fit or physical condition. For example, losing or gaining about fifteen pounds can alter respirator fit. Industrial hygienists or trained representatives of respirator manufacturers are usually able to perform fit tests.

Training is needed to instruct users about the proper use and limitations of the equipment. Users need to know that different cartridges and filters are designed to trap specific gases, vapors, fumes, dusts, and mists. (See table below.) No filter or cartridge can remove all of a contaminant from the air. Instead, respirators are capable of reducing the amount of a particular contaminant to an acceptable level as defined by NIOSH standards. There also are many contaminants for which there are no NIOSH approved filters or cartridges (see table).

TABLE 3-4 RESPIRATOR CARTRIDGES AND FILTERS USED IN PHOTOGRAPHIC PROCESSES

CONTAMINANT	CHEMICAL CARTRIDGE	FILTER
ammonia (4.142)	ammonia	
amine (4.016) vapors	ammonia	
toxic dusts and powders		dusts or dusts/mists
powdered dyes (4.224)		dusts or dusts/mists
formaldehyde (4.023)	formaldehyde	
acid gases	acid gas	
sulfur dioxide (4.141)	" "	
hydrogen selenide (4.147)	" "	
nitrogen dioxide (4.145)	" "	
chlorine gas (4.141)	" "	
solvents, general (4.326)	organic vapor	
acetic acid	" " *	
lacquer thinners (solvents)	" "	
printmaking solvents	" "	
solvent-based photoresists	" "	
conservation solvents (10.002)	" "	
solvent-containing sprays	organic vapor and.........spray prefilter**	
spray adhesives (10.003)	" " "	" "
aerosol spray paints (5.060, 6.013, 9.039)	" " "	" "
airbrushing (water based) (5.060, 6.013, 6.018)	" " "	" "
lacquers and fixatives (5.060, 6.013, 9.009)	" " "	" "
toxic water-based sprays/mists		mists or dusts/mists
water-based paints and dyes (5.060, 6.013, 6.018)		mists or dusts/mists

* Acetic acid is an organic acid vapor. Most manufacturers recommend using an organic vapor cartridge for capture. Photographers may need a combination acid gas/organic vapor cartridge to capture both sulfur dioxide and acetic acid.
** A "paint spray" cartridge combines an organic vapor cartridge with a mist prefilter, and also may be called a "paint, lacquer and enamel mist" or "PLE" cartridge.

TABLE 3-5 WHEN AIR-PURIFYING RESPIRATORS CANNOT BE USED
(instead use ventilation or, if large amounts are present, air-supplied respirators)

In oxygen-deficient atmospheres such as when gas is released in a confined space or in fire-fighting.

Against chemicals which are of an extremely hazardous nature, or lack sufficient warning properties (smell or taste), are highly irritating, or are not effectively captured by filter or cartridge materials. This includes, but is not limited to:

carbon monoxide;

isocyanates (from foaming or casting polyurethane);

nitric acid and nitrogen oxides;

methyl (wood) alcohol;

methyl ethyl ketone peroxide (used to harden polyester resins);

ozone (from carbon arcs, copiers, laser printers. etc.);

phosgene gas (created when chlorinated hydrocarbon solvents come into contact with heat or flame); and

wax when hot or burning (creates acrolein and other hazardous decomposition products).

Both filters and chemical cartridges wear out and become ineffective with use. Filters clog progressively until breathing through them becomes difficult and breathing pressure begins to draw more particles through. Spent chemical cartridges, on the other hand, will simply stop collecting the contaminant and allow it to pass through.

Chemical cartridges usually are considered spent after eight hours of use or two weeks after they have been exposed to air, whichever comes first. Chemical cartridges also wear out with time, even if they are not used. For this reason, many brands of cartridges have an expiration date stamped on them.

No filter or cartridge is designed to be effective when contaminants reach very high concentrations. At high concentrations, more contaminants pass through cartridges and filters than is desirable, and they will wear out in a shorter time—sometimes in minutes.

To be sure they are not spent, chemical cartridges should also be tested before each use. For example, a simple test for organic vapor or spray paint cartridges is to pass an open bottle of nail polish or isoamyl

acetate (banana oil) in front of the respirator when you first put it on. If you can detect the odor, replace the cartridge.

At the end of a work period, clean the respirator and store it out of sunlight in a sealable plastic bag. Respirators never should be hung on hooks in the open or left on counters in the shop. Cartridges left out will continue to capture contaminants from the air. They also should be stored in sealable plastic bags.

If a respirator is shared, it should be cleaned and disinfected between users. Most respirator manufacturers provide educational materials which describe proper break-down and cleaning procedures. Inspect respirators carefully and periodically for wear and damage.

For sources of NIOSH approved respirators, see *Best's Safety Directory* (see Bibliography) or some of companies listed in 3.048.

FACE AND EYE PROTECTION

3.043 All face and eye protection should be American National Standards Institute (ANSI)-approved. These standards are recognized in both the United States and Canada. Approved items will be labeled with the numbers of the standards with which they comply.

The type of protection depends on the type of materials used and on the nature of the process. Any process that involves a risk of splashing, for example, should be performed with ANSI-approved cup goggles or cover goggles. The cover goggles are most useful because they fit over prescription glasses. There are two types which are approved: those with no ventilation and those with indirect ventilation. Indirect ventilation prevents fogging while making it difficult for splashes to penetrate. Cover goggles also will be sufficient for the small amounts of airborne dusts which might be liberated in photographic processes.

Unventilated goggles are needed to protect against irri-tating gases such as ammonia. A nonfogging material should be applied to the lenses of these goggles. For severe exposures to irritating gases or vapors, a full-face respirator is recommended.

Contact lenses, both soft and hard types, are highly hazardous to the eyes in the presence of toxic vapors, gases and dusts produced in photography. See eye hazards (1.018). If contact lenses must be worn while working in the darkroom or printmaking studio, wear unvented safety goggles.

If concentrated alkalis and other corrosive liquids are used, a face shield may be worn over the goggles to protect the face and neck from possible splashes.

Ultraviolet and infrared light, as well as glare from carbon arc lamps, quartz mercury and other types of lighting require goggles with varying degrees of shading to protect against the intensity of the radiation. To protect against radiation from carbon arc lamps, welding goggles with shade number 14 should be worn. For protection against

the glare of quartz lights or strobe lights used in studio photography, spectacles (these can be regular eyeglasses) with tinted, polarizing lenses should be worn.

SKIN PROTECTION

3.044 Skin irritation, dermatitis and other skin disorders are the most common types of injury produced by exposure to photographic chemicals and to the organic solvents used in printmaking, conservation and restoration processes. See skin hazards (1.013). In addition, serious systemic damage can occur when highly toxic chemicals used in these processes are absorbed through the skin.

Since the hands are often the site of skin injuries from other causes, direct contact with chemicals should be avoided whenever possible by the use of tongs, gloves and barrier creams.

3.045 **CHEMICAL GLOVES.** Many photographers are unaware that some common chemicals like acetone, glycol ether, and xylene can penetrate certain chemical gloves in minutes and begin damaging and/or penetrating the skin. Special chemical-resistant gloves must be used with many photochemicals. Surgical or ordinary household gloves should not be expected to stand up to photoprocessing or printmaking.

To purchase the right gloves, find a glove supplier who provides information (usually in the form of a chart) which indicates how long each type of glove material can be in contact with a chemical before it is 1) degraded and 2) permeated. Degradation occurs when the glove deteriorates from the chemical's attack. Permeation occurs when molecules of the chemical squirm through the glove material. Permeated gloves often appear unchanged and the wearer may be unaware they are being exposed to the chemical.

In general, Neoprene gloves will resist most common photochemicals for a significant period of time. However, it is important that the glove manufacturer's specifications be checked for resistance to specific products.

Manufacturers' data also should be used to select proper gloves for other purposes, such as protection from heat, radiation, and abrasion. Asbestos gloves should not be used and substitutes for them are available.

Be sure that chemical gloves are kept clean and uncontaminated. Otherwise, the gloves can actually increase the hazards of skin injury because they can promote skin contact and absorption of chemical contaminants. After handling chemicals, gloves should be rinsed thoroughly before being removed. They should then be washed inside and out with pHisoderm® soap (or other appropriate cleanser) and hung up to dry inside out. This procedure keeps the gloves clean and also reduces the tendency of the glove material to absorb chemicals. After using a pair of gloves for one day, they should be decontaminated as well. Follow decontamination instructions given by manufacturers.

Before rewearing used gloves, they should be tested for permeability. The simplest method is to invert the gloves, fill them with water and squeeze them to see if there are any small punctures in the material which would admit liquids.

To reduce irritation and sweating, lined gloves can be worn, or the inside of the gloves can be dusted with baby powder.

3.046 **BARRIER CREAMS.** Protective barrier creams are a secondary form of skin protection which, when applied to the skin, provide a protective film or "invisible glove." These creams should be used only when gloves are not practical, or in conjunction with gloves to provide an extra layer of defense in case any chemicals accidentally enter the glove. There are two basic types of barrier creams: 1) water-soluble, for protection against organic solvents, lacquers and oil-based materials; and 2) water-resistant, for use with water-based solutions such as dye baths and mild acids. Barrier creams require frequent reapplication to maintain their effectiveness. They do not protect against highly corrosive substances and should not be used without gloves when mixing concentrated acids and alkalis. Even when using a barrier cream, hands should not be put in processing trays. By themselves, the creams may not provide adequate protection, and the cream itself may contaminate developer solutions.

3.047 **SKIN CARE.** The use of either gloves or barrier creams should be supplemented by good skin care. Never use solvents or waterless hand cleaners containing solvents or harsh abrasives to clean the hands. Instead, wash frequently with soap and water. After working with photographic chemicals or solvents, use a mildly acidic cleanser such as pHisoderm® to remove chemicals from the skin. In addition, applying a mild lanolin- or vasoline-based cream after washing will help replace oils in the skin and keep it in good condition.

SAFETY EQUIPMENT SOURCES

3.048 There are several safety equipment directories available. One is *Best's Safety Directory*. It lists manufacturers and distributors of all types of safety equipment and supplies. Many technical libraries have a copy or it can be purchased for about $ 30.00 from A.M. Best Co., Ambest Road, Oldwick, NJ 08858 or call (201) 439-2200.

Some major companies that distribute respirators and other safety equipment include the following:

American Optical Corp.,
14 Mechanic St., Southbridge, MA 01550. (800) 225-7768.

Belcon Safety Products, Limited,
1515 Matheson Blvd., Unit C2, Mississauga L4W 2P5, Ontario.

Direct Safety Co.,
7815 S. 46th St., Phoenix, AZ 85044. (602) 968-7009.

Fisher Scientific Co, (Canadian branches)
10720-178 Street, Edmonton T5S 1J3, Alberta.
196 W. Third Ave., Vancouver V5Y 1E9, British Columbia.
1200 Denison Street, Unionville L3R 8G6, Ontario.
8505 ch. Devonshire Rd., Montreal H4P 2L4, Quebec.

Glendale Protective Technologies, Inc.,
130 Crossways Park Drive, Woodbury, NY 11797. (516) 921-5800.

Industrial Safety & Security,
1390 Neubrecht Rd., Lima, OH 45801. (800) 537-9721.

Lab Safety Supply Co.,
P.O. Box 1368, Janesville, WI 53547. (800) 356-0783.

Mine Safety Appliances Co.,
P.O. Box 425, Pittsburgh, PA 15230. (800) MSA-2222.

North Safety Equipment,
2000 Plainfield Pike, Cranston, RI 02920. (401) 943-4400.

Racal Airstream, Inc.,
7309A Grove Rd., Fredrick, MD 21701. (800) 682-9500.

Scott Aviation,
2225 Erie St., Lancaster, NY 14086. (716) 863-5100.

Standard Glove and Safety Equipment Corp.,
34300 Lakeland Blvd., Eastlake, OH 44094. (800) 223-1434.

SURVIVAIR, Div. of Comasec, Inc.,
3001 S. Susan St., Santa Ana, CA 92704. (800) 821-7236.

U.S. Safety,
1535 Walnut, P.O. Box 417237
Kansas City, MO 64108. (800) 821-5218.

Wilson Safety Products,
P.O. Box 622, Second & Washington Sts.,
Reading PA 19603. (215) 376-6161.

3M Co., Occupational Health and Safety Products Div., 3M Center/ Bldg. 220-3E-04, St. Paul, MN 55144. (800) 328-1667.

Inclusion of a company on this list does not constitute endorsement of their products.

WORK-RELATED ILLNESS

3.049 If symptoms of illness develop, it is important to determine whether they are caused by exposure to any toxic chemicals or materials used in photographic processes, or if they result from other causes. Even a hobbyist's infrequent exposures to photographic chemicals can lead to health problems that should be considered in the context of "occupational illness". Generally, an acute problem such as contact (allergic) dermatitis caused by skin contact with certain developers can be more easily traced to work practices than can chronic illnesses. In illness such as chronic bronchitis from repeated exposure to acid vapors or irritating gases, symptoms are usually vague and can be mistaken for other types of illnesses, including chronic fatigue or the flu. Members of high-risk groups, such as those with suppressed immune systems, a history of allergies, heavy drinkers, smokers or persons with chronic heart, lung or kidney impairment, should be particularly alert to the subtle symptoms of chronic occupational illness.

FINDING AN OCCUPATIONAL PHYSICIAN

3.050 Choosing the right tests and interpreting the results can be done best by doctors who are Board Certified in Occupational Medicine or Toxicology, or who have experience with occupational health problems. Such doctors may be found by contacting your state or provincial health departments or artists' advocacy organizations such as ACTS (see 3.013).

Only consult physicians who explain the results of medical tests in meaningful terms so you can be an active participants in your own health care. The doctor will need to know exactly what materials have been used. Supply chemical names whenever possible. Occupational physicians also can provide medical approval for workers who need to wear respirators (see 3.042).

DIAGNOSTIC TESTS

3.051 Photographers should keep in mind that there are no tests for some types of chemical exposures, and there are no treatments for many kinds of bodily damage from workplace chemical and physical agents. Diagnostic tests are never a replacement for preventing exposure to toxic substances.

Medical monitoring, however, can be a valuable tool in early recognition and prevention of occupational illnesses. Such tests can serve three purposes: 1) to identify preexisting disorders so photographers can avoid chemicals that would put them at great risk; 2) to detect early changes in performance before serious damage occurs; 3) and to detect damage that has already occurred and which may be permanent.

Examples of some types of useful medical tests might a regular (in some cases yearly) lung function test. This test can detect the onset of asthma and other lung diseases related to photochemical exposure. These and other organ function tests can help detect physiological changes before overt symptoms of disease appear, and thus may provide early warning signals. Other tests might include blood and urine tests to detect the presence of toxic metals in the body. Any photographer using lead materials should have blood tests for lead at least once a year. Other medical tests, such as chest x-rays and blood tests should be done regularly to monitor organ systems function.

FIRST AID

3.052 Ideally, all photoprocessing or printmaking facilities should have at least one person present who is trained in first aid procedures and CPR (cardio-pulmonary resuscitation). Many health agencies also promote such training for ordinary householders. This training is especially applicable if the household is one in which photochemicals are used.

Training and good intentions will be useless, however, unless someone is present who can assist an injured person. This means that the first rule to be followed is that photographers should never work alone or without someone in voice range who can come to their aid.

General first-aid texts are listed in the Bibliography and some basic rules of first aid are listed below. However, these should not be expected to substitute for actual training.

FIRST AID FOR ACUTE CHEMICAL POISONING

3.053 **SKIN AND EYE CONTACT.** All darkrooms and studios should have emergency eyewashes and showers near areas where chemicals are used, since immediate treatment is needed to prevent damage to the skin or eyes (3.006. 3.043). In cases of splashes or spills of corrosive chemicals on the skin or in the eyes, take the following steps immediately:

• Flush affected areas with large amounts of water for at least fifteen minutes. Removing all contaminated clothing while under the shower (do not take clothing off first).

• If the eyes are affected, continue rinsing while someone calls a phy-

sician and poison control. For all but minor skin injuries, a physician should be contacted.

• Do not use salves, ointments or home remedies on chemical burns from acids or alkalis unless instructed to do so by the doctor or poison control. Some burn medications actually increase absorption of the chemicals. Follow precisely the directions given by the physician or poison control center until medical treatment is obtained.

3.054 CHEMICAL INHALATION. If a person is overcome by inhalation of toxic vapors, gases or powders, take the following measures:

• Remove the person from the source of exposure. Wear appropriate respiratory equipment or protective clothing if necessary when removing the person.

• Make sure the injured person gets plenty of fresh air.

• Call emergency rescue services immediately. Follow their directions for treatment until they arrive.

3.055 CHEMICAL INGESTION. If someone accidentally swallows potentially toxic materials, take the following steps:

• CALL THE LOCAL POISON CONTROL CENTER IMMEDIATELY and report the material swallowed, including the dose. Assume that if the chemical is taken into the mouth, some of it has been swallowed.

• Do nothing unless poison control instructs you to. Especially DO NOT INDUCE VOMITING unless told to do so. Your first aid kit or home medicine cabinet should be stocked with syrup of Ipecac for induction of vomiting if necessary.

FIRST AID KITS

**3.056 **Every darkroom and photographic printmaking studio should have a comprehensive first aid kit for emergencies, and everyone using the workspace should know how to use it. Simple first aid kits available in pharmacies for home use are not adequate for photographic darkrooms and studios where hazards are greater. Many safety equipment companies furnish standard industrial first aid kits that are adequate for photography, printmaking and photographic conservation purposes. See Safety Equipment Sources (3.048).

CHAPTER

Which Photographic Chemicals are Harmful?

4.000 Photographers use an incredibly large number of chemicals. These chemicals range from the most toxic to the most benign. Even more importantly, the hazards of a large percentage of photographic chemicals are essentially unknown. Many chemicals, especially in color chemistry, have never been studied for toxicity at all. Data on others may only include an acute animal study or two, but no long-term, chronic data. Photographers must understand that warnings on labels or on Material Safety Data Sheets only applies to known hazards. To be safe and healthy, good work habits, ventilation and other precautions should be practiced with all photographic chemicals.

In this chapter, the hazards of chemically similar materials are evaluated together. General hazards of materials within each class are discussed in a preliminary section, followed by hazards of specific chemicals within the class. When data on long term, chronic effects such as cancer and reproductive damage are available they will be included, but absence of such data should never be construed as an absence of such effects.

Likewise, most photochemicals have not been studied sufficiently to set Threshold Limit Values (TLVs) or to regulate exposure to them in the workplace (see 2.038). When TLVs have been set, they will be reported. But absence of such limits does not mean that airborne exposure is safe.

The term "avoid" will be used to convey a warning that the degree of hazard is sufficiently high to warrant discarding or eliminating the material or procedure in order to prevent the hazardous exposure. Whenever possible, less toxic chemicals and safer procedures should be substituted for those which are extremely hazardous even if proper precautions are taken. If it is not possible to avoid the more toxic chemicals, or if this is unacceptable for aesthetic reasons, then extra precautions should be taken. Chemicals with significant health hazards that are not recommended for use are discussed in Chapter Three (3.012).

DEVELOPERS

4.001 Photographic developers are special organic chemicals that have the ability, when incorporated in a developer solution, to develop the exposed silver halides without affecting the unexposed halides. Developer solutions contain other chemicals that act as accelerators, preservatives, restrainers or antifoggants. These chemicals are listed in other sections of this chapter.

Many color developers are dye coupling agents, and tend to be complex molecules with long side chains. Para-phenylene diamine and its dimethyl and diethyl derivatives are still commonly used as color developers. Newer color coupling agents with extremely complicated molecular structures have been widely introduced. Color developing solutions contain a wide range of chemicals in addition to the developing agents. These chemicals are listed under in other sections of this chapter.

HAZARDS OF DEVELOPERS

4.002 **GENERAL HAZARDS.** Developing chemicals tend to be the cause of the most common health problems among photographers. They are skin, eye and respiratory irritants, and many are potent allergic sensitizers. Some developers can be absorbed through the skin to cause systemic toxicity. Most developers are moderately to highly toxic by ingestion, and inhalation of developer powders can result in similar effects on the body.

4.003 **AMINOPHENOL** (para-aminophenol hydrochloride). Aminophenol is moderately toxic by skin contact, inhalation and ingestion. Prolonged and repeated skin contact can cause irritation and skin allergies. Ingestion or inhalation of large amounts of the powder may cause the acute blood disease methemoglobinemia, with resulting cyanosis (blue lips and nails, difficulty in breathing). Chronic inhalation of the powder may cause bronchial asthma. Causes birth defects and other reproductive damage in experimental animals.

4.004 **AMIDOL** (diaminophenol hydrochloride, hydroxy-para-phenylene diamine hydrochloride). This compound is moderately toxic by skin contact and highly toxic by inhalation or ingestion. Skin contact can cause severe irritation and skin allergies. Amidol can also be absorbed through the skin, causing systemic injury. Inhalation of the powder may cause bronchial asthma, and inhalation or ingestion can result in gastritis, elevation of blood pressure, vertigo, tremors, convulsions and coma. Avoid, if possible.

4.005 **HYDROQUINONE** (para-hydroxy benzene). Hydroquinone is moderately toxic by skin contact and inhalation, and highly toxic by ingestion. Skin contact can cause irritation and allergies. After five years of repeated eye contact with hydroquinone, depigmentation (loss of color in the iris) and eye injury may occur. Inhalation and ingestion may cause ringing in the ears (tinnitus), dizziness, nausea, muscular twitching, increased respiration, headaches, cyanosis (blue lips and nails), delirium and coma. The first long term toxicity test of hydroquinone released in October, 1989, by the National Toxicology Program (NTP Technical Report, Series No. 366) showed some evidence of cancer effects in mice and rats. Hydroquinone has a Threshold Limit value (TWA) of 2.0 milligrams per cubic meter and is regulated by OSHA at this limit (2.038).

4.006 **GLYCIN** (para-hydroxyphenyl aminoacetic acid). This is a moderately toxic developer that may cause skin irritation and allergies, or symptoms of anemia, cyanosis, difficulty in breathing, nausea, dizziness and other systemic effects if inhaled or ingested. Very little data is available on this chemical.

4.007 **CATECHIN** (catechol, pyrocatechol, o-dihydroxybenzene). Catechin is a highly toxic developer by every route of exposure. It may be absorbed through the skin, causing systemic effects. Skin contact can cause irritation and possible allergies. Inhalation of the powder can cause severe acute poisoning, with symptoms of cyanosis, anemia, convulsions, vomiting, increased respiration and damage to liver and kidneys. Ingestion of less than one gram of the powder can be fatal. Catechin has a Threshold Limit Value (TWA) of 5 parts per million and is regulated by OSHA at this level in the workplace (see 2.038). It causes reproductive effects in animals. Avoid if possible.

4.008 **CHLORQUINOL** (chlorhydroquinone). This developer is moderately toxic by skin contact and by inhalation. It is highly toxic by ingestion, and causes systemic effects similar to symptoms of catechin poisoning (4.007). Very little data is available on this chemical.

4.009 **PYROGALLIC ACID** (pyrogallol, 1,2,3-trihydroxybenzene). Pyrogallol is highly toxic by every route of exposure and can also readily be absorbed through the skin. Skin contact can cause severe irritation and allergies. Inhalation of the powder can cause severe acute poisoning with symptoms of cyanosis, anemia, convulsions, vomiting, and liver and kidney damage. Ingestion can be fatal. Causes birth defects and other reproductive damage in experimental animals. Avoid, if possible.

4.010 **METOL, ELON** (monomethyl para-aminophenol sulfate). This is a moderately toxic developer that may cause skin irritation and allergies fol-

lowing skin contact. Inhalation of the powder or ingestion can cause anemia, cyanosis, difficulty in breathing, dizziness, nausea and other symptoms of systemic damage.

4.011 **PHENIDONE** (1-phenyl-3-pyrazolidone). Phenidone is slightly toxic by skin contact and moderately toxic by inhalation or ingestion. It is a skin and eye irritant; prolonged contact with the powder can cause skin allergies. Its hazards by inhalation and ingestion are similar to those of other black and white developers, Dimezone (1-phenyl-4, 4-dimethyl-3-pyrazolidinone) is a compound similar to phenidone and has similar hazards.

4.012 **PARA-PHENYLENEDIAMINE** (p-phenylene diamine). This com-pound, used both for black and white and color development, is highly toxic by all routes of exposure. By skin contact it causes severe skin allergies. Para-phenylenediamine may also be absorbed through the skin. Inhalation of the powder can cause severe asthma, and irritation of upper respiratory passages. Ingestion may cause vertigo, nervous system damage, gastritis, liver and spleen damage, double vision and weakness. It causes tumors in animals. It has a Threshold Limit Value (TWA) of 0.1 milligrams per cubic meter and is regulated by OSHA at this level in the workplace (2.038).

The hazards of ortho-phenylenediamine, diethyl-para-phenylenediamine and dimethyl-paraphenylenediamine are similar to those of para-phenylenediamine. Both of these developers should be avoided.

4.013 **OTHER COLOR DEVELOPERS.** Color developers 4-(N-ethyl-N-2-methanesulfonylaminoethyl)-2-methylphenylenediamine sesquisulfate monohydrate (Kodak CD-3) and 4-(N-ethyl-N-2-hydroxyethyl)-2-methlyphenylenediamine sulfate (Kodak CD-4) are among the new, widely used color developers that are designed to have reduced toxicity. Their hazards are largely unknown. Color developers are known to cause severe skin irritation and allergies, especially by skin contact with the powders. Solutions can also be irritating.

N,N-diethylhydroxlamine is another color developer whose hazards are largely known except that it is an experimental reproductive hazard.

PRECAUTIONS FOR DEVELOPERS

4.014 • Follow all general precautions in Chapters Two and Three.

• Buy premixed developer solutions whenever possible, in order to avoid inhalation of toxic powders or skin contact with concentrated solutions.

- Always use the least toxic developer available for any given process. If possible, avoid highly toxic developers including catechin, pyrogallol, and para-phenylenediamine.

- Avoid direct skin contact with developers. Never put bare hands into the developer bath. Use tongs to agitate solutions and to pick up prints. Wear gloves and goggles when preparing and handling developer solutions. Gloves should be washed with an acidic hand cleaner such as pHisoderm® and then with water before removing them.

- Mix developer powders in a fume hood or glove box, or wear a toxic dust mask (3.016, 3.042).

- For skin splashes, immediately flush affected area with water; for eye splashes, flush for at least 15 minutes and get medical attention. Darkrooms should have a deluge-type shower and an eyewash fountain for such emergencies. (For home darkrooms, see 3.002-3.006).

- Follow proper precautions for housekeeping (3.021). Label all developer solutions carefully. Make sure that children cannot get into developers and other toxic chemicals.

- All darkrooms require adequate ventilation. Local exhaust ventilation, preferably a slot exhaust hood, is recommended for handling highly toxic developers. See (3.032).

- Clean up spills of developer liquids or powders immediately to prevent unnecessary exposure or contamination of darkroom air. Wear gloves, respirator and protective clothing for cleaning up large spills. Prepare for accidents with a supply of spill control materials (3.022).

OTHER ORGANIC CHEMICALS

4.015 In addition to developers, a variety of organic chemicals, including amines, phenols and aldehydes, are used in photographic processes. Many amines are used in color processing, while phenol and phenolic compounds are used as preservatives and fungicides in conservation. Formaldehyde, in the liquid (e.g. formalin) or the powder (paraformaldehyde) form, is another organic chemical that is widely used as a preservative and hardener. Miscellaneous organic chemicals include benzotriazole and 6-nitrobenzimidazole nitrate, two azimide compounds used as antifoggants in black and white developers.

HAZARDS OF ALIPHATIC AMINES

4.016 GENERAL HAZARDS. Many of the amines are closely related chemically and have somewhat similar toxic effects. Three such amines are:

AMINE	TLV-TWA*
ethanolamine (2-hydroxyethlamine)	3.0 ppm
diethanolamine (2,2'-dihydroxydiethylamine)	3.0 ppm
triethanolamine (2,2',2"-trihydroxytriethylamine)	0.5 ppm

* 8-hour Threshold Limit Values in parts per million (ppm) (2.038)

All three of these amines are corrosive to the skin and eyes, and moderately acutely toxic by ingestion and skin contact. The triethanolamine is also considered a suspect carcinogen by the American Conference of Industrial Hygienists.

As a group, the aliphatic amines form strongly alkaline solutions and are moderately to highly corrosive to skin. Many amines can be absorbed through the skin as well. Amine vapors are irritating to the mucous membranes of the throat and upper airways. The mists are irritating to the eyes and may even cause corneal damage. Some individuals may develop skin allergies to amines; others may develop skin irritation. The aliphatic amines also are flammable.

4.017 ETHYLENE DIAMINE (a color control agent) is moderately toxic by skin contact, inhalation and ingestion. It may also be absorbed through the skin. Concentrated solutions are corrosive to skin and especially to the eyes. Repeated exposure can cause skin and respiratory allergies, including asthma. Inhalation or ingestion may cause imitation of mucous membranes and liver and kidney damage. It has a Threshold Limit Value (TWA) of 10 parts per million and is regulated by OSHA at the same level in the workplace (2.038). It reacts explosively or ignites spontaneously with many substances including potassium dichromate and metals such as zinc and copper.

4.018 HYDROXYLAMINE HYDROCHLORIDE (a color fog restrainer) is highly toxic by skin contact and moderately toxic by inhalation and ingestion. It is highly irritating to skin, eyes and mucous membranes. Repeated exposure may cause skin allergies. Inhalation or ingestion can cause methemoglobinemia, cyanosis (blue lips and nails), convulsions and coma. It causes birth defects in experimental animals.

4.019 HYDROXYLAMINE SULFATE (a color neutralizer) is moderately toxic by every route of exposure. Skin contact may cause irritation and al-

lergies. Inhalation or ingestion hazards are similar to those of hydroxylamine hydrochloride. It causes birth defects in experimental animals.

4.020 **TERTIARY-BUTYLAMINE BORANE (TBAB**, color fogging agent). This compound is highly toxic by every route of exposure. TBAB can cause skin irritation; it may also be absorbed through the skin. TBAB is extremely irritating to eyes and to the respiratory tract. Systemic effects may include nervous system damage. Very little data is available on this highly toxic chemical.

PRECAUTIONS FOR AMINES

4.021 • Wear gloves and goggles when handling amines.

• Use with local exhaust ventilation or wear an approved respirator with a cartridge for ammonia and amines.

• Pregnant women should avoid exposure to hydroxylamine compounds because of their ability to cause birth defects in animals. Other amines that can be absorbed through the skin should also be avoided.

• Whenever possible, use light instead of the highly toxic foggant TBAB between the first and second developer in color processes requiring re-exposure.

HAZARDS OF ALDEHYDES

4.022 **GENERAL HAZARDS.** The aldehydes commonly used in photographic processes, formaldehyde and succinaldehyde, are moderately irritating to skin and moderately to highly toxic by other routes of exposure.

4.023 **FORMALIN/FORMALDEHYDE** (hardener, preservative). Formalin solutions consist of formaldehyde gas dissolved in water and methanol (some as high as 15%). Methanol is also highly toxic by ingestion.
 Formaldehyde is moderately toxic by skin contact and highly toxic by inhalation and by ingestion. Formaldehyde is a strong irritant to the skin, eyes and respiratory system. Repeated exposures may result in allergic reactions, including asthma. It causes cancer in animals, and is thus a suspected human carcinogen. Formaldehyde has a Threshold Limit Value (TWA) of 1 part per million and is regulated by OSHA in the workplace at this level (2.038).
 OSHA has instituted a special standard for workers exposed to formaldehyde which requires air-monitoring. If monitoring detects levels of formaldehyde above one-half of the one part per million Permissible Exposure Limit (above 0.5 parts per million), the standard requires

worker protective equipment, ventilation, education, medical surveillance and other provisions.

In addition, both OSHA and the American Conference of Governmental Industrial Hygienists have proposed to lower their airborne limits for formaldehyde. Substitutes for formaldehyde should be used, rather than meet the expensive and time-consuming regulations which are likely to become even stricter.

4.024 **SUCCINALDEHYDE** (prehardener). Succinaldehyde (or succinaldehyde disodium bisulfite) is moderately toxic by every route of exposure. It is a skin and eye irritant. Inhalation of succinaldehyde may cause imitation of the respiratory system. Very little data is available on this chemical.

PRECAUTIONS FOR ALDEHYDES

4.025 • Wear gloves and goggles when handling formaldehyde or succinaldehyde, and avoid direct skin contact with solutions or powders.

• Use formaldehyde-containing solutions in local exhaust or wear an approved respirator with a formaldehyde cartridge.

• Avoid accidental ingestion of formalin or formaldehyde or succinaldehyde powders, and keep these compounds out of the reach of children.

• Whenever possible, use succinaldehyde as a substitute for the more toxic formaldehyde.

HAZARDS OF PHENOLS

4.026 **GENERAL HAZARDS.** Phenol and its derivatives are widely used as insecticides or fungicides (or both), and as preservatives in many photographic processes, including conservation. These compounds are usually highly toxic by inhalation and by ingestion. Many are highly toxic by skin contact and may be absorbed through the skin. Chlorinated phenol compounds used as fungicides vary in toxicity (10.002).

4.027 **PHENOL** (carbolic acid). Pure phenol is highly toxic by every route of exposure. Spills of pure liquid on the skin can be fatal through rapid skin absorption. Single exposures by skin absorption, inhalation or ingestion can severely damage the liver, kidney and spleen and can cause nervous system depression. Repeated exposures cause severe systemic injury to the digestive system, nervous system and other organs. Dilute solutions of phenol can cause severe skin burns. It has a

Threshold Limit Value (TWA) of 5 parts per million and is regulated by OSHA at this limit in the workplace (2.038).

4.028 **THYMOL** (methyl isopropyl phenol) is only slightly toxic by skin contact. It is moderately toxic by inhalation and ingestion, and can be absorbed through the skin. Thymol can be irritating to the eyes. Symptoms of acute overexposure include gastric pain, nausea, vomiting and central nervous system stimulation (e.g., talkativeness). Very high levels of exposure can cause convulsions, coma and cardiac or respiratory arrest. Thymol has a pungent and irritating odor that provides ample warning that exposure is occurring. Thymol is an allergen. It causes reproductive effects in animals.

4.029 **O-PHENYL PHENOL** (ortho-phenyl phenol). O-Phenyl phenol is not significantly toxic by skin contact and cannot be absorbed through the skin. It is only slightly toxic by inhalation and ingestion. 0-phenyl phenol is much less toxic than thymol, but can cause eye irritation and possible corneal injury from acute exposure. Inhalation of the powder can cause upper respiratory irritation and chronic exposure can result in kidney damage.

PRECAUTIONS FOR PHENOLS

4.030 • Do not use pure phenol. Whenever possible, use less toxic o-phenyl phenol as a substitute for phenol or thymol.

• Wear gloves when handling thymol or o-phenyl phenol. If a thymol fumigation cabinet is used, follow precautions in Chapter Ten (10.003-10.005).

HAZARDS OF MISCELLANEOUS ORGANIC CHEMICALS

4.031 Organic antifoggants benzotriazole (1,2,3-benzotriazole) and 6-nitrobenzimidazole nitrate (used in phenidone developers) are potential allergic sensitizers, causing contact dermatitis by skin contact. There has been recent concern over the possible carcinogenicity of benzotriazole; at present, the cancer studies in animals are inconclusive. However, 6-nitrobenzimidazole causes cancer in animals, and therefore is a suspected human carcinogen. Another miscellaneous organic chemical, sodium nitrobenzenesulfonate, is a strong skin irritant and severe eye irritant. Not much else is known. However, most nitrobenzenes are also skin-absorbed. There are many more miscellaneous chemicals which photographers will see listed on Material Safety Data Sheets.

PRECAUTIONS FOR MISCELLANEOUS ORGANIC CHEMICALS

4.032 • Try to avoid 6-nitrobenzimadazole because of its suspected carcinogen status.

• Wear gloves when handling products containing benzotriazole and sodium nitrobenzenesulfonate. Avoid inhaling powders.

ACIDS

4.033 Most acids are liquids or solutions of gases in liquids, although a few, such as tannic acid and sodium bisulfate, are solids. Most acids are available in concentrated solutions, such as pure glacial acetic acid (99.8% pure) or 28% acetic acid. Concentrated solutions of acids are obviously more hazardous than dilute solutions.

HAZARDS OF ACIDS

4.034 **GENERAL HAZARDS.** Concentrated acids are highly corrosive to skin and eyes, and ingestion can cause severe stomach damage and death. Inhalation of acid vapors can irritate the respiratory system; acute inhalation of either the vapors or the liquid may cause chemical pneumonia. Diluted acids are less hazardous, but still may irritate skin, eyes and respiratory system.

Mixing or diluting acids can be highly hazardous unless handled properly. Adding water to a concentrated acid may cause the liquid to boil and spatter in a violent, exothermic (heat-producing) reaction. This reaction produces a shower of acid droplets and greatly increases the risk of acid burns to skin and eyes.

4.035 **ACETIC ACID** (glacial acetic acid). In concentrated form, acetic acid is highly toxic by every route of exposure (4.034). It is highly corrosive to skin, eyes, respiratory system and stomach. Vinegar is 4% acetic acid (the legal minimum concentration) and is only slightly toxic. Chronic inhalation of acetic acid vapors from dilute solutions (e.g., stop baths) may cause chronic bronchitis. Acetic acid has a Threshold Limit Value (TWA) is 10 parts per million and is regulated by OSHA at this level in the workplace (2.038). It is incompatable with chromic acid, nitric acid, many amines, and other chemicals. Store glacial acetic acid separately.

4.036 **BORIC ACID.** Boric acid, mainly used as a buffering agent, is moderately toxic by skin contact, inhalation and ingestion. Absorption through broken skin, ingestion or inhalation of may cause severe gastrointestinal symptoms and skin rash. Absorption of old fashioned boric acid burn ointments through burned skin has caused deaths. Chronic

exposure can cause borism, a disease with symptoms of dry skin, skin eruptions, and gastrointestinal upsets. It causes reproductive effects in animals. An insecticide. See borax (4.056).

4.037 CHROMIC ACID. Concentrated chromic acid is highly toxic by skin contact, ingestion and inhalation of the vapors. Even dilute solutions of chromic acid are moderately toxic because it can cause ulcers and skin allergies. Chromic acid is also a suspected carcinogen. It has a Threshold Limit Value (TWA) of 0.05 milligrams per cubic meter, and is regulated by OSHA at Ceiling Limit of 0.1 milligrams per cubic meter (2.038). It reacts dangerously with acetic acid, acetone, alcohols, ammonia, and many other chemicals store separately.

4.038 CITRAZINIC ACID (2,6-dihydroxy-isonicotinic acid). Concentrated citrazinic acid is moderately toxic by skin contact, inhalation and ingestion. Dilute solutions are mildly irritating to skin and mucous membranes, and may cause allergies in some people. Very little data is available on this chemical.

4.039 CITRIC ACID. Concentrated citric acid is moderately toxic by skin contact, inhalation and ingestion. Dilute solutions are mildly irritating, and may cause allergies in some people.

4.040 GALLIC ACID (3,4,5-trihydroxybenzoic acid). Gallic acid, used in cyanotype printing, is moderately toxic in concentrated form. Dilute solutions are mildly irritating to skin and mucous membranes of the respiratory system. Causes experimental reproductive effects.

4.041 HYDROCHLORIC ACID (muriatic acid). Concentrated hydrochloric acid is highly toxic by every route of exposure (4.034). Regular inhalation of small amounts can cause chronic bronchitis and emphysema. Hydrochloric acid gas (hydrogen chloride) has a Threshold Limit Value-Ceiling Limit of 5 parts per million and is regulated by OSHA at this limit (2.038). Store away from ammonia and amines.

4.042 NITRIC ACID. The concentrated acid is highly toxic by every route of exposure (4.034). The fumes that are given off by nitric acid solutions are highly toxic by inhalation. Repeated inhalation exposure may cause chronic bronchitis and emphysema. It has a Threshold Limit Value (TWA) of 2 parts per million and is regulated by OSHA at this level (2.038). Reacts with many other chemicals. Store separately from solvents and other acids.

4.043 OXALIC ACID. Oxalic acid, commonly used as a toner, is highly toxic by every route of exposure (4.034). Skin or eye contact can cause severe corrosion and ulcers, and repeated skin contact can cause gan-

grene (of extremities). Inhalation can cause severe respiratory irritation and possible ulceration. Ingestion of large amounts can cause severe corrosion of the mouth, esophagus and stomach, resulting in shock, possible convulsions and death. Oxalic acid can also cause severe kidney damage. It has a Threshold Limit Value (TWA) of 1 milligram per cubic meter and is regulated by OSHA at this level (2.038).

4.044 **PHOSPHORIC ACID** (orthophosphoric acid). This acid is highly toxic by every route of exposure (4.034). Skin or eye contact with concentrated solutions can cause severe burns. Inhalation of the acid mist can cause irritation of the upper respiratory tract. Repeated or prolonged skin contact can result in dermatitis. It has a Threshold Limit Value (TWA) of 1.0 milligrams per cubic meter and is regulated by OSHA at this level (2.038).

4.045 **PROPIONIC ACID** (methylacetic acid). Concentrated propionic acid is highly toxic by skin contact, and moderately toxic by ingestion or inhalation of the vapors. It is highly irritating to skin and eyes (4.034). It has a Threshold Limit Value (TWA) of 10 parts per million and is regulated by OSHA at this level (2.038).

4.046 **SUCCINIC ACID** (ethylene dicarboxylic acid). Concentrated succinic acid is moderately toxic by skin contact, ingestion or inhalation. Dilute solutions are mildly irritating.

4.047 **SULFAMIC ACID** (amidosulfonic acid). Sulfamic acid is moderately toxic by skin contact and highly toxic by ingestion or inhalation. This acid, used in bleaches, is corrosive to skin, eyes, respiratory system and the gastrointestinal system. Heating causes the formation of highly toxic sulfur dioxide gas.

4.048 **SULFURIC ACID.** Concentrated sulfuric acid is highly toxic by every route of exposure (4.034). It is highly corrosive to skin, eyes, mucous membranes and stomach. Ingestion of small amounts can be fatal. Heating can release large amounts of highly toxic sulfur oxides. Repeated inhalation can cause chronic bronchitis and emphysema. It has a Threshold Limit Value (TWA) of 1.0 milligram per cubic meter and is regulated by OSHA at this level (2.038). Reacts hazardously with acetic acid, ammonia and many other chemicals. Store separately.

4.049 **TANNIC ACID** (tannin). Concentrated tannic acid is moderately toxic by skin contact, inhalation and ingestion. Tannin is also a suspected carcinogen. Ingestion of large amounts may cause gastritis, vomiting, pain and diarrhea or constipation. Solutions are slightly irritating to skin.

4.050 **TARTARIC ACID** (racemic acid). Concentrated tartaric acid is moderately toxic by skin contact, inhalation and ingestion.

4.051 **PARA-TOLUENE SULFONIC ACID** (p-toluene sulfonic acid). This acid, used in Cibachrome (color) processing, is highly toxic by every route of exposure (4.034). It is highly corrosive to skin, eyes and mucous membranes of the respiratory tract. If ingested, it can cause severe corrosive damage. Inhalation of the vapors can cause severe respiratory irritation.

PRECAUTIONS FOR ACIDS

4.052 • Always wear protective elbow-length gloves and safety goggles when handling concentrated acids. When mixing or diluting concentrated acids, always add the acid slowly to the solution, never the reverse; otherwise the solution may boil and spatter, causing possible acid burns.

• Acid splashes on skin or eyes require immediate flushing with water. For eye splashes, flush for at least 15 minutes and get medical attention.

• If a strong acid is ingested, do not induce vomiting. Call your Poison Control Center immediately and tell them the exact name of the acid and the estimated amount ingested. Have container label and Material Safety Data Sheet at hand.

• Darkrooms require good ventilation to control the level of acid vapors and gases produced by processing baths. See ventilation systems (3.032).

• Cover the acid bath (and other baths) between printing sessions to prevent evaporation and contamination. Discard used solutions that have been contaminated with chemicals. Store concentrated acids and other corrosives on low shelves so as to reduce the risk of face or eye injury in case of accidental breakage. (See 3.017, 3.022.)

• Plan darkroom storage with individual cabinets for separate storage of incompatible acids and other chemicals.

ALKALIS

4.053 Alkalis, which belong to a large class of compounds known as bases, have the ability to react with (neutralize) acids to form salts. Most alkalis are dissolved in water, the solution having a pH range of 7.1 to 14. Weaker alkalis such as phosphates and sulfates tend to have a lower

pH value within this range, and are less irritating and corrosive. Common strong alkalis include sodium hydroxide (caustic soda), potassium hydroxide (caustic potash) and ammonium hydroxide (ammonia). These compounds tend to have higher pH values and are more caustic and corrosive. Sodium chloride (table salt) and ammonium chloride are examples of alkali salts that are rather neutral and non-corrosive, although large oral doses can be irritating.

HAZARDS OF ALKALIS

4.054 GENERAL HAZARDS. Most alkalis are highly corrosive to the skin and eyes, causing burns and ulceration of mucous membranes. Ammonia is particularly irritating to the eyes. Ingestion of small amounts of a concentrated alkali can cause severe pain and damage to mouth and esophagus. This damage can be fatal. Inhalation of alkali dusts can cause pulmonary edema. Some inhalation of alkaline solutions may occur with ingestion. Dilute alkaline solutions are more irritating to skin and eyes than dilute acid solutions.

4.055 AMMONIA (ammonium hydroxide). Concentrated ammonia solutions (28%) are moderately corrosive to skin and highly corrosive to eyes. Household ammonia (5% solution) is less hazardous to skin. Ammonia is highly toxic by inhalation and by ingestion. Inhalation of vapors can cause severe respiratory irritation and chronic lung problems. Large exposures may cause pulmonary edema. Ammonia vapors are also highly irritating to the eyes. Ingestion causes painful damage to the mouth and esophagus, and can be fatal. Ammonia has a Threshold Limit Value (TWA) of 25 parts per million and is regulated by OSHA at a Ceiling Limit of 35 parts per million (2.038). Store separately from bleach and acids.

4.056 BORAX (sodium borate, sodium tetraborate). Borax is slightly toxic by skin contact and moderately toxic by inhalation and ingestion. If absorbed through abraded or burned skin, ingested or inhaled, this compound can cause severe gastrointestinal symptoms and skin rash. Chronic absorption can cause gastroenteritis, skin rash and possible kidney damage. See boric acid (4.036). Borates have Threshold Limit Values (TWA) varying from 1 to 5 milligrams per cubic meter depending upon the number of chemically bonded water molecules present in the molecule. All borates including borax are regulated by OSHA (TWA) at 10 milligrams per cubic meter (2.038).

4.057 POTASSIUM BISULFITE (potassium hydrogen sulfite). Potassium bisulfite is slightly toxic by skin contact and moderately toxic by inhalation and ingestion. Its hazards are similar to those for potassium sulfite (4.061), except that it is more imitating. Heating or adding acid to

potassium bisulfite causes the formation of highly toxic sulfur dioxide gas. Store separately from acids.

4.058 **POTASSIUM CARBONATE** (potash). Potassium carbonate is moderately toxic by skin contact and highly toxic by inhalation and ingestion. Concentrated forms are corrosive to skin, mucous membranes and especially to eyes. Ingestion can result in painful damage to mouth and esophagus, and may be fatal. Dilute solutions are also very irritating.

4.059 **POTASSIUM CITRATE.** Potassium citrate is only slightly toxic by skin contact, inhalation and ingestion.

4.060 **POTASSIUM METABISULFITE.** See potassium sulfite (4.062).

4.061 **POTASSIUM PHOSPHATE.** Potassium phosphate is only slightly toxic by any route of exposure.

4.062 **POTASSIUM SULFITE.** Potassium sulfite is not significantly toxic by skin contact, but is moderately toxic by inhalation and ingestion. Inhalation of the dusts can irritate the respiratory system. Ingestion of small amounts can cause gastric irritation; ingestion of large amounts can cause severe colic, diarrhea, circulatory disorders and central nervous system depression. Heating or treating potassium sulfite with acid causes the formation of highly toxic sulfur dioxide gas.

4.063 **SODIUM ACETATE.** Sodium acetate is only slightly toxic by skin contact, inhalation and ingestion. Concentrated forms may be mildly irritating. Acute ingestion can cause vomiting/diarrhea.

4.064 **SODIUM BISULFITE** (sodium hydrogen sulfite). Sodium bisulfite is slightly toxic by skin contact and moderately toxic by inhalation and ingestion. Its hazards are similar to those for sodium sulfite (4.071) except that it is more irritating. Heating or adding acid to sodium bisulfite causes the formation of highly toxic sulfur dioxide gas. It has a Threshold Limit Value (TWA) of 5.0 milligrams per cubic meter and is regulated by OSHA at this level (2.038). Store away from acids.

4.065 **SODIUM CARBONATE** (soda ash). Sodium carbonate is moderately toxic by skin contact and highly toxic by inhalation and by ingestion. Concentrated forms are corrosive to skin, mucous membranes and, especially, to eyes. Ingestion causes painful damage to mouth and esophagus and can be fatal. Dilute solutions are also very irritating.

4.066 **SODIUM/POTASSIUM HYDROXIDES. SODIUM HYDROXIDE** (caustic soda). This is a highly toxic alkali by every route of exposure. Caustic soda is highly corrosive to skin, eyes and mucous membranes.

115

Ingestion causes painful damage and can be fatal. Inhalation of dust or solutions can cause pulmonary edema. Dilute solutions are also very irritating. POTASSIUM HYDROXIDE (caustic potash) is often used in place of sodium hydroxide. Its hazards are similar. Both hydroxides have Threshold Limit Values (Ceiling) of 2.0 milligrams per cubic meter and they are regulated by OSHA at this level (2.038). Store away from acids.

4.067 **SODIUM METABISULFITE** See hazards for sodium sulfite (4.072). It has a Threshold Limit Value (TWA) of 5 milligrams per cubic meter and is regulated by OSHA at this level. Store away from acids.

4.068 **SODIUM METABORATE** (Kodak). Sodium metaborate is made by fusing sodium carbonate (soda ash) with borax (sodium borate). It is moderately toxic by skin contact, and highly toxic by inhalation and ingestion. Concentrated forms are corrosive to skin, mucous membranes and especially to eyes. See borax (4.056) and sodium carbonate (4.065).

4.069 **SODIUM PHOSPHATE** (trisodium phosphate). Sodium phosphate is moderately toxic by skin contact and inhalation, and only slightly toxic by ingestion. Contact may cause skin or eye burns. Inhalation of the dusts can cause respiratory irritation.

4.070 **SODIUM POTASSIUM TARTRATE** (rochelle salt). Rochelle salt has no significant hazards.

4.071 **SODIUM SULFATE** (salt cake). Sodium sulfate is not significantly toxic. If heated, however, it will decompose to form highly toxic sulfur oxide gases (4.141).

4.072 **SODIUM SULFITE.** Sodium sulfite is not significantly toxic by skin contact, but is moderately toxic by inhalation and ingestion. Inhalation can irritate the respiratory system. Ingestion can result in gastric irritation in small doses. Large doses can cause severe colic, diarrhea, circulatory disorders and central nervous system depression. Heating and treating sodium sulfite with acid causes the formation of highly toxic sulfur dioxide gas (4.141). Store away from acids.

GENERAL PRECAUTIONS FOR ALKALIS

4.073 • Wear gloves and goggles when handling alkaline powders or solutions.

• For concentrated alkali spills or splashes on skin or eyes, flush affected areas immediately with water. Flush until the skin no longer feels "soapy." For eye splashes, flush for at least 15 minutes and get medical attention.

• Protect hands after use of dilute alkali solutions by washing up with a slightly acidic hand cleaner such as pHistoderm™.

• If alkali is ingested, call the Poison Control Center immediately and tell them exactly what alkali was ingested and an estimate of the amount. Have container label and Material Safety Data Sheet at hand.

• Wear gloves and goggles when handling ammonia solutions, and use with good dilution ventilation to remove the vapors. Because ammonia can rapidly damage the eyes, it is important to have a readily accessible source of water in the darkroom.

• Do not heat or mix strong alkalis with concentrated acids.

METAL COMPOUNDS

4.074 Metal compounds such as metal oxides, sulfides, chlorides, nitrates and other salts are used in many photographic processes. Most photographic toners and intensifiers are metal compounds. Metallic compounds are also used as dye mordants, as pigments for paints and as glazes and colorants for various printmaking processes. They are usually obtained in powder form.

HAZARDS OF METAL COMPOUNDS

4.075 **GENERAL HAZARDS.** Metal compounds can vary in toxicity from highly to substances such as mercuric chloride and lead acetate to slightly toxic potassium alum. Some, including those containing chromium, uranium and lead, are suspected human carcinogens. The dusts of metals and their compounds can be highly hazardous by inhalation, depending to a large extent on the solubility of the compound in body fluids. Highly soluble toxic compounds are more dangerous since they can dissolve readily in the body and immediately affect internal organs. Some metals and their salts can cause skin irritation and allergies.

Because the hazards of metallic compounds are so variable, specific precautions are given for each of the compounds in this group.

4.076 **AMMONIUM ALUM** (ammonium aluminum sulfate; toner). Ammonium alum is slightly toxic by skin contact, inhalation and ingestion. Repeated exposures may cause slight irritation or allergies.

Specific Precautions. Avoid skin contact if using frequently, and do not inhale the powder.

4.077 **AMMONIUM DICHROMATE** (intensifier, sensitizing agent). Ammonium dichromate is moderately toxic by skin contact and by ingestion; it is highly toxic by inhalation. Dichromates are also suspected carcino-

117

gens. Skin contact can cause irritation, allergies and possible ulceration. Ingestion of large amounts can cause symptoms of poisoning, including gastroenteritis, muscle cramps, vertigo and kidney damage. Chronic inhalation of the powder can cause irritation, respiratory allergies and perforation of the nasal septum. Chromates have a Threshold Limit Value (TWA) of 0.05 milligrams per cubic meter (2.038). Ammonium dichromate is flammable and will react hazardously with reducing agents.

Specific Precautions. Wear gloves and goggles when handling the powder or solutions. Mix dichromate powders in a fume hood or a glove box, or wear an approved toxic dust mask. Store ammonium dichromate separately and away from sources of heat.

4.078 AMMONIUM EDTA, IRON SALT (iron salt of ammonium ethylene diamine tetraacetic acid) and **DI-, TRI- AND TETRAPOTASSIUM SALTS OF EDTA.** The iron salt of EDTA is only slightly toxic by skin contact, inhalation and ingestion, causing slight irritation. A number of other metal salts and alkali salts of EDTA are used for similar purposes. Some of these EDTA salts are known under trade names such as Celon, Versene, Sequestrene NaFe. It is expected that these compounds have similar hazards.

Specific Precautions. Avoid skin contact; do not inhale the powder.

4.079 COBALT CHLORIDE (toner). Cobalt chloride is only slightly toxic by skin contact and ingestion, but moderately toxic by inhalation of the dusts. Repeated skin contact may cause allergies, especially at the neck, ankles and elbows. Chronic inhalation causes sensitization of the respiratory tract with a type of asthma ("obstructive airways syndrome") and possible fibrosis of the lungs. There is also some evidence of cardiomyopathy (atrophy of heart muscles) resulting from repeated exposure to cobalt compounds. Ingestion of large amounts can cause acute illness with vomiting and diarrhea.

Specific Precautions. Wear gloves when handling. Mix powders in a fume hood or glove box, or wear an approved toxic dust mask.

4.080 COPPER IODIDE (intensifier). Copper iodide is slightly toxic by skin contact and moderately toxic by inhalation and ingestion. It can cause skin allergies and irritation to skin, eyes and mucous membranes of nose and throat, including possible ulceration and perforation of the nasal septum. Prolonged absorption can cause severe skin boils and blisters, weakness, anemia, weight loss and central nervous system depression.

Specific Precautions. Wear gloves and goggles when handling. Mix powders in a fume hood or glove box, or wear an approved toxic dust mask.

4.081 **COPPER SULFATE** (cupric sulfate, blue vitriol; bromoil process bleach bath). Copper sulfate is slightly hazardous by skin contact and moderately toxic by inhalation or by ingestion. This compound may cause skin allergies and irritation of skin, eyes, nose and throat, including possible ulceration and perforation of the nasal septum. Acute ingestion causes gastrointestinal disturbances with vomiting; chronic ingestion can cause anemia. Copper salts have a Threshold Limit Value (TWA) of 1.0 milligrams per cubic meter and are regulated by OSHA at this limit (2.038).

Specific Precautions. Wear goggles and avoid skin contact when handling. Do not inhale the powder.

4.082 **FERRIC AMMONIUM SULFATE** (toner). Ferric ammonium sulfate is slightly toxic by skin contact, inhalation and ingestion, causing slight irritation or allergies. Soluble iron salts have a Threshold Limit Value (TWA) of 1.0 milligram per cubic meter and are regulated by OSHA at this limit (2.038).

Specific Precautions. Avoid skin contact if using frequently; do not inhale the powder.

4.083 **FERRIC AMMONIUM CITRATE** (cyanotype and Van Dyke process sensitizer). Ferric ammonium citrate is slightly toxic by skin contact, inhalation or ingestion. It may cause slight irritation and allergies with repeated exposures. (Threshold Limit Value: see 4.082.)

Specific Precautions. Avoid skin contact if using frequently.

4.084 **FERRIC CHLORIDE** (iron perchloride; photogravure process). Ferric chloride is moderately toxic by skin contact, inhalation and ingestion. It forms hydrochloric acid in solution. Ferric chloride baths are irritating to skin, eyes and mucous membranes of the respiratory system. Ingestion of large amounts may cause iron poisoning, especially in children. (For the Threshold Limit Value: see 4.082.)

Specific Precautions. Wear gloves and goggles when handling ferric chloride.

4.085 **FERRIC OXALATE** (platinum sensitizer). Ferric oxalate is moderately toxic by skin contact and highly toxic by inhalation and by ingestion. Oxalates are corrosive to skin, eyes, nose and throat. Ingestion can cause intense damage to mouth, esophagus and stomach, and may also damage kidneys. Ferric oxalate can be fatal by ingestion. (For the Threshold Limit Value: see 4.082.)

Specific Precautions. Wear gloves and goggles when handling this compound. Mix solutions in a fume hood or glove box, or wear an approved toxic dust mask.

4.086 **FERROUS SULFATE** (toner). Ferrous sulfate is only slightly toxic by any route of exposure. It is slightly irritating to skin, eyes, nose and throat. Ingestion of large amounts may cause iron poisoning, especially in children. (For the Threshold Limit Value: see 4.082.)
 Specific Precautions. None.

4.087 **GOLD CHLORIDE** (toner). Gold chloride is moderately toxic by every route of exposure. It can cause severe skin and respiratory allergies. Chronic inhalation or ingestion can cause anemia, and liver, kidney and nervous system damage.
 Specific Precautions. Avoid repeated skin contact; do not inhale the powder.

4.088 **LEAD ACETATE** (cyanotype toner). Lead acetate is a soluble lead compound that is highly toxic by inhalation and by ingestion, although not significantly toxic by skin contact. Chronic inhalation or ingestion can cause lead poisoning, affecting the gastrointestinal system (lead colic), red blood cells (anemia) and neuromuscular system (weakening of extremities). Other symptoms of lead poisoning may include weakness, malaise, headaches, irritability, pain in joints and muscles and liver and kidney damage. Lead is a known teratogen (causes birth defects) and is also a suspected mutagen. Lead acetate is listed as a suspect cancer agent by the National Toxicology Program. Inorganic lead compounds have a Threshold Limit Value (TWA) of 0.15 milligrams per cubic meter and are regulated by OSHA (TWA) at 0.05 milligrams per cubic meter (2.038).
 Specific Precautions. DO NOT USE. Use a safer alternative toner such as tannic acid (3.049) for cyanotype. Gold chloride (3.087) is a less toxic brown toner.

4.089 **LEAD NITRATE** (salted paper toner). Lead nitrate is a very soluble lead compound that is slightly toxic by skin contact and highly toxic by inhalation and by ingestion. In other respects, its hazards and Threshold Limit Value are similar to those of lead acetate (4.088).
 Specific Precautions. DO NOT USE. Safer alternative toners are gold chloride (4.087) and platinum chloride (4.095).

4.090 **LEAD OXALATE** (platinum toner). This lead compound, used in platinum and palladium printing, is highly toxic by every route of exposure. Skin contact may result in corrosion of skin and eyes. It is also corrosive to nose and throat if powders are inhaled. Ingestion can cause intense pain and damage to mouth, esophagus and stomach, as well as kidney damage. Ingestion can be fatal. In other respects, its hazards and Threshold Limit Value are like to those of lead acetate (4.088).
 Specific Precautions. DO NOT USE. A safer alternative toner is potassium phosphate (4.061).

4.091 **MERCURIC CHLORIDE** (intensifier, preservative). Mercuric chloride is highly toxic by every route of exposure and can also be absorbed through the skin. Skin contact can result in severe corrosion. Skin absorption, ingestion or inhalation of mercuric chloride can cause acute or chronic mercury poisoning, primarily affecting the kidneys and gastrointestinal system, and later damaging the nervous system. Symptoms of acute poisoning may include metallic taste, swelling of gums, vomiting and bloody diarrhea. Ingestion of 0.5 gram of the powder can be fatal. Chronic mercury poisoning can cause severe kidney disease. It can also damage both the central and peripheral nervous systems, resulting in neurologic and psychic disturbances (the syndrome known as "erethism") and fine muscle tremors. See other symptoms of chronic mercury poisoning discussed under hazards of mercury (4.093). Mercury-containing salts and metallic mercury have Threshold Limit Values (TWA) of 0.05 milligrams per cubic meter and are regulated by OSHA at these limits (2.038).

Specific Precautions. DO NOT USE. Chromium intensifiers are less toxic alternatives (5.025).

4.092 **MERCURIC IODIDE** (intensifier). See hazards for mercuric chloride (4.091).

Specific Precautions. DO NOT USE. See precautions for mercuric chloride (4.091).

4.093 **MERCURY** (quicksilver; Daguerreotype sensitizer). Metallic mercury is highly toxic by skin contact, by skin absorption and by inhalation of the vapors. It readily vaporizes at room temperature, and the vapor has no odor-warning properties. Mercury is not significantly toxic by ingestion since it is only minimally absorbed through the gastrointestinal tract. Acute inhalation or skin absorption of mercury can cause acute mercury poisoning, associated with such symptoms as metallic taste, nausea, vomiting, abdominal pain, diarrhea, headache and marked kidney damage, usually of delayed onset. Chronic mercury poisoning, which is much more common than the acute form, severely affects both the central and peripheral nervous systems and is characterized by neurologic and psychic disturbances (the syndrome known as "erethism") and fine muscle tremors. Symptoms of chronic exposure often include incoordination, motor tremors and jerky movements followed by psychic disturbances such as insomnia, irritability, indecision and psychological deterioration (depression, loss of memory and frequent outbursts of anger). Kidney disease is also common. Other symptoms of chronic poisoning may include severe stomatitis with excessive salivation, anorexia, digestive disturbances, weight loss and skin, eye and respiratory irritation with possible skin allergies. Inhalation of the vapors can also cause chronic bronchitis and pneumonitis. (For the Threshold Limit Value, see 4.091.)

Specific Precautions. DO NOT USE. Use the Becquerel method for daguerreotype instead (7.002).

4.094 PALLADIUM CHLORIDE and SODIUM PALLADIUM CHLORIDE (sensitizers, toners). Palladium chlorides are slightly toxic by skin contact and by inhalation. Their hazards by ingestion are unknown. Palladium chloride causes cancer and reproductive effects in experimental animals.

Specific Precautions. Avoid repeated skin contact and do not inhale the powder.

4.095 PLATINUM CHLORIDE (sensitizer, toner). This platinum salt is moderately toxic by skin contact and highly toxic by inhalation. Its hazards by ingestion are unknown. Skin contact can cause severe skin allergies. Inhalation can cause nasal allergies (similar to hay fever) and platinosis, a severe type of asthma. Some lung scaring and emphysema may also result from repeated inhalation. Persons with red or light hair and fine textured skin appear to be most susceptible. Soluble platinum salts have a Threshold Limit Value (TWA) of .002 milligrams per cubic meter and are regulated by OSHA at this limit (2.038). (See also 4.098)

Specific Precautions. Wear gloves or barrier cream and goggles when handling platinum salts. Mix in a fume hood or glove box, or wear an approved toxic dust mask.

4.096 POTASSIUM ALUMINUM SULFATE (alum; hardener). Alum is slightly toxic by skin contact, inhalation and ingestion, causing mild irritation and possible allergies.

Specific Precautions. Avoid skin contact if used frequently; do not inhale the powder.

4.097 POTASSIUM CHLOROCHROMATE (intensifier). This compound is moderately toxic by skin contact and ingestion, and highly toxic by inhalation. Skin contact can cause irritation, allergies, ulceration and eye burns. Inhalation of the powder may cause respiratory irritation, allergies and possible perforation of the nasal septum. Ingestion may result in acute poisoning with symptoms including gastroenteritis, vertigo, muscle cramps and kidney damage. Heating or adding acids to potassium chlorochromate causes release of highly toxic chlorine gas. Chromates have a Threshold Limit Value (TWA) of 0.05 milligrams per cubic meter (2.038) and is regulated by OSHA at a Ceiling Limit 0.1 milligrams (CrO_3) per cubic meter.

Specific Precautions. Wear gloves and goggles when handling powder or solutions. Mix the powder in a fume hood or glove box, or wear an approved toxic dust mask. Do not heat or add acid to potassium chlorochromate.

4.098 POTASSIUM CHLOROPLATINITE (potassium tetrachloroplatinate; toner). See hazards of platinum chloride. Repeated exposure to platinum salts, including sodium chloroplatinite and potassium chloroplatinite, will cause skin and respiratory allergies in the majority of individuals exposed. (For Threshold Limit Value, see 4.095.)

Specific Precautions. See precautions for platinum chloride (4.095). Platinum salts have a Threshold Limit Value (TWA) of 0.002 milligrams per cubic meter and are regulated by OSHA at this limit.

4.099 POTASSIUM CHROME ALUM (chrome alum, potassium chromium sulfate; hardener). Potassium chrome alum is moderately toxic by skin contact and ingestion and highly toxic by inhalation. Skin contact can cause irritation, allergies, ulceration and eye burns. Inhalation of the powder can cause respiratory irritation, allergies and possible perforation of the nasal septum. Ingestion may result in acute poisoning with symptoms including gastroenteritis, vertigo, muscle cramps and kidney damage. This chrome salt has a Threshold Limit Value (TWA) of 0.5 milligrams (Cr) per cubic meter and is regulated by OSHA at this limit (2.038).

Specific Precautions. Wear gloves and goggles when handling powder or solutions. Mix powders in a fume hood or glove box, or wear an approved toxic dust mask.

4.100 POTASSIUM DICHROMATE (intensifier, sensitizing agent). Potassium dichromate is moderately toxic by skin contact and by ingestion; it is highly toxic by inhalation. Dichromates are also suspected carcinogens. Skin contact may cause irritation, allergies and possible ulceration. Ingestion of large amounts can cause symptoms of poisoning, including gastroenteritis, muscle cramps, vertigo and kidney damage. Chronic inhalation can cause perforation of the nasal septum, irritation and respiratory allergies. Adding hydrochloric acid to potassium dichromate (during intensification) produces highly toxic chromic acid (4.037), which is a suspected lung carcinogen. Chromates have a Threshold Limit Value (TWA) is 0.05 milligrams per cubic meter and is regulated by OSHA at a Ceiling Limit of 0.1 milligrams ($CrO3$) per cubic meter (2.038).

Special Precautions. Wear gloves and goggles when handling the powder or solution. Mix dichromate powders in a fume hood or glove box, or wear an approved toxic dust mask. Do not add hydrochloric acid.

4.101 POTASSIUM FERRICYANIDE (Farmer's reducer). Potassium ferricyanide is only slightly toxic by skin contact, inhalation or ingestion. Exposing potassium ferricyanide to intense heat, hot acid or strong ultraviolet light can cause decomposition and release of highly toxic hydrogen cyanide gas (4.150).

Specific Precautions. Do not heat, add acid or expose potassium ferricyanide to ultraviolet light.

4.102 **POTASSIUM FERROCYANIDE** (carbro printing process, reducer). Potassium ferrocyanide is only slightly toxic by skin contact, inhalation or ingestion. Exposing potassium ferrocyanide to intense heat, hot acid or strong ultraviolet light can cause decomposition and can release highly toxic hydrogen cyanide gas (4.150).

Specific Precautions. Do not heat, add acid or expose potassium ferrocyanide to ultraviolet light.

4.103 **SELENIUM POWDER** (toner). Selenium metal is only slightly toxic by skin contact or ingestion, but is highly toxic by inhalation of the powder. Acute inhalation can cause severe irritation of the mucous membranes of the respiratory system. The powder is also irritating to eyes, and may cause conjunctivitis. Selenium has a Threshold Limit Value (TWA) is 0.2 milligrams per cubic meter and it is regulated by OSHA at this level (2.038).

Specific Precautions. Mix powders in a fume hood or glove box or wear an approved toxic dust mask. Wear gloves and goggles when handling.

4.104 **SILVER NITRATE** (sensitizer, toner). Silver nitrate is moderately toxic by skin contact, inhalation and ingestion. It is corrosive to skin, eyes and mucous membranes. Eye contact may cause blindness. Ingestion can cause severe gastroenteritis, shock, vertigo, convulsions and coma. Soluble silver compounds have a Threshold Limit Value (TWA) of 0.01 milligrams per cubic meter and are regulated by OSHA at this level (2.038).

Specific Precautions. Avoid skin contact and wear goggles when handling. Do not inhale silver nitrate dust.

4.105 **SODIUM CHLOROPALLADITE** (sodium tetrachloropalladate; toner). See the hazards for palladium chloride (4.094).

Specific Precautions. See precautions for palladium chloride (4.094).

4.106 **SODIUM SELENITE** (toner). Sodium selenite is moderately toxic by skin contact and highly toxic by inhalation and ingestion. This compound can cause skin and eye irritation, skin bums and allergies; it may also be absorbed through the skin. Acute inhalation of the powder can cause respiratory imitation, pulmonary edema and bronchitis. Chronic inhalation or ingestion can cause garlic odor, nausea, vomiting, nervous disorders and possible liver and kidney damage. Adding acid to sodium selenite can cause formation of the highly toxic gas hydrogen selenide (4.147). Selenium compounds have been tested for carcinogenicity in a limited number of animal experiments. Although in one experiment,

rats developed an increased incidence of liver tumors, the available data is insufficient to allow an evaluation of the carcinogenicity of selenium compounds in humans. Soluble selenium compounds have Threshold Limit Values (TWA) of 0.2 milligrams per cubic meter and they are regulated by OSHA at this level (2.038).

Specific Precautions. Wear gloves and goggles when handling. Use with local exhaust ventilation. Do not add acid.

4.107 **STANNIC CHLORIDE** (tin chloride, tin tetrachloride; "dippit" fixer for black and white instant process). Stannic chloride is moderately toxic by skin contact, inhalation and ingestion. In solution it is caustic and irritating to the skin, eyes, nose, throat and gastrointestinal system. Inorganic tin compounds have Threshold Limit Values (TWA) of 2 milligrams per cubic meter and are regulated by OSHA at these limits (2.038).

Specific Precautions. Wear gloves when handling the small amounts of the fixer solution required for instant processes. Wear gloves and goggles when handling larger amounts. In case of eye contact, rinse eyes immediately with water for at least fifteen minutes.

4.108 **URANIUM NITRATE** (intensifier, platinum toner). This very soluble uranium salt is highly toxic by every route of exposure. It can also be absorbed through the skin. Entry into the body by any method can cause severe liver and kidney damage due to the chemical toxicity of uranium. Uranium compounds have a Threshold Limit Value (TWA) of 0.2 milligrams per cubic meter. OSHA regulates soluble uranium compounds at 0.05 milligrams per cubic meter (2.038).

Specific Precautions. DO NOT USE. Safer alternative toners are silver nitrate (4.104) and gold chloride (4.087).

4.109 **VANADIUM CHLORIDE** (vanadium tetrachloride; toner). Vanadium chloride is moderately toxic by skin contact and highly toxic by inhalation and ingestion. It is corrosive to skin, eyes and mucous membranes of the respiratory tract as well as the gastrointestinal tract. Acute inhalation can cause respiratory irritation and possible pulmonary edema; chronic inhalation can cause dyspnea (shortness of breath), asthma and bronchitis. Inhalation and ingestion can also result in green tongue, metallic taste, intestinal disorders and heart problems. Vanadium compounds have a Threshold Limit Value (TWA) of 0.05 milligrams per cubic meter and are regulated by OSHA at this level (2.038).

Specific Precautions. Wear gloves and goggles when handling. Use with local exhaust ventilation.

4.110 **ZINC CHLORIDE** (preservative, salted paper sensitizer). Zinc chloride is moderately toxic by skin contact and highly toxic by inhalation and ingestion. Zinc chloride and its solutions are corrosive to skin, eyes and

mucous membranes of the respiratory and gastrointestinal systems. Acute inhalation of the powder can cause severe respiratory irritation and possible pulmonary edema; chronic inhalation can cause chronic bronchitis.

Specific Precautions. Wear gloves and goggles when handling. Mix powders in a fume hood or glove box, or wear an approved toxic dust mask.

OXIDIZING AGENTS

4.111 Oxidizing agents comprise another large group of photographic chemicals. They include ammonia, cyanides, halides, persulfates, thiosulfates, thiocyanates and others. These compounds function as photographic reducers, silver bleaches, stain removers, fixing agents and hypo eliminators. (Ammonia, which is also discussed under Alkalis (4.055), is included in this group since it is used as an oxidizing agent in many photographic processes.)

HAZARDS OF OXIDIZING AGENTS

4.112 **GENERAL HAZARDS.** Many of the oxidizing agents are skin and respiratory irritants, and some are corrosive to skin, eyes, nose and throat. The alkali cyanide salts are highly poisonous, and may be rapidly fatal if small amounts are absorbed. Because the hazards of these compounds vary widely, they are discussed individually, and precautions are given for specific chemicals in this group.

4.113 **AMMONIA** (ammonia gas in water; ammonium hydroxide; hypo eliminator). Concentrated ammonia solutions (28%) are moderately corrosive to skin and highly corrosive to eyes. Household ammonia (5% solution) is less hazardous to skin. Ammonia is highly toxic by inhalation and ingestion. Inhalation of ammonia which off-gases from the solution can cause severe respiratory irritation and chronic lung problems. Large exposures can cause pulmonary edema. Ammonia is also highly irritating to eyes. Ingestion causes painful damage to mouth and esophagus, and can be fatal. (For the Threshold Limit Value, see 4.055)

Specific Precautions. Wear gloves and goggles when handling ammonia solutions, and use with good dilution ventilation to remove the gas. For large amounts, work in a fume hood or wear an approved respirator with an ammonia cartridge. In case of eye contact, rinse immediately with plenty of water for at least 15 minutes and get medical attention.

4.114 **AMMONIUM BROMIDE** (bleach bath). Ammonium bromide is slightly toxic by skin contact and moderately toxic by inhalation and ingestion. Bromides are known to cause nervous system damage. Inhalation or

ingestion of large amounts can cause symptoms such as depression, emaciation, somnolence, vertigo, mental confusion and, in severe cases, psychosis and mental deterioration. Ingestion often causes vomiting. Prolonged inhalation or ingestion can cause skin rashes, especially of the face, which resemble acne.

Specific Precautions. Avoid inhalation of the powder. For large amounts, mix in a fume hood or glove box, or wear an approved toxic dust mask.

4.115　**AMMONIUM PERSULFATE** (reducer). Ammonium persulfate is only slightly toxic by any route of exposure. Persulfates are skin, eye and respiratory irritants in concentrated solutions or as powders. They can also cause allergies. If heated, persulfates release highly toxic sulfur dioxide gas (4.141).

Specific Precautions. Wear gloves and goggles when handling. Keep away from sources of heat.

4.116　**AMMONIUM THIOCYANATE** (silver bleach in color processing). Ammonium thiocyanate is only slightly toxic by inhalation and moderately toxic by ingestion. It is not significantly toxic by skin contact. Ingestion of large amounts can cause vomiting, delirium and convulsions. Chronic poisoning resembles bromide poisoning with severe psychological symptoms. Heating or treating ammonium thiocyanate with acid can cause the formation of highly poisonous hydrogen cyanide gas (4.150).

Specific Precautions. Do not heat or add acid.

4.117　**AMMONIUM THIOSULFATE** (rapid fixer). Ammonium thiosulfate is not significantly toxic by skin contact and is slightly toxic by ingestion. It can be highly toxic by inhalation. Heating or treating with acid causes decomposition to sulfur dioxide gas. Aqueous solutions of ammonium thiosulfate can also decompose to form sulfur dioxide. If exposed to intense heat or hot acid, ammonia gas (4.142) may also be released. Chronic inhalation of sulfur dioxide can cause chronic bronchitis and emphysema. Ingestion of large amounts of ammonium thiosulfate can cause purging.

Specific Precautions. Use with local exhaust ventilation. Do not heat or add acid except in a fume hood. Cover solutions between printing sessions to prevent evaporation and contamination. Do not use old fixing solutions.

4.118　**BROMINE** (daguerreotype accelerator). Bromine is highly toxic by skin contact, inhalation and ingestion. The volatile liquid is a severe irritant to the skin, eyes, mucous membranes and lungs. Bromine can cause severe skin or eye burns; if it is not removed from the skin immediately, deep burns, brown discoloration and slow-healing ulcers

127

may result. Inhalation can cause severe respiratory irritation and possible pulmonary edema and pneumonia. Acute inhalation or ingestion can result in symptoms of poisoning including dizziness, headache, nosebleeds, cough, abdominal pain, diarrhea and measles-like eruptions of the face, trunk and extremities. Symptoms of chronic poisoning are similar to those of bromide poisoning, with severe psychological effects (4.122). Heating bromine greatly increases inhalation hazards. Bromine has a Threshold Limit Value (TWA) of 0.1 parts per million and is regulated by OSHA at this limit (2.038).

Specific Precautions. DO NOT USE. Use the Becquerel method for daguerreotype instead (7.002).

4.119 CHLORINE (daguerreotype accelerator). Chlorine is highly toxic by skin contact, inhalation and ingestion. The liquid form is severely irritating to skin, eyes, mucous membranes and lungs, causing skin and eye burns and intense respiratory irritation with possible pulmonary edema and pneumonia. There is evidence of chronic impairment of pulmonary function following acute or chronic exposure. Acute inhalation or ingestion can cause symptoms of poisoning, such as nausea, vomiting, headache, transient loss of consciousness and dermatitis. Heating chlorine causes the release of highly toxic chlorine gas (4.141), which greatly increases inhalation hazards. Chlorine has a Threshold Limit Value (TWA) of 0.5 parts per million and is regulated by OSHA at this limit (2.038).

Specific Precautions. DO NOT USE. Use the Becquerel method for daguerreotype instead (7.002).

4.120 HYDROGEN PEROXIDE (3% solution; hypo eliminator). Solutions of hydrogen peroxide are only slightly toxic by skin contact and ingestion, causing slight irritation from repeated exposures. Dilute hydrogen peroxide solutions are not significantly toxic by inhalation. Concentrated solutions (e.g. 90 %) are corrosive and fire hazards. Hydrogen peroxide has a Threshold Limit Value (TWA) and an OSHA Permissible Exposure Limit of 1.0 part per million, but this concentration in air is not likely to occur from use of dilute solutions such as hypo eliminators.

Specific Precautions. None for 3% solutions.

4.121 IODINE (reducer, daguerreotype sensitizer). Iodine is moderately toxic by skin contact and highly toxic by inhalation and ingestion. Skin contact can cause a hypersensitivity reaction and skin burns. Inhalation of iodine vapors causes severe respiratory irritation like that of chlorine gas, but vaporization of iodine is unlikely at room temperature because of its low volatility. This type of severe respiratory effect readily occurs if iodine crystals are heated, as is done in daguerrotyping. Ingestion of iodine, even in small amounts, causes intense corrosive damage and may be fatal; chronic absorption of iodine causes "iodism, " a syndrome

characterized by insomnia, conjunctivitis, rhinitis, bronchitis, tremor, tachycardia, diarrhea and weight loss. Iodine has a Threshold Limit Value-Ceiling Limit of 0.1 part per million and is regulated by OSHA at this limit (2.038).

Specific Precautions. Avoid skin contact with iodine solutions. Wear goggles and an approved respirator with an acid gas cartridge to prevent inhalation of iodine vapors if crystals are heated.

4.122 POTASSIUM BROMIDE (restrainer, bleach bath). Potassium bromide is slightly toxic by skin contact and moderately toxic by inhalation and by ingestion. Inhalation or ingestion of large amounts can cause symptoms such as depression, emaciation, somnolence, vertigo, mental confusion and, in severe cases, psychosis and mental deterioration. Ingestion often causes vomiting. Prolonged inhalation or ingestion may cause skin rashes.

Specific Precautions. Avoid inhalation of the powder. For large amounts, mix in a fume hood or glove box, or wear an approved toxic dust mask.

4.123 POTASSIUM CHLORATE (platinum sensitizer, Dutch mordant). Potassium chlorate is moderately toxic by skin contact and ingestion, but may be highly toxic by inhalation. Combining potassium chlorate with hydrochloric acid (during the preparation of Dutch mordant) will cause the release of highly toxic chlorine gas (4.141). Chlorine gas is highly irritating to the eyes and the mucous membranes of the respiratory system. Potassium chlorate is a fire hazard when in contact with flammable materials, and can be explosive in contact with organic materials such as salts and resins. When spilled on the floor or mixed with small amounts of impurities, it becomes very sensitive to shock, heat or friction, and may explode.

Specific Precautions. Avoid if possible. Use in a fume hood or wear an approved respirator with an acid gas cartridge. Store potassium chlorate away from heat and combustible materials to prevent fire or explosion. If it spills or is contaminated with combustible materials, avoid sources of heat, friction or mechanical shocks (e.g. dropping objects) that might cause an explosion. Flush area with water to dissolve the potassium chlorate.

4.124 POTASSIUM CYANIDE (reducer). Potassium cyanide is moderately toxic by skin contact and highly toxic by inhalation and by ingestion. Chronic skin contact can cause skin rashes. Potassium cyanide may also be absorbed through the skin. Ingestion or inhalation of even very small amounts can be fatal due to rapid metabolic asphyxia, the arrest of cellular respiration. Chronic inhalation can cause nasal and respiratory irritation, possible nasal ulceration and systemic effects including loss of appetite, headaches, nausea, weakness, dizziness and malaise. In

the presence of even weak acids (including stomach acids), highly toxic hydrogen cyanide gas (4.150) is liberated from cyanide salts. Hydrogen cyanide gas can be rapidly fatal by inhalation. Potassium cyanide has a Threshold Limit Value (TWA) of 5 milligrams per cubic meter and is regulated by OSHA at this limit (2.038).

Specific Precautions. DO NOT USE UNDER ANY CIRCUMSTANCES. Cyanide poisoning can be so rapidly fatal that in many cases there would not be enough time to reach a hospital or emergency treatment center, even if an antidote kit is used and all precautions are taken. A safer alternative reducer is potassium ferricyanide (4. 101).

4.125 POTASSIUM IODIDE (reducer). Potassium iodide is slightly toxic by skin contact and moderately toxic by inhalation and ingestion. Iodide toxicity is similar to bromide poisoning (see potassium bromide, 4.122). Prolonged absorption of potassium iodide can cause iodide poisoning with symptoms of depression, emaciation, weakness, anemia, headache, running nose and skin rash. In severe cases the skin may show boils, bruises, hives and blisters. When heated, potassium iodide can decompose to form highly toxic fumes of iodine (4.121).

Specific Precautions. Avoid inhalation of the powder. For large amounts, mix in a fume hood or glove box,. or wear an approved toxic dust mask. Do not heat.

4.126 POTASSIUM OXALATE (platinum developer). Potassium oxalate is moderately toxic by skin contact, and highly toxic by inhalation and by ingestion. Oxalates are corrosive to skin, eyes, nose and throat. Ingestion causes intense damage to mouth, esophagus and stomach, and may also cause kidney damage. Ingestion of potassium oxalate can be fatal.

Specific Precautions. Wear gloves and goggles when handling. Mix solutions in a fume hood or glove box, or wear an approved toxic dust mask.

4.127 POTASSIUM PERBORATE (hypo eliminator). Potassium perborate is slightly toxic by skin contact and moderately toxic by inhalation and ingestion. If ingested or absorbed through abraded or burned skin, or if the powders are inhaled, potassium perborate can cause severe gastrointestinal symptoms and skin rash. Chronic absorption can cause similar symptoms of poisoning and possible kidney damage. Potassium perborate can be explosive in contact with combustible materials.

Specific Precautions. Avoid if possible. Wear gloves when handling and avoid inhalation of powder.

4.128 POTASSIUM PERMANGANATE (reducer, hypo eliminator). Potassium permanganate is highly toxic by skin contact, inhalation and ingestion. Concentrated solutions or powders are highly corrosive to skin, eyes,

lungs, mouth, stomach and internal organs if ingested. Dilute solutions are mildly irritating. Manganese compounds have a Threshold Limit Value (TWA) of 5 milligrams per cubic meter and is regulated by OSHA at a Ceiling Limit of 5 milligrams per cubic meter.

Specific Precautions. Wear gloves when handling. Mix powders in a fume hood or glove box, or wear an approved toxic dust mask.

4.129 **POTASSIUM PERSULFATE** (reducer, hypo eliminator). Potassium persulfate is moderately toxic by every route of exposure. Persulfates are eye, skin and respiratory irritants in concentrated solutions or as powders. They can also cause allergies. When heated, persulfates release highly toxic sulfur dioxide gas. Potassium persulfate can be explosive in contact with combustible materials.

Specific Precautions. Wear gloves and goggles when handling. Do not heat.

4.130 **POTASSIUM SULFIDE** (liver of sulphur, polysulfide; toner). Potassium sulfide and sodium sulfide are often used interchangeably, and have similar hazards. Potassium sulfide is moderately toxic by skin contact and inhalation, and highly toxic by ingestion. Skin contact can cause skin softening and irritation, similar to that caused by alkalis. Dust can cause eye, nose and throat irritation. Ingestion may result in corrosive damage; hydrogen sulfide poisoning may occur due to decomposition of potassium sulfide in the stomach. Sulfide toning solutions may decompose to form highly toxic hydrogen sulfide gas (4.151); adding acid also causes the formation of hydrogen sulfide gas. Hydrogen sulfide poisoning can be even more rapidly fatal than cyanide poisoning. The gas is particularly hazardous since some people are insensitive to its characteristic rotten egg odor. Low level exposures can cause olfactory fatigue in most people. The Threshold Limit Value (TWA) for hydrogen sulfide is 10 parts per million and is regulated by OSHA at that level (2.038).

Specific Precautions. Wear gloves and goggles when handling, and use only with local exhaust ventilation. Do not add acid to sulfide toning solutions. Do not use sulfide toners if insensitive to the odor-warning properties of hydrogen sulfide gas.

4.131 **POTASSIUM THIOCYANATE** (silver bleach in color processing). Potassium Thiocyanate is only slightly toxic by inhalation and moderately toxic by ingestion. It is not significantly toxic by skin contact. Ingestion of large amounts can cause vomiting, delirium and convulsions. Chronic poisoning resembles bromide poisoning, with severe psychological effects. Heating or treating potassium thiocyanate with hot acid can cause the formation of highly poisonous hydrogen cyanide gas (4.150).

Specific Precautions. Do not heat or add acid.

131

4.132 SODIUM BROMIDE (color developer starter). See hazards for potassium bromide (4.122).
Specific Precautions. See precautions for potassium bromide (4.122).

4.133 SODIUM CYANIDE (reducer). See hazards for potassium cyanide (4.124).
Specific Precautions. See precautions for potassium cyanide (4.124).

4.134 SODIUM FLUORIDE (preservative). Sodium fluoride is moderately toxic by skin contact and highly toxic by inhalation and ingestion. It is a skin and respiratory irritant and a systemic poison. Ingestion of less than one gram (less than one teaspoon) can be fatal. Symptoms of poisoning include salty or soapy taste, nausea, vomiting, diarrhea and abdominal pain, followed by muscular weakness, tremors, central nervous system depression and shock.
 Specific Precautions. If possible, do not use. Safer alternative preservatives are zinc chloride (4.110) and thymol (4.028). If used, wear gloves and a respirator. Buy preservatives in liquid form rather than the easily inhaled powder form.

4.135 SODIUM HYPOCHLORITE (household bleach, 5% solution; hypo eliminator). Sodium hypochlorite is moderately toxic by skin contact, highly toxic by inhalation and only slightly toxic by ingestion. Repeated or prolonged skin contact can cause dermatitis. Inhalation of chlorine gas from the bleach can cause severe lung irritation. Heating or adding acid to sodium hypochlorite releases large amounts of highly toxic chlorine gas. Adding ammonia causes the formation of nitrogen trichloride, a highly poisonous gas.
 Specific Precautions. Wear gloves and goggles when handling bleach solutions. Do not heat; do not add acid or ammonia.

4.136 SODIUM NITRATE (silver bleach in color processing). Potassium nitrate is often substituted for sodium nitrate, and has similar hazards. Sodium nitrate is not significantly hazardous by skin contact or by inhalation; it is only slightly toxic by ingestion. If ingested, sodium nitrate may be converted by intestinal bacteria into more toxic nitrites, causing possible anemia and cyanosis (blue lips and nails). Sodium nitrate is a fire hazard near organic materials, and can greatly accelerate an ongoing fire.
 Specific Precautions. Avoid accidental ingestion. Keep sodium nitrate away from open flames or sources of heat.

4.137 SODIUM THIOCYANATE (silver bleach in color processing). See the hazards for potassium thiocyanate (4.131).
Specific Precautions. See precautions for potassium thiocyanate (4.131).

4.138 SODIUM THIOSULFATE (sodium hyposulfite, hypo; fixer). Sodium thiosulfate is not significantly toxic by skin contact. It is slightly toxic by ingestion and can be highly toxic by inhalation. Ingestion of large amounts can cause purging. Treating sodium thiosulfate with acid, or heating it, causes decomposition to sulfur dioxide gas, which is highly irritating by inhalation. Aqueous solutions of hypo can also decompose to form sulfur dioxide. Chronic inhalation can cause chronic bronchitis and emphysema.

 Specific Precautions. Do not heat or add acid except in a fume hood. Do not use old hypo solutions. Cover solutions between printing sessions to prevent evaporation and contamination.

4.139 THIOUREA (thiocarbamide; toner, stain remover). Thiourea is only slightly toxic by the different routes of exposure. Its acute oral toxicity is slight, but it causes cancer, birth defects and reproductive damage in animals. It is considered a carcinogen by the National Toxicology Program and the International Agency for Research on Cancer.

 Specific Precautions. Avoid repeated direct contact with solutions or powders.

GASES

4.140 Many photographic processes release toxic gases. These gases may be released slowly from baths or stored chemicals as they degrade with time. Gases usually are generated at faster rates if photochemicals are heated or if certain chemicals are mixed with acid. For example, fixer solutions slowly release sulfur dioxide as they age. When these solutions are contaminated with acid from the stop bath, the gas sulfur dioxide is released at a more rapid rate. Heat will also speed this process.

 Gases are also generated when materials are subject to high heat or burned. For example, the incomplete combustion of carbon arc lamp electrodes produces highly toxic nitrogen oxides, ozone and carbon monoxide.

 The gases most commonly produced by photographic processes can be divided into two groups: those that are irritating, and those that are poisonous. These gases and their sources are listed in the table on the next page.

TOXIC GASES AND THEIR COMMON SOURCES

Irritating gases	Chemical which may release them
sulfur oxides (especially sulfur dioxide)	Any bath containing sulfites affected by acid, aging, or heat including:
	sodium thiosulfate
	ammonium thiosulfate
	sodium or potassium sulfite
	sulfuric acid (bleach)
	sulfamic acid
	heat and persulfates (reducers)
chlorine	heat or acid and hypochlorite (bleach)
	heat or acid and potassium chlorochromate (intensifier)
	preparation and use of Dutch mordant (hydrochloric acid and potassium chlorate)
hydrogen selenide	acid and sodium selenite (sepia toner)
ammonia	ammonia solutions (ammonium hydroxide)
formaldehyde	formalin (solutions) and paraformaldehyde (powder)
nitrogen dioxide	nitric acid etching carbon arc lamps
ozone	carbon arc lamps
phosgene	chlorinated hydrocarbons and flames, lighted cigarettes or ultraviolet light
Poisonous gases	
carbon monoxide	carbon arc lamps
hydrogen cyanide	acid and cyanides (reducers)
	heat, hot acid and/or ultraviolet light and the ferricyanides and ferrocyanides, e.g. potassium ferricyanide
	heat or acid and thiocyanates (silver bleach)
hydrogen sulfide	from sulfide toning solutions
	acid and potassium sulfide or sodium sulfide

HAZARDS OF IRRITATING GASES

4.141 **GENERAL HAZARDS.** Some of the more common health problems among photographers and printmakers are caused by irritating gases. These gases are damaging to the eyes and respiratory system. Acute exposure to sulfur dioxide, chlorine, ammonia, phosgene, nitrogen dioxide, formaldehyde, hydrogen selenide and ozone can cause eye

irritation, sore throat, bronchospasms and dyspnea (shortness of breath). Massive exposures may result in pulmonary edema and pneumonia. Chronic exposure to lower levels of these gases may cause increased susceptibility to respiratory infection, chronic bronchitis, and emphysema.

Several of these gases including ammonia, phosgene, formaldehyde, nitrogen dioxide, ozone and hydrogen selenide can cause some systemic effects in addition to irritant effects. The hazards of all these gases are listed below followed by general precautions for gases (4.152).

4.142 **AMMONIA.** Ammonia is highly toxic causing severe irritation of the eyes, respiratory tract and skin. Acute exposure by inhalation may cause dyspnea (labored breathing), bronchospasm, chest pain and pulmonary edema, which may be fatal. Acute exposure of the eyes to ammonia gas or to liquid ammonia can cause severe corneal irritation and damage which may result in blindness. Mild to moderate exposure to the gas can produce symptoms of headache, salivation, burning of throat and eyes, nausea and vomiting. It has a Threshold Limit Value (TWA) of 25 parts per million and is regulated by OSHA at 35 parts per million (2.038). Ammonia solutions react hazardously with many substances, most notably with bleach and other chlorites to produce other extremely toxic gases including nitrogen trioxide, nitrogen oxides, and chlorine. (see 3.135).

4.143 **PHOSGENE** (carbonyl chloride). Phosgene is a highly toxic gas causing severe irritation to the eyes and respiratory tract. It is used in chemical warfare. Even brief exposures to high concentrations of phosgene may be rapidly fatal. However, in photography, only moderate or slight exposures could ever be expected. Moderate exposures may result in symptoms of dryness or burning sensations in the throat, vomiting, chest pain and dyspnea. Phosgene decomposes in the lungs to form carbon monoxide and hydrochloric acid which irritates and damages lung tissue. Phosgene's odor and irritant properties do not provide adequate warning of the presence of hazardous concentrations. It has a Threshold Limit Value (TWA) of 0.1 parts per million and is regulated by OSHA at this limit (2.038).

4.144 **FORMALDEHYDE.** Formaldehyde is moderately toxic by skin contact and highly toxic by inhalation and ingestion. The gas is highly irritating to eyes and mucous membranes, and repeated exposure can cause severe allergies, including asthma. Chronic exposure to formaldehyde gas, even at low levels, may result in symptoms of dyspnea, eye and skin irritation, headaches, dizziness, nausea, vomiting and nosebleeds. Prolonged exposure to high concentrations can cause tachycardia, inflammation of respiratory passages and in some cases it has even

135

caused death. It is considered a carcinogen by OSHA. It has a Threshold Limit Value (TWA) of 1.0 parts per million and is regulated by OSHA at this limit (2.038). For additional OSHA regulations which apply to formaldehyde, see also Formalin (4.023).

4.145 NITROGEN DIOXIDE. Nitrogen dioxide is highly toxic by inhalation. Exposure to high concentrations can cause pulmonary edema and methemoglobinemia and may be fatal. Symptoms include malaise, cyanosis, cough, dyspnea, chills, fever, headache, vomiting and tachycardia. Chronic exposure may result in pulmonary dysfunction, decreased lung capacity and symptoms of wheezing and coughing suggestive of emphysema. Its relatively inoffensive odor has cause many to ignore its presence until serious damage has occurred. It has a Threshold Limit Value (TWA) of 3 parts per million and is regulated by OSHA at a Short Term Exposure Limit (STEL) of 1 part per million (2.038).

4.146 OZONE. Ozone is highly toxic by skin contact and by inhalation. It is extremely irritating to skin, eyes and mucous membranes. Acute exposures can result in pulmonary edema and hemorrhage, and may be fatal. Exposure to lower concentrations can cause symptoms of systemic effects, including headache, malaise, dizziness, reduced ability to concentrate, slowing of heart and respiration rates and changes in vision. Systemically, ozone has been reported to producing chromosomal changes (mutations) of human lung cells. It has a Threshold Limit Value (Ceiling) of 0.1 parts per million and is regulated by OSHA at a Ceiling Limit of 0.3 parts per million (2.038).

4.147 HYDROGEN SELENIDE. Hydrogen selenide is highly toxic by inhalation, and is highly irritating to the eyes, nose and throat. Symptoms of chronic exposure to low levels of hydrogen selenide include nausea, vomiting, diarrhea, metallic taste, garlic odor of breath, dizziness and fatigue. By analogy with effects caused in animals, it may cause pneumonitis and liver damage. The odor of hydrogen selenide does not provide sufficient warning of its presence because olfactory fatigue sets in rapidly. It has a Threshold Limit Value (TWA) of 0.05 parts per million and is regulated by OSHA at this limit (2.038). Hydrogen selenide can be an explosive hazard at high concentrations.

HAZARDS OF NON-IRRITATING POISONOUS GASES

4.148 GENERAL HAZARDS. This group of highly toxic gases includes carbon monoxide, hydrogen cyanide and hydrogen sulfide. They may produce some symptoms of respiratory irritation, but they are primarily known for their rapid and sometimes fatal damage to the whole body by depriving its cells of oxygen.

4.149 CARBON MONOXIDE. Carbon monoxide is highly toxic by inhalation. It combines with the hemoglobin in the blood, preventing it from carrying oxygen to the body tissues. Exposure to large amounts of carbon monoxide can cause severe frontal headache, nausea, dizziness, mental confusion, hallucinations, fainting and cyanosis. Massive exposures can cause brain damage, heart attacks, coma and death. It is odorless. It has a Threshold Limit Value (TWA) of 50 parts per million and is regulated by OSHA at 35 parts per million (2.038).

4.150 HYDROGEN CYANIDE. Hydrogen cyanide is highly poisonous by skin contact, inhalation and ingestion. It can also be absorbed through the skin. Inhalation can lead to chemical (metabolic) asphyxiation, and is often fatal within ten minutes. Hydrogen cyanide can also be formed in the stomach following ingestion of cyanide salts and their subsequent reaction with stomach acids. At high levels, cyanide gas acts so rapidly that its odor has no warning value; at lower levels its odor may provide forewarning, although many individuals are unable to recognize the characteristic odor of bitter almonds. It has a Threshold Limit Value (Ceiling Limit) of 10 parts per million and is regulated by OSHA at a Ceiling Limit of 4.7 parts per million (2.038).

4.151 HYDROGEN SULFIDE. Hydrogen sulfide is highly toxic by every route of exposure. It is extremely corrosive to the eyes and mucous membranes of the respiratory system. Acute exposure by inhalation may cause immediate coma, sometimes with convulsions, and death from respiratory failure. Fatal poisoning can occur even more rapidly than with hydrogen cyanide. Lower level exposures can cause nervous system and gastrointestinal damage, with symptoms including headache, dizziness, staggering gait, excitement, nausea and diarrhea. Its offensive "rotten egg" odor is unreliable as a warning signal because olfactory fatigue occurs at low levels and some people (an estimated two to three percent) are insensitive to this odor. It has a Threshold Limit Value (TWA) of 10 parts per million and is regulated by OSHA at this limit (2.038).

PRECAUTIONS FOR GASES

4.152 • Provide ventilation sufficient to prevent a build-up of contaminant gases in the darkroom or studio. For processes producing highly toxic gases, local exhaust ventilation will be needed, with a lateral exhaust (slot) hood or fume hood located over processing tanks or trays. Do not heat solutions except in a fume hood. For hobbyists doing only occasional black and white processing, the small amounts of toxic gases (mostly sulfur dioxide from fixer) and acid vapors produced can probably be controlled by dilution ventilation (see 3.032).

• If local exhaust ventilation is not available, processes which generate the three poison gases (4.148), or hydrogen selenide, nitrogen dioxide, and phosgene, must not be done. There are no approved air purifying respirators for these gases (3.042). An approved respirator with an acid gas cartridge will provide protection against sulfur dioxide and small amounts of chlorine.

• Practice good housekeeping to prevent the formation of toxic gases. Cover processing trays between printing sessions to prevent evaporation and contamination of solutions. Do not allow acids or acid vapors to contaminate solutions. This is especially important for intensifiers, reducers and toners.

• Do not use cyanide reducers. Use potassium ferricyanide (Farmer's reducer) instead.

• Do not use sulfide-toners (or selenium-sulfide toners) unless there is adequate local exhaust ventilation.

• Do not use carbon arc lamps unless they are directly vented to the outside by a local exhaust system.

• Do not allow smoking or open flames in or around the darkroom or studio. Keep chlorinated hydrocarbons away from lighted cigarettes, open flames and sources of ultraviolet light to avoid the production of phosgene gas.

• Never work alone if using sulfide toners that generate hydrogen sulfide gas, or cyanide reducers which generate hydrogen cyanide. These gases render people unconscious with such rapidity that help must be immediately available. Users of cyanide must arrange in advance to provide a special intravenous antidote to someone medically trained on site or at the nearest emergency room.

PIGMENTS AND DYES

4.153 Many types of pigments and dyes are used in various retouching and printmaking processes (dye transfer, gum printing, Kwik printing and others), in hand coloring techniques and in photoceramic processes. There are literally thousands of dyes and around 300 pigments which can be used for these processes. A single dye or pigment may have as many as one hundred commercial or common names. For this reason, British and American color chemists developed an identification system called the *Color Index International*[1]. This index identifies almost all commercially available dyes and pigments by internationally accepted Color Index (C.I.) names and/or numbers. The pigment names

include the color (e.g., C.I. Pigment Blue 15, C.I. 74160). Dyes are identified by both color and class. For Example, C.I. Acid Red 51, C.I. 45430 is a red acid class dye.

FOOTNOTE 1. *Color Index International,* The Society of Dyers and Colourists (England) and The American Association of Textile Chemists and Colorists, Vol. 1 to 8, 1971-1987. This reference should be found in most good technical libraries. Those who do not have access to a *Color Index* may call or write Arts, Crafts and Theater Safety, Inc. (see 3.013) for information on specific dyes and pigments.

Some substances have both dye and pigment names. This is because the distinction between them is based on usage and physical properties rather than on chemical constitution. The principle characteristic of a pigment which distinguishes it from a dye is that it is substantially insoluble in the medium in which it is used. By changing the medium, the same chemical product can serve as either a dye or a pigment. In addition, dyes can bind or adhere to the material being colored. Pigments must be attached to a binder in order to adhere to a surface.

Some dyes and pigments also may be identified by Chemical Abstracts Service Registration Numbers (CAS numbers). CAS numbered chemicals are easy to look up in various references. However, not all color chemicals have CAS numbers.

For the sake of clarity, photo artists should insist that manufacturers and suppliers provide the C.I. names and numbers of their dye- and pigment-containing products and their CAS numbers when available. This information is not only needed for health and safety, but to maintain the professional quality and consistency of the work.

Today most dyes are synthetically derived from petrochemicals. Most traditional pigments, such as earth colors from iron oxides, are inorganic pigments consisting of minerals or metallic compounds. A few traditional pigments such as rose madder are based on animal or plant materials. As with dyes, a large number of synthetic organic pigments have replaced traditional materials.

HAZARDS OF PIGMENTS

4.154 GENERAL HAZARDS. At present, much more is known about the hazards of inorganic pigments than about those of organic pigments. Little research has been done on natural or synthetic organic pigments to determine their long-term toxicity, particularly with regard to possible cancer hazards.

Although there is little danger of acute, immediate damage from accidental ingestion or inhalation of large amounts of pigment powders, many of these pigments can cause chronic poisoning or other serious, long-term effects from repeated exposures to very small amounts. Some pigments are known or suspected carcinogens. Pigment

grinding or spray painting can be extremely hazardous because chronic poisoning can result from inhalation of the powders or spray mists.

The hazards of pigments used in photographic processes are described below. The Color Index (C.I.) name and number and other names for each pigment follow the common name in parentheses. For some pigments, the chemical composition of the compound is included in brackets.

4.155 **ALIZARIN CRIMSON** (C.I. Pigment Red 83, 58000, rose madder [natural or synthetic anthraquin¡one, 1,2-dihydroxyanthraquinone]). Alizarin crimson is only slightly toxic by skin contact, inhalation and ingestion. It may cause allergies in a few people. Its long term hazards are unknown and being studied.

4.156 **ALUMINA** (C.I. Pigment White 24, 77002 [aluminum hydrate]). No significant hazards.

4.157 **ANTIMONY WHITE** (C.I. Pigment White 11, 77052 [antimony oxide, stibium oxide]). Antimony compounds are highly toxic by skin contact, inhalation and ingestion. Skin contact may cause metallic taste, vomiting, diarrhea, severe irritation of the mouth and nose, pulmonary congestion and slow, shallow breathing. Chronic exposure may cause loss of appetite and weight, nausea, headache, insomnia and, later, liver and kidney damage.

4.158 **BARIUM WHITE** (C.I. Pigment White 21 or 22, 77120, barytes, blanc fixe, permanent white [barium sulfate]). No significant hazards because it is insoluble. If it is of poor quality and contaminated with soluble barium compounds, it is poisonous. See barium poisoning (4.159).

4.159 **BARIUM YELLOW** (C.I. Pigment Yellow 31, 77103, barta yellow [barium chromate]). Barium yellow is moderately toxic by skin contact and highly toxic by inhalation and ingestion. This pigment is a known human carcinogen. Skin contact may cause irritation, allergies and skin ulcers. Acute inhalation or ingestion may cause barium poisoning with intestinal spasms, heart irregularities and severe muscle pain; acute or chronic ingestion can cause chromium poisoning with gastroenteritis, vertigo, muscle cramps and kidney damage. Chronic inhalation may cause lung cancer, perforation of the nasal septum and respiratory allergies.

4.160 **BONE BLACK** (C.I. Pigment Black 9, 77267, ivory black, Frankfurt black [carbon from charred animal bones]). No significant hazards.

4.161 **BURNT SIENNA** (C.I. Pigment Brown 6, 77491 [iron oxides]). No significant hazards.

140

4.162 BURNT UMBER (C.I. Pigment Brown 7, 77492 [iron oxides and manganese dioxide]). Burnt umber is not significantly toxic by skin contact, but is highly toxic by inhalation and by ingestion. Chronic inhalation or ingestion of manganese dioxide can cause manganese poisoning, a serious nervous system disease resembling Parkinson's disease.

4.163 CADMIUM BARIUM ORANGE (C.I. Pigment Orange 20:1, 77202:1 [cadmium sulfide, cadmium sulfoselenide, and barium sulfate])[2]. See cadmium barium red (4.164).

4.164 CADMIUM BARIUM RED (C.I. Pigment Red 108, 77202:1 cadmium lithopone red [cadmium sulfide, cadmium selenide and barium sulfate])[2]. This pigment is not significantly toxic by skin contact but is highly toxic by inhalation and ingestion. It is also a suspected human carcinogen. Chronic inhalation or ingestion may cause kidney damage, anemia, loss of smell, gastrointestinal problems and bone, tooth and liver damage. This pigment may also be associated with prostate cancer and lung cancer.

4.165 CADMIUM BARIUM YELLOW (C.I. Pigment Yellow 35:1, 77205, cadmium lithopone yellow [cadmium sulfide and barium sulfate]). See cadmium barium red (4.164).

4.166 CADMIUM ORANGE (C.I. Pigment Orange 20, 77202, [cadmium sulfide and cadmium selenide])[2]. See cadmium barium red (4.164).

4.167 CADMIUM RED (C.I. Pigment Red 108, 77202 [cadmium sulfide and cadmium selenide]). See cadmium barium red (4.164).

FOOTNOTE 2: The apparent confusion of cadmium C.I. names and numbers is explained by the fact that the same chemical formula will increase in redness and blueness with the proportion of selenide present.

4.168 CADMIUM VERMILION RED (C.I. Pigment Red 113, 77201 [cadmium sulfide and mercuric sulfide]). This pigment is moderately toxic by skin contact and highly toxic by inhalation and ingestion. It is also a suspected human carcinogen. The cadmium sulfide component has the same hazards as those discussed for cadmium barium red (4.164). Skin contact with the mercuric sulfide may cause skin allergies, and inhalation or ingestion may cause mercury poisoning, severely affecting the nervous system and kidneys.

4.169 CADMIUM YELLOW (C.I. Pigment Yellow 37, 77199 [cadmium sulfide]). Cadmium yellow is not significantly toxic by skin contact, but is highly toxic by inhalation and by ingestion, and is a suspected human carcinogen. Chronic inhalation or ingestion may cause kidney

damage, anemia, gastrointestinal disorders, loss of smell and bone, tooth and liver damage. It may also be associated with prostate cancer and lung cancer.

4.170 CARBON BLACK (C.I. Pigment Black 6, 77266, lamp black [carbon]). Carbon black is moderately toxic by skin contact and inhalation, and not significantly toxic by ingestion. Chronic inhalation can cause respiratory irritation. Carbon black is a known human carcinogen due to impurities. Cosmetic grade and other high quality carbon blacks do not contain these impurities.

4.171 CERULEAN BLUE (C.I. Pigment Blue 35, 77368 [artificial mineral of cobalt, tin and calcium sulfate]). Cerulean blue is slightly toxic by skin contact and ingestion, and moderately toxic by inhalation. Repeated skin contact may cause allergies, especially at the elbows, neck and ankles. Chronic inhalation can cause asthma and possible fibrosis. Ingestion can cause gastrointestinal illness with sensations of hotness. These effects are due to the cobalt contained in the pigment.

4.172 CHALK (C.I. Pigment White 18, 77220 [calcium carbonate]). No significant hazards.

4.173 CHROME GREEN (C.I. Pigment Green 15, 77600 plus 77520, Milori green, Prussian green [a mixture of lead chromate and potassium ferric ferrocyanide]). Chrome green is moderately toxic by skin contact and highly toxic by inhalation and ingestion. This pigment is a known human carcinogen and teratogen, and a suspected human mutagen. Skin contact can cause allergies, irritation and skin ulcers due to the presence of chromate. Chronic inhalation of the lead chromate may cause lung cancer, perforation of the nasal septum, respiratory irritation and allergies as well as lead poisoning. Ingestion may cause immediate chromium poisoning with gastroenteritis, vertigo, muscle cramps and kidney damage as well as delayed lead poisoning. See flake white (4.184).

4.174 CHROME ORANGE. See chrome yellow (4.175).

4.175 CHROME YELLOW (C.I. Pigment Yellow 34, 77600 [lead chromate]). Chrome yellow is moderately toxic by skin contact and highly toxic by inhalation and ingestion. It is also a known human carcinogen and teratogen, and a suspected human mutagen. Skin contact may cause allergies, irritation and skin ulcers. Chronic inhalation may cause lung cancer, perforation of the nasal septum, respiratory imitation and allergies as well as lead poisoning. Ingestion may cause immediate chromium poisoning with gastroenteritis, vertigo, muscle cramps and kidney damage, as well as delayed lead poisoning. See flake white (4.184).

4.176 CHROMIUM OXIDE GREEN (C.I. Pigment Green 17, 77288 [chromic oxide]). This pigment is moderately toxic by skin contact and inhalation, and only slightly toxic by ingestion. It is also a suspected human carcinogen. Chromic oxide may cause skin and respiratory irritation and allergies. It causes cancer in animals and may cause cancer in humans.

4.177 COBALT BLUE (C.I. Pigment Blue 28, 77346 [cobaltous aluminate]). Cobalt blue is slightly toxic by skin contact and ingestion, and moderately toxic by inhalation. Repeated skin contact may cause allergies, especially at the elbows, neck and ankles. Chronic inhalation may cause asthma and possible fibrosis. Ingestion may cause gastrointestinal illness with sensation of hotness. These effects are due to cobalt.

4.178 COBALT GREEN (C.I. Pigment Green 19, 77335 [calcined cobalt, zinc and alumina]). Hazards are the same as hazards for cobalt blue (4.177).

4.179 COBALT VIOLET (C.I. Pigment Violet 14, 77360 [cobalt phosphate]). Cobalt violet is slightly toxic by skin contact and ingestion and moderately toxic by inhalation. Hazards are the same as hazards for cobalt blue (4.177).

4.180 COBALT VIOLET (C.I. Pigment Violet, 77350 [cobaltous arsenate). This pigment is not often used today. It has same name as 4.179, but is much more toxic. It is moderately toxic by skin contact and highly toxic by inhalation and ingestion. In addition to causing effects of cobalt toxicity, cobalt arsenate may cause burning, itching and ulceration by skin contact. Acute, fatal poisoning can result from ingestion. Chronic ingestion and inhalation can cause digestive disturbances and liver, kidney, blood and peripheral nervous system damage.

4.181 COBALT YELLOW (C.I. Pigment Yellow 40, 77357, aureolin [potassium cobaltinitrite]). Cobalt yellow is slightly toxic by skin contact and moderately toxic by inhalation and ingestion. Ingestion may cause acute poisoning with symptoms of a fall in blood pressure, headaches, nausea, vomiting and cyanosis (due to formation of methemoglobin). Chronic effects from small doses include a drop in blood pressure, headache, rapid pulse and visual disturbances.

4.182 DIARYLIDE YELLOW (C.I. Pigment Yellow 12, 21090, benzidine yellow, disazo yellow). This pigment was found negative on cancer tests in its pure form, however, commercial grades are contaminated with highly carcinogenic 3,3-dichlorobenzidine. It also breaks down and releases this compound when heated above 200 degrees Centigrade.

4.183 **ENGLISH RED** (C.I. Pigment Red 101, 77015, 77491, 77538, light red [various iron oxides]). No significant hazards.

4.184 **FLAKE WHITE** (C.I. Pigment White 1, 77597, Cremnitz white, white lead [basic lead carbonate]). Flake white is slightly toxic by skin contact and highly toxic by inhalation and ingestion. It is a known human teratogen and a suspected human mutagen. Both acute and chronic ingestion or inhalation can cause lead poisoning. Lead affects the gastrointestinal system (lead colic), the red blood cells (anemia) and the neuromuscular system (wrist-drop). Other common effects include weakness, headaches, irritability, malaise, pain in joints and muscles, liver and kidney damage and possible birth defects.

4.185 **HANSA RED** (C.I. Pigment Red 3, 12120, toluidine red). The toxicity of this pigment by skin contact and inhalation is unknown. It is moderately toxic by ingestion. Ingestion by children has caused cyanosis due to methemoglobinemia (lack of oxygen).

4.186 **HANSA YELLOWS** (C.I. Pigment Yellow 1,3,5 and 10, arylide yellows). The toxicity of these pigments is unknown. Preliminary studies indicate that they may be toxic or might help promote carcinogenic effects.

4.187 **INDIAN RED**, see English red (4.183).

4.188 **IVORY BLACK,** see bone black (4.160).

4.189 **LEMON YELLOW** (C.I. Pigment Yellow 31, 77103 [barium chromate] or C.I. Pigment Yellow 32, 77839 [strontium chromate]). Both lemon yellows are moderately toxic by skin contact and highly toxic by inhalation and ingestion. They are known human carcinogens. Strontium chromate is a particularly potent carcinogen in test animals. Skin contact may cause skin irritation, allergies or ulcers. Acute inhalation or ingestion may cause barium poisoning with intestinal spasms, heart irregularities and severe muscle pain. Acute or chronic ingestion can cause chromium poisoning with gastroenteritis, vertigo, muscle cramps and kidney damage. Chronic inhalation may cause lung cancer, perforation of the nasal septum and respiratory allergies and irritation.

4.190 **LITHOL RED** (C.I. Pigment Red 49, 15630). Lithol red is slightly toxic by skin contact and highly toxic by inhalation and ingestion. It is also a suspected human carcinogen. Its presence in lipstick has caused allergies. Some grades are highly contaminated with soluble barium, which can cause severe poisoning with symptoms of intestinal spasms, heart irregularities and severe muscle pains. This pigment may also be contaminated with cancer-causing chemicals.

4.191 LITHOPONE (C.I. Pigment White 5, 77115 [barium sulfate/zinc sulfide co-precipitate]). Lithopone is not significantly toxic by skin contact and is only slightly toxic by inhalation. It is highly toxic by ingestion since zinc sulfide may react with stomach acids to produce the highly poisonous gas hydrogen sulfide.

4.192 MAGNESIUM CARBONATE (C.I. Pigment White 18, 77713 [magnesite]). Magnesium carbonate is not significantly toxic by skin contact or inhalation. It is only slightly toxic by ingestion, and may cause purging.

4.193 MANGANESE BLUE (C.I. Pigment Blue 33, 77112 [barium manganese salts]). Manganese blue is not significantly toxic by skin contact but is highly toxic by inhalation and ingestion. Acute inhalation or ingestion may cause barium poisoning with intestinal spasms, heart irregularities and severe muscle pains. Chronic ingestion or inhalation may cause manganese poisoning, a serious nervous system disease resembling Parkinson's disease. Early symptoms include apathy, loss of appetite, weakness, spasms, headaches and irritability.

4.194 MANGANESE VIOLET (C.I. Pigment Violet 16, 77742 [manganese ammonium pyrophosphate]). Manganese violet is not significantly toxic by skin contact but is highly toxic by inhalation and ingestion. Chronic inhalation or ingestion may cause manganese poisoning, a serious nervous system disease resembling Parkinson's disease. Early symptoms include apathy, loss of appetite, weakness, spasms, headaches and irritability.

4.195 MARS BLACK (C.I. Pigment Black 11, 77499 [black iron oxides). No significant hazards.

4.196 MARS ORANGE, see English red (4.183).

4.197 MARS RED, see English red (4.138).

4.198 MARS VIOLET, see English red (4.138).

4.199 MARS YELLOW (C.I. Pigment Yellow 42, 77492, (hydrated iron oxide). No significant hazards.

4.200 MIXED WHITE (C.I. Pigments 1 and 4 [basic lead carbonate and zinc oxide]). This pigment is slightly toxic by skin contact and highly toxic by inhalation and ingestion. It is a known human teratogen and a suspected mutagen. Acute and chronic inhalation or ingestion can cause lead poisoning. See flake white (4.184).

4.201 **MOLYBDATE ORANGE** (C.I. Pigment Red 104, 77605 (lead chromate, lead molybdate and lead sulfate). Molybdate orange is moderately toxic by skin contact and highly toxic by inhalation and ingestion. It is a known human carcinogen and teratogen, and a suspected human mutagen. Skin contact can cause irritation, allergies and skin ulcers due to the chromate. Chronic inhalation of lead chromate may cause lung cancer, perforation of the nasal septum, respiratory irritation and allergies, as well as lead poisoning. Ingestion may cause immediate chromium poisoning with gastroenteritis, vertigo, muscle cramps and kidney damage, as well as delayed lead poisoning. See flake white (4.184).

4.202 **NAPLES YELLOW**, (C.I.Pigment Yellow 41, 77588, 77589 [lead antimoniate]). Naples Yellow is moderately toxic by skin contact and highly toxic by inhalation and ingestion. It is a known human teratogen and suspected mutagen. Skin contact may cause severe skin lesions, including ulcers. Acute inhalation or ingestion may cause antimony poisoning with symptoms of metallic taste, vomiting, colic, diarrhea, severe irritation of mouth and nose, pulmonary congestion and slow, shallow respiration. Chronic exposure may cause chronic antimony poisoning with loss of appetite and weight, nausea, headaches, sleeplessness and, later, liver and kidney damage, as well as lead poisoning. See flake white (4.184). (Pigments sold as Naples Yellow today may be mixtures of less expensive pigments.)

4.203 **PARA RED** (C.I. Pigment Red 1, 12070). The toxicity of this compound by skin contact and inhalation is unknown. It is moderately toxic by ingestion. Ingestion by children has caused acute cyanosis due to methemoglobinemia. This pigment causes bacterial mutations.

4.204 **PHTHALOCYANINE BLUE** (C.I. Pigment Blue 15, 74160, thalo blue, monastral blue, cyan blue [copper phthalocyanine]). The toxicity of this pigment is unknown. Some commercial grades of this pigment are contaminated with 3,3-diclorobenzidine and polychlorinated biphenyls (PCB's), which can cause chloracne, and possibly cancer and birth defects.

4.205 **PHTHALOCYANINE GREEN** (C.I. Pigment Green 7, 74260, thalo green, cyan green [chlorinated copper phthalocyanine]). See hazards for phthalocyanine blue (4.204).

4.206 **PRUSSIAN BLUE** (C.I. Pigment Blue 27, 77510, Paris blue, Berlin blue, iron blue, [ferric ferrocyanide]). Prussian blue is only slightly toxic by skin contact, inhalation and ingestion. However, it can decompose to produce highly poisonous hydrogen cyanide gas if exposed to intense heat, hot acid or strong ultraviolet radiation.

146

4.207 **RAW SIENNA** (C.I. Pigment Brown 6, 77491 [a variety of iron oxides]). No significant hazards.

4.208 **RAW UMBER** (C.I. Pigment Brown 7, 77492 [ron oxides and manganese silicates]). This pigment is not significantly toxic by skin contact, but is toxic by inhalation and by ingestion. See hazards for burnt umber (4.162).

4.209 **RED LAKE C** (C.I. Pigment Red 53:1 and 2 [barium and calcium salt precipitates of an azo dye]). This pigment is not significantly toxic by skin contact but is highly toxic by inhalation and ingestion. Pigments laked on barium salts may have a high level of soluble barium contamination, which may cause acute poisoning with symptoms of intestinal spasms, heart irreg-ularities and severe muscle pains.

4.210 **STRONTIUM YELLOW** (C.I. Pigment Yellow 32, 77839 [strontium chromate]). Strontium yellow is moderately toxic by skin contact and highly toxic by inhalation and ingestion. It is a known human carcinogen and an exceptionally potent animal carcinogen. Skin contact may cause allergies, irritation and ulcers. Acute ingestion may cause chromium poisoning with gastroenteritis, vertigo, muscle cramps and kidney damage. Chronic inhalation may cause lung cancer, perforation of the nasal septum and respiratory allergies and irritation.

4.211 **TALC** (C.I. Pigment White 26, 77718). Industrial talc, which may contain asbestos and free silica, is not significantly toxic by skin contact, but is highly toxic by inhalation. Inhalation of talc may cause fibrosis. Chronic inhalation may cause silicosis if silica is present, or lung cancer and mesothelioma if asbestos is present. Ingestion of asbestos is suspected to contribute to stomach and intestinal cancer.

4.212 **TITANIUM OXIDE** (C.I. Pigment White 6, 77891, titanium white [titanium dioxide]). No significant hazards.

4.213 **ULTRAMARINE BLUE** (C.I. Pigment Blue 29, 77007 [complex silicate of sodium and aluminum with sulfur varying widely in color with changes in composition]). No significant hazards.

4.214 **ULTRAMARINE GREEN**. See ultramarine blue (4.213).

4.215 **ULTRAMARINE RED** (C.I. Pigment Violet 15, 77007). See ultramarine blue (4.213).

4.216 **ULTRAMARINE VIOLET** (C.I. Pigment Violet 15, 77007). See ultramarine blue (4.213).

4.217 VAN DYKE BROWN. See raw umber (4.208).

4.218 VENETIAN RED, see English red (4.138).

4.219 VERMILION (C.I. Pigment Red 106, 77766, cinnabar [mercuric sulfide]). Vermilion is moderately toxic by skin contact and highly toxic by inhalation and ingestion. Repeated skin contact may cause skin allergies. Inhalation or ingestion may cause mercury poisoning, which can severely damage the nervous system and kidneys.

4.220 YELLOW CHROME ORANGE. See chrome yellow (4.175).

4.221 YELLOW OCHRE (C.I. Pigment Yellow 42 or 43 [hydrated iron oxides]). No significant hazards.

4.222 ZINC WHITE (C.I. Pigment White 4, 77947, Chinese white [zinc oxide]). Zinc white is not significantly toxic by skin contact, and is only slightly toxic by inhalation and by ingestion. Ingestion or inhalation may cause slight irritation of respiratory or gastrointestinal systems.

4.223 ZINC YELLOW (C.I. Pigment Yellow 36, 77955 [zinc/potassium chromate complex]). Zinc yellow is moderately toxic by skin contact and highly toxic by inhalation and ingestion. It is a known human carcinogen. Skin contact may cause allergies, irritation and ulcers. Acute ingestion may cause chromium poisoning with gastroenteritis, vertigo, muscle cramps and kidney damage. Chronic inhalation may cause lung cancer and perforation of the nasal septum as well as respiratory allergies and irritation.

HAZARDS OF DYES

4.224 GENERAL HAZARDS. A number of dyes are used in photographic processes such as retouching dyes and the synthetic mordant dyes used in dye transfer. The hazards of most natural and synthetic dyes, including the azo, quinone and phthalocyanine dyes used in retouching and hand-coloring and those used in dye-transfer, have not been adequately investigated.

Food dyes, on the other hand, have been more thoroughly studied. Nearly 200 dyes provisionally listed in 1960 for general use in food. After they were studied, only twenty-two natural substances (e.g. beet powder, carmine, saffron, etc.) and six synthetic dyes are still considered safe for food. If the hundreds of synthetic dyes which were not proposed for food use were tested, it is assumed that similar numbers of them also would be found hazardous.

Dyes often are found to cause cancer in animal tests. Dyes that are known human carcinogens include the benzidine congener dyes

which incorporate benzidine and its derivatives. These dyes are extremely hazardous by inhalation, by skin absorption and by ingestion. Japanese silk kimono painters who habitually formed the point on their brushes with their mouths had a high rate of bladder cancer as a result of chronic ingestion of these dyes.

 Dyes commonly used in photographic processes are listed below. Most are only referred to by class or chemical group since manufacturers often will not divulge their exact composition. The cancer-causing potential of many dyes and the toxic impurities with which most are contaminated suggests that all dyes of unknown composition should be handled with care.

DYES USED IN PHOTOGRAPHY

Indicator/toner dyes
 Bromcresol Purple (Indicator stop bath)
 Pinacryptol Yellow (High acutance developer)

Retouching dyes (powder or liquid)
 Azo dyes (a class of hundreds of dyes containing an azo group)
 Quinone (a class of dyes containing nitroso groups)
 Phthalocyanine (one of the dyes based on phthalocyanine)
 Opaque black
 Opaque red Crocein scarlet (C.I. Acid Violet 2, 17190)

Optical brighteners
 Fluorescent dyes (proprietary)
 Blancophore (a group of bluish white dyes based on stilbene,
 e.g., C.I.Fluorescent Brightener 260)
 Uvitex (a group of violet-bluish dyes of varying composition)
 Tinopal (a group of bluish-violet dyes based on stilbene)

Process E-6 (Kodak) retouching dyes
 Alizarin (magenta) C.I. 58000, see 4.155
 Anthraquinone (cyan) C.I. numbers 58000-72999
 Azo (yellow) a very large group of yellow azo dyes

Dye transfer dyes
 Cyan
 Magenta
 Yellow

Photo resist dyes (Kodak KPR dyes in xylene)
 Black
 Blue

149

Instant process dyes (Polaroid)

 image-forming dyes (metallized)

 yellow and magenta (chromium)

 cyan (copper-phthalocyanine, see 4.204)

 opacifying dyes (phthalein indicator dyes in titanium dioxide)

 indole-naphthalein

 a-naphthol-naphthalein

PRECAUTIONS FOR PIGMENTS AND DYES

4.225 • Use premixed paints and inks to avoid the hazards of grinding and handling colorants. Avoid spray painting, airbrushing, or grinding colorant powders which are carcinogens (e.g. chromates or cadmium pigments, benzidine dyes) or highly toxic colorants such as lead- or mercury-containing pigments.

• Pigment grinding and handling of dye powders should only be done in a fume hood or when wearing an approved toxic dust respirator.

• Practice good hygiene and housekeeping when handling colorants to avoid inhalation or accidental ingestion. Wipe surfaces carefully so that colorant dust does not accumulate. Wash hands after handling colorants, and do not eat, drink or smoke in the studio. Make sure dust does not get transported into living areas on clothing or shoes. Keep colorants out of the reach of children.

• If toxic metal-containing pigments or dyes are used, get regular medical check-ups which include tests for absorption of these metals.

• Handle all organic pigments and dyes with the same caution that would be used for handling inorganic pigments that are highly toxic since the long-term hazards of most are not yet known.

• Never form the point of a dye-laden brush with the lips.

• Do not use benzidine congener dyes.

RESINS

4.226 Several natural resins are used in photographic processes, including the natural gums (damar, gum arabic and gum tragacanth) used in gum printing and retouching, and Japanese lacquer used in some of the historical processes. In addition, natural or synthetic resins are found in lacquers, varnishes (including shellac) and in the polyvinyl acetate/polyvinylalcohol (PVA) colloidal materials used in photographic printmaking processes.

HAZARDS OF RESINS

4.227 **GENERAL HAZARDS.** Most natural resins can cause allergies in some people. Some resins are more potent allergens.

4.228 **COPAL.** Copal resin is only slightly toxic by skin contact and by inhalation. It is not significantly toxic by ingestion. Copal resin may cause allergies in a few people.

4.229 **GUM DAMAR.** Same as hazards for copal (4.228).

4.230 **GUM TRAGACANTH.** Same as hazards for copal (4.228).

4.231 **GUM ACACIA** (gum arabic). Gum arabic is slightly toxic by skin contact and by ingestion, and highly toxic by inhalation. Gum arabic causes a high frequency of severe respiratory allergies when sprayed (printer's asthma). It can also cause skin allergies.

4.232 **JAPANESE LACQUER.** This resin is moderately toxic by skin contact, causing severe skin irritation and allergies. It contains urushiol (a mixture of catechol derivatives), the same substance that causes poison ivy rash. Its hazards by inhalation and ingestion are unknown.

4.233 **ROSIN** (colophony). Rosin is slightly toxic by skin contact and moderately toxic by inhalation, possibly causing asthma. Its hazards by ingestion are unknown.

4.234 **VENICE TURPENTINE** (a viscous balsam from larch trees). This resin is moderately toxic by skin-contact and inhalation; it is highly toxic by ingestion. It can cause dermatitis and allergies, and is similar to turpentine.

PRECAUTIONS FOR RESINS

4.235 Avoid inhaling resin dusts. If highly susceptible to allergies, take extra precautions to avoid exposure to resins, especially gum arabic, Japanese lacquer and Venice turpentine.

SOLVENTS

4.236 Solvents are liquids that can dissolve other materials, including a variety of chemicals, lacquers, varnishes and paints. For this reason, solvents can be used as vehicles to carry resins, pigments, dyes and chemical compounds. Water is an inorganic solvent used in most photographic processes. Organic solvents are also used in some photochemicals and in many paints, lacquers and other surface coatings. The common uses of organic solvents are listed below.

USES OF ORGANIC SOLVENTS

PROCESS
 solvent uses

Black and white processing
 film cleaners
 tray cleaners

Color processing
 penetrating agents
 bleach bath components

Photographic printmaking
 photoresist vehicles
 photoresist thinners
 photoresist strippers
 clean-up solvents
 degreasing agents
 lacquer thinners

Hand coloring and retouching
 clean-up solvents
 lacquer thinners
 paint thinners
 wetting agents

Conservation and restoration
 adhesive removal agents
 emulsion transfer
 de-acidification
 demounting
 film base identification
 clean-up solvents
 lacquer thinners
 wetting agents

HAZARDS OF SOLVENTS

4.237 **GENERAL HAZARDS.** Almost all solvents are drying or irritating to the skin, irritate the eyes and respiratory tract, cause a narcotic effect on the nervous system, and will damage internal organs such as the liver and kidneys. These kinds of damage can result from both acute and chronic exposure. There are no "safe organic solvents."

In general, Threshold Limit Values (TLV-TWA) of below 100 parts per million indicate the solvent is highly toxic by inhalation (see 2.038). Odor is a poor warning signal for most hazardous solvents, because odors often cannot be detected until the concentration of solvent in the air is above the Threshold Limit Value. Many solvents with pleasant odors such as the aromatic hydrocarbons are highly toxic, while other, less toxic solvents such as acetone and most acetates have unpleasant odors. Most of the chlorinated hydrocarbons have very poor odor-warning properties.

Most organic solvents are either flammable or combustible, with the exception of the chlorinated hydrocarbons. The flammability of a solvent is determined by its flash point, which is the lowest tempera-ture at which the solvent vapors are given off in sufficient quantities to form an ignitable mixture in the air. If a source of ignition is present, a flame will spread through the vapor/air mixture and a fire can result. In addition, most can be explosive if the concentration in the air is high

enough and there is a source of ignition. This point is called the lower explosion limit, but the concentration required for explosion is much higher than the levels of solvent vapors that have been shown to cause illness. As defined by OSHA and the National Fire Protection Association Code (NFPA 30), a flammable liquid is any liquid with a flash point below 100° F (37.80° C); combustible liquids have flash points at or above 100° F. See Storage and Handling of Flammable Materials (3.019).

The hazards of organic solvents most commonly used in photographic processes are listed in this section according to their chemical classes.

ALCOHOLS

4.238 Alcohols are widely used as solvents for lacquers, varnishes, shellacs, paints and other materials. They are also used as penetrating agents in color processing and for cleaning and degreasing purposes in photographic printmaking, conservation and restoration.

Alcohols are eye, nose and throat irritants. They also are mildly narcotic. Some alcohols such as methyl alcohol are highly toxic by ingestion.

4.239 **METHYL ALCOHOL** (methanol, wood alcohol, methylated spirits). Flash Point: 52° F (11° C). Methyl alcohol is moderately toxic by skin contact and absorption, as well as by inhalation, and is highly toxic by ingestion. Its Threshold Limit Value (TWA) is 200 parts per million and is regulated by OSHA at this level (see 2.038). It has very poor odor warning properties. Skin absorption or inhalation of methyl alcohol can cause narcosis, nervous system damage (especially to vision) and possible liver and kidney damage. By ingestion, it is highly poisonous, and may cause blindness or even death. Both acute and chronic effects are serious.

4.240 **ISOPROPYL ALCOHOL** (rubbing alcohol). Flash Point: 53° F (12° C). This alcohol is only slightly toxic by skin contact and by inhalation, and moderately toxic by ingestion. It has a Threshold Limit Value (TWA) of 400 parts per million and is regulated by OSHA at this limit (2.038) and is an eye, nose and throat irritant with mild narcotic properties. It has good odor-warning properties.

4.241 **ETHYL ALCOHOL** (ethanol, grain alcohol, denatured alcohol). Flash Point: 55° F (13° C). Ethyl alcohol is only slightly toxic by skin contact and by inhalation, and is moderately toxic by ingestion. It has a Threshold Limit Value (TWA) of 1000 parts per million and is regulated by OSHA at this limit (2.038). Acute ingestion causes intoxication, while chronic ingestion of large amounts can cause liver damage. It

is highly toxic to the fetus and can cause birth defects. Denatured alcohol contains a denaturing agent (e.g. 5% methyl alcohol, jet fuel, MIBK) which makes it a little more toxic.

4.242 BENZYL ALCOHOL. Flash Point: 200° F (94° C). Benzyl alcohol is only slightly toxic by skin contact, inhalation and ingestion. It has no Threshold Limit Value. It is an eye, nose and throat irritant with mild narcotic properties.

4.243 POLYETHER ALCOHOL or p-tert-OCTYLPHENOXY POLYETHOXYETHANOL. Flash Point: none. This compound is not really an alcohol, but a polyethylene glycol polymer incorporating a complex glycol ether. It has low volatility and is primarily used as a surfactant (wetting agent). It is only slightly toxic by skin contact, inhalation and ingestion, but is an irritant to the eyes. Its long term hazards are unstudied.

AROMATIC HYDROCARBONS

4.244 Aromatic hydrocarbons are used as solvents for lacquers, varnishes and paints. They are usually present in lacquer thinners and solvent mixtures. Photoresist materials and retouching fluids also contain aromatic hydrocarbons.

The aromatic hydrocarbons generally have strong narcotic properties and most have good odor-warning properties. They are skin irritants and some may also be absorbed through the skin. If ingested, induced vomiting may cause aspiration into the lungs, resulting in pulmonary edema.

4.245 BENZENE (benzol). Flash Point: 12°F (-11° C.) Benzene is highly toxic by all routes of entry and can readily be absorbed through the skin. It is a known human carcinogen and for this reason it has an OSHA Permissible Exposure Limit (TWA) of 1 part per million (2.038). Benzene may destroy bone marrow, causing aplastic anemia and leukemia in humans. Benzene is highly flammable. DO NOT USE. Benzene has been removed from consumer products for domestic use, but may be present as a contaminant in gasoline and some industrial solvent mixtures.

4.246 TOLUENE (toluol, aromatic naphtha). Flash Point: 40° F (4.5° C). Toluene is moderately toxic by skin contact, but highly toxic by inhalation and by ingestion. It has a Threshold Limit Value (TWA) of 100 parts per million and is regulated by OSHA at this limit (2.038). It causes skin defatting, is a nose and throat irritant, and can cause narcosis and possible chronic liver and kidney damage. Inhalation of large amounts can cause heart sensitization and death (glue sniffer's syndrome). It may also cause menstrual disorders.

4.247 **XYLENE** (xylol, aromatic naphtha). Flash Point (average): 86° F (30° C). Xylene is moderately toxic by skin contact, but highly toxic by inhalation and by ingestion. It has a Threshold Limit Value (TWA) of 100 parts per million and is regulated by OSHA at this limit (2.038). It causes skin defatting and may be absorbed through the skin. The hazards of xylene are similar to those of toluene.

CHLORINATED HYDROCARBONS

4.248 Chlorinated hydrocarbons are widely used as cleaning fluids, lacquer solvents, photoresist developers and strippers and for various other purposes in photographic printmaking, conservation and restoration processes.

 The chlorinated hydrocarbons are strong narcotics that may cause liver and kidney damage. These solvents are skin defatters, and may be absorbed through the skin. There is evidence that consumption of alcoholic beverages before or after exposure to chlorinated hydrocarbons may increase their adverse effects. Most chlorinated hydrocarbons are suspected carcinogens. The least toxic is CHLOROETHANE (ethyl chloride), but all these solvents should be avoided whenever possible.

 Any chlorinated hydrocarbon which is stable enough to migrate to the stratosphere will damage the ozone layer. The new U.S. Clean Air Act (Title VI) divides ozone depleting substances into two categories. Class I contains fluorocarbons, halons, carbon tetrachloride and methyl chloroform (1,1,1-trichloroethane). These are scheduled for complete phase-out over a number of years. Carbon tetrachloride is scheduled for phase-out by the year 2000, and methyl chloroform by 2005.

 Class II contains less destructive compounds used as temporary replacements for Class I substances. These less destructive chemicals are also scheduled for phase out by the year 2030.

4.249 **CARBON TETRACHLORIDE.** Nonflammable. Carbon tetrachloride is highly toxic by every route of exposure including skin absorption. It has an OSHA Permissible Exposure Limit of 2 parts per million. It can cause severe liver and kidney damage even in small amounts. It is synergistic with alcohol and drinking while working with carbon tetrachloride has caused many fatalities. It causes cancer in animals, and is a suspected human carcinogen. Carbon tetrachloride decomposes in the presence of flames, lighted cigarettes, and ultraviolet light to form the highly toxic gas phosgene. DO NOT USE.

4.250 **TRICHLOROETHYLENE** (TCE). Flammable if heated. Trichloroethylene is moderately toxic by skin contact, and highly toxic by inhalation and by ingestion. It has a Threshold Limit Value (TWA) of 50 parts per million and is regulated by OSHA at this limit (2.038). It is also a suspected human carcinogen. Trichloroethylene may cause chronic nerve dam-

155

age, liver and heart damage. Trichloroethylene decomposes in the presence of flames, lighted cigarettes and ultraviolet light to form the highly toxic gas phosgene (4.143). DO NOT USE.

4.251　**METHYLENE CHLORIDE** (methylene dichloride, dichloromethane). Practically nonflammable. Methylene chloride is moderately toxic by skin contact and by ingestion; it is highly toxic by inhalation. It has a Threshold Limit Value (TWA) of 50 parts per million (2.038). OSHA is in the processes of rulemaking for methylene chloride. This is a highly volatile solvent that can cause skin defatting. Acute exposure can cause severe lung irritation and narcosis. Methylene chloride breaks down in the body to form carbon monoxide and has caused fatal heart attacks. Methylene chloride decomposes in the presence of flames, lighted cigarettes and ultraviolet light to form the highly toxic gas phosgene (4.143). Methylene chloride is also a suspected human carcinogen since it causes cancer in animals.

4.252　**METHYL CHLOROFORM** (1,1,1-trichloroethane). Practically nonflammable. Methyl chloroform is slightly toxic by skin contact and ingestion, and moderately toxic by inhalation. It has a Threshold Limit Value (TWA) of 350 parts per million and is regulated by OSHA at this limit (2.038). Its cancer-causing potential has not been well-studied. It is a mild narcotic, and may cause heart sensitization to epinephrine, as well as heart arrhythmias. Chronic exposure to large amounts of this solvent may cause some liver damage. Methyl chloroform decomposes in the presence of flames, lighted cigarettes and ultraviolet light to form the highly toxic gas phosgene (4.143).

FLUOROCARBONS

4.253　Fluorocarbons currently are used as film cleaners and degreasers, and as aerosol propellants. Soon they will be phased out of use due to their ability to damage the stratospheric ozone layer. Environmentally conscious photographers should cease using them now. Fluorocarbons are mildly irritating to the respiratory system, and at very high concentrations they may cause narcosis and irregular heart rhythms. Heating chlorinated fluorocarbons may cause the formation of highly toxic chlorine gas and other toxic decomposition products. See Chlorinated Hydrocarbons above for stratospheric ozone effects.

4.254　**DICHLORODIFLUOROMETHANE** (Freon 12). Nonflammable. Dichlorodifluoromethane is only slightly toxic by any route of exposure. Inhalation of high concentrations can cause numbness or tingling, tinnitus (ringing in ears), slurred speech, apprehension and other signs of central nervous system depression, as well as cardiac arrhythmias. It has a Threshold Limit Value (TWA) of 1000 parts per million and is

156

regulated by OSHA at this limit (2.038). Its use has been limited because it damages the ozone layer.

4.255 TRICHLOROFLUOROMETHANE (Freon 11). Nonflammable. Trichlorofluoromethane is only slightly toxic by any route of exposure. Inhalation of high concentrations can cause narcosis, anaesthesia and other signs of central nervous system depression in addition to cardiac arrhythmias. It has a Threshold Limit Value (Ceiling) of 1000 parts per million and is regulated by OSHA at this limit (2.038). Its use has been limited because it damages the ozone layer.

ESTERS

4.256 Esters are lacquer solvents (present in lacquer thinners) used in photographic printmaking and for general purposes. As a group, esters are eye, nose and throat irritants which have some narcotic effects. Esters have good odor-warning properties.

4.257 ISOAMYL ACETATE (amyl acetate, banana oil). Flash Point: 77° F (25° C). Isoamyl acetate is moderately toxic by every route of exposure. It has a Threshold Limit Value (TWA) of 100 parts per million and is regulated by OSHA at this limit (2.038) and one of the most toxic of the acetates.

4.258 BUTYL ACETATE (n-butyl acetate). Flash Point: 72° F (22° C). Butyl acetate is slightly toxic by skin contact; it is moderately toxic by inhalation and by ingestion and has a Threshold Limit Value (TWA) of 150 parts per million and is regulated by OSHA at this limit (2.038).

4.259 ETHYL ACETATE (acetic ester). Flash Point: 24° F. (-5° C). Ethyl acetate is slightly toxic by skin contact; it is moderately toxic by inhalation and by ingestion. It has a Threshold Limit Value (TWA) of 400 parts per million and is regulated by OSHA at this limit (2.038).

KETONES

4.260 Ketones are usually lacquer solvents (present in lacquer thinners) used in printmaking and conservation processes. In general, ketones are skin, eye, nose and throat irritants. They can cause narcosis if large amounts are inhaled. Ingestion causes vomiting, nausea and stomach pain. Ketones usually have good odor-warning properties.

4.261 METHYL BUTYL KETONE (MBK, 2-hexanone). Flash Point: 77° F. (25° C). Methyl butyl ketone is highly toxic by all routes of entry, including by skin absorption. It has a Threshold Limit Value (TWA) of 5 parts per million and is regulated by OSHA at this limit (2.038). Chronic absorp-

tion of MBK by all routes may cause neuropathy-loss of sensation, weakness, loss of coordination and possible paralysis of arms and legs, as well as central nervous system damage. DO NOT USE.

4.262 METHYL ETHYL KETONE (MEK, 2-butanone). Flash Point: 16° F (-27 ° C). Methyl ethyl ketone is moderately toxic by skin contact and by inhalation, and only slightly toxic by ingestion. It has a Threshold Limit Value (TWA) of 200 parts per million and is regulated by OSHA at this limit (2.038). Repeated exposures frequently result in dermatitis. MEK compounds the hazards of hexane and methyl butyl ketone (4.261) when used simultaneously.

4.263 ACETONE (dimethyl ketone, 2-propanone). Flash Point: -0° F (-18° C). Acetone is only slightly toxic by any route of exposure. It has a Threshold Limit Value (TWA) of 750 parts per million and is regulated by OSHA at this limit (2.038). It is irritating to the eyes and mucous membranes. Eye contact with acetone is especially hazardous and may cause blindness. No chronic systemic effects are known. Acetone is extremely flammable.

GLYCOL ETHERS (CELLOSOLVES)

4.264 Glycol ethers and their acetates are solvents for lacquers, color bleach baths, dyes and photographic resist materials. This is a very large class of chemicals. Each chemical also has dozens of legitimate chemical names which makes it difficult to know if it is a glycol ether or not. Photochemical manufacturers could solve the problem for us if they would follow OSHA's instruction to list each chemical's class on the MSDS.

The simplest glycol ethers and their acetates (4.265-9) have been shown to cause poisoning by skin absorption, ingestion and sometimes by inhalation. They are eye irritants. These solvents can also cause narcosis, kidney damage and possible anemia. Their odor-warning properties are unreliable. Most importantly, they also cause atrophy of the testicles, birth defects and blood changes in several animal species.

Most experts consider them reproductive hazards for humans as well. Most photographic manufacturers should be commended for removing these hazardous chemicals from their products. However, they often replace the simple glycol ethers with more complex ones and other closely related chemicals. It is suspected that these chemicals will have similar hazards. However, since years of testing will be needed before their hazards are determined, these chemicals still can be included in products without chronic hazard warnings. Three of these related chemicals are diethlene glycol (see diethylene glycol in 4.270), dioxane (4.278), and carbitol (below). All three of these chemicals are listed as glycol ethers on the EPA Community Right to Know list.

CARBITOL (ethoxydiglycol, diethylene glycol monoethyl ether, and other names) has not been as extensively studied as the simpler glycol ethers. Test so far indicate the chemical is moderately toxic by skin contact, a skin and eye irritant, and an experimental reproductive hazard. However, reproductive hazards have only been determined by one test, and more study is needed. At this time, OSHA has not set a Permissible Exposure Limit for this chemical.

4.265 **METHYL CELLOSOLVE** (ethylene glycol monomethyl ether, 2-methoxy ethanol). Flash Point: 102^O F (39^O C). Methyl cellosolve is highly toxic by every route of exposure and can also be absorbed through skin. It is slightly irritating to skin and eyes. Skin absorption, inhalation and ingestion can cause kidney damage, anemia and central nervous system instability. It has a Threshold Limit Value (TWA) of 5 parts per million (2.038). OSHA is in the process of rulemaking on this chemical. Inhalation can cause narcosis and pulmonary edema. Studies have shown that methyl cellosolve can cause serious reproductive damage including birth defects, miscarriages and testicular atrophy in animals, even at low levels of exposure.

4.266 **METHYL CELLOSOLVE ACETATE** (ethylene glycol monomethyl ether acetate). Flash Point: 120^O F (49^O C). Methyl cellosolve acetate is highly toxic by every route of exposure and can also be absorbed through skin. Its hazards are similar to those of methyl cellosolve, including its reproductive hazards and Threshold Limit Value.

4.267 **BUTYL CELLOSOLVE** (ethylene glycol monobutyl ether). Flash Point: 143^O F (62^O C). Butyl cellosolve is highly toxic by every route of exposure, including by skin absorption. It has a Threshold Limit Value (TWA) of 25 parts per million and is regulated by OSHA at this limit (2.038). Its hazards are similar to those of methyl cellosolve acetate, except that it is more irritating and it reproductive hazards may not be as severe.

4.268 **CELLOSOLVE** (ethylene glycol monoethyl ether, 2-ethoxy-ethanol). Flash Point: 110^O F (43^O C). Cellosolve is moderately toxic by skin contact and by inhalation, and highly toxic by ingestion. It has a Threshold Limit Value (TWA) of 5 parts per Million (2.038). OSHA is in the process of rulemaking on this chemical. Cellosolve is an eye, nose and throat irritant. Its hazards are similar to other compounds of this category. Studies have shown that cellosolve can cause serious reproductive damage including birth defects, miscarriages and testicular atrophy in animals, even at low levels.

4.269 **CELLOSOLVE ACETATE** (ethylene glycol monoethyl ether acetate, 2-ethoxyethanol acetate). Flash Point: 124^O F (51^O C). Cellosolve acetate is moderately toxic by skin contact and inhalation, and highly toxic by

159

ingestion. It is more irritating than cellosolve. Otherwise, its hazards are similar to those of cellosolve, including its reproductive hazards and Threshold Limit Value.

GLYCOLS

4.270 **GLYCOLS** are a large class of chemicals. They are often used as a wetting agents in retouching and hand-coloring, and to give photosolutions and adhesive emulsions stability in cold temperatures (they are used as anti-freeze). The toxicity of the glycols varies widely.

ETHYLENE GLYCOL (Flash Point: 232° F [111° C]), is the first member of the class. It is moderately toxic by skin contact, slightly toxic by inhalation and highly toxic by ingestion. Ingestion can cause severe and fatal poisoning, damaging the kidneys and central nervous system. Ingestion of even small amounts (3 ounces or 100 mi) can be fatal in adults. This solvent has low volatility unless heated and is therefore less of an inhalation hazard. It has a Threshold Limit Value (Ceiling) of 50 parts per million for its vapor, and it is regulated by OSHA at this limit (2.038).

BUTYLENE GLYCOL and PROPYLENE GLYCOL are two of the more complex glycols. They are much less toxic than ethylene glycol and often are substituted for it. However, this is not the case with diethylene glycol.

DIETHYLENE GLYCOL (2-hydroxy ethyl ether, and other names, Flash Point: 255°F (160°C). This chemical is currently used in a number of color processes. Preliminary studies indicate it possess some of the hazards of both glycols and glycol ethers. It is an eye and skin irritant, moderately toxic by ingestion and experimentally it causes cancer, tumors, and birth defects. At this time, OSHA has not set a Permissible Exposure Limit for this chemical.

PETROLEUM DISTILLATES/ALIPHATIC HYDROCARBONS

4.271 Petroleum distillates are used as general solvents, thinners and cleaning fluids in printmaking, conservation, retouching and hand-coloring processes. They are distilled from petroleum and hence are a mixture of hydrocarbons. For this reason their Threshold Limit Values (2.038) also may vary with composition, and in some cases they are not given here. Users should obtain Material Safety Data Sheets (2.014) on these products for more accurate Threshold Limit Value data.

Petroleum distillates are primary skin irritants, as well as eye, nose, throat and lung irritants and narcotics. Ingestion of this group of solvents is highly hazardous if accidental entry into the lungs occurs during ingestion, especially if vomiting is subsequently induced. This can cause fatal pulmonary edema.

4.272 **PETROLEUM ETHER** (petroleum spirits, petroleum benzin, lactol spirits). Flash Point: -57° F (-50° C). This highly flammable solvent is moderately toxic by skin contact and highly toxic by inhalation and by ingestion. Chronic inhalation of petroleum ether can cause nervous system damage, including possible paralysis of arms and legs due to the presence of n-hexane.

N-HEXANE and commercial grades of hexane which contain 40-55% n-hexane are common solvents for many adhesives such as rubber cement and spray adhesives. Hexanes also are used as a surface cleaner by some photoconservators. It would be safer to replace hexane with heptane, which is must less toxic.

4.273 **GASOLINE** (petrol). Boiling Point: 100 to 400° F (38 to 205° C). Flash Point: -45° F (-43°C). Gasoline is moderately toxic by skin contact and by inhalation, and highly toxic by ingestion. Gasoline may also contain other extremely toxic chemicals including benzene (benzol) and tetraethyl lead, which can both be absorbed through the skin as well as inhaled. It is also highly flammable. Surprisingly, this solvent is still use by some people, especially in photoprintmaking. DO NOT USE.

4.274 **VM&P NAPHTHA** (benzine, odorless paint thinner, turpenoid). Flash Point: 20° F (-6.6° C). Naphtha is moderately toxic by skin contact and by inhalation, and highly toxic by ingestion. It usually has a Threshold Limit Value (TWA) of 300 parts per million and is regulated by OSHA at this limit (2.038). Odorless paint thinner and turpenoid are less toxic because they do not contain the aromatic hydrocarbons which significantly contaminate petroleum distillates such as Stoddard solvent.

4.275 **MINERAL SPIRITS** (Stoddard solvent and other grades). Flash Point for Stoddard solvent is a minimum of 100° F (38° C) and can be much higher. Mineral spirits are moderately toxic by skin contact and by inhalation, and highly toxic by ingestion. Grades of mineral spirits and Stoddard solvent containing aromatic hydrocarbons usually have a Threshold Limit Value (TWA) of 100 parts per million and are regulated by OSHA at this limit (2.038). Grades from which the aromatic hydrocarbons have been removed are similar in toxicity to VM & P naphtha (4.274).

4.276 **KEROSENE** (#l fuel oil). Flash Point: 100 to 150° F. (38 to 66° C). Kerosene is moderately toxic by skin contact and by inhalation, and highly toxic by ingestion.

MISCELLANEOUS SOLVENTS

4.277 **CARBON DISULFIDE** (carbon bisulfide). Used in conservation for fumigation chambers. Flash Point: -22° F (-30°C). Carbon disulfide is highly toxic by every route of exposure, including by skin absorption.

161

It has an OSHA Permissible Exposure Limit (TWA) of 4 parts per million (2.038). Acute exposure can cause very strong narcosis, nerve damage, psychosis and death. Chronic exposure causes central and peripheral nervous system damage, and affects blood, liver, heart and kidneys. Chronic exposure may also be fatal. This solvent has poor odor-warning properties and is extremely flammable. DO NOT USE.

4.278 **DIOXANE** (1,4-dioxane, glycol ethylene ether, or dioxyethylene ether). Used as a movie film cleaner. Flash Point: 54° F (12° C). Dioxane is moderately toxic by skin contact, and is highly toxic by inhalation and by ingestion. It has a Threshold Limit Value (TWA) of 25 parts per million and is regulated by OSHA at this limit (2.038). It can also be absorbed through the skin. Dioxane is an eye, nose and throat irritant. Acute exposure may cause narcosis and liver and kidney damage. Repeated exposure to low concentrations has resulted in human fatalities through chronic liver and kidney damage. It causes reproductive effects and birth defects in animals. It also causes cancer in animals and is a suspected carcinogen in humans. DO NOT USE.

4.279 **TURPENTINE** (gum turpentine, gum spirits, spirits of turpentine, wood turpentine, steam-distilled turpentine). Flash Point: 95° F (35° C). Turpentine is moderately toxic by skin contact and inhalation, and highly toxic by ingestion. Ingestion of one-half ounce can be fatal in children. Accidental entry into the lungs during ingestion can cause fatal pulmonary edema. This may also occur if vomiting is induced after ingestion. Turpentine causes skin irritation and allergic sensitization, which sometimes does not appear until after years of exposure. It has a Threshold Limit Value (TWA) of 100 parts per million and is regulated by OSHA at this limit (2.038). Some skin absorption may occur. Chronic long-term exposure to turpentine can cause an immune-mediated type of kidney damage with eventual kidney failure. The vapors are irritating to eyes, nose and throat. Wood and steam-distilled turpentines are more irritating than gum turpentine.

4.280 **LITHOTINE.** Flash Point: 118° F (48° C). Lithotine, which is mineral spirits with added pine oil, is moderately toxic by skin contact and by inhalation, and highly toxic by ingestion. Accidental entry into the lungs can cause fatal pulmonary edema. This may also occur if vomiting is induced after ingestion. See mineral spirits (4.275).

4.281 **TETRAHYDROFURAN** (THF). Flash Point: 6° F (-15° C). Used in prehardening bath for color processing. THF is moderately toxic by skin contact and skin absorption, as well as by inhalation. It has a Threshold Limit Value (TWA) of 200 parts per million and is regulated by OSHA at this limit (2.038). Its hazards by ingestion are unknown. THF is an irritant to the eyes and to the mucous membranes of the upper

respiratory tract. Acute inhalation can cause headache, nausea, dizziness and other symptoms of central nervous system depression. No chronic systemic effects are known. The hazards of closely related chemicals such as 2,5-dimethyl THF, though unstudied, are likely to be similar.

PRECAUTIONS FOR SOLVENTS

4.282 • Whenever possible, replace highly toxic solvents and solvents that are suspected human carcinogens with less toxic solvents. To determine the safest solvents, choose solvents with the highest Threshold Limit Values and refer to the other toxicity data provided in this chapter.

• Wear gloves and goggles when handling solvents. Make sure that the type of glove selected will protect against the solvent being used. See glove types (3.045).

• Use adequate ventilation with solvents. Highly toxic solvents require local exhaust ventilation or an organic vapor respirator for all but small amounts. See guidelines for ventilation (3.032).

• When handling solvents, take precautions against fire and explosion. See discussion of flammable and combustible materials (3.019). Do not allow smoking or open flames in the work area.

• Wash hands carefully after handling solvents, and take precautions for good skin care (see 3.014). Do not wash hands with solvents, since this can cause dermatitis. If necessary, use an acid-type hand cleaner such as pHisoderm® to clean the skin.

AEROSOL SPRAYS

4.283 Aerosol sprays, or mists, are composed of tiny particles suspended in a liquid that is ejected through a small orifice under pressure, producing very fine liquid droplets in the air. Aerosol sprays and air brushes are used in retouching of photographs and for various fixing and adhesive purposes. They are also used in photographic printmaking to apply photo resist materials, and in hand coloring techniques involving lacquer-based spray paints. Lacquer thinners and other solvent products may be applied by spray methods. Finally, aerosol sprays are used in conservation and restoration for adhesive removal, deacidification procedures, and for the application of lacquers, varnishes and other materials to photographic works.

There are four main types of sprays: spray guns or airbrushes powered by air compressors; aerosol spray cans containing propellant gases; pump or hand sprayers; and mouth atomizers.

Aerosol spray cans usually contain a mixture of organic solvents to dissolve or suspend the material being sprayed. These solvents may include petroleum distillates, toluene, chlorinated hydrocarbons and ketones. Propellants commonly used include propane, butane and carbon dioxide. Freons have been banned for use as propellants due to the damage they cause the ozone layer. (Freons used to dust off photoprints are exempted because the freon is not actually the propellant. Freon is the active ingredient.)

Airbrushes, spray guns, hand pumps, and atomizers may use either organic solvents or water to suspend the material being applied.

HAZARDS OF AEROSOL SPRAYS

4.284 The solvent mist droplets in aerosol sprays are extremely hazardous by inhalation, since they are fine enough to penetrate deeply into the lungs and contain highly concentrated amounts of liquid solvent. Although the solvent usually evaporates quickly to the vapor form, very fine particles of pigment or other materials can remain in the air, where they can be inhaled for hours even though there is no detectable odor. The degree of hazard will depend on the nature of the material being sprayed.

Aerosol spray cans can also result in physical hazards. These include explosions if the can is punctured; flash fires if a source of ignition is present during spraying; freezing, blistering and inflammation of the skin, and eye injuries, from spraying near the face. The Consumer Product Safety Commission reports that there are thousands of injuries each year from the use of aerosol spray cans. If the spray vehicle contains organic solvents, the hazards of airbrushes, spray guns and atomizers are similar to those for aerosol spray cans.

High-pressure, airless spray guns have caused severe injuries when they accidentally inject paint into fingers.

Mouth atomizers pose the additional hazard of accidental ingestion or entry into lungs from a back-up of liquids into the mouth. Pump sprays are the least hazardous, but they are not used much in photography at this time.

PRECAUTIONS FOR SPRAYS

4.285 • Use water-based materials whenever possible, and avoid toxic organic solvents.

• If possible, do not use aerosols. Use other techniques such as dipping or brushing.

• Spraying should be done in a spray booth, or using a spray paint respirator with an exhaust fan. Both procedures are detailed in Chapter 3 (3.035, 3.042).

• Do not spray at close range or in the direction of the face and eyes.

• Do not use mouth atomizers.

MISCELLANEOUS MATERIALS

4.286 A number of other materials are used in photographic processes. Their properties, hazards and precautions are extremely varied, and are thus discussed in other sections of this book. These miscellaneous materials and the sections in which they are discussed are listed below.

Colloidal Materials
 albumen (7.017)
 casein (7.012)
 gelatin (7.012)
 cellulose nitrate (7.007)
 polyvinyl acetate (9.028)
Paints and components (6.017)
Glazes and components (9.033)
Enzymes (9.028)
Carbon arc lamps (3.030, Chapter 9)
Conservation materials (10.002, 10.006)
 adhesives and pastes
 buffered papers
 fungicides
 insecticides
 fumigants

The hazards of standard printmaking materials such as blockouts, etches or inks are not discussed in this book. Sources of information on printmaking hazards are listed in the Bibliography.

5
Processes in Black and White Photography

5.001 Black and white photographic processing involves a wide variety of chemicals, ranging from complex organic developing agents to acids, alkalis, metal salts, oxidizing agents and various solvents. In general, the principle hazards arise in handling these chemicals, especially when mixing concentrated powders and solutions. Both film and print processing use developers, stop baths, fixers, washes and cleaning and drying solutions. After-treatments may include the use of hardeners, intensifiers, reducers, toners and hypo eliminators. These chemicals are normally purchased as ready-to-use, brand name products, although they can usually be obtained in stock or raw form as individual chemicals that the photographer then mixes.

DEVELOPERS

5.002 All photographic developers, either packaged or prepared, contain ingredients that perform similar functions. The developing bath includes one or more developing agents and various other ingredients that play important roles in the development process. The hazards of these individual chemicals vary significantly. The most commonly used developers are hydroquinone, metol or elon (monomethyl-para-aminophenol sulfate) and phenidone, although many other developing agents are used for special purposes. Normally, the developing bath also includes an alkali, often sodium carbonate or borax serving as an accelerator, sodium sulfite as a preservative and potassium bromide as a restrainer or antifogging agent. Acetone, an organic solvent, is sometimes used instead of an alkali in phenolic developers; organic antifoggants benzotriazole and 6-nitro-benzimidazole nitrate may be used instead of potassium bromide as restrainers.

HAZARDS OF DEVELOPERS

5.003 Generally, developers are sources of the most common health problems in photography-skin and respiratory disorders and allergies. Photographers are most at risk when handling developers in concentrated forms, especially during mixing procedures.

Developers are skin and eye irritants, and many are strong allergic sensitizers. Common developers such as metol can cause severe skin irritation and allergies, although the allergies are thought to be caused by the presence of trace or contaminant quantities of the highly toxic developer, para-phenylenediamine. Hydroquinone developers can cause skin depigmentation and eye injury after five or more years of exposure to the powders.

Photographic developers are also associated with lichen planus, an inflammatory skin disease characterized by tiny reddish papules that itch and can spread to form rough scaly patches on the hands. Lichen planus is also associated with subsequent development of skin cancer.

Several developers can also be absorbed through the skin to cause severe systemic effects. These highly toxic compounds include para-phenylenediamine and its derivatives, amidol, catechin and pyrogallic acid. Phenidone is the least toxic developer by skin contact, while para-phenylenediamine and its derivatives are probably the most hazardous developing agents, causing severe skin and respiratory allergies, including asthma.

Alkali accelerators in the developing bath increase the risk of corrosive injury to the skin. Handling the pure alkali or a concentrated stock solution can be especially hazardous to skin or eyes if splashes of the liquid occur. Acetone is a serious eye hazard and is extremely flammable.

By ingestion, most developers are moderately to highly toxic. Some fatalities and severe poisonings have been caused when concentrated developer solutions were drunk accidentally. Symptoms of poisoning include the acute blood disease, methemoglobinemia, and other systemic effects (see 4.002). Ingestion of less than one tablespoon of the powders of some developers including para-phenylenediamine, hydroquinone, metol, or catechin may be fatal for adults. Even smaller amounts can kill children. For this reason, darkrooms in homes where there are children are especially hazardous.

Inhalation of the powders can result in similar effects. Repeated inhalation of the powders of several developers such as aminophenol, amidol, and para-phenylenediamine compounds can result in respiratory irritation and severe respiratory allergies including bronchial asthma.

CHEMICAL HAZARDS

5.004 *Developers*
> aminophenol (4.003)
> amidol (4.004)
> hydroquinone (4.005)
> glycin (4.006)
> catechin (4.007)
> pyrogallic acid (4.009)
> metol, elon (4.010)
> phenidone (4.011)
> para-phenylenediamine (4.012)

Other Organic Chemicals
> benzotriazole (4.031)
> 6-nitro-benzimidazole nitrate (4.031)

Alkalis
> sodium carbonate (4.065)
> sodium hydroxide (4.066)
> borax (4.056)
> sodium sulfite (4.072)

Oxidizing Agents
> potassium bromide (4.122)

Solvents
> acetone (4.263)

OTHER HAZARDS

5.005 • The sodium sulfite preservative in developers gives off sulfur dioxide gas as it slowly decomposes in water solutions. Production of the gas is accelerated if the bath is heated or if acid is added. Sulfur dioxide gas is highly toxic by inhalation and is associated with respiratory allergies.

PRECAUTIONS FOR DEVELOPERS

5.006 • Follow all general precautions in Chapters Two and Three.

• Do not use para-phenylenediamine and its derivatives if at all possible. Replace other highly toxic developers such as catechin or pyrogallol with less toxic developers.

• Avoid direct contact with developer powders or solutions. Buy premixed solutions whenever possible to avoid inhalation of powders or skin contact with concentrated solutions or powders. Never put bare hands into developer baths. Use tongs instead.

• Wear safety gloves (any rubber or plastic safety gloves are acceptable) and goggles when handling developer powders. Mixing should be done in local exhaust such as a fume hood or inside a glove box (3.016, Figure 3-1), or wear an approved toxic dust mask or respirator while mixing (3.042).

• In some cases, water-insoluble barrier creams (such as KerodexT creams) may be used to protect the skin from contact with developers, but they must be reapplied frequently. Ideally, these creams should be used as a second layer of defense under the gloves. Barrier creams alone are not effective against highly toxic developers that can be absorbed through the skin. They may also affect the chemical action of the developer.

• If developer solution splashes on the skin, flush affected areas immediately with water. For eye splashes, flush for at least 15 minutes and get medical attention. Darkrooms should have an eyewash fountain and deluge shower for such emergencies.

• Take proper precautions for housekeeping and ventilation of the processing area of the darkroom. Cover the developing bath (and other baths) between printing sessions to prevent evaporation or release of toxic vapors and gases. Store corrosive chemicals (acids and alkalis) on lower shelves to prevent injury to face or eyes in case of breakage.

• Keep developer solutions (and other photographic chemicals) out of the reach of children. If the darkroom is at home, keep chemicals in locked cabinets when not in use. If acetone is used as an accelerator, take precautions against fire.

STOP BATHS

5.007 Stop baths usually consist of acetic acid in a weak solution derived from either pure glacial acetic acid (99.8% minimum) or, more commonly, 28% acetic acid (three parts of glacial acetic acid diluted with eight parts of water). Some acid rinse baths also contain hardening agents such as potassium chrome alum (chrome alum) and miscellaneous anti-swelling agents, usually sodium sulfate.

HAZARDS OF STOP BATHS

5.008 Acetic acid, in concentrated forms, is highly toxic by skin contact, inhalation and ingestion. Exposure to the highly corrosive solutions, particularly the glacial or pure form, can cause dermatitis and skin ulceration, and can severely irritate mucous membranes of the eyes and respiratory passages. Although the dilute form of acetic acid used as

the stop bath is only slightly hazardous by skin contact, continual inhalation of the acid vapors may cause chronic sinusitis and bronchitis. Contamination of the stop bath by developer components can increase inhalation hazards. Chrome alum hardeners can cause skin and respiratory allergies in some individuals.

CHEMICAL HAZARDS

5.009 *Acids*
 acetic acid (4.035)
 glacial acetic acid (4.035)
 Alkalis
 sodium sulfate (4.071)
 Metals
 potassium chrome alum (4.099)

OTHER HAZARDS

5.010 • Sodium sulfite from the developer, if carried over into the stop bath, will combine with acetic acid to form highly toxic sulfur dioxide gas.

• If water is added directly to a concentrated acid such as glacial acetic acid, a violent, heat-producing reaction occurs. See correct acid dilution procedures (4.034).

PRECAUTIONS FOR STOP BATHS

5.011 • Follow all general precautions in Chapters Two and Three.

• Purchase dilute solutions of acetic acid rather than concentrated ones whenever possible.

• Use a water rinse step between developer and stop bath whenever possible to reduce the formation of sulfur dioxide gas. Discard used stop solutions that have become contaminated with developer.

• Wear protective gloves (elbow length) and goggles when handling concentrated solutions of acetic acid, or when handling chrome alum.

• *Always add acids to water, never the reverse.* See acid dilution procedures (4.034).

• Be prepared for acid splashes on the skin or eyes. Flush affected areas immediately with water. For large splashes, use a deluge shower. For eye splashes, flush for 15 minutes in an eye wash fountain and get medical attention.

• Clean up liquid spills immediately. Always cover the acid bath (and other baths) between printing sessions to reduce evaporation and release of toxic vapors and gases.

• Make sure there is adequate ventilation in the darkroom, including some form of local exhaust for acid vapors, or at least good dilution ventilation.

• Store concentrated acids and other corrosive chemicals on low shelves to reduce the risk of face or eye injury in case of accidental breakage. Store acids separately from solvents.

FIXING BATHS

5.012 Most fixing baths contain a thiosulfate fixing agent, or "hypo", which acts as a silver halide solvent; a weak acid to neutralize the alkaline developer solution (usually acetic acid or an acid salt, such as sodium bisulfite); and sodium sulfite as a preservative to inhibit the formation of colloidal sulfur. In addition, acid-hardening fixing baths generally contain potassium alum (potassium aluminum sulfate) as a hardener and boric acid as a buffer and anti-sludging agent.

HAZARDS OF FIXING BATHS

5.013 Sodium thiosulfate powder is not significantly hazardous by skin contact. The main hazard of hypo solutions is the inhalation hazard that occurs if the bath is heated or left standing, causing the sodium thiosulfate to decompose to release highly toxic sulfur dioxide gas. Ammonium thiosulfate will also decompose to produce sulfur dioxide gas. Contamination of the fixer with acid from the stop bath can accelerate generation of sulfur dioxide gas (4.141).

Alum is irritating to skin and may cause skin allergies in some individuals. Boric acid, if absorbed through abraded or burned skin, can be very toxic, causing systemic effects.

CHEMICAL HAZARDS

5.014 *Oxidizing Agents*
 sodium thiosulfate (4.138)
 ammonium thiosulfate (4.117)
Acids
 acetic acid (4.035)
 boric acid (4.036)
Alkalis
 sodium sulfite (4.072)

Metals
 potassium aluminum sulfate (4.096)

OTHER HAZARDS

5.015 • If heated or if allowed to stand for long periods in water or acid, sodium sulfite also will decompose to form highly toxic sulfur dioxide gas, increasing the inhalation hazards of the fixer.

PRECAUTIONS FOR FIXING BATHS

5.016 • Follow all general precautions in Chapters Two and Three.

• Do not use old hypo solutions. Cover the fixer between printing sessions to prevent evaporation and decomposition. Do not heat.

• Make sure there is adequate ventilation for the fixing bath, preferably some form of local exhaust such as a fume hood or slot exhaust hood, or at least good dilution ventilation.

• Wear safety gloves when handling boric acid powder (especially if skin is abraded) and alum. Avoid inhalation of the dusts by providing local exhaust ventilation (3.035) or respiratory protection (3.042).

HYPO CLEAR AND OTHER WASHING AIDS

5.017 Hypo clear and other washing aids are solutions containing sodium chloride or other inorganic salts (similar to salts found in sea water) that can rapidly remove residual hypo from negatives and prints. Commercial hypo cleaning baths are mild alkali solutions containing a small amount of potassium sulfite or sodium sulfite. Hypo clearing is sometimes used in archival processing since it helps to prevent image fading.

HAZARDS OF HYPO CLEAR

5.018 Hypo clearing agents and similar washing aids are not significantly toxic.

PRECAUTIONS FOR HYPO CLEAR

5.019 • Practice good hygiene.

HYPO ELIMINATION

5.020 Hypo eliminators are used as post-washing baths, after the bulk of the hypo has been removed by hypo clearing baths and routine washing.

Hypo eliminators are designed to oxidize thiosulfates in the fixer to simple sulfates that are more or less inert and will not damage the silver image, even if not completely washed out. Eliminators include dilute solutions of potassium permanganate, sodium hypochlorite, persulfates, iodine, potassium perborate, ammonia and hydrogen peroxide.

HAZARDS OF HYPO ELIMINATORS

5.021 Many hypo eliminators are skin and respiratory irritants, and some are corrosive to skin, eyes, nose and throat. Ammonia is especially hazardous to eyes and to the mucous membranes of the respiratory system. Skin contact with iodine can cause a hypersensitivity reaction and skin burns. Iodine can also be highly irritating if the vapors are inhaled.

CHEMICAL HAZARDS

5.022 *Oxidizing Agents*
 ammonia (4.113)
 ammonium persulfate (4.115)
 hydrogen peroxide (4.120)
 iodine (4.121)
 potassium perborate (4.127)
 potassium permanganate (4.128)
 potassium persulfate (4.129)
 sodium hypochlorite (household bleach) (4.135)

OTHER HAZARDS

5.023 • Strong oxidizing agents such as potassium persulfate, potassium perborate and potassium permanganate can be explosive when in contact with easily oxidizable materials such as solvents and other organic substances.
• Sodium hypochlorite (bleach) will release highly toxic chlorine gas when heated or if acid is added.

PRECAUTIONS FOR HYPO ELIMINATORS

5.024 • Follow all general precautions in Chapter Two and Three.

• Keep hypo eliminators such as potassium persulfate, potassium perborate, and potassium permanganate away from flammable or combustible substances.

• Wear gloves and goggles when handling persulfates, and keep away from sources of heat. Wear gloves when handling potassium perman-

ganate, and mix powders in a fume hood or inside a glove box or wear an approved toxic dust mask.

• Wear gloves when handling iodine.

• Wear gloves and goggles when handling hypochlorite bleach solutions. Do not heat, add acid or ammonia to sodium hypochlorite.

• Wear gloves and goggles when handling ammonia solutions, and use with good dilution ventilation to remove vapors. In case of eye contact, rinse immediately with plenty of water for at least 15 minutes and get medical attention.

INTENSIFICATION

5.025 Among the common after-treatments for negatives (and sometimes prints) are intensification and reduction. Intensification, the increase in the optical density of a negative, is accomplished either by adding more silver to existing deposits, or by combining some other dense metal with the silver, to increase the density of the original deposits. Intensification may involve a two-step process (bleach and redevelop steps) or may be done with a single solution. Metals commonly used for intensification include mercury, chromium and certain compounds such as copper, sulfide (sepia) and uranium toners. The composition and steps of various intensifiers are listed below.

Intensifier	Bleach	Redeveloper
Monckhoven's	mercuric chloride	silver nitrate potassium cyanide or sodium cyanide
single solution mercury	mercuric chloride, hypo, potassium bromide or sodium sulfite, ammonia or a strong black and white developer used as a blackening agent	
chromium	potassium dichromate hydrochloric acid potassium bromide	strong black and white developer
chromium	potassium chlorochromate hydrochloric acid	strong black and white developer

Intensifier	Bleach	Redeveloper
toner	copper iodide	silver nitrate
intensifiers		sodium acetate
	potassium ferricyanide	potassium sulfide
	potassium bromide	
	potassium ferricyanide	uranium nitrate
	potassium bromide	

HAZARDS OF INTENSIFIERS

5.026 Several intensifiers contain extremely hazardous compounds such as mercuric chloride, mercuric iodide, potassium cyanide, sodium cyanide and uranium nitrate. These compounds are all highly toxic by every route of exposure; absorption of very small amounts can cause severe systemic injury or death. Chromium intensifiers are probably the least toxic intensifiers available, but chromium compounds are skin and respiratory irritants capable of causing ulceration and allergies. Potassium dichromate is also a suspected carcinogen.

Most manufacturers have discontinued the use of uranium salts for intensification because of the toxicity of the metal.

CHEMICAL HAZARDS

5.027 *Developers*
aminophenol (4.003) amidol (4.004)
hydroquinone (4.005) metol (4.010)
Acids
hydrochloric acid (4.041)
Alkalis
sodium acetate (4.063)
sodium sulfite (4.072)
Metal Compounds
copper iodide (4.080)
mercuric chloride (4.091)
mercuric iodide (4.092)
potassium chlorochromate (4.097)
potassium dichromate (4.100)
potassium ferricyanide (4. 101)
silver nitrate (4.104)
uranium nitrate (4.108)
Oxidizing Agents
ammonia (4.113)
potassium bromide (4.122)
potassium cyanide (4.124)

potassium sulfide (4.130)
sodium cyanide (4.133)
sodium thiosulfate (4.138)

OTHER HAZARDS

5.028 • In the presence of even weak acids, alkali cyanide salts are readily converted to highly poisonous hydrogen cyanide gas (4.150), which can be rapidly fatal by inhalation.

• Combining potassium dichromate with hydrochloric acid may result in the production of highly toxic chromic acid (4.037), a suspected lung carcinogen.

• If heated, or if acid is added, potassium chlorochromate will release highly toxic chlorine gas (4.141)

• Potassium ferricyanide (Farmer's reducer), only slightly toxic by itself, may release highly toxic hydrogen cyanide gas (4.150) if exposed to intense heat, hot acid or strong ultraviolet light.

• Potassium sulfide (liver of sulfur) decomposes in the presence of acid (including stomach acids) to form highly poisonous hydrogen sulfide gas (4.151). This same decomposition occurs in toning solutions and is signaled by the "rotten egg" odor of hydrogen sulfide.

PRECAUTIONS FOR INTENSIFIERS

5.029 • Follow all general precautions in Chapter Two and Three.

• Do not use highly hazardous compounds such as mercuric chloride, mercuric iodide, uranium nitrate, potassium cyanide or sodium cyanide. Chromium intensifiers are less toxic alternatives to these compounds.

• Practice good housekeeping and cover all baths, especially the acid baths, when not in use. Temperature control is also important, since many of the components of intensifiers will release toxic gases if heated.

• Make sure there is good dilution ventilation with a source of fresh air for intensification processes. Local exhaust ventilation, preferably a lateral slot exhaust system, is needed for sulfide solutions and for chromium intensifiers combining potassium dichromate and hydrochloric acid. See ventilation systems (3.032).

• Safety gloves and goggles should be worn when handling, and especially when mixing chromium intensifiers. Mix powders in a fume

hood or use a glove box to enclose the mixing process. Otherwise, wear an approved toxic dust mask.

• To prevent the formation of highly toxic chlorine gas, do not heat or add acid to potassium chlorochromate.

• Wear safety gloves and goggles when handling silver nitrate, and avoid inhalation of the dusts.

• Avoid inhalation of potassium bromide powders. Mix inside a fume hood or glove box, or wear a toxic dust mask.

• Wear gloves and goggles when handling hydrochloric acid (3.045). Always add acid to water, never the reverse. See acid dilution procedures (4.034).

• Wear gloves and goggles when handling ammonia, and use with good dilution ventilation to remove vapors. If splashed in the eyes, flush with water for at least 15 minutes and get medical attention.

• Do not heat or add acid to potassium ferricyanide (Farmer's reducer). Do not expose this compound to ultraviolet light.

• Wear gloves and goggles when handling potassium sulfide and avoid inhalation of dusts. Use only with local exhaust ventilation. Do not add acid.

REDUCTION

5.030 Reduction, which here refers to the selective removal of silver from parts of the developed image, is actually a type of chemical oxidation process—the opposite of the chemical reduction that occurs during development. Reduction as an after treatment is accomplished by the use of strong oxidizing agents. The most commonly used of these is Farmer's reducer, which consists of potassium ferricyanide and sodium thiosulfate; a modification of this formula uses ammonium thiosulfate. The composition of several common photographic reducers is listed below.

• potassium ferricyanide and hypo (Farmer's reducer)
• iodine and potassium cyanide
• potassium permanganate and sulfuric acid
• potassium permanganate, sulfuric acid and ammonium persulfate (permanganate proportional reducer)
• potassium ferricyanide and hypo with ammonium bromide
• thiourea, potassium ferricyanide and hypo (non-staining reducer)

Reduction can also be accomplished by adding citric acid to an ammonium thiosulfate fixing bath ("rapid fixer") to accelerate its action. A solution of oxalic acid and sodium sulfite can be used to remove brown stains following reduction.

An intermediate process known as harmonizing combines intensification and reduction by bleach and partial redevelopment. Bleaching solutions may contain hydrochloric acid, potassium dichromate and alum, or a modified version using chromic acid and potassium bromide.

HAZARDS OF REDUCERS

5.031 Reducers containing potassium cyanide are highly toxic by every route of exposure, and absorption of very small amounts can rapidly result in severe systemic injury or death. Many other reducers containing strong oxidizing agents and acids are highly corrosive to skin, eyes and mucous membranes of the respiratory tract. Oxidizing agents such as potassium permanganate and the persulfates are also fire and explosion hazards when in contact with organic materials. Many reducers pose inhalation hazards because of the production of highly toxic byproduct gases. Thiourea and chromic acid are suspected carcinogens.

CHEMICAL HAZARDS

5.032 *Acids*
 chromic acid (4.037)
 citric acid (4.039)
 hydrochloric acid (4.041)
 oxalic acid (4.043)
 sulfuric acid (4.048)
Alkalis
 sodium sulfite (4.072)

Metal Compounds
 potassium aluminum sulfate (4.096)
 potassium dichromate (4. 100)
 potassium ferricyanide (4. 101)

Oxidizing Agents
 ammonium bromide (4.114)
 ammonium persulfate (4.115)
 ammonium thiosulfate (4.117)
 iodine (4.121)
 potassium cyanide (4.124)
 potassium permanganate (4.128)
 sodium thiosulfate (4.138)
 thiourea (4.139)

OTHER HAZARDS

5.033 • In the presence of even weak acids, potassium cyanide is readily converted to highly poisonous hydrogen cyanide gas which can be rapidly fatal by inhalation.

• Potassium ferricyanide may release highly poisonous hydrogen cyanide gas (4.150) if exposed to intense heat, hot acid or strong ultraviolet light.

• If heated, ammonium persulfate may produce highly toxic sulfur dioxide gas (4.141).

• If heated, sulfuric acid will release highly toxic sulfur oxide gases. (4.141)

• Adding citric acid to ammonium thiosulfate ("rapid fixer") will result in the production of large amounts of highly toxic sulfur dioxide gas (4.141).

• Potassium permanganate and ammonium persulfate are fire and explosion hazards when in contact with organic materials.

• Combining potassium dichromate with hydrochloric acid may result in the production of highly toxic chromic acid (4.037), a suspected lung carcinogen. Chromic acid is also a fire and explosion hazard.

PRECAUTIONS FOR REDUCERS

5.034 • Follow all general precautions in Chapters Two and Three.

• Do not use highly hazardous potassium cyanide reducers. Potassium ferricyanide is a safer alternative.

• Do not add acid to ammonium thiosulfate. Use less hazardous reducers.

• Practice good housekeeping. Cover all baths, especially acid baths, when not in use. Temperature control is also important, since many components of reducers will release toxic gases if heated.

• Make sure there is adequate dilution ventilation, with a source of replacement air. Local exhaust ventilation is needed for reduction using ammonium thiosulfate ("rapid fixer") and citric acid, for bleaches containing potassium dichromate and hydrochloric acid or for chromic acid bleaches. See ventilation systems (3.032).

• Do not heat or add acid to potassium ferricyanide. Do not expose this compound to ultraviolet light.

• When handling potassium permanganate, ammonium persulfate, or chromic acid reducers, keep them away from flammable and combustible materials and take general fire precautions.

• Wear safety gloves when handling potassium permanganate. Mix in a fume hood or glove box, or wear a toxic dust mask to avoid inhalation of the powder. Keep away from heat sources.

• Wear gloves and goggles while handling ammonium persulfate solutions or powders. Keep away from sources of heat.

• Wear gloves and goggles when handling oxalic acid solutions, as well as concentrated chromic acid and sulfuric acid. Do not expose these acids to heat.

• Avoid repeated contact with thiourea or chromic acid because of their suspected carcinogen status.

• Avoid skin contact when handling iodine solutions. Wear goggles and an approved respirator with an acid gas cartridge to prevent inhalation of iodine vapors if crystals or solutions are heated.

TONING

5.035 Toning is the most frequent after-treatment used on prints, and usually involves the replacement of silver with another metal such as gold, selenium, uranium, lead, cobalt, platinum or iron. Sulfide toning involves replacement of metallic silver by the brown-colored silver sulfide. Toning may be done directly, by immersion in a single solution toner, or by the bleach-and-redevelop method that is commonly used with most brown toners. The table lists a number of common toners with their components. Other toning compounds used for special purposes include cobalt chloride, lead acetate, lead nitrate, lead oxalate, palladium chloride, platinum chloride, uranium nitrate and vanadium chloride.

TONER COMPOSITION

	Direct	Bleach	Redeveloper
copper	copper sulfate potassium ferricyanide potassium citrate or ammonium carbonate		
gold		sodium thiosulfate ammonium persulfate	silver nitrate sodium chloride gold chloride
gold	ammonium thiocyanate gold chloride		
hypo-alum		sodium thiosulfate potassium aluminum sulfate	silver nitrate sodium chloride
iron		potassium ferricyanide ammonia	silver nitrate hydrochloric acid
iron	ferric ammonium sulfate potassium oxalate tartaric acid potassium ferricyanide		
iron	ferric ammonium citrate potassium ferricyanide acetic (or nitric or oxalic) acid		
selenium	sodium selenite ammonium thiosulfate sodium sulfite		
selenium	selenium powder sodium sulfide		
silver- mercury- sulfide*		potassium ferricyanide potassium bromide mercuric chloride	sodium sulfide or potassium sulfide or thiourea and sodium hydroxide
hypo-sulfide	sodium sulfide sulfide sodium thiosulfate		
polysulfide	potassium sulfide sodium carbonate		
sulfide		potassium ferricyanide potassium bromide	potassium sulfide or sodium sulfide
thiourea**	thiourea citric acid gold chloride		

* A series of dilute hydrochloric acid baths may be used between steps.
** Potassium thiocyanate or ammonium thiocyanate can be substituted for thiourea.

HAZARDS OF TONERS

5.036 Several toners contain highly hazardous metal compounds such as lead acetate, lead nitrate, lead oxalate, mercuric chloride and uranium nitrate. Mercuric chloride and uranium nitrate are highly toxic by every route of exposure, and absorption of very small amounts can cause severe systemic injury or death. Lead and its soluble compounds are highly toxic by inhalation and by ingestion, and acute or chronic exposures can result in lead poisoning. Lead is also a known teratogen (causes birth defects) and a suspected mutagen (1.027).

Toning is usually a multi-step process that can involve serious inhalation hazards from by-product gases and vapors that are produced when toning solutions are heated or contaminated with acids. For example, sulfide toners and selenium toners containing sulfides may release highly poisonous hydrogen sulfide gas in solution (4.151), especially if contaminated with acids carried over from the fixer into the toning bath. Contaminated selenium toners may also produce highly toxic hydrogen selenide and sulfur dioxide gases (see also 5.038 for hazards of selenium toners).

Sepia toners may contain potassium ferricyanide, potassium bromide and sodium sulfite. Sodium sulfite in these toners releases sulfer dioxide gas during use. Acid contamination and heating of the solution should be avoided to preclude release of bromine or hydrogen cyanide gas. Some toners require a series of dilute acid baths between bleaching and redeveloping and these can result in the formation of additional highly toxic gases and vapors.

Some toners containing sodium thiosulfate such as hypo-alum, hypo-sulfide, and some gold toners often require heating, which will result in the liberation of highly toxic sulfur dioxide gas as well as other gases. Toning involves exposure to many corrosive substances such as strong oxidizing agents and concentrated acids that can damage skin, eyes and mucous membranes.

Toning chemicals such as copper sulfate, gold chloride, palladium chloride, platinum chloride, selenium oxide, vanadium chloride and ammonium persulfate are irritating compounds that are capable of causing severe skin and respiratory allergies. Thiourea is a suspected carcinogen.

CHEMICAL HAZARDS

5.037 *Acids*
 acetic acid (4.035)
 citric acid (4.039)
 hydrochloric acid (4.041)
 nitric acid (4.042)
 oxalic acid (4.043)

tartaric acid (4.050)

Alkalis

potassium citrate (4.059)

sodium carbonate (4.065)

sodium chloride (table salt)

sodium hydroxide (4.066)

sodium sulfite (4.072)

Metal Compounds

cobalt chloride (4.079)

copper sulfate (4.081)

ferric ammonium sulfate (4.082)

ferric ammonium citrate (4.083)

ferrous sulfate (4.086)

gold chloride (4.087)

lead acetate (4.088)

lead nitrate (4.089)

lead oxalate (4.090)

mercuric chloride (3.091)

palladium chloride (4.094)

platinum chloride (4.095)

potassium aluminum sulfate (4.096)

potassium ferricyanide (4.101)

selenium powder (4.103)

silver nitrate (4.104)

sodium selenite (4.106)

uranium nitrate (4.108)

vanadium chloride (4.109)

Oxidizing Agents

ammonia (4.113)

ammonium persulfate (4.115)

ammonium thiocyanate (4.116)

potassium bromide (4.122)

potassium oxalate (4.126)

potassium sulfide (4.130)

sodium thiosulfate (4.138)

thiourea (4.139)

OTHER HAZARDS

5.038 • If water is added to a concentrated acid, a violent, heat-producing reaction will occur. See procedures for mixing or diluting acids (4.034).

• Potassium ferricyanide may release highly poisonous hydrogen cyanide gas (4.150) if exposed to intense heat, hot acid or strong ultraviolet light.

• Sodium thiosulfate will release highly toxic sulfur dioxide gas (4.141) if heated or if acid is added.

• Ammonium persulfate will release highly toxic sulfur dioxide gas (4.141) if heated. Ammonium persulfate is also a fire and explosion hazard when in contact with organic materials.

• Ammonium thiocyanate will release highly poisonous hydrogen cyanide gas (4.150) if heated or if hot acid is added.

• Adding acid to potassium sulfide or sodium sulfide causes the formation of highly poisonous hydrogen sulfide gas (4.151). These sulfides may also decompose in aqueous solutions to form hydrogen sulfide gas during the toning process.

• Selenium toners containing sulfides may decompose to produce highly poisonous hydrogen sulfide gas in solution (4.151). In addition, some hydrogen selenide gas (4.147) may be released if concentrated acids are present in the toning solution. If fixer components sodium thiosulfate and sodium sulfite are carried over into the toning bath, highly toxic sulfur dioxide gas may be released.

• Rapid Selenium Toner (Kodak) will decompose to produce the highly toxic gases ammonia (4.142) and sulfur dioxide (4.141) if strong acids are added to the toning bath. Some hydrogen selenide gas (4.147) is also produced.

PRECAUTIONS FOR TONERS

5.039 • Follow all general precautions in Chapter Two and Three.

• Do not use toners containing highly hazardous compounds such as mercuric chloride or uranium nitrate. Also avoid using toners containing lead and its soluble compounds, such as lead acetate, lead nitrate and lead oxalate. The least hazardous toning compounds include copper sulfate, gold chloride and iron compounds. Platinum chloride, palladium chloride, vanadium chloride and thiourea (thiocarbamide) should be used with much care. Sulfide or selenium/sulfide toners should only be used in local exhaust ventilation.

• Practice good housekeeping. Wash prints thoroughly between fixing and subsequent steps to avoid contaminating the bleach or toning bath. If acid rinse baths are used between steps, make sure that prints always go through a careful washing to remove any residual acid. Cover all baths, especially acid baths, when not in use. Discard used hypo solutions to prevent decomposition and contamination of other baths.

• Use premixed toning solutions whenever possible, to avoid the hazards of mixing. Do not use toners that require heating if at all possible, since many of the components of toning solutions will release highly toxic gases when heated. If heated solutions are used, make sure the ventilation is adequate and other precautions are taken.

• Local exhaust ventilation, preferably a lateral slot exhaust system, is recommended for most toning processes including those employing toners containing sulfides or selenium, and toning processes requiring heat. Sepia toning may be done with good dilution ventilation if acid contamination is avoided and no heat is involved. See ventilation (3.032).

• For handling concentrated acids, wear safety gloves (elbow length) and goggles to protect against splashes. When mixing, always add acids to water, never the reverse. See procedures for mixing acids (4.034). Store acids and other corrosives on low shelves to reduce the risk of face or eye injury in case of accidental breakage. For acid splashes on the skin or eyes, rinse affected areas immediately with plenty of water. For eye splashes, continue rinsing for 15 minutes and call a doctor.

• Do not heat or add acid to potassium ferricyanide, and do not expose this compound to ultraviolet light.

• Wear goggles when handling copper sulfate, and avoid skin contact if using it frequently. Do not inhale powders.

• Wear gloves and goggles when handling ammonium persulfate solutions or powders. Keep away from flammable and combustible materials, and do not heat.

• Do not heat sodium thiosulfate, and do not add acid.

• Wear gloves and goggles when handling silver nitrate, and avoid inhaling the dusts.

• Avoid repeated skin contact with gold chloride. Do not inhale the powder.

• Do not heat or add acid to ammonium thiocyanate.

• Avoid skin contact with potassium aluminum sulfate, ferric ammonium sulfate, ferric ammonium citrate or ferrous sulfate if they are used frequently. Do not inhale the powders.

• Wear gloves and goggles when handling potassium oxalate. Mix in a fume hood or glove box, or wear an approved toxic dust mask.

• Wear gloves and goggles when handling selenium powders. Mix powders in a fume hood (for large amounts) or in a glove box, or wear a toxic dust mask. Do not add acid to selenium toning solutions. Use a water rinse step after fixing to prevent contamination of the toning bath with fixer components.

• Wear gloves and goggles when handling sodium sulfide or potassium sulfide. Avoid inhalation of the dusts. Do not add acid to sulfide solutions. Use a water rinse step after fixing to prevent contamination of the toning bath with fixer components. Use only with local exhaust ventilation.

• Avoid repeated direct contact with thiourea or palladium chloride because of the suspected carcinogenic status of these compounds. Avoid inhalation of the powders.

• Wear gloves or barrier cream and goggles when handling platinum chloride. Mix in a fume hood or glove box, or wear a toxic dust mask.

• Avoid repeated skin contact with cobalt chloride and vanadium chloride. Avoid inhalation of the powders. Wear goggles when mixing vanadium chloride.

HARDENING

5.040 A formalin hardening bath is often used for negatives that are to receive after-treatment. This bath usually contains formalin (40% formaldehyde solution with 0-5% methanol) and an alkali such as sodium carbonate. Some manufacturers now offer succinaldehyde hardeners as a substitute for formalin. This type of bath may also be used for prehardening, before development.

HAZARDS OF HARDENING

5.041 Formaldehyde is a highly irritating chemical that is a potent allergic sensitizer and a systemic poison. Chronic exposure frequently results in the development of skin and respiratory allergies, including asthma. Formaldehyde is also a suspected carcinogen. OSHA has instituted a special standard for workers exposed to formaldehyde. In addition,
 OSHA plans to lower their airborne limits for formaldehyde. It is important that products which use substitutes for formaldehyde by used, rather than meet these demanding and expensive regulations which are likely to become even stricter. Succinaldehyde (or succinaldehyde

disodium bisulfite) can be used as a substitute. Not much is known about this chemical. It is also irritating, but appears to be much less allergenic.

The hardening bath also contains some methanol (methyl alcohol), a moderately toxic solvent that is poisonous by ingestion.

CHEMICAL HAZARDS

5.042 *Aldehydes*
 formalin (4.023)
 succinaldehyde (4.024)
 Alkalis
 sodium carbonate (4.065)
 Alcohols
 methyl alcohol (4.239)

PRECAUTIONS FOR HARDENING

5.043 • Follow all general precautions in Chapters Two and Three.
 • Replace formaldehyde-containing solutions whenever possible.
 • If formaldehyde is used on the job, make sure your employer meets the OSHA Formaldehyde Standard's special requirements.
 • Wear gloves and goggles when handling formaldehyde or succinaldehyde in powder or solution form.
 • For large amounts, use with local exhaust ventilation or wear an approved respirator with a formaldehyde cartridge.

SILVER AND HYPO TESTING

5.044 When fixing baths are used until the concentration of silver complexes is high, prints and negatives tend to retain some of these compounds even after careful washing. To test for residual silver, a very dilute sodium sulfide solution is dropped on a small area to see whether or not any stain is formed. An alternative test for residual silver can be accomplished with a dilute solution of selenium toner containing sodium sulfide.

A quantitative test for the estimation of residual hypo in prints involves immersion in an acidified solution of silver nitrate, which reacts with hypo to form a stain of silver sulfide. The most common hypo test solutions for prints contain silver nitrate and 28% acetic acid. A standard test for residual hypo in negatives involves immersion of a small piece of film in a solution containing mercuric chloride and potassium bromide if hypo is present, a milky precipitate will occur. An alternative to these tests, based on the chemical reactions between reagents and the drippings from negatives or prints, uses a solution containing potassium permanganate and sodium hydroxide (caustic soda).

HAZARDS OF SILVER AND HYPO TESTING

5.045 Although concentrated solutions of sulfides are corrosive and may release highly toxic hydrogen sulfide gas in aqueous solutions, the small amounts of dilute sodium sulfide used in testing for residual silver should not be significantly hazardous.

Solutions used for testing residual hypo contain chemicals that are moderately to highly corrosive to skin, eyes and mucous membranes. Mercuric chloride is highly toxic by every route of exposure; absorption of very small amounts can cause severe systemic effects.

CHEMICAL HAZARDS

5.046 *Acids*
 acetic acid (4.035)
Alkalis
 sodium hydroxide (4.066)
Metal Compounds
 mercuric chloride (4.091)
 selenium powder (4.103)
 silver nitrate (4.104)
Oxidizing Agents
 potassium bromide (4.122)
 potassium permanganate (4.128)
 sodium sulfide (4.130)

OTHER HAZARDS

5.047 • Potassium permanganate is a fire hazard when in contact with combustible materials.

• Sulfides may decompose in solution and especially in the presence of acid (even stomach acids) to form highly poisonous hydrogen sulfide gas (4.151)

PRECAUTIONS FOR SILVER AND HYPO TESTING

5.048 • Follow all general precautions in Chapter Two and Three.

• When handling dilute sulfide solutions, or dilute solutions of selenium toner, be careful to avoid contact with skin or eyes. Do not add acid.

• When handling acidified silver nitrate solutions, wear goggles and avoid skin contact.

189

• Do not use mercuric chloride as a hypo test agent. Other methods are safer alternatives.

• Wear gloves when handling potassium permanganate solutions. If mixing, use a fume hood or glove box, or wear a toxic dust mask. Keep away from sources of heat.

PRINT AND NEGATIVE CLEANING

5.049 Chlorinated and fluorinated hydrocarbon solvents are usually used to clean prints and negatives. Included are methyl chloroform, chloroethane, dichlorodifluoromethane (Freon 12), trichloro-fluoromethane (Freon 11) and other Freons.

HAZARDS OF PRINTS AND NEGATIVE CLEANING

5.050 By inhalation, these fluorocarbons are slightly hazardous; methyl chloroform is moderately hazardous. High concentrations of these solvents can cause narcosis and other signs of central nervous system depression, as well as cardiac arrhythmias (irregular heart beat). Fluorocarbons and many of the chlorinated hydrocarbons damage the stratospheric ozone layer and are being phased out of production over the next few decades.

CHEMICAL HAZARDS

5.051 *Chlorinated Hydrocarbons*
 chloroethane (4.248)
 methyl chloroform (4.252)
Fluorocarbons
 dichlorodifluoromethane (4.254)
 trichlorofluoromethane (4.255)

OTHER HAZARDS

5.052 • Chlorinated hydrocarbons decompose in the presence of flames, lighted cigarettes and ultraviolet light to produce highly toxic phosgene and other toxic gases (4.143).

• Heating chlorofluorocarbons may cause the formation of highly toxic chlorine- and fluorine-containing gases (4.141) and other toxic decomposition products.

PRECAUTIONS FOR CLEANING SOLVENTS

5.053
- If possible, do not use fluorocarbons. If they must be used, provide adequate dilution ventilation.
- Wear gloves when handling methyl chloroform or chloroethane.
- If large amounts are used, work in a local exhaust hood or wear an approved respirator with an organic vapor cartridge.
- Do not heat, expose to flames or ultraviolet light, and do not smoke when using this or any solvent.

TRAY CLEANING

5.054 Strong oxidizing solutions used to clean trays and utensils usually contain concentrated acids or alkalis. A common cleaning solution is the acid-bichromate tray cleaner containing potassium dichromate (bichromate) and concentrated sulfuric acid. Other strong acids used for tray cleaning include hydrochloric acid and nitric acid. Some solutions consist of strong alkalis such as potassium permanganate with sodium sulfite, or a concentrated solution of sodium hydroxide (caustic soda).

HAZARDS OF TRAY CLEANING

5.055 Concentrated acids and alkalis used traditionally as tray cleaners are highly corrosive to skin and eyes, and to the gastrointestinal tract if ingested. Repeated inhalation of acid vapors or alkali dusts can cause chronic lung problems. Potassium dichromate is a skin and respiratory irritant that can cause ulceration and allergies. Potassium dichromate is also a suspected carcinogen.

New powerful detergents specially designed for plastic and laboratory glassware are much safer replacements. They can be found in any laboratory supply catalog. Excessive exposure can dry and chap skin. Detergents containing enzymes are associated with allergic symptoms.

CHEMICAL HAZARDS

5.056 *Acids*

hydrochloric acid (4.041)
nitric acid (4.042)
sulfuric acid (4.048)

Alkalis

sodium sulfite (4.072)
sodium hydroxide (4.066)

Metals

potassium dichromate (4.100)

Oxidizing Agents
 potassium permanganate (4.128)

OTHER HAZARDS

5.057 • If water is added to a concentrated acid, a violent, exothermic reaction may occur. See correct procedures for mixing acids (4.034).
 • Potassium permanganate is a fire and explosion hazard when in contact with organic materials.
 • Heating or treating sodium sulfite with acid results in the formation of highly toxic sulfur dioxide gas.

PRECAUTIONS FOR TRAY CLEANERS

5.058 • Replace acid cleaners with laboratory glassware detergents. If trays are stained beyond the detergent's capacity to clean them, purchasing new trays is a better alternative than using the acid cleaners. Use gloves to protect hands from drying and chapping.

RETOUCHING

5.059 Black and white retouching consists of adding pigments and dyes to the negative surface to make a portion of the print lighter, or removing by mechanical means part of the silver deposit to make an area of the print darker.

 The gelatin surface is usually first prepared with a special varnish (retouching medium or dope) containing natural gums (gum arabic, gum damar, gum tragacanth) and oils (oil of juniper and oil of turpentine). In some cases the medium also contains organic solvents such as turpentine, or an aromatic hydrocarbon such as toluene or xylene as the vehicle. Retouching medium is either wiped or sprayed on, usually with an airbrush.

 Reticulating lacquers may also be applied to the photographic surface, and sometimes a build-up of layers is required. These lacquers are usually applied by airbrushing or with spray cans. Spray can propellants usually are gases of very low toxicity such as propane or butane. Most lacquers contain solvents such as turpentine or mineral spirits, and some contain complex mixtures of solvents including toluene or xylene. Resins found in lacquers may be natural or synthetic.

 Dye retouching (often done prior to pencil work) may involve "spotting" techniques using a finely pointed brush or airbrushing dyes onto the surface. Dyes commonly used include Crocein Scarlet dye and red and black opaques, which are water-soluble paints with adhering properties. A wetting agent containing a complex polyethylene glycol ether (polyether alcohol) and sometimes ethylene glycol or other gly-

cols may be used to facilitate the removal of dyes.

A neutral gray dye can be used to correct pinhole spots in the negative caused by dust or other foreign matter. These spotting fluids and powders are also used for correcting dust spots in prints. Spotting colors, which are manufactured by several different companies, contain water-soluble dyes such as azo, quinone and phthalocyanine dyes in liquid or solid (powder) form.

Retouching can also be accomplished chemically, using Farmer's reducer either locally or generally for negatives. On prints, spotting reducers can be used to remove black spots caused by negative flaws. Spotting reducers may contain potassium ferricyanide; sometimes a thiourea reducer containing a methyl alcohol solution of iodine is used.

Pencil retouching may be done with or without a varnish or medium. Retouching fluid is often used instead as a surface primer, and consists of aromatic hydrocarbons (toluene, xylene) thinned with turpentine or mineral spirits. Pinholes are filled with black water color or India ink, using a finely pointed brush.

Solvents used for removal of retouching materials from the negative surface may range from turpentine and mineral spirits to lacquer thinners or solvent mixtures containing aromatic hydrocarbons (toluene and xylene) and chlorinated hydrocarbons.

HAZARDS OF BLACK AND WHITE RETOUCHING

5.060 Black and white retouching can involve severe inhalation hazards, particularly if solvent-based materials or dyes are sprayed or airbrushed onto the photographic surface. These sprays produce fine mists which carry toxic materials deep into the lungs.

Resins found in lacquers and varnishes, especially gum arabic, can cause respiratory allergies including asthma when sprayed. Turpentine is a strong allergic sensitizer and is poisonous by ingestion. Oil of turpentine and oil of juniper can also cause allergies.

Retouching medium, retouching fluids, reticulating lacquers and lacquer thinners may contain aromatic hydrocarbon solvents such as toluene and xylene that are highly toxic by inhalation. Commercial solvent mixtures used for removal may also contain chlorinated hydrocarbons (often trichloroethylene), highly toxic solvents which are also suspected carcinogens. These solvents are strong narcotics and skin defatters, and can be absorbed through the skin to cause systemic damage. Most solvents used in retouching are either fire or explosion hazards.

The hazards of most dyes, including retouching dyes have not been extensively studied, particularly with regard to their possible long-term carcinogenic effects. In addition to the inhalation hazard of airbrushing with dyes, dye retouching can involve an ingestion hazard resulting from the common practice of pointing brushes with the lips.

Wetting agents may include glycols such as ethylene glycol and

propylene glycol, and more complex polyethylene glycols (4.243). Ethylene glycol is highly toxic by ingestion.

CHEMICAL HAZARDS

5.061 *Metal Compounds*
 potassium ferricyanide (4.101)
 Oxidizing Agents
 iodine (4.121)
 sodium thiosulfate (4.138)
 thiourea (4.139)
 Pigments and Dyes
 individual pigments (4.155-4.223)
 azo dyes (4.224)
 quinone dyes (4.224)
 phthalocyanine dyes (4.224)
 Resins
 gum damar (4.229)
 gum tragacanth (4.230)
 gum arabic (4.231)
 Alcohols
 methyl alcohol (4.239)
 Aromatic Hydrocarbons
 toluene (4.246)
 xylene (4.247)
 Chlorinated Hydrocarbons
 trichloroethylene (4.250)
 Glycols
 ethylene glycol (4.270)
 propylene glycol (4.270)
 polyethylene glycol polymer (4.243)
 Petroleum Distillates
 mineral spirits (4.275)
 Fluorocarbons
 dichlorodifluoromethane (4.254)
 trichlorofluoromethane (4.255)

OTHER HAZARDS

5.062 • Most chlorinated hydrocarbons such as trichloroethylene will decompose in the presence of flames, lighted cigarettes and ultraviolet light to produce highly toxic phosgene gas (4.143). Many also damage the stratospheric ozone layer.

• Fluorocarbons damage the stratospheric ozone layer. Do not use.

• Potassium ferricyanide may release highly toxic hydrogen cyanide gas (4.150) if exposed to intense heat, hot acid or strong ultraviolet light.

PRECAUTIONS FOR RETOUCHING

5.063 • Follow all general precautions in Chapters Two and Three.

• Avoid inhalation of resin dusts, especially if susceptible to allergies. Air brushing or spraying of retouching medium or reticulating lacquers should be done in local exhaust such as a spray booth, fume hood, or slot exhaust. Otherwise wear a respirator with cartridges approved for paint, lacquer and emamel mist. There should be an exhaust system in the studio to remove the excess spray so the respirator can be taken off safely.

• Wear gloves when handling varnishes, lacquers and their thinners. Use with good general or local exhaust ventilation. Keep these materials away from sources of heat.

• Wear appropriate gloves to avoid skin contact when handling organic solvents. See (3.045).

• Use the least toxic solvents available. Moderately toxic solvents such as turpentine or mineral spirits are preferable to highly toxic aromatic hydrocarbons (toluene or xylene) or solvent mixtures (including lacquer thinners) containing these solvents in addition to highly toxic chlorinated hydrocarbons.

• When using solvents that are highly toxic by inhalation, such as toluene or xylene, special precautions are required. Preferably use them in a fume hood, or wear an organic vapor respirator. Small amounts can be handled with good dilution ventilation.

• If possible, do not use trichloroethylene or other chlorinated hydrocarbons (or solvent mixtures that contain them) since they are suspected carcinogens. If they must be used, work in a fume hood or wear an organic vapor respirator. Keep away from sources of heat, lighted cigarettes and ultraviolet light.

• Take proper storage and handling precautions for solvents and take precautions against fire. See precautions for flammable and combustible materials (3.019).

• Do not wash hands with solvents since this is a major cause of dermatitis. Wash frequently with soap and water, and take other measures (such as using a lanolin-containing cream) to keep skin in good condition.

• Airbrushing water-based retouching dyes should be done in a spray booth or fume hood. Otherwise wear a respirator or mask approved for toxic dusts and mists.

• Never point the retouching brush with the lips to avoid accidental ingestion of retouching dyes.

• Avoid eye contact with wetting agent solutions. If splashed in the eyes, flush with water for at least 15 minutes and get medical attention. Avoid accidental ingestion of ethylene glycol.

• Do not heat or add acid to potassium ferricyanide, and do not expose this reducer to ultraviolet light.

• Wear gloves and goggles when handling thiourea reducers containing methyl alcohol. Avoid accidental ingestion of methyl alcohol. Avoid repeated, direct contact with thiourea because it is a suspected carcinogen.

CHAPTER

Processes in Color Photography

6.001 Color processing, which is usually based on the chemical procedure of dye-coupling development, utilizes more exotic organic chemicals and is considerably more hazardous than black and white photography. Furthermore, color films and the processing systems of various manufacturers are constantly changing to provide better and safer products and to avoid patent infringement. Often the new chemicals have never been studied for long-term hazards. Some also are protected as trade secrets. Thus, the hazards of some of the newer processes are not yet known.

For this reason, it is especially important to institute a Right-to-Know program (See Chapter 2) and excellent safety and health training in all color processing facilities. The only sure way to work safely with color processes is to reduce or eliminate exposure to them while working.

Despite the lack of chemical information, the basic steps in all color negative processing are similar. They usually include development in a dye-coupling developer that forms the color image and silver image, bleaching to remove the silver image, and fixing to reduce the bleached silver image and unexposed silver halides. Color transparency processing (reversal processing) involves development first with black and white developers, reexposure to light (sometimes this is omitted), then development in a dye-coupling developer, bleaching to remove both positive and negative silver images and fixing. Intermediate steps may include hardening, neutralizing and stabilizing the dye image.

COLOR DEVELOPING

6.002 Color developers, including those used for negative processing and the second developers in color reversal processing, contain a number of chemical components. These may include a developing agent or color-coupling agent in addition to other chemicals with the following functions:

accelerators	potassium or sodium carbonate
	potassium bicarbonate
	sodium or potassium phosphate
	sodium or potassium hydroxide
restrainers	potassium bromide
	potassium iodide
	potassium chloride
preservative	sodium or potassium sulfite
	sodium bisulfite
	lithium sulfite
penetrating solvents	benzyl alcohol
	ethylene glycol
	diethylene glycol
	ethoxydiglycol (carbitol)
special antifoggants	benzotriazole
	hydroxylamine hydrochloride
	hydroxylamine sulfate
contrast control agents	citrazinic acid
	ethylene diamine
	mono-, di-, and triethanol amines
other chemicals	lithium sulfate
	substituted phosphonic acids
	e.g. 1-hydroxyethylidene-1,1-
	diphosphonic acid
	salts of pentetic acid
	substituted stilbene
	and many more

HAZARDS OF COLOR DEVELOPERS

6.003 Color developers are more hazardous than black and white developers because they may contain a number of highly toxic chemicals. These include various amines and organic solvents that can be absorbed through the skin, resulting in severe systemic effects. The developing agent para-phenylenediamine and its diethyl and dimethyl derivatives are highly toxic by every route of exposure and can cause severe skin allergies and asthma. If absorbed, these compounds can result in nervous system damage and poisoning. The newer color developing agents are designed to have reduced toxicity, but still may cause skin irritation and allergies. Other amines, including ethylene diamine, tertiary-butylamine borane (TBAB) and hydroxylamine sulfate, N,N-diethylhydroxylamine, monoethanolamine (2-aminoethanol), di- and triethanolamines (4.016-4.020) can also cause severe skin and eye irritation, allergies, and other systemic effects.

 Some components of color developers can have reproductive hazards. Recent studies have shown that some glycol ethers and diethylene

glycol can cause birth defects and other reproductive problems in animals. Hydroxylamine compounds (also used in neutralizing solutions) are suspected teratogens since they cause birth defects in animals. See (4.268).

There are many chemicals in color developers for which little or no hazard no data can be found. Two such chemicals which are listed above are:

1. Pentasodium salt of pentetic acid (DTPA-sodium salt). This is the sodium salt of diethylenetriamine pentaacetate. Although there is very little data on this chemical, it is very closely related to the calcium/trisodium salt of the same acetate which is an experimental teratogen and mutagen.

2. Substituted stilbene. There are dozens of substituted stilbenes. The one used by Kodak is apparently new since the chemical has no CAS (Chemical Abstract Service) number. With no complete formula and no CAS number, it cannot be researched and, in fact, there probably is no data. The most famous substituted stilbene is diethyl stilbesterol or DES, which has been shown to be a human carcinogen which usually expresses itself in the offspring of an exposed mother when the child reaches puberty.

These examples are not meant to alarm readers or to suggest that color work is too risky to be done safely. Rather, it is hoped that we will follow precautions scrupulously in order to avoid exposure to these chemicals and others whose hazards are largely unknown.

CHEMICAL HAZARDS

6.004 *Developers*
 metol (4.010)
 phenidone (4.011)
 hydroquinone (4.005)
 para-phenylenediamine (4.012)
 ortho-phenylenediamine (4.012)
 diethyl-para-phenylenediamine (4.012)
 dimethyl-para-phenylenediamine (4.012)
 N,N-diethylhydroxylamine (4.013)
 color developer (Kodak CD-1, DISCONTINUED): N,
 N-diethyl-p-phenylenediamine monohydrochloride (4.012)
 color developer (Kodak CD-2, BEING DISCONTINUED): 4-N,
 N-diethyl-2-methyl phenylenediamine
 monohydrochloride (4.012)
 color developer (Kodak CD-3): 4-(N-ethyl-N-2-
 methanesulfonylaminoethyl)-2-methylphenylenediamine

sesquisulfate monohydrate (4.013)

color developer (Kodak CD-4): 4-(N-ethyl-N-2
hydroxyethyl)-2-methylphenylenediamine sulfate (4.013)

color developer (Kodak CD-6): 4-(N-ethyl-N-2-methoxyethyl)-
2-methylphenylenediamine di-p-toluene sulfonate (4.013)

Amines (4.016-4.020)

Acids

citrazinic acid (4.038)

also some very complex organic acids for which little data is
available

Alkalis

lithium sulfite and sufate (6.006, last precaution)

potassium carbonate (4.059)

sodium carbonate (4.065)

sodium and potassium hydroxide (4.066)

sodium sulfite (4.072)

Oxidizing Agents

potassium bromide (4.122)

potassium iodide (4.125)

potassium thiocyanate (4.131)

sodium thiocyanate (4.137)

sodium thiosulfate (4.138)

Alcohols

benzyl alcohol (4.242)

Glycols

ethylene glycol, diethylene glycol (4.270)

Glycol ethers

e.g. ethoxydiglycol, (4.264)

OTHER HAZARDS

6.005 • Sodium sulfite in color developers will decompose if carried over into
an acid stop bath or an acid bleach bath, forming highly toxic sulfur
dioxide gas (4.141).

• In reversal processing, using acid stop baths after the first and sec-
ond developers may produce highly toxic sulfur dioxide gas when
sulfites in both developers are carried over into the acid stop bath.

• Certain methods of temperature control for color developer solutions
increase the hazards of possible electrical shock. They may also cause
solutions to overheat producing highly toxic gases and vapors. Meth-
ods that are hazardous and should not be used are therapeutic heat-
ing pads, food warming trays, aquarium heaters submerged in
waterjackets and adjustable hotplates under stainless steel trays.

• If exposed to intense heat or hot acid, potassium thiocyanate or sodium thiocyanate may release highly poisonous hydrogen cyanide gas (4.150).

PRECAUTIONS FOR COLOR DEVELOPERS

6.006 • Follow all general precautions in Chapters Two and Three. * Provide dilution ventilation for work areas, and local exhaust ventilation for color chemical mixing and processing.

• Exposure to color chemistry can be reduced by using automatic color processors. Purchase models with factory built-in local exhaust systems. Many common processors can be purchased with an exhaust, but you may need to ask for it. Sales people may not volunteer this information because they fear that discussing the need to exhaust toxic emissions will discourage customers. Install processors where they can be vented to the outside.

• Mixing of large batches of chemicals for processors in particular should be done in local exhaust. One good system is to provide a hood with slots at the exact level of the top of a wheeled color mixing unit. Then the unit can be rolled to the hood when mixing is done. See figure 6-1.

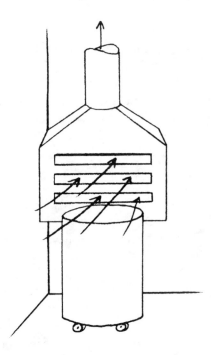

Fig 6-1

• For mixing, wear an approved respirator with appropriate cartridges (see 3.042). If local exhaust is capable of preventing exposure during mixing, respiratory protection will not be required. If a glove box (Figure 3-1) is used to enclose the mixing process, respiratory protection may be required only for handling large amounts, or later, while discarding solutions.

• Take stringent hygiene and housekeeping precautions when handling color developers to prevent skin contact and absorption. Label all color chemicals in accordance with Right-to-Know regulations, keep them stored in a locked cabinet, inaccessible to children.

• Wear rubber gloves and goggles when handling color developers. Wash gloves with pHisoderm® or similar acid-type hand cleaners and then rinse with water before removing them. According to Kodak guidelines, barrier creams are not effective in preventing sensitization due to color developers.

• Avoid color developers containing para-phenylenediamine and its derivatives.

• Do not use tertiary-butylamine borane (TBAB) unless ventilation is adequate and all manufacturers directions are followed carefully.

• Reduce sulfur dioxide emissions if possible. Ciba-Geigy recommends using a water rinse step between developer and bleach baths to reduce the formation of sulfur dioxide.

• To avoid possible electrical shock and overheating of color developer solutions, use one of the following methods of temperature control: trickle-flow water jackets, photo-therm water jacket trays (following manufacturers safety recommendations) and insulated processing drums.

• Pregnant women should avoid exposure to color developers and other color chemicals that may involve reproductive hazards, particularly during the first trimester of pregnancy. Photographers of both sexes who are planning a family should avoid exposure to glycol ethers, their acetates, and diethylene glycol. Hydroxylamines (and probably other amines) and benzotriazole should also be avoided. See reproductive hazards (1.027).

• Allergic individuals should avoid prolonged contact with color developers and other color chemicals, since many of these compounds can cause severe allergic sensitization.

• Photographers taking lithium carbonate medication should exercise special care when using dry chemicals or solutions containing lithium compounds (e.g. Kodak Ektacolor RA developer Replenisher RT Part B which contains lithium sulfate, Ilford Cibachrome-A P-30 Developer Part B contains lithium sulfite). Lithium toxicity can occur at doses close to therapeutic doses. Even small amounts (a few milligrams) additional lithium from accidental ingestion, inhalation of dust from dried spills, or any other source may be a danger.

BLEACHING, STABILIZING AND OTHER STEPS IN COLOR PROCESSING

6.007 Other steps in color processing include stop, bleaching, fixing, stabilizing, prehardening or hardening and neutralizing. The stop and fixing baths consist of essentially the same chemicals used in black and white processing.

The silver bleach may have a number of components that vary according to the process and manufacturer. A typical bleach containing potassium ferricyanide, potassium bromide (or ammonium bromide) and sodium thiocyanate (or potassium thiocyanate), is similar to that used in bleach-and-redevelop toners, but is considerably stronger. Color bleaches may also contain potassium ferrocyanide, potassium alum and various buffers such as boric acid, sodium nitrate, phosphates and other salts. A number of salts of EDTA (ethylenediaminetetraacetic acid), a metal chelating agent, are used in color bleaches. Some are sodium or ammonium salts and others, known under trade names such as Versene, Sequestrene NaFe, or Celon E, may be iron or other metal salts. Special organic chemicals may be added as bleach accelerators.

The stabilizing bath usually consists of a solution of formaldehyde (usually around 30% formaldehyde solution with 5-10% methanol) and a wetting agent. Methods which eliminate formaldehyde such as Ilford's Cibachrome P-30 are available and new ones are coming to market. In some processes color films are treated in a hardener-stop bath containing potassium chrome alum after the first and sometimes after the second developer.

Bleaching, fixing, conditioning, and replenishing chemicals are similar in color print processing and color negative or transparency processing since essentially the same chemicals are used. Solutions may contain:

Ferri- and ferrocyanides,
EDTA salts,
bromides such as potassium or ammonium bromide,
 or hydrobromic acid,
acids such as acetic acid, nitric acid, and sulfamic acid,
 para-toluenesulfonic acid,
ammonia,

sulfite preservatives,

various buffers,

solvents such as n-methyl pyrrolidone or tetrahydrofuran

antifogging agents such as 6-nitrobenzimidazole and
 benzothiazole, sodium nitrobenzenesulfonate, and

emulsifiers such as Tween 20 (sorbitan monolaureate), organo
 silicones and polyvinylpyrrolidone.

HAZARDS OF BLEACHING, STABILIZING AND OTHERS STEPS

6.008 The standard bleach bath containing potassium ferricyanide, potassium bromide and sodium thiocyanate is only slightly hazardous under normal circumstances, but may contain additional compounds that have special hazards. Material Safety Data Sheets on each must be evaluated for hazards.

Acids such as nitric, sulfuric, sulfamic and para-toluenesulfonic acid are all highly toxic by every route of exposure and can cause severe corrosive damage if contact occurs with skin or eyes, or by inhalation of the vapors.

The organic solvents may be irritating to skin, eyes and respiratory passages. Formaldehyde is an irritant by skin or eye contact or by inhalation of the vapors.

Formaldehyde is a potent allergic sensitizer and a systemic poison, with chronic exposure frequently causing skin and respiratory allergies including asthma. Formaldehyde also is a suspected human carcinogen.

Succinaldehyde is sometimes substituted for formaldehyde. Much less is known about this aldehyde, but it is also irritating. It probably is less sensitizing.

The antifoggants 6-nitrobenzimidazole and sodium nitrobenzene sulfonate can irritate an sensitize the skin, and are severe eye irritants. 6-nitrobenzimidazole is a suspected human carcinogen. Both are likely to be skin absorbed. The other antifoggant, benzotriazole, causes tumors in experimental animals.

The organic solvent tetrahydrofuran and related chemicals such as 2,5-dimethoxytetrahydrofuran are skin, eye and respiratory irritants. N-methyl pyrrolidone is only moderately irritating, but causes birth defects and reproductive effects in test animals.

Solutions containing hydroxylamine sulfate and other components are also irritating to skin and the respiratory system, with repeated exposure causing possible skin allergies. Hydroxylamine sulfate can cause nervous system and other systemic effects, and it causes birth defects in test animals. Acetic acid and other acids in neutralizing baths irritating and corrosive by every route of exposure, causing damage to skin, eyes and mucous membranes if contact occurs.

CHEMICAL HAZARDS

6.009 *Aldehydes*
> formaldehyde (4.023)
> succinaldehyde (4.025)

Amines
> ethylene diamine (4.017)
> hydroxylamine sulfate (4.019)

Miscellaneous Organic Chemicals
> benzotriazole (4.031)
> 6-nitrobenzimidazole nitrate (4.031)

Acids
> acetic acid (4.035)
> boric acid (4.036)
> citrazinic acid (4.038)
> sulfamic acid (4.047)
> sulfuric acid (4.048)
> tartaric acid (4.050)
> para-toluene sulfonic acid (4.051)

Alkalis
> borax (4.056)
> potassium carbonate (4.058)
> potassium metabisulfite (4.060)
> sodium acetate (4.063)
> sodium phosphate (4.069)
> sodium sulfate (4.071)
> sodium sulfite (4.072)

Metal Compounds
> ammonium EDTA,
> iron salt and other salts (4.078)
> potassium aluminum sulfate (4.096)
> potassium chrome alum (4.099)
> potassium ferricyanide (4. 101)
> potassium ferrocyanide (4.102)

Oxidizing Agents
> ammonium bromide (4.114)
> ammonium thiocyanate (4.116)
> ammonium thiosulfate (4.117)
> potassium bromide (4.122)
> potassium nitrate (4.136)
> potassium thiocyanate (4.131)
> sodium nitrate (4.136)
> sodium thiocyanate (4.137)
> sodium thiosulfate (4.138)

Pigments and Dyes
> fluorescent dyes (4.224)

Glycols
> ethylene glycol (4.270)
Glycol ethers (4.264-4.269)
Miscellaneous solvents
> tetrahydrofuran (4.281)
> n-methyl pyrollidone

OTHER HAZARDS

6.010 • In processes using acid stop baths, developer components may be carried over into the acid, increasing inhalation hazards. In combination with acid, sulfites will release highly toxic sulfur dioxide gas (4.141). Heating also increases production of sulfur dioxide gas.

• If exposed to intense heat, hot acid or strong ultraviolet light, potassium ferricyanide (Farmer's reducer) may release highly poisonous hydrogen cyanide gas (4.150). Under similar conditions, thiocyanates may release hydrogen cyanide gas.

• Fixers containing sodium thiosulfate (hypo) may decompose to form highly toxic sulfur dioxide gas (4.141) if heated, if contaminated with acid or if old hypo is used. Ammonium thiosulfate can decompose similarly to form sulfur dioxide gas.

• Neutralizing solutions containing concentrated acids and sulfite will produce highly toxic sulfur dioxide gas (4.141) if left standing, if heated or if acid is carried over into the developer bath containing sulfites.

• When mixing or diluting acids, a violent, exothermic reaction will occur if water is added to a concentrated acid. See proper acid dilution procedures (4.034).

PRECAUTIONS FOR BLEACHING, STABILIZING AND OTHER STEPS

6.011 • Follow all general precautions in Chapters Two and Three.

• Take stringent hygiene and housekeeping precautions when handling bleaches, stabilizers and other processing solutions to prevent skin contact and absorption. Label color chemicals clearly in accordance with Right-to-Know rules and store in a locked cabinet, inaccessible to children.

• Use premixed solutions whenever possible to avoid the hazards of mixing.

• Avoid overheating solutions. Many components of bleaches and other solutions will release highly toxic gases and vapors when heated. Follow manufacturer's recommendations carefully for temperature control.

• Local exhaust ventilation, preferably a lateral slot exhaust system, is recommended for bleaching, stabilizing and other steps in color processing. Processes using acid bleaches or other acid baths should only be done with proper local exhaust ventilation. See ventilation (3.032).

• For handling concentrated acids, wear elbow length safety gloves and goggles to protect against splashes. When mixing, always add acid to water, never the reverse (4.034). Store acids and other corrosives on low shelves to reduce the risk of face or eye injury in case of accidental breakage. For acid splashes on skin, flush affected areas immediately with water. For eye splashes, flush for at least 15 minutes and get medical attention.

• Wear safety gloves and goggles when handling stabilizers, prehardeners, hardeners and neutralizers. Gloves and goggles should also be worn when handling highly toxic bleaches.

• Take normal precautions for stop and fixing baths discussed in black and white processing (5.011, 5.016). Discard used hypo solutions and stop baths that have become contaminated with developer components. Do not heat or add acid to hypo. Cover baths between printing sessions to prevent evaporation and contamination.

• When handling ferricyanide bleaches, do not heat or add acid, and do not expose to ultraviolet light. Do not heat or add acid to thiocyanates.

• In some processes, sulfur dioxide production can be reduced by using water rinses between steps.

• When mixing or disposing of solutions, wear an approved respirator with an organic vapor/acid gas cartridge. To reduce the amount of sulfur dioxide gas produced during disposal, neutralize the developer, bleach and fixer before discarding them (one at a time) down the sink with copious amounts of water. Check local, state/provincial and federal regulations to find out whether this procedure is allowed in your area.

• When handling formaldehyde or succinaldehyde solutions, use local exhaust ventilation or wear an approved respirator with a formaldehyde cartridge. If required, comply with the OSHA Formaldehyde Standard.

• When handling chrome alum, mix powders in a local exhaust hood or glove box, or wear an approved toxic dust mask.

• When handling neutralizing solutions, do not heat, add acid or allow solutions to stand after use. Use with local exhaust ventilation or wear an approved respirator with an acid gas cartridge.

• When handling solutions containing ethylene diamine or other amines, use with local exhaust ventilation or wear an approved respirator with an amine vapor cartridge.

• Since the hazards of most dyes are still unknown, particularly their possible long-term hazards, handle all dye powders or solutions with caution, avoiding skin contact.

COLOR RETOUCHING

6.012 Color retouching can be done using a variety of techniques to apply water soluble dyes to color transparencies, negatives and prints. Black leads and colored pencils are used for retouching limited areas. Pencil retouching is similar to black and white pencil retouching, but requires a somewhat thicker application of retouching fluid to give a "tooth" to the surface. Retouching fluid consists of a mixture of aromatic hydrocarbons such as toluene and xylene. Pencil retouching can be removed with methyl alcohol.

Retouching dyes are organic molecules containing chemical groupings that absorb specific wavelengths of light or color and have binding or adhering properties. Most of these dyes are petrochemical derivatives and are completely soluble in water.

Wet techniques include applying retouching dyes with a cotton tuft, brush or airbrush. Dye penetration can be hastened by adding a dilute solution of acetic acid. Dampening and removal of excess is achieved with a wetting agent solution that contains a polyether alcohol or glycol, or with water-moistened cotton.

Removal of retouching dye is achieved by various methods. One method uses a water wash followed by a stabilizing rinse in formalin (40% formaldehyde and 0-5% methanol). Other removal methods involve treatment in a 14% ammonia solution or in a dye bleach consisting of potassium permanganate and sulfuric acid. Bleaching may be followed by stain removal using a sodium bisulfite solution. Removal of specific dye colors can also be achieved with selective dye bleaches, or by using a combination of these bleaches.

The simplest dry-dye technique involves the application of retouching colors in the form of dry cakes or powders. (Powdered dyes can also be applied wet, by diluting them with water and brushing on). The application procedure involves first breathing onto the dry cake of pow-

der dye, then spreading it on with a cotton tuft, using denatured alcohol to remove excess dye. Steam is used to set powdered dyes in the gelatin, and removal is done by washing with water. In some cases, removal is accelerated by first wiping the surface with an undiluted wetting agent solution.

HAZARDS OF COLOR RETOUCHING

6.013 Color retouching, like black and white retouching, can involve inhalation hazards if retouching dyes are sprayed or airbrushed onto the photographic surface. These sprays produce fine mists which can carry the dye molecules deep into the lungs. Another inhalation hazard can result from the application of dye powders. This procedure involves breathing onto the dye cake to moisten surface layers, and can easily result in inhalation of the dye dusts.

An ingestion hazard can result from the habit of pointing retouching brushes with lips, or from wetting pencils by mouth contact. This practice may lead to considerable quantities of dyes being ingested over a period of time, particularly by professional retouchers who use these dyes on a daily basis. The hazards of most dyes, including retouching dyes, have not been adequately determined, particularly with regard to their possible long-term carcinogenic effects.

If a wetting agent containing ethylene glycol or a dye reducer containing methyl alcohol is used, ingestion hazards can be acute. Both these solvents are poisonous by ingestion of very small amounts. In addition, wetting agents that also contain a polyether alcohol can be eye irritants.

Retouching fluid contains highly toxic aromatic hydrocarbon solvents that are strong narcotics, and can be absorbed through the skin to cause systemic effects. Most solvents used in color retouching are also fire hazards.

CHEMICAL HAZARDS

6.014 *Aldehydes*
formalin (formaldehyde) (4.023)
Acids
acetic acid (glacial acetic acid) (4.035)
sulfuric acid (4.048)
Alkalis
sodium bisulfite (4.064)
Oxidizing Agents
ammonia (4.113)
potassium permanganate (4.128)
Pigments and Dyes
individual pigments (4.155-4.223)

azo dyes (4.224)

phthalocyanine dyes (4.224)

quinone dyes (4.224)

Alcohols

methyl alcohol (4.239)

denatured alcohol (4.241)

polyether alcohol (4.243)

Aromatic hydrocarbons

toluene (4.246)

xylene (4.247)

Glycols

ethylene glycol (4.270)

OTHER HAZARDS

6.015 • If heated, sulfuric acid will release highly toxic sulfur dioxide gas (4.141).

• Potassium permanganate is a fire and explosion hazard when in contact with organic materials.

• If water is added to a concentrated acid, a violent, exothermic reaction may occur. See correct procedures for mixing and diluting acids (4.034).

• Dye bleaches may contain concentrated acids and oxidizing agents that are highly corrosive by skin contact. Selective dye bleaches may also contain chlorine compounds such as "Chloramine T" (Kodak) that are highly volatile and may release highly toxic chlorine gas (4.119) when dissolved in water.

PRECAUTIONS FOR COLOR RETOUCHING

6.016 • Follow all general precautions in Chapters Two and Three.

• Retouching dyes should be handled with care, since little is known about their long-term hazards. Avoid accidental ingestion or inhalation of retouching dyes. Never point a retouching brush with the lips, or wet pencils by mouth contact.

• Retouching with very small amounts of solvent-containing liquids can be done safely with good dilution ventilation (3.032). If fluids or colors containing highly toxic solvents is used in large amounts, local exhaust ventilation is recommended. Otherwise, wear a respirator with NIOSH-approved organic vapor cartridges.

• Sprays containing solvents should be used in local exhaust. Airbrushing of dyes should be done in local exhaust ventilation such as a spray booth or fume hood (3.035). If this is not possible, wear a respirator which is NIOSH-approved for dusts and mists for water-based dyes, or one approved for paint, lacquer or enamel mists if the dye contains solvents (3.042).

• Wear appropriate gloves to avoid skin contact with organic solvents. See gloves (3.045).

• Use the least toxic solvents available for retouching processes.

• Follow the usual precautions for handling and storage of solvents including precautions against fire (3.014-3.020).

• If eye contact occurs with wetting agents, rinse eyes immediately with plenty of water. Continue rinsing for at least 15 minutes and get medical attention.

• Wear gloves and goggles when handling solutions containing formalin or ammonia. For large amounts, use with local exhaust ventilation. Otherwise, wear an approved respirator with appropriate cartridges. In case of eye contact with ammonia, rinse for at least 15 minutes and call a doctor.

• Follow manufacturer's instructions carefully when using dye bleaches, particularly if a combination of bleaches must be used. Wear gloves and goggles when handling bleaches containing strong acids and oxidizing agents, and use with local exhaust ventilation. If local exhaust ventilation is not available, wear an approved respirator with an acid gas cartridge.

• Do not heat bleaching solutions containing sulfuric acid. When mixing, always add acid to water, never the reverse. Take normal precautions for handling and storage of concentrated acids (3.017). For acid splashes on skin or eyes, rinse affected areas immediately with plenty of water. For eye splashes, continue rinsing for at least 15 minutes and get medical attention.

• Keep retouching materials out of the reach of children.

HAND-COLORING ON PHOTOGRAPHIC SURFACES

6.017 Materials used to hand-color photographic surfaces can be divided into three categories: oil-based, lacquer-based and water-based.

Oil coloring can be done with special photo oil paints (e.g., Marshall's Photo Oils), ordinary artist's oil paints, or with oil-color pencils. Oil paints and pencils contain pigments and vehicles. Paint vehicles are usually oils, waxes, stabilizers such as stearates or palmitates and additives including preservatives, antioxidants and driers. Driers commonly found in either artists paint or linseed oil are lead, manganese or cobalt compounds. The oil method also employs mediums, pre-color sprays, color removers, and extenders which often contain solvents.

Lacquer-based photo paints containing pigments, natural or synthetic resins and solvent mixtures, are usually applied with aerosols or airbrush sprays.

There are many brands of water-based hand-coloring materials specially made for photo hand coloring. Ordinary artist's water colors used with Kodak Photo-Flo can also be used.

Some people also recommend using food colors, medicinal dyes such as merthiolate and gentian violet. However, food colors are fugitive and will fade with exposure to light. Merthiolate is an organic mercury compound (sodium ethylmercuric thiosalicylate) which, though still available, is somewhat out of favor as a treatment to sterilize small wounds because it is a nervous system poison. Gentian violet is also toxic and not light fast.

Other medicinal dyes have similar problems which makes them unsuitable for use in hand coloring of photographs. Other materials used in water-based methods include rubber cement, rubber cement thinner, frisket, and wetting agents. These contain solvents. Household ammonia is also used for color removal. Other non-traditional materials have been suggested such as alcohol-based permanent markers to add wet-on-wet color quality to glossy photographs, color Xeroxes®, and laser copies. Most manufacturers consider the identity of their marker dyes as trade secrets so their qualities cannot be assessed. It is common, however, for colorants in markers, gouaches and other art materials used in commercial design not to be as light fast as artist paints.

Artist's acrylics also have been used, but these may be limited by their opaque quality. Colored pencils, crayons, and pastels also can be used if the surface of the photograph is prepared with a layer of workable fixative.

Other coloring methods include overall toning and bleaching, selective toning or bleaching (brush-on methods) for local effects. Toners may include any of the overall toners used for after-treatment of black and white prints (5.035). The bleach is usually a dilute solution of potassium ferricyanide (4.101).

HAZARDS OF HAND-COLORING

6.018 Hand-coloring techniques can be moderate to high inhalation hazards, depending on the type of materials used for coloring, as well as the method of application. Spraying lacquer-based paints can involve severe inhalation hazards. These sprays contain highly toxic organic solvents, including aromatic hydrocarbons and chlorinated hydrocarbons, in addition to other solvents, resins and pigments. Airbrushes and aerosol sprays produce a fine mist that is easily inhaled, carrying these materials deep into the lungs. The spray mist can remain suspended in air for hours. Chronic poisoning from toxic pigments can result from repeated use of spray paints.

Turpentine can cause allergic sensitization, and is poisonous by ingestion. Trichloroethylene is an eye and skin irritant, narcotic, and causes cancer, birth defects and reproductive problems in animals. Most rubber cements, thinners, and friskets contain hexane which is known to cause permanent nerve damage in humans after chronic exposure. Most solvents used in hand-coloring also are fire hazards.

Oil paints are mainly hazardous by inhalation or ingestion of toxic pigment. Many inorganic pigments are derived from highly toxic metals, and chronic exposure to small amounts of the powders can result in serious long-term effects including cancer. Poisoning from pigment powders is primarily a problem if pigments are ground or sprayed. See hazards of specific pigments (4.155-4.223).

Other components of oil paints can involve serious hazards. Lead and manganese compounds used as driers are highly toxic by inhalation, ingestion and skin absorption. Cobalt driers are less toxic, but may cause allergies. Components of oil paints that are not significantly hazardous include linseed oil and stabilizers such as beeswax, palmitates and stearates.

Water-soluble dyes such as the azo, quinone and phthalocyanine dyes used in retouching colors and other direct colors have not been extensively studied with regard to their possible long-term hazards, including their potential cancer hazards. Wetting agents may contain a polyether alcohol that is an eye irritant. They may also contain ethylene glycol, a solvent that is highly toxic by ingestion.

Overall toners used in hand-coloring such as sepia toners, gold toners, silver nitrate and others are moderately to highly hazardous. See the hazards of photographic toners (5.035).

CHEMICAL HAZARDS

6.019 *Aldehydes*
 formalin (4.023)
 Metal Compounds
 potassium ferricyanide (4.101)

Oxidizing Agents
> ammonia (4.113)

Pigments and Dyes
> see specific pigments (4.155-4.223)
> azo dyes (4.224)
> phthalocyanine dyes (4.224)
> quinone dyes (4.224)

Resins
> see specific resins (4.228-4.234)

Alcohols
> methyl alcohol (4.239)
> polyethyl alcohol (4.243)

Aromatic hydrocarbons
> toluene (4.246)

Chlorinated hydrocarbons
> trichloroethylene (4.250)

Glycols
> ethylene glycol (4.270)

Petroleum distillates
> hexane-petroleum ether (4.272)
> mineral spirits (4.275)

Miscellaneous solvents
> turpentine (4.279)

OTHER HAZARDS

6.020 • Potassium ferricyanide (Farmer's reducer), used for local bleaching, is only slightly hazardous. If exposed to intense heat, hot acid or strong ultraviolet light, however, it may release highly toxic hydrogen cyanide gas (4.150).

• Hazards of toners are described in Chapter 5 (5.035).

PRECAUTIONS FOR HAND-COLORING

6.021 • Follow all general precautions in Chapters Two and Three.

• When using oil paints, avoid contact with pigment dusts. To reduce inhalation hazards, buy ready-made paints instead of mixing paints from raw pigments or powdered paints. If powdered ingredients are used, wear an approved toxic dust respirator and follow stringent hygiene and housekeeping precautions. Do not eat, drink, smoke, apply make-up or do any personal hygiene task in the work area. Clean up all powders on working surfaces or clothing immediately. Never spray paint or grind pigment powder with chromate pigments or other pig-

ments that are human carcinogens. Highly toxic pigments such as lead, manganese and cadmium should not be ground or sprayed.

• Never form the point on the paintbrush with the lips.

• Avoid paints containing lead and manganese driers if possible. Use cobalt linoleate or oleate as the least toxic driers.

• Toxic solvents such as turpentine, rubber cement thinner, and mineral spirits require good general ventilation. If possible, substitute less toxic odorless paint thinner or turpenoid for turpentine. Rubber cements and thinners which contain heptane are also less toxic than those containing hexane. Wear gloves to avoid skin contact with solvents. Handcreams are not protective enough and may affect the photograph surface. Do not wash hands with solvents, since this can cause dermatitis. Wash frequently with soap and water, and take other measures to ensure that skin stays in good condition (3.044).

• Avoid lacquer-based spray paints containing highly toxic solvents and pigments.

• Sprays of any kind should be used in local exhaust such as a spray booth or fume hood. Otherwise wear a respirator with NIOSH-approved organic vapor cartridges and spray prefilters for solvent-containing sprays or a dust/mist filter for water-based paint sprays. There should be a good dilution exhaust system in the studio to remove overspray so the respirator can be taken off safely after spraying.

• Wear goggles and gloves during heavy or power spraying of very large or wall-sized works. Wear nitrile gloves to avoid skin contact with large amounts of paint and solvent.

• Coloring with very small amounts of solvent-containing liquids can be done safely with good dilution ventilation (3.032). If fluids or colors containing highly toxic solvents is used in large amounts, local exhaust ventilation is recommended. Otherwise, wear a respirator with NIOSH-approved organic vapor cartridges.

• Take usual precautions for handling and storage of solvents, including precautions against fire. Do not allow smoking in or around the work area. See precautions for flammable and combustible materials (3.019).

• If retouching dyes or other direct colors are used, be careful to avoid accidental inhalation or ingestion of dyes. These dyes should be handled with care, since little is known about their long-term hazards.

• Be careful to avoid accidental ingestion of wetting agents containing ethylene glycol. If eye contact with wetting agent solutions occurs, flush with water for at least 15 minutes and get medical attention.

• When using potassium ferricyanide, do not heat, add acid or expose it to ultraviolet light.

• See precautions for photographic toners (5.036).

DYE TRANSFER PROCESS

6.022 The dye transfer process is a method of producing high-quality, three-color prints from color transparencies, negatives or internegatives. Black and white separation negatives can also be used for dye transfer.

First, a photographic matrix film is prepared. There are two types of matrix films. Ortho-chromatic matrix film is used to make matrices from black and white separation negatives (made from color transparencies or in-camera negatives exposed through tricolor filters). Panchromatic matrix film (discontinued by Kodak in 1991) is used to make matrices from color negatives. In this case the matrix film is exposed directly from the color negative using tricolor filters. (No black and white separation negatives are needed.)

After exposure, the matrix films are developed, fixed, rinsed in hot water or stop bath to remove the gelatin in unexposed areas, and dried. The remaining images are gelatin reliefs, their thickness varying with the degree of exposure. Matrices are processed in a tanning developer containing metol (elon), a Kodak proprietary formula (using a two part mix which eliminates the need for bleach), or a hardening-bleach method. The bleach method consists of development in either a metol-hydroquinone developer or a special hydroquinone developer containing amine compounds as accelerators. If needed, the matrix is bleached in a hardening bleach containing ammonium dichromate, sulfuric acid and sodium chloride. After washing off the soft, unexposed gelatin in hot water, the matrix is fixed in a nonhardening hypo solution. Sometimes a rapid fixer with the hardener omitted is used for this purpose. Common fixers used include C-41 fixer and Rapid Fixer "A" only.

After processing, the matrices, which are the tricolor (red, green and blue) separation positives, are soaked in solutions of cyan, magenta and yellow dye. Each matrix takes up dye in proportion to the thickness of the gelatin. The dye bath requires continuous agitation of the solution, which is often done with automatic tray rockers, or it can be done in a deep tray with enough solution to cover the matrix can be used. The trays must be covered to avoid contamination from dust and to reduce evaporation. Two acid rinse baths follow the dye bath. The first bath contains the control solutions: a 5 % sodium acetate solution and a 1% Calgon solution. They are added to selectively rinse out dye

from the matrix, and effect changes in the print's color balance and contrast. Sodium acetate rinses dye from the entire gelatin surface, "Calgon" only rinses dye from the thinner (high light) areas of gelatin, and hence only effecting the lightest portions of the print.

The dye is then transferred to the receiving paper (which has been pretreated with Kodak Dye Transfer Paper Conditioner™). After the print is made, the matrices are rinsed in water, and returned to the dye for subsequent printing, or hung up to dry. Periodically, or at the end of the day (or several days) a bath of ammonium hydroxide (ammonia) is used to clean the film of residual dye stains. The matrix may be used again form many prints, even up to 100 in an edition.

If the matrices are used to make many prints, they are rinsed in warm water after contact with the paper, then reimmersed in the dye bath. After reabsorbing the dye they are printed as before (first rinse of 1% acetic acid with control solutions of sodium acetate and Calgon, then a second rinse of 1% acetic acid only). A stronger solution of acetic acid is sometimes used in the first rinse in lieu of sodium acetate. Small amounts of 28% acetic acid are added to the first rinse and extra dye is carried over with the matrix to be rinsed. The effect is to increase the absorption of the dye into the matrix (as opposed to the sodium acetate which washes the dye out).

Retouching and selective dye bleaching are sometimes done on dyetransfer prints. Light spots can be corrected by filling them with diluted dye solution, applying the dye with a small brush. Dark spots can be removed by applying a bleach solution containing potassium permanganate and sulfuric acid, followed by a dilute sodium sulfite solution and rinsing.

Individual dyes in prints may be bleached using a diluted potassium permanganate solution for cyan dye, a wetting agent containing ethylene glycol (e.g. "Photo-Flo") for magenta dye, and a 5% solution of sodium hypochlorite (e.g., Clorox®) to remove a yellow dye. Following any of these bleach treatments, the treated area is rinsed with a 1% solution of acetic acid, which is blotted off.

HAZARDS OF DYE TRANSFER

6.023 The preparation of the matrix film for dye transfer involves many of the same chemicals used for black and white processing. Refer to the discussion of these chemicals and their hazards in Chapter 5. The special hydroquinone developer containing amine compounds is a strongly alkaline solution that can cause skin and eye burns and severe skin allergies; amines may also be absorbed through the skin to cause systemic effects.

The hardening bleach containing ammonium dichromate and sulfuric acid can be highly corrosive to skin, eyes and mucous membranes.

Ammonium dichromate is moderately irritating to skin and highly irritating to the respiratory system if powders are inhaled. Dichromates can cause skin and respiratory allergies and ulceration. They are also suspected human carcinogens. Ammonium dichromate is also moderately flammable and unstable.

Dyeing and transferring steps can also involve skin, eye and respiratory hazards. In addition to skin contact and possible skin absorption of the dyes from handling dye solutions and rinse baths, an ingestion hazard can result from the practice of pointing dye-laden brushes with the lips during retouching of dye-transfer prints. The hazards of most dyes, including the cyan, magenta and yellow dyes used in dye transfer, have not been adequately determined, particularly with regard to their possible long-term cancer hazards.

The dilute acetic acid rinse baths are only slightly irritating to skin, but repeated inhalation of the acid vapors can cause chronic lung problems. Mixing and handling glacial acetic acid can result in severe corrosive damage to skin or eyes if splashes occur. The matrix clearing bath containing ammonia can also be irritating to the eyes and respiratory system.

Selective dye bleaching and retouching of dye transfer prints may be done with strong oxidizing agents such as potassium permanganate and sodium hypochlorite, which are skin and respiratory irritants. Ethylene glycol is poisonous by ingestion.

CHEMICAL HAZARDS

6.024 *Developers*
 metol, elon (tanning developer) (4.010)
 hydroquinone (4.005)
Other Organic Chemicals
 amines (4.016)
Acids
 acetic acid (4.035)
 sulfuric acid (4.048)
Alkalis
 sodium acetate (4.063)
 sodium hexametaphosphate (sodium phosphate) (4.069)
 sodium sulfite (4.072)
Metal Compounds
 ammonium dichromate (4.077)
Oxidizing Agents
 ammonium hydroxide (4.113)
 ammonium thiosulfate (4.117)
 potassium permanganate (4.128)
 sodium hypochlorite (4.135)
 sodium thiosulfate (4.138)

Pigments and Dyes
>dye transfer dyes (4.224)

Glycols
>ethylene glycol (4.270)

OTHER HAZARDS

6.025 • If heated, sulfuric acid will release highly toxic sulfur oxide gases.

• If water is added to a concentrated acid, a violent, exothermic reaction may occur. See correct procedures for mixing or diluting acids (4.034).

• If heated or treated with acid, hypo solutions will release highly toxic sulfur dioxide gas (4.141). Old hypo solutions can also decompose to release sulfur dioxide. Ammonium thiosulfate can decompose similarly.

• Potassium permanganate can be explodes, ignites, or reacts violently when in contact with many acids, organic solvents and other materials. Store separately and carefully.

• Ammonium dichromate is unstable and reacts with many substances. Store separately and carefully.

• Sodium hypochlorite (bleach) will release highly toxic chlorine gas (4.119) when heated or if acid is added.

PRECAUTIONS FOR DYE TRANSFER PROCESS

6.026 • Follow all general precautions in Chapters Two and Three.

• Wear gloves and goggles when handling matrix developers. Mix powders inside a fume hood or a glove box, or use an approved toxic dust mask. See also precautions for handling developers and other chemicals used in black and white processing in Chapter 5 (5.006).

• Wear gloves and goggles when handling ammonium dichromate. Mix powders inside a fume hood or a glove box, or wear an approved toxic dust mask. Store ammonium dichromate separately and away from sources of heat.

• Wear elbow-length gloves and goggles when handling concentrated acids. For large amounts, use local exhaust ventilation or wear an approved respirator with an acid gas cartridge. When mixing, always add acid to water, never the reverse (4.034). For acid splashes on skin, flush affected areas with water. For eye splashes, flush for at least 15 minutes and get medical attention.

• Cover all solutions, including processing baths, dye baths and acid rinse baths, whenever possible to prevent evaporation and contamination. Discard used hypo and stop solutions separately after processing to prevent decomposition.

• Do not heat or add acid to hypo solutions or bleach solutions.

• Make sure there is adequate dilution ventilation for dyeing and transferring processes, and a source of replacement air. If concentrated acids are added to the rinse baths for additional transfers, some form of local exhaust ventilation may be required to exhaust acid vapors. See discussion of ventilation (3.032).

• Wear gloves to prevent skin contact with dye solutions. Since the hazards of dyes are largely unknown, take careful housekeeping and hygiene precautions when handling these dyes, avoiding unnecessary exposures. Never form the point of a brush with the lips. Do not eat, drink or smoke when handling dyes.

• Wear gloves and goggles when handling the matrix clearing. bath containing ammonia. Use with good dilution ventilation. If splashed in the eyes, flush with water for at least 15 minutes and get medical attention.

• Wear gloves when handling potassium permanganate. Mix powders in a fume hood or glove box, or wear an approved toxic dust mask. Keep away from sources of heat.

• Wear gloves and goggles when handling hypochlorite bleach solutions. Do not heat or add acid or ammonia to sodium hypochlorite.

• Avoid accidental ingestion of ethylene glycol.

INSTANT PROCESSES

6.027 Instant processes such as those developed by Polaroid are designed to take place inside the camera or within the film structure itself, so that there is only limited contact with photographic chemicals. Generally, there are two types of instant films available. One is an assembly, or peel-apart structure that has been increasingly replaced by a second type, the integral film such as Polaroid's SX-70®, Time-Zero Spectra® and 600 Plus films. New instant color processes constantly introduce changes in the complex chemistry of the film structure. New formulas are protected as proprietary secrets, and therefore, precise and up-to-date information about the chemistry of instant processes is difficult to obtain. The following material is based on information supplied by Polaroid and taken from papers published in the photographic litera-

ture by Dr. Edwin H. Land in 1977. Although much has changed since then, the basic processes remain the same.

The processing of most peel-apart films involves a sequence ranging from fifteen to sixty seconds. A pod containing an alkaline processing jelly ("pod jelly") is ruptured by a mechanism in the camera, spreading this material between the negative and positive portions of the film. The viscous fluid usually contains sodium hydroxide or potassium hydroxide (with a Ph of 13 to 14). It acts as a processing reagent, activating molecules of developer (usually hydroquinone derivatives) to reduce the exposed grains of silver halide in the negative. In color peel-apart films (such as Polacolor™) the developer molecules are linked to preformed dyes present in the negative part of the film structure.

As the image forms in the positive layer (by a process known as "diffusion-transfer") polymeric acid molecules neutralize the alkaline reagent and stop the development process. After the film is peeled apart, the pH of the positive (print) drops to neutral within two minutes, but the wet negative (discard) remains highly alkaline for up to two hours. The wet Polacolor negative remains at a pH of 10 to 11. All peel-apart films have a potential for edge build-up of the alkaline reagent or "pod jelly". Some of the black and white peel-apart films require post-treatment. Reversal films, such as Polaroid's PN 55® films, may require clearing in an 18% sodium sulfite solution before printing. Certain black and white films must be treated with a "print coater solution" after processing. This is an aqueous solution of isopropyl alcohol containing acetic acid, an inert polymer and several trace chemicals. In the past (and now no longer made), black and white transparencies were fixed with a "Dippit" solution (50% isopropyl alcohol in water with stannic chloride). Color peel-apart films (Polacolor) do not require any coating.

The processing of integral films such as SX-70 films is completed within the film structure after the film is ejected from the camera. The entire sequence takes place within the sealed envelope, and does not normally involve contact with photographic chemicals since the sheets are not peeled apart. The chemistry of integral film processing is similar to that of the color peelapart films, but is much more complex. For example, the SX-70 film structure consists of a 17-layer "sandwich". The process begins as the pod containing the alkaline processing fluid is ruptured and the fluid spread between the negative and positive layers. This fluid contains potassium hydroxide as well as a white pigment (titanium dioxide), opacifying dyes and other photographically active chemicals. The opacifying dyes, which are phthalein-type indicator dyes, are mixed with the highly reflective titanium dioxide to form a protective layer that shields the developing image from light after the exposed film leaves the camera. These dyes are highly colored in a strong alkaline medium but rapidly lose their color as alkalinity decreases at the end of the processing sequence. The reagent containing potassium hydroxide diffuses through the negative layer, first activat-

ing a special intermediate or "messenger" developer (methyl phenyl hydroquinone) that in turn activates the dye developers (also hydroquinones attached to image-forming dyes). These dyes are stable, metallized dyes—the yellow dye is metallized with chromium, and the cyan dye is a copper phthalocyanine dye. In certain films, the magenta dye is also metallized with chromium.

At the end of the chemical sequence the image-forming dyes and their developers have diffused through the film structure to the positive layer. Long-chain polymeric acid molecules stop the process and renders the dyes insoluble. At this point the opacifying dyes have lost color, and the dye image is viewed against the white background of titanium dioxide pigment.

Experimental techniques using integral color films such as Polaroid's Time Zero™ films include "photo-impressionism" or "instant painting." "Instant painting" usually involves the use of simple tools such as hairpins or paper clips to shift the malleable layers containing dyes encased in the mylar envelope just after the film is ejected from the camera, thereby achieving a fluid quality or "impressionistic" effect as the image forms.

In "instant printmaking" the print is not allowed to develop fully. Instead, it is interrupted to prevent the dyes from migrating to the positive. The dyes are prevented from migrating to the positive by prematurely separating it from the negative. The dye laden negative then can be bonded to a new surface such as a dry or wet receptor sheet, paper, silk, or some other substrate.

The peeled off negative reveals an image that appears to be part photograph, part painting. At this point the negative can be manipulated with watercolors, colored pencils, markers, and other tools. Depending on the film format and other factors, transferring the manipulated negative usually takes from between ninety seconds to two minutes.

HAZARDS OF INSTANT PROCESSES

6.028 The main hazards of peel-apart films result from potential exposure to small amounts of the highly caustic processing jelly, which contains sodium hydroxide or potassium hydroxide. This jelly, which may appear along the edges of the film and remains at a high pH on the discarded portion, i.e. the non-picture or negative, for up to two hours, is highly corrosive to skin, eyes and mucous membranes. It may cause an alkali burn following skin contact if the jelly is not rinsed promptly. If a portion of the edge of a fresh print or the discarded portion is accidentally chewed, licked or otherwise eaten by a child, the small amount of residual jelly could cause damage to the mouth and esophagus. Such damage may be quite painful.

Chemicals used post-development treatment of black and white peel apart films can be irritating to the skin and eyes. Sodium sulfite

clearing solutions, used to fix the negative in some professional films, are not significantly toxic by skin contact, although they may be irritant to the skin with repeated use. They may also be moderately hazardous if accidentally ingested.

Films requiring print coater solutions such as "Dippit" are no longer made or sold by Polaroid. These solutions contain isopropyl alcohol, zinc acetate and acetic acid, can be irritating to eyes and respiratory system. They may be slightly irritating to skin. While the contain isopropyl alcohol, this form has been tested and does not pose a fire hazard.

Under normal conditions of use, integral-type films do not involve any contact with hazardous chemicals. However, in experimental techniques where the unit is opened, the film unit structure may be separated during picture development. During this stage, contact may occur with the highly caustic jelly found in the integral structure. Skin or eye contact with these components may result in corrosive damage.

The negative side of the integral structure contains the dye molecules which migrate to the positive surface during development. This transfer is facilitated by the alkaline jelly.

The hazards of most dyes, including the phthalein-type "opacifier" dyes, have not been adequately determined, particularly with regard to their possible long-term cancer hazards. More is known about the toxicity of metallized dyes. See specific hazards of chromium and phthalocyanine pigments (4.204, 4.205). Most hexavalent chromium pigments are known human carcinogens and teratogens, and suspected human mutagens. In the case of the integral film system, even if opened (which is not advised by Polaroid), minimal transfer of dye molecules to the skin is likely to occur. Such transfer requires close contact under wet, alkaline conditions. Thus, an absence of exposure and low bioavailability are the best protection against an unknown hazard.

CHEMICAL HAZARDS

6.029 *Developers*
 hydroquinone (4.005)
 Acids
 acetic acid (4.035)
 Alkalis
 potassium hydroxide (4.066)
 sodium hydroxide (4.066)
 sodium sulfite (4.072)
 Metal Compounds
 stannic chloride (4.107)
 Pigments and Dyes
 chromium pigments (4.173-4.176)
 copper phthalocyanine (4.204, 4.205)
 phthalein dyes (4.224)

Alcohols
> isopropyl alcohol (4.240)

OTHER HAZARDS

6.030 • If heated or if allowed to stand for long periods in water or acid, sodium sulfite may decompose to form sulfur dioxide gas (4.140), which is highly toxic by inhalation.

PRECAUTIONS FOR INSTANT PROCESSES

6.031 • Be careful to avoid skin or eye contact with residual processing fluid on peel-apart films, especially when handling the edges of wet prints or the wet negative discards. Dispose of wet negatives in a closed waste container to prevent further contact. Keep these materials out of the reach of children. If the caustic jelly comes in contact with the skin, flush affected areas with water. If gotten in the eyes, flush with water for at least 15 minutes and get medical attention.

• If wet peel-apart film materials are accidentally chewed, licked or otherwise "eaten" by a child, rinse the area thoroughly with water. Have the child drink water or citrus juice. If any material is thought to have been swallowed, call a Poison Control Center. Do not induce vomiting except on medical advice.

• Do not heat or add acid to sodium sulfite clearing solutions. Discard solutions after use to avoid decomposition to sulfur dioxide gas.

• The print coater applicator should be returned to its vial after each use. If print coater solution gets in the eyes, flush with water for at least 15 minutes. If some solution is swallowed by a child, give the child 1-2 glasses of water to dilute the solution.

• Wear gloves when handling sodium sulfite solutions for negatives. If gotten in the eyes, flush with water for at least 15 minutes.

• Wear gloves to avoid skin contact with emulsion components of integral-type films if the film structure is opened up during the processing sequence. If gotten in the eyes, flush with water for at least 15 minutes and get medical attention.

• Keep opened film units out of the reach of children until dry. Even dry prints should not be given to infants and very young children to play with.

7

Historical Silver Processes

7.001 In recent years, a renewed interest in the work and methods of the early photographers has generated a major revival of historical photographic techniques. The re-exploration of the aesthetic parameters of historical techniques such as daguerreotyping, platinum and palladium printing, gum printing and other processes has reawakened a concern about exposure to mercury, platinum, lead, uranium, iodine, bromine and other materials used in these techniques. Chapters 7 and 8 focus on the hazards of these techniques and provide guidelines for working safely with the processes. Some of the materials, such as mercury and uranium, are so extremely hazardous that they should be discarded in favor of less toxic compounds. Most others can be handled safely if specific precautions are taken.

This chapter discusses historical silver processes, including daguerreotype, wet-plate collodion, ambrotype, tintype, salted paper printing, casein printing, albumen printing and printing-outpapers (P. 0. P.). Non-silver historical processes—cyanotype, platinum and palladium printing, Kallitype and Van Dyke printing, and early dichromate processes such as the carbon, carbro, gum, oil and bromoil processes—are included in Chapter Eight.

DAGUERREOTYPE

7.002 The original daguerreotype process introduced by Louis Jacques Mandé Daguerre in the 1830s involved sensitizing a thin layer of metallic silver on a polished copper support with vapors of iodine to form light-sensitive compound silver. After camera exposure, the latent image was developed with the vapors of heated mercury. The plate was fixed by dissolving the silver iodide layer in a solution of salt and water. The developed image consisted of mercury droplets that formed an amal-

gam with the metallic silver. As the basic daguerreotype process was improved upon, a dilute solution of nitric acid was used to clean the copper plate. To suspend the plate during sensitization and development, a special mercury box containing a source of iodine vapors with a pool of mercury below it was constructed. The mercury was heated with a spirit lamp, causing it to vaporize. Fixing was accomplished with a hot solution of sodium thiosulfate. Soon the practice of toning daguerreotypes in a solution of gold chloride became common, as did the practice of adding "accelerators" such as bromine and chlorine, which were vaporized onto the plate along with the iodine to increase the sensitivity of the process.

While maintaining the essential principle of the original process, many different daguerreotype techniques were evolved. Methods used by modern daguerreotypists often differ significantly from the standard technique of the nineteenth century. One alternative method, the Becquerel development, is a simplified daguerrean process that does not involve the use of mercury vapors, and is much less hazardous. The Becquerel method relies on the fact that an iodized daguerreotype plate can be developed by the action of light alone. A copper plate electroplated with a thin layer of silver is first cleaned and polished before being exposed to the vapors of iodine. Iodine crystals are placed at the bottom of a box. The plate is sensitized by exposure to the rising vapors, as silver iodide forms on the plate surface. After camera exposure, the plate is exposed to sunlight under a filter (artificial light can also be used), causing fine crystals of silver to form out of the iodide layer. Fixing is done with a weak solution of salt and water; a zinc or aluminum rod is used to galvanize the silver iodide layer. This method minimizes image fading, which tends to occur if the plate is fixed in hypo.

HAZARDS OF DAGUERREOTYPE

7.003 Any method of daguerreotyping that uses metallic mercury or its salts is extremely hazardous, even if proper precautions are taken and expensive industrial ventilation systems are used. In addition, the cost of proper environmental disposal of mercury materials is prohibitive for most photographers.

Mercury readily vaporizes at room temperature. Since the vapor is odorless, it is very difficult to detect and almost impossible to control completely once it has contaminated a workspace, or even the surface of clothing. Exposure to mercury vapors or mercuric salts such as mercuric chloride or mercuric iodide always involves the risk of acute or chronic mercury poisoning from skin absorption, inhalation or ingestion. Mercuric salts are highly corrosive to skin and mucous membranes of the respiratory tract.

Acute or chronic mercury poisoning primarily affects the nervous

system but also severely damages the gastrointestinal system and kidneys. Symptoms of chronic mercury poisoning such as muscle tremors, irritability and psychic disturbances were well known by the mid-nineteenth century among hatters who used mercuric nitrate to make felt hats. There is also evidence that some early daguerreotypists suffered from symptoms of mercury poisoning.

Also hazardous are the vapors of iodine, bromine or chlorine used as accelerators, or to form the primary light-sensitive compound. They are hazards by inhalation, ingestion, and to skin and eyes. These vapors are highly corrosive and can cause both acute and chronic respiratory problems. Eye contact with concentrated vapors may cause severe and painful burns. Skin contact can cause deep, slow-healing ulcers. Skin contact with iodine can also cause a hypersensitivity reaction. Chronic absorption of halogens, especially iodine or bromine, can cause severe symptoms of poisoning with nervous system damage.

Concentrated hydrochloric and nitric acids are also highly corrosive to skin, eyes and mucous membranes. Repeated inhalation of the acid gases can cause chronic lung problems. Gold chloride is a moderately irritating compound capable of causing severe skin and respiratory allergies. Other toners may be moderately to highly hazardous. See hazards of specific toners (5.036).

CHEMICAL HAZARDS

7.004 *Acids*
> hydrochloric acid (4.041)
> nitric acid (4.042)

Metal Compounds
> gold chloride (4.087)
> mercuric chloride (4.091)
> mercuric iodide (4.092)
> mercury (elemental) (4.093)

Oxidizing Agents
> bromine (4.118)
> chlorine (4.119)
> iodine (4.121)
> sodium thiosulfate (4.138)

OTHER HAZARDS

7.005 • Old hypo solutions, or solutions that are heated or treated with acid can decompose to form highly toxic sulfur dioxide gas (4.141).

• If water is added to a concentrated acid, a violent, exothermic reaction may occur. See procedures for mixing or diluting acids (4.034).

PRECAUTIONS FOR DAGUERREOTYPE

7.006 • Follow all general precautions in Chapters Two and Three.

• Choose the safest methods and materials possible. Use the Becquerel method, or other methods that do not require mercury or mercury compounds. Use of mercury constitutes too great a risk.

• Wear gloves and goggles when handling concentrated acids. For large amounts, work inside a fume hood or wear an approved respirator with an acid gas cartridge. When mixing, always add acids to water, never the reverse (4.034). Store nitric acid separately from other acids.

• For acid splashes on the skin, flush affected areas immediately with water. For eye splashes, flush for at least 15 minutes and seek medical attention.

• When heating iodine, bromine or chlorine, make sure there is local ventilation of the vapors or wear a respirator with approved acid gas cartridges. Wear gloves and goggles when handling the crystals or solutions.

• If sodium thiosulfate is used, do not heat the solution. Also take care not to contaminate the fixer with acid. Discard used hypo to prevent decomposition.

• Wear gloves when handling gold chloride toners. See precautions for other toners (5.039).

WET-PLATE COLLODION, AMBROTYPE AND TINTYPE

7.007 The early wet-plate collodion negatives were made by coating a glass plate with collodion, a viscous fluid consisting of potassium iodide or potassium bromide and guncotton (highly explosive cellulose nitrate) dissolved in alcohol and ether. Before the collodion dried, the plate was sensitized in a solution of silver nitrate to produce silver iodide, then exposed in the camera, developed in pyrogallic acid (later ferrous sulfate was used as the developer) and fixed with hypo or potassium cyanide. Ambrotypes and tintypes (ferrotypes) were direct positive modifications of the collodion negative process. Ambrotypes were made by adding mercuric chloride or nitric acid to the developer, and then blacking out the back of the glass plate with a black varnish, or using a metal or velvet background, to yield a positive image. Tintypes were similarly made on metal plates that had been "japanned," or lacquered black. They were sometimes mounted under glass, but were

more frequently varnished and displayed without glass. These black varnishes and lacquers contain natural resins, usually Japanese lacquer resins, dissolved in organic solvents such as turpentine or mineral spirits.

HAZARDS OF WET-PLATE COLLODION PROCESSES

7.008 Wet-plate collodion negatives are rarely made today. The hazards to early photographers included the fire and explosive hazards of the collodion emulsion itself, as well as severe inhalation, ingestion and skin absorption hazards from the highly toxic developer pyrogallic acid and the potassium cyanide fixer. Guncotton (cellulose nitrate or nitrocellulose) is extremely flammable when in a dry state, or when exposed to heat, flames or strong oxidizing agents. Guncotton is also an explosion hazard under certain circumstances. When dry, it ignites easily and burns rapidly. These properties led to its wide use as an igniting material in guns in the nineteenth century. This is the same material that after 1910 began to be used with flexible film base (nitrate films). There is no evidence, however, that old collodion negatives decompose in contact with air as do the cellulose nitrate films. (See Chapter 9 for a discussion of nitrate films and their hazards.) The presence of an ether (ethyl ether or methyl ether) in the collodion emulsion greatly increased the fire and explosion hazards of the process. These ethers ignite explosively when heated or exposed to flames or sparks. Ethers oxidizes with time to form compounds which are shock sensitive and can explode when the container is moved or handled. They are also eye and respiratory irritants, and at high concentrations can cause central nervous system depression and coma.

The making of ambrotypes and tintypes involves additional hazards. Highly corrosive mercuric chloride or nitric acid increases the hazard of the developer. Both mercuric chloride and pyrogallic acid are highly toxic by every route of exposure, and may be absorbed through skin to cause severe systemic effects. Repeated inhalation of the nitric acid vapors can cause chronic respiratory problems. Japanese lacquers and other natural resins can cause allergies.

Japanese lacquers contain urushiol, a naturally occurring mixture of catechol derivatives, which also is present in poison ivy. Urushiol causes the typical poison ivy skin rash. Similar reactions to Japanese lacquer have been noted.

Turpentine and mineral spirits are moderately toxic solvents. Turpentine can cause allergic sensitization and is poisonous by ingestion. Lacquer thinners may contain a mixture of solvents ranging from highly toxic aromatic hydrocarbons (toluene, xylene) to moderately toxic solvents. These lacquers, varnishes and solvents are also fire and explosion hazards.

CHEMICAL HAZARDS

7.009 *Developers*
> pyrogallic acid (4.009)
> *Acids*
> nitric acid (4.042)
> *Metal Compounds*
> ferrous sulfate (4.086)
> mercuric chloride (4.091)
> silver nitrate (4.104)
> *Oxidizing Agents*
> potassium bromide (4.122)
> potassium cyanide (4.124)
> potassium iodide (4.125)
> sodium thiosulfate (4.138)
> *Resins*
> Japanese lacquer (4.232)
> *Alcohols*
> ethyl alcohol (4.241)
> denatured alcohol (3.240)
> *Petroleum Distillates*
> mineral spirits (4.275)
> *Miscellaneous Solvents*
> turpentine (4.279)

OTHER HAZARDS

7.010 • In the presence of even weak acids, potassium cyanide is readily converted to highly poisonous hydrogen cyanide gas (4.150), which can be rapidly fatal.

• Sodium thiosulfate (hypo) will release highly toxic sulfur dioxide gas (4.141) if heated or if acid is added.

• If water is added to a concentrated acid, a violent, exothermic reaction may occur. See procedure for mixing or diluting acids (4.034).

PRECAUTIONS FOR WET-PLATE COLLODION PROCESSES

7.011 • Follow all general precautions in Chapters Two and Three.

• If making collodion negatives, omit ether from the solvent and handle the emulsion with extreme care, avoiding sources of heat, flames, sparks or strong oxidizing agents.

• Do not use the highly toxic developer pyrogallic acid if a less toxic compound such as ferrous sulfate can be substituted. If pyrogallic acid is used, wear gloves and goggles when handling powders or solutions. Mix inside a fume hood or glove box, or wear an approved toxic dust mask.

• Do not use the highly toxic compounds mercuric chloride and potassium cyanide. Safer alternatives are nitric acid (or similar acids) and sodium thiosulfate, respectively.

• Wear gloves and goggles when handling concentrated acids. For large amounts, use local ventilation or wear an approved respirator with an acid gas cartridge. When mixing, always add acids to water, never the reverse (4.034). For acid splashes on the skin, flush affected areas immediately with water. For eye splashes, flush for at least 15 minutes and get medical attention.

• Do not heat or add acid to hypo bath. Discard used hypo solutions to prevent decomposition.

• Ambrotypes were—and can be—made on ruby glass or a similar colored glass. This would eliminate the need for toxic lacquers, varnishes and their solvents.

• Wear gloves when handling organic solvents, or solvent-based lacquers and varnishes. For moderately toxic solvents such as turpentine or mineral spirits, good dilution ventilation is adequate. If large amounts of lacquer thinner are used, make sure there is local exhaust ventilation or wear an approved organic vapor respirator.

• Take normal precautions for storing and handling flammable and combustible materials, including precautions against fire (3.019). Store acids and solvent separately and store nitric acid away from other acids.

SALTED PAPER PRINTING AND CASEIN PRINTING

7.012 Salted paper printing, introduced by William Henry Fox Talbot as part of his collotype process, involves first applying to the paper support a salting solution consisting of citric acid, sodium chloride and/or ammonium chloride and a sizing agent such as gelatin, arrowroot starch or resin, sometimes with an alum added. Bleached shellac with gelatin may also be used as a size, and zinc chloride is sometimes used with ammonia and a gelatin size for the salting solution.

Papers are sensitized by brushing on a silver solution. This may consist of silver nitrate alone or in combination with lead nitrate or ura-

nium nitrate, citric or tartaric acid, or ammonia. Following exposure, the paper is fixed with hypo or potassium bromide and toned with gold chloride or potassium chloroplatinite, although a variety of toners may be used.

Casein paper printing can be done by modifying this process slightly. A casein/ammonia solution is added to the salted paper, followed by a silver nitrate solution. This paper is sometimes immersed in dilute citric acid solution to make it more stable.

Light sources for printing salted paper and casein paper can be sunlight or any artificial source of ultraviolet light, such as a sunlamp, quartz halogen lamp or carbon arc lamp.

HAZARDS OF SALTED PAPER AND CASEIN PRINTING

7.013 The main hazards of salted paper and casein printing result from exposure to highly toxic chemicals used for sensitizing and toning papers. The silver sensitizing solution may contain highly toxic metal compounds such as lead nitrate or uranium nitrate, as well as corrosive acids and ammonia, both of which are highly irritating to skin and mucous membranes, and may cause immediate damage to eyes. Lead nitrate is an inhalation and ingestion hazard, and acute or chronic exposure can result in lead poisoning. Lead is also a known teratogen (causes birth defects) and a suspected mutagen. Uranium nitrate is highly toxic by every route of exposure, and absorption of very small amounts can cause severe systemic injury or death.

Silver nitrate is moderately corrosive to skin, eyes and mucous membranes. Eye contact can cause blindness. Platinum and gold toners are moderately irritating compounds capable of causing severe skin and respiratory allergies.

Some components of the salting solution are relatively non-toxic materials. Zinc chloride solutions are corrosive to skin, eyes and mucous membranes. Inhalation of the powders or vapors can cause respiratory problems. If bleached shellacs are used, the sizing process is more hazardous. These shellacs, consisting of resins dissolved in methyl alcohol or ethyl alcohol, must be prepared by mixing with borax or another alkali, and heating the solution. This procedure will cause the solvents to vaporize, increasing inhalation hazards as well as fire hazards.

The salting solution for casein printing includes ammonia. Ammonia vapors can be highly, irritating to eyes and mucous membranes of the respiratory tract.

If carbon arc lamps are used for printing, they add severe inhalation hazards and excessive ultraviolet light to the dangers (3.030). Use other light sources such as quartz halogen, xenon, and metal halide lamps.

CHEMICAL HAZARDS

7.014 *Acids*
> citric (4.039)
> tartaric (4.050)

Alkalis
> borax (4.056)

Metal Compounds
> gold chloride (4.087)
> lead nitrate (4.089)
> potassium aluminum sulfate (alum) (4.096)
> potassium chloroplatinite (4.098)
> silver nitrate (4.104)
> uranium nitrate (4.108)
> zinc chloride (4.110)

Oxidizing Agents
> ammonia (4.113)
> potassium bromide (4.122)
> sodium thiosulfate (4.138)

Resins
> see specific resins (4.228-4.234)

Alcohols
> ethyl alcohol (4.241)
> methyl alcohol (4.239)

OTHER HAZARDS

7.015 • If heated or if acid is added, sodium thiosulfate (hypo) will release highly toxic sulfur dioxide gas (4.141).

PRECAUTIONS FOR SALTED PAPER AND CASEIN PRINTING

7.016 • Follow all general precautions in Chapters Two and Three.

• Do not use highly toxic lead nitrate or uranium nitrate sensitizers. Use silver nitrate instead. Wear gloves and goggles when handling silver nitrate, and avoid inhalation of the dust.

• Use ammonium chloride instead of zinc chloride in the salting solution to reduce corrosive hazards.

• Do not use bleached shellac if plain gelatin or arrowroot can be used. If a shellac is used, buy those that are dissolved in denatured alcohol instead of methyl alcohol. Wear gloves when handling any solvents or shellacs.

• Wear gloves or barrier cream and goggles when handling platinum toners. Use with local exhaust ventilation or wear a toxic dust mask. Wear gloves for handling gold toners.

• Wear gloves and goggles when handling salting solutions containing zinc chloride with ammonia or casein with ammonia. Use with good dilution ventilation to remove ammonia vapors. Mix zinc chloride powder in a fume hood or inside a glove box, or wear an approved toxic dust mask.

• Make sure there is good dilution ventilation for processing baths, and for any moderately toxic solvents or shellacs used. Take normal precautions for handling and storing solvents, including precautions against fire.

• Wear gloves and goggles when handling concentrated acids. For large amounts, use local ventilation or wear a respirator with an approved acid gas cartridge. When mixing, always add acid to water, never the reverse. For acid splashes on the skin, flush affected areas immediately with water. For eye splashes, flush for at least 15 minutes and seek medical attention.

• Do not heat or add acid to sodium thiosulfate. Discard used hypo solutions to prevent decomposition.

• Replace carbon arc lamps with other light sources (3.030).

ALBUMEN PRINTING

7.017 Early printing papers such as albumen paper, which formed a visible image during exposure to light, were known as printing-out-papers. Albumen papers were developed by Louis Blanquart-Evrard in the 1860s, and until the introduction of the developing-out-papers some twenty years later, albumen paper was the only printing process in general use.

Albumen paper surfaces vary from matte to glossy depending on the number of albumen coats and the type of albumen used. Albumen from egg whites is added to a salting solution based on sodium chloride or ammonium chloride and glacial acetic acid. The paper is sensitized in a solution of silver nitrate just before use, then exposed to sunlight in contact with the negative. Eventually, commercially-produced, presensitized albumen papers became available.

Following exposure and a water rinse, albumen paper is usually toned with gold chloride, fixed in hypo and finally given another water rinse. Sodium carbonate is sometimes added to the fixer for print permanence.

HAZARDS OF ALBUMEN PRINTING

7.018 Albumen printing involves relatively few hazardous chemicals. The salting solution contains glacial acetic acid, which is highly corrosive to skin, eyes and mucous membranes, and can cause respiratory problems from repeated inhalation of the vapors.

Silver nitrate is moderately corrosive; eye contact can result in blindness. Gold chloride is a moderately irritating compound that can cause severe skin and respiratory allergies. Sodium carbonate, if added to the fixer, can be irritating to skin and eyes.

CHEMICAL HAZARDS

7.019 *Acids*
glacial acetic acid (4.035)
Alkalis
sodium carbonate (4.065)
Metal Compounds
gold chloride (4.087)
silver nitrate (4.104)
Oxidizing Agents
sodium thiosulfate (4.138)

OTHER HAZARDS

7.020 • If heated, or if acid is added, sodium thiosulfate (hypo) will release highly toxic sulfur dioxide gas (4.141).

• If water is added to a concentrated acid, a violent exothermic reaction will occur. See procedures for mixing or diluting acids (4.034).

PRECAUTIONS FOR ALBUMEN PRINTING

7.021 • Follow all general precautions in Chapters Two and Three,

• Wear gloves and goggles when handling concentrated acids. For large amounts, ventilate locally or wear an approved respirator with an acid gas cartridge. When mixing, always add acid to water, never the reverse (4.034). For acid splashes on the skin, flush affected areas immediately with water. For eye splashes, flush for at least 15 minutes and seek medical attention.

• Avoid skin and eye exposure and wear goggles when handling silver nitrate. Do not inhale the dusts.

• Wear gloves when handling gold chloride. Do not inhale the powders.

• Wear gloves and goggles when handling alkaline powders or concentrated solutions.

• Do not heat or add acid to sodium thiosulfate. Discard used hypo solutions to prevent decomposition.

• Make sure there is good dilution ventilation for albumen printing.

PRINTING-OUT-PAPER (P.O.P.)

7.022 The term P. 0. P. (for printing-out-paper) came into use in the 1890s to distinguish the gelatin chloride printing-out-papers then being introduced from the developing-out-papers (D.O.P.) that had been introduced in the 1880s. Gelatin chloride printing-out-paper is sold pre-sensitized and can be printed-out, washed, toned and fixed using the same steps and chemicals as those used for salted paper printing. Sunlight or any artificial light-such as a sunlamp, quartz halogen lamp or carbon arc lamp may be used for printing. Many toning formulas are used for P.O.P. including the standard toner gold chloride and platinum toners. See discussion of photographic toners (4.035). Prints may be fixed with hypo or potassium bromide. In some cases, an acid fixing bath or a hypo/sodium sulfite bath may be used.

HAZARDS OF P.O.P.

7.023 The hazards of P.O.P. can vary according to the chemicals used for toning. Gold chloride and potassium chloroplatinite toners are both moderately irritating to skin and can cause severe skin and respiratory allergies. See the hazards for other photographic toners (5.036).

If carbon arc lamps are used, they add severe inhalation hazards and excessive ultraviolet light to the dangers (3.030).

CHEMICAL HAZARDS

7.024 *Acids*
 acetic acid (4.035)
Alkalis
 sodium sulfite (4.072)
Metal Compounds
 gold chloride (4.087)
 platinum toners (4.095, 4.098)
Oxidizing Agents
 potassium bromide (4.122)
 sodium thiosulfate (4.138)

OTHER HAZARDS

• If heated or if acid is added (or carried over from an acid toning solution), sodium thiosulfate will decompose and release highly toxic sulfur dioxide gas (4.141). An acid fixer will decompose similarly to form sulfur dioxide gas.

• If acid is added (or carried over from the toner), sodium sulfite will release highly toxic sulfur dioxide gas.

PRECAUTIONS FOR P.O.P.

7.026 • Follow all general precautions in Chapters Two and Three.

• Wear gloves or barrier cream and goggles when handling platinum salts. Mix powders in a fume hood or in a glove box, or wear an approved toxic dust mask.

• Wear gloves when handling gold chloride, and do not inhale powders.

• Do not heat or add acid to sodium thiosulfate. Use a water rinse step between an acid toner and the fixer to prevent contamination. Discard used hypo solutions to prevent decomposition.

• Make sure there is good general ventilation for P.O.P. processing, unless more toxic toners are used that require local exhaust ventilation. See precautions for specific toners (5.039).

• Replace carbon arc lamps with other light sources.

Non-Silver Photographic Processes

8.001 During the 1840s, a great number of photographic printing processes were developed as the basic photochemical reaction was explored by individuals such as Sir John Herschel, Mongo Ponton, Edmond Becquerel, William Henry Fox Talbot, Alphonse Louis Poitevin and others. Many of these processes were based on the light sensitivity of metals other than silver, such as iron, platinum and chromium. This chapter focuses on the hazards associated with the most important non-silver processes that have survived and are being explored by contemporary photographers. These are divided into two groups; the ferric (iron) processes, which include the cyanotype, platinum and palladium printing, and the Kallitype and Van Dyke brown printing; and the dichromate (or bichromate) processes, which include the carbon printing processes, gum printing, and oil and bromoil printing.

Most of the materials used in non-silver processes can be handled safely if proper precautions are taken. A few, such as mercury, lead and uranium compounds that are sometimes used in platinum printing, should be avoided because of their extreme toxicity, corrosivity, or potentially severe systemic effects. The two groups of non-silver processes are discussed with regard to their significant hazards, and guidelines are provided for working safely with the materials.

FERRIC PROCESSES—CYANOTYPE

8.002 In the cyanotype process (also known as the ferroprussiate process or blueprinting), the image is toned by a blue iron compound, Tarbell's blue. The paper is sensitized with ferric ammonium citrate and potassium ferricyanide. Exposure to light reduces a portion of the ferric salt to the ferrous state, and a portion of the ferricyanide to ferrocyanide, resulting in the formation of a pale, blue-white image consisting of

ferrous ferrocyanide. After exposure, the cyanotype is washed in water to remove the soluble, unreduced salts. Once it is thoroughly washed, the image is permanent and as it dries the ferrocyanide slowly oxidizes to a deep blue tone that consists of a mixture of compounds. A weak image can be intensified by putting the print in an oxidation bath of diluted hydrogen peroxide, a weak bath of potassium ferricyanide, dilute potassium dichromate, or in water to which a very small amount of household bleach has been added. Although toning of cyanotypes is rarely done, two toners seem to produce stable tones. One uses a lead acetate solution; the other bleaches the print in a 5% ammonia solution, then tones it in a saturated solution of tannic or gallic acid. The light source for cyanotypes can be any ultraviolet source such as sunlight, fluorescent black light sources, sunlamps, quartz lamps, or carbon arcs.

HAZARDS OF CYANOTYPE

8.003 Many basic compounds used in cyanotype processes, such as ferric ammonium citrate and potassium ferricyanide, are only slightly hazardous. Potassium dichromate is moderately irritating to skin and highly irritating to the respiratory system. This compound can cause skin and respiratory allergies and ulceration. Potassium dichromate is also a suspected carcinogen.

Toning solutions may consist of moderately to highly hazardous components, including ammonia, which is highly irritating to the eyes and respiratory system; corrosive acids and the toxic metal salt, lead acetate. Although it is not readily absorbed through the skin, lead acetate is highly toxic by inhalation and ingestion, and acute or chronic exposures can result in lead poisoning. Lead is also a known teratogen (causes birth defects) and a suspected mutagen.

If carbon arcs are used, severe inhalation hazards and excessive ultraviolet light also are involved. (See 3.030).

CHEMICAL HAZARDS

8.004 *Acids*
> gallic acid (4.040)
> tannic acid (4.049)

Metal Compounds
> ferric ammonium citrate (4.083)
> lead acetate (4.088)
> potassium dichromate (4.100)
> potassium ferricyanide (4.101)

Oxidizing Agents
> ammonia (4.113)
> hydrogen peroxide (4.120)

OTHER HAZARDS

8.005 • Potassium ferricyanide is only slightly hazardous by itself. If exposed to intense heat, hot acid or strong ultraviolet light, it may decompose and release highly poisonous hydrogen cyanide gas (4.150).

• If water is added to a concentrated acid, a violent, exothermic reaction may occur. See procedures for mixing or diluting acids (4.034).

PRECAUTIONS FOR CYANOTYPE

8.006 • Follow all general precautions in Chapters Two and Three.

• Replace carbon arcs with other ultraviolet light sources. To prevent eye damage from these lights, contain them or use behind a barrier.

• Do not heat or add acid to potassium ferricyanide, and keep away from sources of strong ultraviolet light.

• Never mix ammonia and bleach which form lethal gases.

• Do not use lead acetate for toning. Tannic acid toner discussed above (8.002) is a less hazardous alternative.

• Wear gloves and goggles when handling ammonia solutions, and use with good dilution ventilation. For large amounts, work in a fume hood or wear an approved respirator with an ammonia cartridge. In case of eye contact, flush with water for at least 15 minutes and get medical attention.

• If ferric ammonium citrate is used frequently, avoid skin contact.

• If potassium dichromate is used, wear gloves and goggles and mix powders in a fume hood or inside a glove box, or wear an approved toxic dust mask.

• Wear gloves and goggles when handling concentrated acids. For large amounts, ventilate locally or wear an approved respirator with an acid gas cartridge. When mixing, always add acid to water, never the reverse (4.034). For acid splashes on the skin, flush affected areas with plenty of water immediately. For eye splashes, flush for at least 15 minutes and get medical attention.

PLATINUM AND PALLADIUM

8.007 In platinum printing, paper is sensitized with light-sensitive ferric oxalate and potassium chloroplatinite or platinum chloride. After the sensitizing solution is brushed on and has dried, a negative is placed in contact with the paper and exposure is made with sunlight, black light, quartz lamp or similar light. On exposure to the light, the ferric salts are reduced to the ferrous state. When the paper is placed in a potassium oxalate developer, these ferrous salts are dissolved and in turn reduce the platinum salts to a metallic state. The print is then cleared in a series of diluted hydrochloric acid baths to remove the ferric salts remaining in the paper. The image that is produced consists of metallic platinum in a finely divided state.

 The sensitizing solution, which is usually mixed in three parts, contains ferric oxalate, oxalic acid, potassium chlorate and potassium chloroplatinite. Occasionally very small amounts of compounds containing other metals such as gold, silver, and iridium are added to shift the tone a little. Developing is traditionally done with a saturated solution of potassium oxalate. A clearing bath of citric acid is sometimes used. Ammonium citrate and sodium citrate can be substituted for the developer. Ammonium citrate produces blacker tones, while sodium citrate produces slightly warmer tones with palladium (see Bibliography, Bostick and Sullivan).

 Certain toning procedures may be done during development. These include heating the (potassium oxalate) developer, adding mercuric chloride (for warm brown tones), adding potassium phosphate (for blueblack tones) or lead oxalate (for blacks), or brushing on glycerin (glycerol).

 Clearing the print can be done with a series of three hydrochloric acid baths or with EDTA. Common after-treatments may include uranium toning (with uranium nitrate) or gold toning (with gold chloride). The image may also be intensified with a silver salt bleach (potassium ferricyanide) followed by toning in a potassium chloroplatinite/phosphoric acid solution.

 Palladium printing is done with essentially the same procedures and materials as those used for platinum printing, but a palladium compound such as sodium chloropalladite or palladium chloride is substituted for the platinum compound in the sensitizer solution. Platinum and palladium solutions can also be mixed together for combination printing.

HAZARDS OF PLATINUM AND PALLADIUM

8.008 Platinum and palladium printing can involve a number of serious skin and inhalation hazards, as well as severe systemic hazards from exposure to the highly irritating, corrosive and toxic compounds used. Plati-

num salts (especially chloroplatinite salts) are irritating to skin, eyes and respiratory system. These compounds, and palladium salts to a lesser extent, are capable of causing skin allergies and platinosis, a severe form of asthma. For this reason, soluble platinum salts have an extremely low eight-hour Threshold Limit Value of 0.002 parts per million and are regulated by OSHA at this limit (2.038). Gold chloride, frequently used as a toner, can also cause severe allergies.

The sensitizer, developer, clearing baths and some of the toning formulas contain highly corrosive acids and oxalates that have significant skin, eye, respiratory and ingestion hazards. The oxalate developer, which is saved and re-used, picks up metals from the paper and becomes more toxic with use. Several toners for platinum and palladium contain highly hazardous metal compounds such as lead oxalate, mercuric chloride and uranium nitrate. Mercuric chloride and uranium nitrate are highly toxic by every route of exposure, and may be absorbed through skin to cause severe systemic effects. Absorption of mercuric salts can cause both acute and chronic mercury poisoning. Lead oxalate is highly toxic by inhalation or ingestion, and like other soluble lead compounds, acute or chronic absorption can result in lead poisoning. Lead is also a known teratogen and a suspected mutagen.

If carbon arc lamps are used, they add severe inhalation hazards and excessive ultraviolet light to the list of dangers (3.030).

CHEMICAL HAZARDS

8.009 *Acids and acid salts*
 citric acid, ammonium citrate, and sodium citrate (4.039)
 hydrochloric acid (4.041)
 oxalic acid (4.043)
 phosphoric acid (4.044)
Alkalis
 potassium phosphate (4.061)
Metal Compounds
 ferric oxalate (4.085)
 gold chloride (4.087)
 lead oxalate (4.090)
 mercuric chloride (4.091)
 palladium chloride or sodium palladium chloride (4.094)
 platinum chloride (4.095)
 potassium chloroplatinite (4.098)
 sodium chloroplatinite (4.098)
 potassium ferricyanide (4.101)
 tetrasodium EDTA (4.078)
 uranium nitrate (4.108)

Oxidizing Agents
 potassium chlorate (4.123)
 potassium oxalate (4.126)

OTHER HAZARDS

8.010 • Potassium chlorate can be explosive in contact with combustible organic materials, including glycerin (glycerol) if glycerin is used as a brush-on toner.

 • Combining potassium chlorate with hydrochloric acid (in the clearing baths) may cause the release of highly toxic chlorine gas. Chlorine gas is highly irritating to the eyes and the respiratory system.

 • Potassium ferricyanide is only slightly toxic by itself, but if exposed to intense heat, hot acid or strong ultraviolet light, it may release highly toxic hydrogen cyanide gas.

 • If water is added to a concentrated acid, a violent, exothermic reaction may occur. See procedures for mixing and diluting acids, (4.034).

PRECAUTIONS FOR PLATINUM AND PALLADIUM

8.011 • Follow all general precautions in Chapters Two and Three.

 • When doing platinum or palladium printing, use the safest methods and materials available. Do not use highly toxic metal compounds for toning such as mercuric chloride, lead oxalate or uranium nitrate. Less toxic alternative toners are potassium phosphate and gold chloride. The intensifier-toner method using platinum salts and phosphoric acid is also somewhat safer, but extreme care must be taken to avoid exposure to platinum salts.

 • Replace carbon arcs with other light sources. Protect eyes from light by containing them or using behind a barrier.

 • When handling potassium chlorate, especially when combining it with hydrochloric acid, work in a fume hood or wear an approved respirator with an acid gas cartridge. Store potassium chlorate separately and away from heat and combustible materials.

 • Do not use glycerin for local toning, because it creates an explosion hazard when combined with potassium chlorate.

• Wear gloves or barrier cream and goggles when handling platinum or palladium salts. Mix in a fume hood or inside a glove box, or wear an approved toxic dust mask.

• Wear gloves and goggles when handling powdered oxalic acid or oxalate solutions. Mix powdered oxalic acid inside a fume hood or a glove box, or wear an approved toxic dust mask.

• Wear gloves when handling gold chloride, and avoid inhalation of dusts.

• Wear gloves and goggles when handling concentrated acids. For large amounts, ventilate locally or wear an approved respirator with an acid gas cartridge. When mixing, always add acid to water, never the reverse (3.034). For acid splashes on skin, flush affected areas immediately with plenty of water. For eye splashes, flush for at least 15 minutes and get medical attention.

• Do not heat or add acid to potassium ferricyanide; keep it away from strong sources of ultraviolet light.

KALLITYPE (VAN DYKE)

8.012 The chemistry of Kallitype is similar to that of platinum printing, except that the Kallitype image consists of metallic silver. Kallitype paper is first coated with a sensitizer containing silver nitrate and ferric salts. It is then printed by contact in sunlight or by strong artificial light, reducing some of the ferric salts to the ferrous state. During development in plain water, the silver is in turn reduced by the ferrous salts to metallic silver, forming a brown image.

The Van Dyke, or brownprint method is the simplest Kallitype technique, and uses for sensitizing and printing a combined solution containing ferric ammonium citrate, tartaric acid and silver nitrate. The paper is coated by brushing, dipping, or spraying the solution. It is printed in sunlight or with an artificial light source, developed in water and then fixed in hypo. Gold chloride toning is a common aftertreatment.

Another Kallitype formula uses ferric oxalate, oxalic acid and silver nitrate for the sensitizer, and requires a developer and clearing bath in addition to the fixer. The developer usually consists of sodium potassium tartrate (Rochelle Salts) and borax, with potassium dichromate added for contrast control. The clearing bath is a potassium oxalate solution. The fixing bath contains hypo and ammonia. In addition, a hypo-clearing bath may be used, and gold-toning is commonly done.

HAZARDS OF KALLITYPE

8.013 The Van Dyke or brownprinting method can involve significant skin, eye and respiratory hazards. The sensitizer containing silver nitrate is corrosive to skin, eyes and mucous membranes of the respiratory system. Spraying on the sensitizer can cause corrosive damage to eyes and possible blindness. Gold chloride used for toning is a moderately irritating compound that can cause severe skin and respiratory allergies.

The other Kallitype formula uses highly corrosive compounds including oxalic acid and ferric oxalate in the sensitizer. The developer may contain potassium dichromate, increasing skin and respiratory hazards. Potassium dichromate is moderately irritating to skin. It is highly irritating to the respiratory system, and can cause skin and respiratory allergies and ulceration. Potassium dichromate is also a suspected human carcinogen. The fixer contains ammonia, which is highly irritating to the eyes and respiratory system.

If carbon arcs are used, they add severe inhalation hazards and excessive ultraviolet light to the list of dangers (3.030).

CHEMICAL HAZARDS

8.014 *Acids*
> oxalic acid (4.043)
> tartaric acid (4.050)

Alkalis
> ammonia (4.055)
> borax (4.056)
> sodium potassium tartrate (4.070)

Metal Compounds
> ferric ammonium citrate (4.083)
> ferric oxalate (4.085)
> gold chloride (4.087)
> potassium dichromate (4.100)
> silver nitrate (4.104)

Oxidizing Agents
> ammonia (4.113)
> sodium thiosulfate (4.138)

OTHER HAZARDS

8.015 • If heated, if acid is added, or is stored too long, sodium thiosulfate will release highly toxic sulfur dioxide gas (4.141).

• If water is added to a concentrated acid, a violent, exothermic reaction will occur. See procedures for mixing and diluting acids (4.034).

PRECAUTIONS FOR KALLITYPE

8.016 • Follow all general precautions in Chapters Two and Three.

• Use the Van Dyke brownprinting method if possible, since it involves fewer hazards than the Kallitype formula.

• Wear gloves and goggles when handling silver nitrate. Do not spray on the silver nitrate sensitizer solution unless it is done inside a spray booth.

• Wear gloves when handling gold chloride, and avoid inhalation of dusts.

• Wear goggles and thick gloves (silver nitrate has been known to penetrate thin gloves) when handling ferric oxalate or oxalic acid solutions. Mix in a fume hood or inside a glove box, or wear an approved toxic dust mask.

• Wear gloves and goggles when handling potassium dichromate or potassium oxalate. Mix solutions in a fume hood or inside a glove box, or wear an approved toxic dust mask.

• Wear gloves and goggles when handling ammonia solutions, and use with good dilution ventilation to remove vapors. In case of eye contact, rinse immediately with plenty of water for at least 15 minutes and get medical attention.

• Wear gloves and goggles when handling concentrated acids. For large amounts, ventilate locally or wear an approved respirator with an acid gas cartridge. When mixing, always add acid to water, never the reverse (4.034). For acid splashes on skin or eyes, rinse affected areas with plenty of water immediately. For eye splashes, continue rinsing for at least 15 minutes and get medical attention.

• If using ferric ammonium citrate frequently, avoid skin contact to prevent allergies.

• Wear gloves when handling borax and avoid inhalation of the dusts.

• Do not heat or add acid to sodium thiosulfate. Discard used hypo solutions to prevent decomposition.

• Replace carbon arcs with sunlight or an artificial light source.

DICHROMATE PROCESSES—CARBON PRINTING

8.017 Carbon printing, or pigment printing, is done with a special carbon tissue, a sheet of paper coated on one side with a layer of pigmented gelatin. The carbon process involves first sensitizing the pigmented tissue with potassium dichromate or ammonium dichromate, and when dry, exposing it in contact with a negative. The exposure causes the gelatin to become insoluble in proportion to the amount of light that passed through the negative. The carbon tissue is then placed gelatin side down on a sheet of transfer paper that is coated on one side with plain, insoluble gelatin. After a period of contact the two sheets are placed in a warm water bath which softens the soluble gelatin and allows the paper back of the carbon tissue to be pulled away, leaving the pigmented gelatin attached to the transfer paper. The image appears as the soluble, unexposed gelatin melts and washes away in the warm water.

German-made carbon tissues are now available in several different colors, including those for three-color carbro. These tissues can also be made by hand, using a great variety of pigments, but this procedure is rarely done today.

The sensitizer for carbon printing is potassium dichromate or ammonium dichromate. Sometimes fast-drying spirit sensitizers are prepared, using isopropyl alcohol or acetone with ammonium dichromate, or acetone by itself with potassium dichromate. Ammonia may be added to some solutions as a preservative.

The tissue is exposed, in contact with the negative, to an ultraviolet light source, frequently a carbon arc lamp. Daylight, a mercury vapor lamp or a sunlamp may also be used. Following development in warm water, cooling and drying, a clearing bath containing alum or a 5% sodium sulfite solution is used to remove any dichromate stains. A hardening bath consisting of a dilute solution of formalin is the final procedure in the carbon process.

The gelatin size used for the transfer paper usually requires formalin (formaldehyde). Thymol crystals, dissolved in methyl or denatured alcohol, are sometimes added to preserve the sizing solution.

HAZARDS OF CARBON PRINTING

8.018 Carbon printing involves several compounds that can be moderately to highly hazardous depending on the route of exposure, in addition to organic solvents that are fire and explosion hazards. The sensitizer contains potassium dichromate or ammonium dichromate, which are both moderately irritating to skin and highly irritating to the respiratory system. Dichromates can cause skin and respiratory allergies and ulceration. They are also suspected human carcinogens. Ammonium dichromate is flammable and unstable when in contact with many

materials. The sensitizer also may contain acetone and ammonia, both extremely hazardous to eyes. Ammonia vapors are highly irritating to the respiratory system. Acetone is an extremely flammable solvent.

The hardening bath contains formalin which is moderately irritating to skin and highly irritating to the respiratory system, causing severe skin and respiratory allergies, including asthma. Formalin is also poisonous if ingested, and is a suspected human carcinogen. Methyl alcohol (methanol) is classified as a moderately toxic solvent, but is highly toxic if ingested.

The gelatin size containing formalin and thymol in methyl alcohol is highly irritating, and is poisonous if ingested.

CHEMICAL HAZARDS

8.019 *Aldehydes*
 formalin (4.023)
Phenols
 thymol (4.028)
Alkalis
 sodium sulfite (4.072)
Metal Compounds
 ammonium dichromate (4.077)
 potassium aluminum sulfate (4.096)
 potassium dichromate (4.100)
Oxidizing Agents
 ammonia (4.113)
Alcohols
 methyl alcohol (4.239)
 isopropyl alcohol (4.240)
Ketones
 acetone (4.263)

OTHER HAZARDS

8.020 • If heated or treated with acid, sodium sulfite will release highly toxic sulfur dioxide gas (4.141).

PRECAUTIONS FOR CARBON PRINTING

8.021 • Follow all general precautions in Chapters Two and Three.

• Wear gloves and goggles when handling potassium dichromate or ammonium dichromate. Mix powders inside a fume hood or a glove box, or wear an approved toxic dust mask. Keep ammonium dichromate away from sources of heat and store separately from other chemicals.

• If organic solvents are used, wear gloves and take usual precautions for storage and handling solvents, including precautions against fire (3.019). Do not allow smoking or open flames in the work area.

• Wear gloves and goggles when handling ammonia solutions, and use with good dilution ventilation. If splashed in the eyes, flush with water for at least 15 minutes and get medical attention.

• Do not heat or add acid to sodium sulfite solutions.

• Wear gloves and goggles when handling formalin baths. For large amounts use with local exhaust ventilation or wear a respirator with cartridges approved for formaldehyde.

• Wear gloves when handling the gelatin size. Avoid accidental ingestion. Use good dilution ventilation.

• Replace carbon arc lamps with other light sources (3.030).

CARBRO AND THREE-COLOR CARBRO PRINTING

8.022 The carbro (carbon + bromide) printing process is similar to the ozobrome process that was introduced in 1905. In the carbro process, a sheet of carbon tissue is sensitized with a dichromate solution, then placed in contact with a bromide print. While in contact, the silver image of the bromide print is bleached out and the gelatin on the carbon tissue becomes insoluble in proportion to the density of the finely divided silver of the original print.

 To make the bromide print, a special bromide paper is developed in a non-hardening developer such as amidol, rinsed in water and fixed in plain hypo. The sensitizer for the carbon tissue usually consists of potassium ferricyanide, potassium dichromate, potassium bromide, succinic acid and potassium alum. After the sensitized tissue and bromide print have been contacted, the bromide is stripped away. The transfer and development steps are similar to those of carbon printing. The tissue is rinsed to remove excess dichromate, then brought face to face with the transfer paper. This combination is immersed in warm water, and when the soluble pigment begins to melt, the tissue backing is stripped off and the print is developed in the bath. A cold water rinse is used to harden the gelatin following development. After drying, the silver image can either be removed by refixing or re-developed to strengthen the image. If the print is refixed, a hypo clearing bath is used.

THREE-COLOR CARBRO

8.023 In the three-color carbro process, bromide prints are made from three different color-separation negatives and transferred onto yellow, magenta and cyan carbon tissues. The three tissues are in turn transferred in registration onto a single support to produce a full-color print. Color separation negatives may be made directly in the camera or from color transparencies. Bromide prints made from the negatives are processed in a non-hardening developer and fixed in plain hypo. The sensitizing solution for the carbon tissues is the same as that used for regular carbro printing. In three-color carbro printing, the tissues are transferred onto separate supports for development. The supports make it possible to register the three images. After transfer and development, the three images are transferred in registration to a final support. Color reduction is sometimes done, using a dilute potassium ferrocyanide solution to reduce the cyan image or a methyl alcohol solution to reduce the magenta image. The yellow image cannot be reduced.

HAZARDS OF CARBRO AND THREE-COLOR CARBRO

8.024 The main hazards of carbro and three-color carbro printing result from exposure to the bromide developer and to the sensitizer for the carbon tissue. The developer, usually Amidol is a strong skin and respiratory irritant that can cause severe skin allergies and bronchial asthma. This compound is also a systemic poison and can be absorbed through skin to cause severe systemic damage.

The sensitizer for carbon tissue contains potassium dichromate, which is moderately irritating to skin and highly irritating by inhalation. Potassium dichromate can cause skin and respiratory allergies and ulceration. It is also a suspected human carcinogen. Other components of the sensitizer—potassium ferricyanide, alum, succinic acid and potassium bromide—are only slightly irritating to skin. Bromide powders are more hazardous by inhalation.

During transfer and development of the carbon tissue, pigments present in the soluble gelatin may be slight to moderate hazards by skin contact with the warm water solution.

In three-color carbro printing, the magenta reducing solution containing methyl alcohol is moderately hazardous by skin contact and by inhalation. Methyl alcohol is highly toxic by ingestion. It is also a fire hazard.

CHEMICAL HAZARDS

8.025 *Developers*
 amidol (4.004)
Acids
 succinic acid (4.046)
Metal Compounds
 potassium aluminum sulfate (4.096)
 potassium dichromate (4.100)
 potassium ferricyanide (4.101)
 potassium ferrocyanide (4.102)
Oxidizing Agents
 potassium bromide (4.122)
 sodium thiosulfate (4.138)
Alcohols
 methyl alcohol (4.239)

OTHER HAZARDS

8.026 • If heated or if acid is added, sodium thiosulfate will release highly toxic sulfur dioxide gas (4.141).

• Potassium ferricyanide and potassium ferrocyanide are only slightly hazardous, but if exposed to intense heat, hot acid or strong ultraviolet light, these compounds may release highly poisonous hydrogen cyanide gas (4.150).

PRECAUTIONS FOR CARBRO AND THREE-COLOR CARBRO

8.027 • Follow all general precautions in Chapters Two and Three.

• If possible, use a less toxic developer. It is difficult to use amidol safely. If it is used, wear gloves and goggles when handling solutions. Buy premixed solutions to avoid exposure to powders. Otherwise, mix inside a fume hood or a glove box, or wear an approved toxic dust mask. Take usual precautions for storing and handling developers (4.014).

• Do not heat or add acid to sodium thiosulfate. Discard used hypo solutions to prevent decomposition.

• Wear gloves and goggles when applying the dichromate sensitizer. Mix in a fume hood or inside a glove box, or wear an approved toxic dust mask. When handling potassium bromide, take care to avoid inhalation of powders.

• Do not heat potassium ferricyanide or potassium ferrocyanide. Do not add hot acid, to these compounds, nor expose them to strong ultraviolet light.

• Wear gloves when handling solutions during transfer and development of the carbon tissue to avoid skin contact with potassium dichromate and pigments suspended in soluble gelatin.

• Wear gloves when handling methyl alcohol, and avoid accidental ingestion. Use with good dilution ventilation. Take usual precautions for storage and handling of solvents, including precautions against fire (3.015, 3.019).

GUM PRINTING

8.028 Gum dichromate (bichromate) printing involves first coating the paper with a sensitizing solution containing gum arabic, ammonium dichromate (or potassium dichromate) and a watercolor pigment. The sensitizer can be brushed, airbrushed, or sprayed onto the paper. The gum solution may also contain a preservative such as mercuric chloride or formalin.

The developer is plain water. A few drops of ammonia or household bleach is sometimes added to the developer to correct for overexposure or for excessive pigment in the colloid coating.

The coated paper is dried and contact printed with a negative. A sunlamp, carbon arc lamp or other source of ultraviolet light may be used for printing. During exposure, the gum becomes insoluble in proportion to the amount of light that has passed through the negative. As the image is developed (in water), gum gradually dissolves off the print from unexposed areas, carrying pigment with it. The exposed (now insoluble) areas retain the pigmented image in the hardened gum coating. Developed prints are then treated in a sodium sulfite or alum clearing bath to remove sensitizer stains.

For multiple color prints, a sized paper must be used. Gelatin and formaldehyde (formalin) are traditionally used for sizing. Substitutes for this toxic size include dilute acrylic gesso, acrylic polymer medium and spray starch. If spray starch is used, the print must be sized before each color is applied.

Today, most gum printers use a commercially prepared liquid solution of gum arabic which eliminates the need for handling the concentrated preservative and powdered material.

Powdered pigments most commonly used for gum printing include lamp black (carbon black), alizarin crimson, monastral blue (phthalocyanine blue), cadmium yellow, burnt sienna, raw sienna, burnt umber and raw umber. Sepia, ivory black, Indian red, pthalocyanine green

and hansa yellow are also used. To prepare powdered pigments, the powders are first ground into a paste with a small amount of gum before adding them to the gum solution. If pigments clump, a solution containing sugar, hot water, gum solution and an ethylene glycol wetting agent may be added.

Tube colors can also be used for gum printing. These consist of three types of commercially prepared paints—transparent watercolors, gouache and tempera paints. Watercolors and gouache are basically similar, containing a gum (gum arabic or gum tragacanth), water, preservatives and pigments in addition to glycerin, syrup and other nontoxic ingredients. Gouache also contains precipitated chalk (calcium carbonate). Tempera paints contain pigments, preservatives and vehicles that are emulsions such as egg, egg and oil, gum casein and wax. Formalin (formaldehyde) is commonly used as a preservative for commercial paints.

Pigment stains can be removed with household bleach and yellow dichromate stains can be removed with potassium alum.

HAZARDS OF GUM PRINTING

8.029 The main hazards of gum printing are skin and respiratory hazards that can occur from exposure to components of the gum sensitizing solution. The sensitizer contains several compounds that can cause skin and respiratory allergies, including gums, dichromates and a formalin preservative. Potassium dichromate and ammonium dichromate are moderately irritating to skin and highly irritating by inhalation. They can cause severe allergies and ulceration, and are also suspected carcinogens. Ammonium dichromate is flammable and unstable in the presence of many other substances. The sensitizer may also contain ammonia, which is extremely hazardous to eyes and respiratory system. Mercuric chloride, sometimes used as a preservative, is highly toxic by every route of exposure and can be absorbed through skin to cause severe systemic injury.

Pigment grinding or spraying can be highly hazardous. Many pigments used in gum printing are moderately to highly toxic, and can cause chronic poisoning from inhalation or accidental ingestion of pigment powders. Tube colors are less hazardous because they are already mixed.

Wetting agents containing a polyether alcohol are irritating to the eyes. Some wetting agent solutions also contain ethylene glycol, a solvent that is poisonous by ingestion. If carbon arc lamps are used, they add severe inhalation hazards and excessive ultraviolet light to the list of dangers (3.030).

CHEMICAL HAZARDS

8.030 *Aldehydes*
　　　　formalin (4.023)
Alkalis
　　　　sodium sulfite (4.072)
Metal Compounds
　　　　ammonium alum (4.076)
　　　　ammonium dichromate (4.077)
　　　　mercuric chloride (4.091)
　　　　potassium alum (4.096)
　　　　potassium dichromate (4.100)
Oxidizing Agents
　　　　ammonia (4.113)
Pigments and Dyes
　　　　see specific pigments (4.155-4.223)
Resins
　　　　gum tragacanth (4.230)
　　　　gum acacia (gum arabic) (4.231)
Alcohols
　　　　methyl alcohol (4.239)
　　　　polyether alcohol (4.243)
Glycols
　　　　ethylene glycol (4.270)

OTHER HAZARDS

8.031 • If heated, or if acid is added, sodium sulfite will release highly toxic sulfur dioxide gas (4.141).

PRECAUTIONS FOR GUM PRINTING

8.032 • Follow all general precautions in Chapters Two and Three.

• Handle gum arabic carefully; avoid inhalation of dusts. Wear gloves if allergic.

• Wear gloves and goggles when handling dichromates. Mix powders inside a fume hood or a glove box, or wear an approved toxic dust mask. Brush rather than airbrush or spray onto the paper. Store ammonium dichromate separately and away from sources of heat.

• Wear gloves and goggles when handling ammonia solutions, and use with good dilution ventilation to remove vapors. If splashed in the eyes, flush with water for at least 15 minutes and get medical attention.

• Avoid using toxic preservatives such as formalin or mercuric chloride. Preparing a fresh solution is less hazardous. The gum solution will keep for a short period of time without preservatives if refrigerated.

• When selecting pigments, always choose the least toxic pigments. Use tube colors and avoid the hazards of powdered pigments. If powders are used, avoid grinding or spraying pigments whenever possible. Pigment grinding or spraying should be done only in a fume hood or wearing an approved respirator. Use distilled water to prevent clumping of pigment powders when preparing the gum solution. Take careful hygiene and housekeeping precautions when handling pigments to avoid accidental ingestion. Keep pigments out of the reach of children.

• Avoid eye contact or accidental ingestion of wetting agent solutions. If eye contact with solutions containing polyether alcohol occurs, flush with water for at least 15 minutes and get medical attention. Keep solutions out of the reach of children.

• Wear gloves or use tongs throughout development and clearing steps to avoid skin contact with dichromates and pigments in the dissolving gum.

• Do not heat or add acid to sodium sulfite.

• Replace carbon arcs with other light sources.

OIL AND BROMOIL PRINTING

8.033 In the oil process, gelatin-coated paper is sensitized with dichromate and then printed in contact with a negative. The gelatin becomes hardened in proportion to the amount of light that passes through the negative. The paper is washed in cool water, causing the unexposed areas to swell. During printing, ink adheres to the dry, hardened (exposed) areas but is repelled by the water-swollen (unexposed) areas of the gelatin.

In oil printing, the sensitizer is either potassium dichromate or ammonium dichromate. Spirit sensitizers also contain isopropyl alcohol or acetone. After exposure to ultraviolet light, the paper is washed in water to remove the dichromate stain, or is soaked in a 5% solution of sodium sulfite. After surface drying the paper is ready for inking.

The bromoil process is a modification of the oil process. A contact print or enlargement made on a suitable bromide paper is treated in a special bath that bleaches the image and hardens the gelatin. This treatment allows the bromoil print to be inked in the same way that an oil print is inked.

256

Bromoil printing uses special bromide paper that is developed in a non-hardening developer, usually amidol, fixed in hypo and sodium sulfite, then bleached. Many bleaching formulas can be used for bromoil printing. A standard bleach contains copper (cupric) sulfate, 28% acetic acid, potassium bromide and potassium dichromate. A ferricyanide bleach may be used, followed by a dilute sulfuric acid bath. Another common bromoil bleach contains chromic acid, copper (cupric) sulfate and potassium bromide. After bleaching, the gelatin will swell in water, forming a matrix that will accept ink in the shadows but reject it in the highlights. After a final hypo bath and water rinse, the gelatin matrix is ready for inking.

Stiff, lithographic inks are used for oil and bromoil printing. These inks contain printmaking pigments, a vehicle, usually linseed oil or linseed oil varnish (middle varnish), and stiffeners such as magnesium carbonate or aluminum stearate. To remove gloss, prints may be treated in a finishing bath consisting of benzine or gasoline. A final hardening bath contains sodium sulfite and potassium alum.

HAZARDS OF OIL AND BROMOIL PRINTING

8.034 The main hazards of oil printing are skin and respiratory hazards that can occur from exposure to the dichromate sensitizer. Dichromates are moderately irritating to skin and highly irritating by inhalation. They can cause severe skin and respiratory allergies and ulceration, and are also suspected human carcinogens. Ammonium dichromate is flammable and unstable in the presence of many other substances. The sensitizer may also contain acetone, which is extremely flammable and hazardous to eyes.

Bromoil printing is much more hazardous than oil printing. The bromide developer can cause severe skin allergies and bronchial asthma. Amidol is also a systemic poison that can be absorbed through skin to cause severe systemic damage. Bleaches used for bromoil printing are moderately to highly hazardous. Copper (cupric) sulfate is a moderately irritating compound that can cause skin and respiratory allergies and possible ulceration. The copper sulfate bleach also contains highly corrosive acetic acid. Chromic acid bleaches are extremely hazardous by every route of exposure. Even dilute solutions of chromic acid can cause skin allergies and ulceration. Chromic acid is also a suspected human lung carcinogen.

Printmaking pigments used for inking can be moderately to highly toxic. Vehicles for lithographic inks such as linseed oil and linseed oil varnish are only slightly irritating to skin. These materials are also flammable. Other components of the inks are not significant hazards. Moderately toxic solvents are used for the finishing bath. Benzine and especially gasoline are highly flammable. Gasoline may also contain

257

highly toxic benzene and organic lead compounds that can be absorbed through the skin.

CHEMICAL HAZARDS

8.035 *Developers*
 amidol (4.004)
Acids
 acetic acid (4.035)
 chromic acid (4.037)
 sulfuric acid (4.048)
Alkalis
 sodium sulfite (4.072)
Metal Compounds
 ammonium dichromate (4.077)
 copper sulfate (4.081)
 potassium aluminum sulfate (4.096)
 potassium dichromate (4.100)
 potassium ferricyanide (4.101)
Oxidizing Agents
 potassium bromide (4.122)
 sodium thiosulfate (4.138)
Pigments and Dyes
 see individual pigments (4.155-4.223)
Alcohols
 isopropyl alcohol (4.240)
Ketones
 acetone (4.263)
Petroleum Distillates
 gasoline (4.273)
 benzine (4.274)

OTHER HAZARDS

8.036 • If heated, or if acid is added, sodium thiosulfate (hypo) will release highly toxic sulfur dioxide gas (4.141).

• If heated or if acid is added, sodium sulfite will release highly toxic sulfur dioxide gas (4.141).

• If water is added to a concentrated acid, a violent, exothermic reaction may occur. See procedures for mixing or diluting acids (4.034).

• Potassium ferricyanide is only slightly toxic by itself, but if exposed to intense heat, hot acid or strong ultraviolet light it may release highly poisonous hydrogen cyanide gas (4.150).

PRECAUTIONS FOR OIL AND BROMOIL PRINTING

8.037 • Follow all general precautions in Chapters Two and Three.

• Wear gloves and goggles when handling dichromates. Mix powders in a fume hood or inside a glove box, or wear an approved toxic dust mask. Store ammonium dichromate separately and away from sources of heat.

• Wear gloves when handling isopropyl alcohol or acetone, and use with good dilution ventilation. If splashed in the eyes flush with water for at least 15 minutes and get medical attention. Take usual precautions for storage and handling solvents, including precautions against fire (3.017, 3.019). Do not allow smoking or open flames in the work area.

• Do not heat or add acid to sodium sulfite solutions.

• If possible, use a less toxic developer. If amidol is used, wear gloves and goggles when handling solutions. Buy premixed solutions to avoid hazards of mixing. Otherwise, mix powders inside a fume hood or a glove box, or wear an approved toxic dust mask. Take usual precautions for storing and handling developers (4.014).

• Do not heat or add acid to sodium thiosulfate. Discard used solutions to prevent decomposition.

• Do not use highly toxic chromic acid bleaches for bromoil printing. A ferricyanide bleach is a safer alternative. Use a water rinse step between bleach and acid finishing bath to avoid contaminating potassium ferricyanide with acid. Do not heat potassium ferricyanide or expose it to ultraviolet light.

• Wear gloves and goggles when handling copper sulfate. Mix inside a fume hood or a glove box, or wear an approved toxic dust mask. Avoid inhalation of bromide powders.

• Wear gloves and goggles when handling concentrated acids. For large amounts, ventilate locally or wear an approved respirator with an acid gas cartridge. When mixing, always add acid to water, never the reverse (4.034). For acid splashes on skin, rinse affected areas immediately with water. If splashed in they eyes, flush for at least 15 minutes and get medical attention.

• Use premixed inks to avoid the hazards of grinding and mixing pigments.

259

• Wear gloves when handling lithographic inks, and use with good dilution ventilation. Take precautions against possible fire hazards when using flammable linseed oil varnishes or benzine. Do not use gasoline. Do not smoke or use open flames in the work area.

• Wash hands carefully after handling inks, and take usual precautions for good skin care (3.047). Never wash hands with solvents. If necessary, use an acid-type hand cleaner such as pHisoderm® to remove ink from skin.

• Replace carbon arc lamps with other light sources (3.030).

Photographic Printmaking Processes

9.001 In 1827, twelve years before the introduction of the daguerreotype, photomechanical reproduction was achieved by a lithographer, when Nicéphore Niépce developed "heliographic" intaglio plates. Early attempts to reproduce the tonal precision of the "daguerrean" image by means of a printing press included etched daguerreotypes and wood engravings. It was not until the emergence of gelatin processes in the 1850s and 1860s, however, that techniques for printing photographs in ink began to be viable. Talbot's discovery of the property of light-induced insolubilization, or "hardening" of dichromated gelatin and of certain other dichromated colloids became the basic working principle for virtually all photographic printmaking processes that followed.

Today, photographic printmaking processes have expanded in many directions, and both traditional and "alternative" techniques and surfaces are used. This chapter focuses on the photographic hazards that may be encountered in a number of photographic printmaking processes, including the early photomechanical processes (photogravure, collotype and Woodburytype), photoetching, photolithography, photosilkscreen, photoceramics and Kwik-Printing. The main hazards of these processes can result from exposure to a wide range of printmaking and photographic materials. In addition, the widespread use of carbon arc lamps in printmaking processes represents a major source of light and inhalation hazards. Other hazards occur in specific techniques, some of which will not be covered in this discussion since contemporary printmaking is a highly experimental area and new ways of using new materials are continually being developed.

There are significant hazards associated with standard printmaking techniques and materials such as aquatinting, stop-out or block-out procedures, etching, and proofing or printing. Most of these techniques

are beyond the scope of this text; their hazards are thus omitted or mentioned only briefly. Similarly, standard ceramics processes involve significant hazards that are only briefly discussed here. Refer to the Bibliography for references on the hazards of standard printmaking and ceramics processes.

EARLY PHOTOMECHANICAL PRINTING PROCESSES

9.002 The photogravure, the collotype and the Woodburytype are the most important of the photomechanical printing processes that preceded the halftone dot processes used today. All three depend upon the lightsensitivity of dichromated gelatin.

PHOTOGRAVURE

9.003 In hand photogravure, a film positive is first printed in contact with gravure pigment paper sensitized with potassium dichromate. Carbon arcs, mercury vapor lamps, sunlamps, photo floods, xenon pulse exposure units and other sources may be used for ultraviolet exposure. The gelatin on the pigment paper becomes insoluble in proportion to the amount of light that reaches it. The insoluble, dichromated gelatin is then transferred to a copper plate, where it acts as an etching resist. A full-strength solution of isopropyl alcohol or denatured alcohol may be applied to the paper prior to removing the backing and developing the resist by washing away the unhardened gelatin in warm water.

Preparation of the plate usually involves degreasing with sodium hydroxide (caustic soda) followed by an acid cleaning bath using glacial acetic acid or hydrochloric acid. Talc or whiting may also be used to degrease. Plates are grained with asphaltum or rosin dust, and fired on a hot plate or gas flame. Sometimes rosin-treated plates are "silvered" with a silver nitrate/potassium cyanide solution.

Before etching in ferric chloride baths, areas of the plate may be blocked with liquid asphaltum (pitch), using mineral spirits as a thinner. During etching, ammonia may be added to the ferric chloride bath to neutralize the solution to correct for "devils" or dark areas on the plate. Both etching inks and lithographic inks have been used for printing. Etching inks contain pigments and a plate oil vehicle. Litho inks contain pigments, a vehicle (usually linseed oil or a linseed oil varnish) and modifiers (stiffeners) such as magnesium carbonate or aluminum stearate. Mineral spirits or turpentine are commonly used as clean-up solvents.

HAZARDS OF PHOTOGRAVURE

9.004 Hand photogravure can be moderately to highly hazardous at different stages of the process. In addition, the organic solvents used are fire

and explosion hazards. The potassium dichromate sensitizer is moderately irritating to skin and highly irritating by inhalation. Potassium dichromate can cause skin and respiratory allergies and ulceration; it is also a suspected human carcinogen.

Preparation of the plate involves exposure to sodium hydroxide and concentrated acids. These compounds are highly corrosive to skin, eyes and respiratory system. Talc may be contaminated with tremolite asbestos. Asphaltum dust is irritating to skin and may cause skin cancer. Whiting (chalk or calcium carbonate) has no significant hazards. Liquid asphaltum, in an oil or turpentine base, is also flammable. Rosin dust is an inhalation hazard, causing respiratory allergies and possibly asthma. Silvering solutions may contain potassium cyanide, which is highly toxic by every route of exposure. Absorption of small amounts can cause cyanide poisoning, which is often rapidly fatal.

Ferric chloride baths used for etching are irritating to skin, eyes and mucous membranes of the respiratory system. Ammonia is sometimes added to the etching bath, increasing the potential for eye and respiratory irritation.

Etching and lithographic inks contain pigments that may be toxic. Litho inks also contain vehicles such as linseed oil varnish that are irritating to skin. Clean-up solvents, usually mineral spirits or turpentine, are moderately toxic by skin contact. Turpentine may cause allergic sensitization; it is also poisonous by ingestion. Solvents and varnishes used for inking are either fire or explosion hazards.

If carbon arc lamps are used, they add severe inhalation and excessive ultraviolet light to the list of dangers (3.030).

CHEMICAL HAZARDS

9.005 *Acids*
 acetic acid (4.035)
 hydrochloric acid (4.041)
Alkalis
 ammonia (4.055)
 sodium hydroxide (4.066)
Metal Compounds
 ferric chloride (4.084)
 potassium dichromate (4.100)
 silver nitrate (4.104)
Oxidizing Agents
 potassium cyanide (4.124)
Pigments and Dyes
 see specific pigments (4.155-4.223)
 talc (4.211)
 whiting (chalk, 4.171)

Resins
>rosin (4.233)

Alcohols
>ethyl alcohol (4.241)
>isopropyl alcohol (4.240)

Petroleum Distillates
>mineral spirits (4.275)

Miscellaneous Solvents
>turpentine (4.279)

OTHER HAZARDS

9.006 • If water is added to a concentrated acid, a violent, exothermic reaction may occur. See procedures for mixing or diluting acids (4.034).

PRECAUTIONS FOR PHOTOGRAVURE

9.007 • Follow all general precautions in Chapters Two and Three.

• Wear gloves and goggles when handling the potassium dichromate sensitizer. Mix powders in a fume hood or inside a glove box, or wear an approved toxic dust mask.

• Wear gloves when handling alcohols, and take usual precautions for storage and handling solvents, including precautions against fire (3.017, 3.019).

• Wear gloves and goggles when preparing and handling caustic soda solutions, or when handling concentrated acids. For large amounts of acid, ventilate locally or wear a respirator with approved acid gas cartridges. If concentrated acids or caustic soda are splashed on the skin, flush affected areas immediately with water. For eye splashes, flush for at least 15 minutes and get medical attention. When mixing, always add acid to water, never the reverse (4.034).

• Use whiting for degreasing plates if possible. It is the safest material.

• Wear gloves when handling asphaltum (especially liquid asphaltum). Avoid inhalation of asphaltum or rosin powders.

• Do not use the "silvering" solution containing potassium cyanide. Potassium ferricyanide or hypo/alum bleaches are safer alternatives. Wear gloves and goggles when handling silver nitrate, and avoid inhalation of dusts.

- Wear gloves and goggles when handling ferric chloride. Provide ventilation when mixing ferric chloride with water.

- Wear gloves and goggles when handling ammonia solutions, and use with good dilution ventilation. If splashed in the eyes, flush with water for at least 15 minutes and get medical attention.

- Use premixed inks to avoid the hazards of grinding and handling pigments.

- Wear gloves when handling lithographic inks or clean-up solvents such as mineral spirits and turpentine. Use with good dilution ventilation. Take precautions against possible fire hazards when using flammable varnishes or solvents. Do not smoke or use open flames in the work area.

- Wash hands carefully after handling inks, and take usual precautions for good skin care (3.047). Do not wash hands with solvents, since this can cause dermatitis. If necessary, use an acid-type hand cleaner such as pHisoderm® to remove ink from skin.

- Replace carbon arcs with other light sources (3.033). Protect eyes from light by enclosing or using behind a barrier.

COLLOTYPE

9.008 The collotype process is a method of printing directly from a colloid surface. First, a sheet of glass is coated with a chemically hardened substratum of gelatin, alum and sodium silicate. This is the receptive base for a second layer of dichromated gelatin, from which the printing is done. This sensitized layer is dried in an oven, then exposed in contact with the negative to carbon arc or another source of ultraviolet light. After exposure, the plate is washed to remove free dichromate. Lithographic inks are used for printing. These inks contain printmaking pigments, a vehicle (usually linseed oil or a linseed oil varnish) and various modifiers such as magnesium carbonate or aluminum stearate (stiffeners). Benzine may be used for clean-up. Some old texts recommend gasoline for clean up. To prepare for printing, the gelatin plate is dampened and then surface-dried before inking. The ink adheres to the hardened (exposed) areas, and is repelled by the water-swollen (unexposed) highlights. Reticulation lines in the hardened gelatin caused by drying at a high temperature give the appearance of continuous tone.

HAZARDS OF COLLOTYPE

9.009 The main hazards of collotype are skin and inhalation hazards that can result from exposure to the dichromate sensitizer. Potassium dichromate is moderately irritating to skin and highly irritating by inhalation of the powders. Potassium dichromate can cause severe skin and respiratory allergies and ulceration; it is also a suspected human carcinogen.

 The gelatin substratum containing alum and sodium silicate (water glass) can be slightly irritating to skin, and to the respiratory system if dusts are inhaled. Alum may cause allergies in some people. Sodium silicate powder can be moderately caustic to skin and mucous membranes.

 Lithographic inks contain pigments that may be moderately to highly toxic, and some pigments are known or suspected carcinogens. These inks also contain vehicles such as linseed oil varnish that are irritating to skin. Moderately toxic solvents are used for clean-up, with the exception of gasoline. Gasoline contains benzene which is a carcinogen. Leaded gasoline contains highly toxic organic lead compounds. Both benzene and organic lead can be absorbed through the skin. Solvents and varnishes used for inking are also fire and explosion hazards.

 If carbon arc lamps are use, they add severe inhalation hazards and excessive ultraviolet light to the dangers (3.030).

CHEMICAL HAZARDS

9.010 *Metal Compounds*
 potassium aluminum sulfate (4.096)
 potassium dichromate (4.100)
 Pigments and Dyes
 see specific pigments (4.155-4.223)
 Petroleum Distillates
 gasoline (4.273)
 benzine (VM&P naphtha) (4.274)

OTHER HAZARDS

9.011 • Drying the dichromated gelatin at high temperatures in an oven can involve fire and explosion hazards. Ammonium dichromate, which is flammable, should not be used for this process.

PRECAUTIONS FOR COLLOTYPE

9.012 • Follow all general precautions in Chapters Two and Three.

266

• Wear gloves when mixing the gelatin base containing alum and sodium silicate. Avoid inhalation of dusts.

• Wear gloves and goggles when handling potassium dichromate. Mix powders in a fume hood or inside a glove box, or wear an approved toxic dust mask. Do not use ammonium dichromate as the sensitizer for collotype.

• When heating the sensitized gelatin, take usual precautions against fire (3.020). Never use the same oven for preparation of food.

• Use premixed inks to avoid the hazards of grinding and handling pigments. See precautions for pigments (4.225).

• Wear gloves when handling lithographic inks or clean-up solvents such as benzine. Use with good dilution ventilation. Take precautions against possible fire hazards when using flammable varnishes or solvents. Do not smoke or use open flames in the work area. Do not use gasoline.

• Wash hands carefully after handling inks, and take usual precautions for good skin care (3.047). Do not wash hands with solvents. If necessary, use an acid-type hand cleaner such as pHisoderm® to remove ink from skin.

• Replace carbon arc lamps with other sources of light (3.030).

WOODBURYTYPE

9.013 In the Woodburytype process, printing is done from an intaglio mold to form a gelatin image in relief. First, the sensitizer consisting of dichromated gelatin, glycerin, sugar and water is poured onto a piece of photographic film which has been taped (gelatin side up) to a shallow glass tray. After the solution solidifies and is dried in a desiccating chamber, the film base and gelatin layer are exposed in contact with a negative to an ultraviolet light source such as carbon arc, mercury-vapor or metal halide lamps. The exposure time can be as long as 45 minutes. Following exposure, the film base with its gelatin layer is glued using a silicone sealant to a plate glass support. The image is developed in warm water over several days as the soluble (unexposed) gelatin washes away from the film base, and the hardened (exposed) areas form a gelatin relief.

A mold is then made from the gelatin relief, and from this mold final prints are made. In the original Woodbury process, the gelatin relief was impressed into a lead plate with a hydraulic press capable

of exerting tremendous pressure. Today the intaglio mold can be made using acrylic resins. These resins are of two types: monomer and monomer-polymer mixtures. The monomer is methyl methacrylate, and both types of resins use organic peroxides such as benzoyl peroxide or methyl ethyl ketone peroxide as the hardener.

Printing is done by placing the mold in a press and pouring pigmented gelatin into the center of the mold with a piece of paper sandwiched on top of the gelatin. When the press is closed the gelatin cools and solidifies on the surface of the paper. Excess gelatin is released along the sides of the paper. The final print is continuous tone in relief, with thicker deposits of pigmented gelatin in the shadows and thin deposits in the highlights.

HAZARDS OF WOODBURYTYPE

9.014 Woodburytype can involve significant skin and respiratory hazards resulting from exposure to the dichromate sensitizer, the silicone sealant, and the acrylic resins used to make the intaglio mold.

The potassium dichromate sensitizer is moderately irritating to skin and highly irritating if powders are inhaled. Potassium dichromate can cause severe skin and respiratory allergies and ulceration; it is also a suspected human carcinogen.

Pigments used for printing can be moderately to highly toxic, and some pigments are known or suspected human carcinogens.

The silicone sealant used to glue the film base to the plate glass support is an inhalation hazard. Single-component silicones release acetic acid or methanol into the air as they are curing. Acetic acid is irritating to the eyes and respiratory system. Methanol is a moderately toxic solvent that is mainly hazardous if ingested accidentally. It is also a fire hazard.

Acrylic resins contain methyl methacrylate monomer, which is moderately irritating and sensitizing to skin, eyes and respiratory system. It causes headaches, irritability and narcosis when inhaled. The benzoyl peroxide or methyl ethyl ketone peroxide hardener is highly flammable and explosive, and is a slight skin and eye irritant. The finely divided acrylic polymer dust can cause allergic sensitization.

If carbon arc lamps are used, they add severe inhalation hazards and excessive ultraviolet light to the dangers (3.030).

CHEMICAL HAZARDS

9.015 *Metal Compounds*
 potassium dichromate (4.100)
Pigments and Dyes
 see specific pigments (4.155-4.223)

OTHER HAZARDS

9.016 • The benzoyl peroxide hardener (powder) used with acrylic resins becomes a shock-sensitive explosive above 49° C (120° F) and explodes above 80° C (176°F). Both benzoyl peroxide and methyl ethyl ketone peroxide can also decompose explosively when mixed with combustible materials (e.g. acetone) or if they are stored too long. Organic peroxides should be completely used or disposed of within six months after purchase, or three months after the container is opened. They are somewhat less hazardous in paste form than in powders or liquids.

PRECAUTIONS FOR WOODBURYTYPE

9.017 • Follow all general precautions in Chapters Two and Three.

• Wear gloves and goggles when handling potassium dichromate. Mix powders in a fume hood or inside a glove box, or wear an approved toxic dust mask.

• Wear gloves when handling the developer solution containing soluble dichromated gelatin.

• When handling silicone resins, use single-component systems that are cured by atmospheric moisture instead of the more hazardous two-component systems that require peroxides for curing. Wear gloves when handling these resins, and use with good dilution ventilation to prevent a build-up of acid vapors or solvent vapors. Do not allow smoking or open flames in the work area.

• When making the mold with acrylic resins, wear gloves and work in a fume hood. If local exhaust ventilation is not possible, use a window exhaust fan and wear an approved respirator with an organic vapor cartridge. Wear an approved toxic dust mask when handling finely divided acrylic polymer dust.

• When handling organic peroxides, special precautions must be taken. Do not heat benzoyl peroxide, and do not store or keep this material for long periods of time. Never dilute benzoyl peroxide with other materials, and do not add accelerators to it. Use disposable paper cups and wooden sticks for mixing small amounts of resin and peroxide. Otherwise use polyethylene, glass or stainless steel containers. Soak all tools and containers in water before disposing of them. Clean up spills immediately by soaking up the peroxide with vermiculite. Do not sweep since this can cause fires. Use nonsparking tools to clean up vermiculite-peroxide mixtures. Do not discard unused peroxide or ver-

miculite-peroxide mixtures, since these materials might cause fire or an explosion. Fires involving peroxides cannot be put out by fire extinguishers, because the peroxides supply their own oxygen to the combustion process. Peroxides can be disposed of by reacting with 10 percent sodium hydroxide (caustic soda) solution. Store peroxides separately from other combustible materials. Always keep in the original container. Never put in glass containers.

• Whenever possible, use premixed tube colors to avoid the hazards of grinding and handling pigments.

• Replace carbon arc lamps with other light sources (3.030).

PHOTOETCHING

9.018 Photoetching is similar to hand photogravure in its basic principles, but it involves a wider variety of materials and techniques. In photoetching, a metal surface or other substrate is coated with a light-sensitive, acid-resistant layer. There are many different types of photoresists, including dichromated colloids, commercial water-soluble resists, presensitized photoengraving plates and various solvent-based resists, such as Kodak's KPR series, that come with a special developer, thinner, stripper and dyes. Photo resists and their thinners may contain cellosolves (glycol ethers) or related chemicals. The solvent-based resists are packaged in liquid form, and can be applied by spraying, pouring or dip-coating the plate. Resist thinners, developers and dyes often contain xylene. The KPR resist stripper contains butyl cellosolve, methylene chloride and naphtha. Other solvents that may be used as resist strippers include lacquer thinners and trichloroethylene (TCE). Presensitized photoengraving plates are usually developed in TCE.

Ammonia or sodium hydroxide (caustic soda) may be used as plate degreasers prior to application of the resist. Additional procedures may include pre-baking or post-baking the plate in an oven to evaporate solvents in the resist.

The photoresist layer is contact printed by exposure to ultraviolet light. The light source can be a number of artificial sources including mercury vapor lamps, carbon arcs, xenon, or even sunlight. The resist is hardened in exposed areas; the unexposed areas are removed during development. After development, an acid-resistant photographic image remains on the metal plate. Acids are used to etch the surface of the metal in the areas which are not protected by the resist. Different metals require different acids for etching. Common etches include nitric acid, Dutch mordant (a mixture of potassium chlorate, water and hydrochloric acid) and ferric chloride (iron perchloride). The image may be formed in incised intaglio or in a raised relief, depending upon the desired effect.

HAZARDS OF PHOTOETCHING

9.019 Photoetching can be an extremely hazardous process, particularly since it is commonly done using solvent-based materials. Photoresists containing glycol ethers and related solvents are highly toxic chemicals that can be absorbed through skin to cause severe systemic effects and possible reproductive damage.

Xylene, used in some resist developers and strippers (with the chlorinated hydrocarbon methylene chloride), is also highly toxic. It is a strong narcotic by inhalation and can cause systemic effects. Methylene chloride is highly toxic by inhalation, and it is considered a carcinogen by the International Agency for Research in Cancer. Its OSHA Permissible Exposure Limit is currently being re-evaluated on this basis. It also breaks down in the body to form carbon monoxide, and has caused fatal heart attacks. Trichloroethylene (TCE), a resist stripper and developer, is also highly toxic by inhalation and is a suspected liver carcinogen. Lacquer thinner is a mixture of solvents, the most toxic of which are usually the aromatic hydrocarbons toluene and xylene. The hazards of toluene are similar to those of xylene, only xylene is possibly more toxic. Naphtha (benzine) is classified as a moderately toxic solvent. Aromatic hydrocarbons, naphtha and lacquer thinner solvents are flammable, while the glycol ethers are combustible.

Application of solvent-based resists by spray methods can be extremely hazardous since these sprays produce a fine mist which is easily inhaled, carrying highly toxic materials deep into the lungs. The spray mist can remain suspended in the air for up to two hours. Severe respiratory and systemic damage can result from repeated spraying of photoresists and other solvent-based resist materials.

Pre-baking and post-baking procedures are also extremely hazardous because of the flammability or combustibility of solvents in the resists. Chlorinated hydrocarbons methylene chloride and trichloroethylene will decompose in the presence of flames and heat to release the highly toxic gas phosgene.

The hazards of most dyes, including dyes used in photoresists, have not been adequately determined, particularly with regard to their possible long-term cancer hazards.

Plate degreasers ammonia and sodium hydroxide (caustic soda) can be highly irritating to eyes and the respiratory system. Caustic soda is also highly corrosive to skin.

Using dichromated colloids for photoetching is much less hazardous than using solvent-based materials, but involves exposure to potassium dichromate or ammonium dichromate in the sensitizer. Dichromates are moderately irritating to skin and highly irritating by inhalation of the powders. Dichromates can cause skin and respiratory allergies and ulceration; they are suspected human carcinogens. Ammonium dichromate is also flammable.

If carbon arc lamps are used, they add severe inhalation hazards and excessive ultraviolet light to the dangers (3.030).

Other hazards of photoetching include skin, eye and respiratory hazards that can result from exposure to highly corrosive acids used for etching. The main hazards of these acids occur during the preparation of etching solutions, when highly toxic gases are released. The more dilute etching solutions are also skin and eye irritants. Refer to the bibliography for comprehensive texts on the hazards of etching and other standard printmaking processes.

CHEMICAL HAZARDS

9.020 *Acids*
 hydrochloric acid (4.041)
 nitric acid (4.042)
Alkalis
 sodium hydroxide (4.066)
Metal Compounds
 ammonium dichromate (4.077)
 ferric chloride (4.084)
 potassium dichromate (4.100)
Oxidizing Agents
 ammonia (4.113)
 potassium chlorate (4.123)
Pigments and Dyes
 dyes (4.224)
Aromatic Hydrocarbons
 toluene (4.246)
 xylene (4.247)
Chlorinated Hydrocarbons
 trichloroethylene (TCE) (4.250)
 methylene chloride (4.251)
Glycol Ethers (4.264)
 methyl cellosolve (4.265)
 methyl cellosolve acetate (4.266)
 butyl cellosolve (4.267)
 cellosolve acetate (4.269)
Petroleum Distillates
 naphtha (benzine) (4.274)

OTHER HAZARDS

9.021 • During the preparation of Dutch mordant, highly toxic chlorine gas (4.141) is released. Chlorine gas is highly irritating to eyes and the respiratory system.

• Do not allow potassium chlorate to be contaminated with even small amounts of other chemicals, especially organic materials (it becomes explosive). Store in cool, dry area and do not keep material for long periods of time (years).

• If water is added to a concentrated acid, a violent, exothermic reaction may occur. See procedures for mixing and diluting acids (4.034).

• Nitric acid etching can release highly toxic nitrogen oxides. Nitrogen oxide gases (4.145) are highly irritating to lungs and can cause severe respiratory problems. They have poor odor-warning properties. Store nitric acids separately from other acids.

• Chlorinated hydrocarbons such as methylene chloride and trichloroethylene (TCE) will decompose in the presence of flames, lit cigarettes and ultraviolet light to release highly toxic phosgene gas (4.143).

PRECAUTIONS FOR PHOTOETCHING

9.022 • Follow all general precautions in Chapters Two and Three.

• Use the least toxic materials for photoetching whenever possible. Substitute water-soluble resist materials for the more hazardous solvent-based resists. If presensitized plates are used, develop in the least toxic solvent possible to avoid using highly toxic trichloroethylene developers.

• Wear gloves and goggles when handling dichromates in powder or solution form. Mix powders in a fume hood or inside a glove box, or wear an approved toxic dust mask. Store ammonium dichromate separately and away from sources of heat.

• When handling KPR or similar solvent-based resists and their developers, thinners, dyes, strippers and related products, wear goggles and gloves which the manufacturer recommends for use against the particular solvents in the product. Use only if local ventilation is adequate. Kodak recommends local exhaust ventilation for the developer and dye bath trays, and for application of the resist. Do not spray on KPR resists or other solvent-based materials.

• Pregnant women should avoid exposure to solvents, especially glycol ethers and related solvents. Photographers of either sex who are planning a family should also avoid exposure to these chemicals. See discussion of reproductive hazards (1.027). Individuals who have chronic heart disease should not work with methylene chloride.

• Pre-baking or post-baking resists on the plate should only be done in a special oven that is directly vented to the outside. Never use the same oven for preparation of food. Wear an approved respirator with an organic vapor cartridge to reduce inhalation hazards. Take precaution against fire (2.020).

• Use the least toxic solvents possible for resist removal and clean-up. Avoid highly toxic chlorinated hydrocarbons and aromatic hydrocarbons (toluene and xylene) whenever possible; substitute a less toxic solvent such as mineral spirits, benzine, lithotine or turpentine. If a stronger solvent is needed, use mineral spirits with 10% toluene added.

• Use moderately toxic solvents with good general ventilation. For aromatic hydrocarbons that are highly toxic by inhalation, special precautions are required. Preferably use them in a fume hood, although small amounts can be handled with good dilution ventilation. For large amounts, or if local exhaust ventilation is not available, wear a respirator with approved organic vapor cartridges.

• Wear appropriate gloves to avoid skin contact with solvents. Because of the variety of solvents, solvent mixtures, and other chemicals used in this process, contact your glove manufacturer's technical department for recommendations (3.045). Do not wash hands in solvents. Wash frequently with soap and water, or use a mildly acidic hand cleanser such as pHisoderm®. Use a lanolin-containing cream to replace natural oils and keep skin in good condition.

• Take usual precautions for storage and handling solvents, including precautions against fire (3.019). Do not allow smoking or open flames in the work area.

• Replace carbon arc lamps with other light sources (3.030).

• If chlorinated hydrocarbons are used, do not allow them around open flame, lit cigarettes or sources of ultraviolet.

• Wear gloves and goggles when handling sodium hydroxide solutions. In case of spills or splashes on skin or eyes, rinse affected areas immediately with plenty of water. For eye splashes, continue rinsing for at least 15 minutes and get medical attention.

• Wear gloves and goggles when handling ammonia solutions, and use with good dilution ventilation to remove vapors. If splashed in the eyes, flush with water for at least 15 minutes and get medical attention.

• Wear gloves and goggles when handling concentrated acids. When

mixing, always add acid to water, never the reverse (4.034). For acid splashes on skin or eyes, rinse affected areas with plenty of water immediately. For eye splashes, flush for at least 15 minutes and get medical attention.

• Wear heavy gloves when handling plates in acid etching baths. Preparation of etching solutions and the etching process should be done in a fume hood. There are no air-purifying respirators which are approved for nitric acid and the gases it releases.

• Neutralize old acid baths with sodium bicarbonate before disposing of them. Neutralizing does not render the baths non-polluting. They still contains nitrates and metal ions. Check with your local department of environmental protection on correct disposal. If you are allowed to pour them down the sink, flush the sink with cold water for at least five minutes after pouring, to dilute the acid and prevent corrosion of pipes.

• Store potassium chlorate away from heat and combustible materials to prevent fire or explosion. If it spills or is contaminated with combustible materials, avoid heat, friction or mechanical shocks (dropping objects) that might cause an explosion. Flush with water to dissolve the potassium chlorate.

• Store acids and other corrosive chemicals on low shelves to reduce the risk of face or eye injury in case of accidental breakage. When not in use, return acid to containers. Store nitric acid away from other acids.

PHOTOLITHOGRAPHY

9.023 Photographic images can be transferred onto lithographer's stone (limestone) or metal plates that have been coated with a light-sensitive emulsion. Following exposure and development, the image areas are receptive to ink, repelling water, while the non-image areas attract water and repel ink.

The stone or metal plate can be hand-sensitized, or presensitized plates can be used. Early methods used light-sensitive emulsions containing powdered albumen (egg white), ammonium dichromate, water and ammonia. Today there are several commercial sensitizer/development kits for photolithography that contain sensitizing ingredients, developers and gum solution. Most of these brand-name emulsions are based on the light sensitivity of complex organic molecules known as diazo or diazonium compounds. Diazo compounds such as sodium toluoldiazosulfonate and sodium ditolytetrazosulfonate are dye-coupling agents that can form colored images by the action of light (without preliminary mordanting). The sensitizing solution is spread onto the surface with a lintless cloth or fine sponge, and once dry, the metal plate

or stone is contact-printed using an arc lamp, mercury lamp, quartz lamp or other source of ultraviolet light. The developer is a desensitizing lacquer often containing solvents such as methylene chloride and methyl cellosolve acetate. Some lacquer developers contain isoamyl acetate (banana oil) and trichloroethylene (TCE).

Preparation of the plate may include degreasing with ammonia or sodium hydroxide (caustic soda). Clean-up solvents may include thinners containing glycol ethers such as methyl cellosolve acetate or lacquer thinners contain aromatic hydrocarbons such as toluene and xylene. Lithotine, mineral spirits, benzine (naphtha) and turpentine are also commonly used.

Prior to proofing, a gum solution consisting of gum arabic or liquid asphaltum (pitch) may be applied to the plate or stone to prevent oxidation of the non-image areas. The gum solution is rinsed off with water just before inking the plate. Greasy lithographic inks contain printmaking pigments, a vehicle (usually linseed oil or a linseed oil varnish) and various modifiers such as magnesium carbonate or aluminum stearate (stiffeners).

HAZARDS OF PHOTOLITHOGRAPHY

9.024 The hazards of photolithography are similar to the hazards of photoetching if commercial emulsions with solvent-based materials are used. The diazo or diazonium (photosensitive) compounds are eye irritants, and the lacquer developers may contain highly toxic solvents such as the glycol ethers and their acetates. These solvents can be absorbed through skin to cause severe systemic effects and possible reproductive damage. Isoamyl acetate is a moderately toxic solvent. These solvents are also eye irritants.

The developers may also contain the chlorinated hydrocarbons methylene chloride and trichloroethylene (TCE), which are strong narcotics and can cause severe systemic damage. Methylene chloride it is considered a carcinogen by the International Agency for Research in Cancer. Its OSHA Permissible Exposure Limit is currently being re-evaluated on this basis. It also breaks down in the body to form carbon monoxide, and has caused fatal heart attacks. Trichloroethylene (TCE) is also highly toxic by inhalation, and is a suspected human carcinogen. Chronic exposure to TCE can cause nerve, liver and possible heart damage. Lacquer thinner is a mixture of solvents, the most toxic of which are usually the aromatic hydrocarbons toluene and xylene. These solvents are highly toxic by inhalation, strong narcotics and can cause systemic damage.

Several moderately toxic solvents including mineral spirits, benzine (naphtha), turpentine and lithotine (mineral spirits with pine oil added) may be used for clean-up procedures. Many of the solvents used in photolithography are flammable. Turpentine can cause allergic sen-

sitization; it is also poisonous by ingestion.

The gum solution containing gum arabic is slightly hazardous by skin contact, and may cause skin allergies. Liquid asphaltum (pitch) is a skin irritant, and may cause possible skin cancer.

Plate degreasers ammonia and sodium hydroxide can be highly imitating to eyes and the respiratory system. Sodium hydroxide is also highly corrosive to skin.

Using ammonium dichromate for the light-sensitive emulsion is less hazardous than using solvent-based commercial materials, but exposure to ammonium dichromate can be highly irritating, particularly if powders are inhaled. Dichromates can cause skin and respiratory allergies and ulceration; they are also suspected human carcinogens. Ammonium dichromate is flammable.

If carbon arc lamps are used, they add severe inhalation hazards and excessive ultraviolet light to the dangers (3.030).

Lithographic inks contain pigments that may be moderately to highly toxic, and some pigments are known or suspected human carcinogens. These inks also contain vehicles (varnishes) that are slight skin irritants, and are flammable.

CHEMICAL HAZARDS

9.025 *Alkalis*
> sodium hydroxide (4.066)
Metal Compounds
> ammonium dichromate (4.077)
Oxidizing Agents
> ammonia (4.113)
Pigments and Dyes
> see specific pigments (4.155-4.223)
Resins
> gum acacia (4.231)
Aromatic Hydrocarbons
> toluene (4.246)
> xylene (4.247)
Chlorinated Hydrocarbons
> trichloroethylene (4.250)
> methylene chloride (4.251)
Esters
> isoamyl acetate (4.257)
Glycol ethers (cellosolves) (4.264-4.269)
Petroleum Distillates
> benzine (naphtha) (4.274)
> mineral spirits (4.275)
Miscellaneous solvents
> turpentine (4.279) lithotine (4.280)

OTHER HAZARDS

9.026 • Chlorinated hydrocarbons such as methylene chloride and trichloroethylene (TCE) will decompose in the presence of flames, lighted cigarettes and ultraviolet light to release highly toxic phosgene gas (4.143).

PRECAUTIONS FOR PHOTOLITHOGRAPHY

9.027 • Follow all general precautions in Chapters Two and Three.

• Whenever possible, use water-based materials for photolithography instead of the more toxic solvent-based materials.

• Wear appropriate gloves to avoid skin contact with solvents. Because of the variety of solvents, solvent mixtures, and other chemicals used in this process, contact your glove manufacturer's technical department for recommendations (3.045).

• Wear gloves and goggles when handling ammonium dichromate. Mix powders in a fume hood or inside a glove box, or wear an approved toxic dust mask. Store ammonium dichromate separately and away from sources of heat.

• Wear nitrile gloves and goggles when handling commercial solvent-based lithography materials. Use local exhaust ventilation when handling lacquer developers. Individuals who have chronic heart disease should not work with developers containing methylene chloride.

• Pregnant women an both men and women planning families should avoid exposure to glycol ethers (cellosolves). See reproductive hazards (1.027).

•Use the least toxic solvents possible for clean-up procedures. Avoid commercial solvent mixtures and lacquer thinners whenever possible, substituting a less toxic solvent such as mineral spirits or lithotine. If a stronger solvent is needed, use mineral spirits with 10% toluene added.

• Use moderately toxic solvents with good dilution ventilation. Highly toxic solvents such as toluene and xylene should be used in a fume hood. Small amounts can be handled with good dilution ventilation. For large amounts, or if local exhaust ventilation is not available, wear an approved respirator with an organic vapor cartridge.

• Take usual precautions for storage and handing solvents, including precautions against fire (3.019). Do not allow smoking or open flames in the work area.

• Replace carbon arc lamps with other light sources (3.030).

• If chlorinated hydrocarbons are used, keep them away from open flames, lit cigarettes or sources of ultraviolet light.

• Wear gloves and goggles when handling sodium hydroxide solutions. In case of spills or splashes on skin, flush affected areas immediately with water. For eye splashes, flush for at least 15 minutes and get medical attention.

• Wear gloves and goggles when handling ammonia solutions, and use with good dilution ventilation to remove vapors. If splashed in the eyes, flush with water for at least 15 minutes and get medical attention.

• Wear gloves to avoid skin contact with liquid asphaltum. Wash hands carefully after handling gum solutions.

• Use premixed inks to avoid the hazards of grinding and handling pigments.

• Wear gloves when handling lithographic inks or clean-up solvents such as mineral spirits and turpentine. Use with good dilution ventilation. Take precautions against possible fire hazards when using flammable varnishes.

• Wash hands carefully after handling inks, and take usual precautions for good skin care (3.047). Do not wash hands with solvents, since this can cause dermatitis. If necessary, use an acid-type hand cleaner such as pHisoderm® to remove ink from skin.

PHOTOSILKSCREEN

9.028 There are two basic methods for applying a photographic image to a silkscreen: the indirect film stencil or transfer method; and the direct emulsion method. In both methods the emulsion can be either presensitized or unsensitized. Unsensitized emulsions are usually sensitized with ammonium dichromate.

In the indirect stencil method the film is processed on a temporary plastic support and then transferred to the screen. The developer may either be a dilute solution of hydrogen peroxide or a bath of ammonium dichromate or potassium dichromate. For synthetic screen emulsions, a commercial bonding agent or adhering fluid may be used to transfer the film to the screen. These materials contain a mixture of solvents that includes acetates, ketones, and alcohols. For water-soluble emulsions, isopropyl alcohol and water are usually used to condition the mesh for adherence.

Clean-up of indirect stencils can be done with mineral spirits. Commercial film stencil removers and screen cleaners are commonly used. These products contain solvent mixtures that usually include aromatic hydrocarbons toluene and xylene.

In the direct emulsion method, a photosensitive liquid used to coat the mesh creates the image in stencil form directly on the screen. The sensitizer may be a diazo compound or ammonium dichromate, with water as the developer. The direct emulsion contains polyvinyl acetate (PVA).

There are two types of PVA. One is made by reacting a catalyst and vinyl acetate monomer to form polyvinyl acetate plastic. The other is made by reacting vinyl acetate with a chemical which converts it to polyvinyl alcohol plastic. Both are often called simply PVA. Emulsions of PVA, such as white glues, contain very small amounts of vinyl acetate monomer which causes cancer in animals. Usually polyvinyl alcohol types are used for photoemulsions because of their greater solubility in water. These, if purchased dry, should be free of vinyl acetate monomer becasue it will have off-gased.

Direct emulsions usually consists of a blend of the two types of PVA, sometimes with a dye concentrate added. The PVA colloid can be mixed with photosensitive materials and will harden upon exposure to ultraviolet light. Some direct emulsions use a silver nitrate sensitizer with sodium hydroxide (caustic soda) as the developer.

Exposure of screen emulsions is done with an intense light source such as a No. 2 photoflood reflector bulb, a sunlamp or carbon arc lamp. Screens are reclaimed with sodium hypochlorite bleach and, sometimes, with enzymes.

HAZARDS OF PHOTOSILKSCREENING

9.029 The main hazards of the indirect film stencil method of photosilkscreening result from exposure to the dichromate sensitizer, and to highly toxic solvents used in adhering fluids, commercial stencil removers and screen cleaners. The ammonium dichromate sensitizer and dichromates in the developer are highly irritating by inhalation of the powders, and can cause skin and respiratory allergies and ulceration. Dichromates are also suspected human carcinogens. Ammonium dichromate is highly flammable.

Adhering fluids contain a mixture of moderately toxic solvents that includes alcohols, acetates (esters) and ketones. These solvents are eye, nose and throat irritants, and are narcotics by inhalation. Acetone is particularly irritating to eyes. Commercial stencil removers and screen cleaners contain solvent mixtures that usually include highly toxic aromatic hydrocarbons toluene and xylene. These solvents are highly hazardous by inhalation and are strong narcotics. They can be absorbed through skin to cause systemic damage. Most solvents used in

photosilkscreening are flammable. Acetone is extremely flammable. Mineral spirits are classified as combustible.

The primary hazards of the direct emulsion method include exposure to the hazardous dichromate sensitizer or to a silver nitrate sensitizer using sodium hydroxide (caustic soda) as the developer. Silver nitrate is moderately corrosive to skin and highly corrosive to the eyes. Caustic soda is highly corrosive to skin, eyes and the respiratory system. Diazo sensitizing solutions are eye irritants by direct contact, and PVA resins can be hazardous if the dusts are inhaled. PVA colloids can also cause allergies.

Sodium hypochlorite bleach solutions are moderately irritating to skin and highly irritating by inhalation. Enzymes can cause allergies in some people, and inhalation of the powders may cause bronchial asthma.

If carbon arc lamps are used, they add severe inhalation hazards and excessive ultraviolet light to the dangers (3.030).

Standard silkscreening techniques involve other materials with significant hazards such as silkscreen inks and ink components, resist and blockout materials, lacquers, glues and highly toxic solvents that are beyond the scope of this text. Refer to the bibliography for references on the hazards of these materials.

CHEMICAL HAZARDS

9.030 *Alkalis*
　　　　　　sodium hydroxide (4.066)
　　　　Metal Compounds
　　　　　　ammonium dichromate (4.077)
　　　　　　potassium dichromate (4.100)
　　　　　　silver nitrate (4.104)
　　　　Oxidizing Agents
　　　　　　hydrogen peroxide (4.120)
　　　　　　sodium hypochlorite (4.135)
　　　　Alcohols
　　　　　　isopropyl alcohol (4.240)
　　　　Aromatic Hydrocarbons
　　　　　　toluene (4.246)
　　　　　　xylene (4.247)
　　　　Petroleum Distillates
　　　　　　mineral spirits (4.275)

OTHER HAZARDS

9.031 • Sodium hypochlorite (bleach) will release highly toxic chlorine gas (4.141) if heated or if acid is added.

PRECAUTIONS FOR PHOTOSILKSCREENING

9.032 • Follow all general precautions in Chapter Two and Three.

• Use presensitized emulsions whenever possible to avoid the hazards of sensitizing compounds such as dichromates.

• Wear gloves and goggles when handling ammonium dichromate or potassium dichromate. Mix powders inside a fume hood or a glove box, or wear an approved toxic dust mask. Store ammonium dichromate separately and away from sources of heat.

• Wear appropriate gloves to prevent skin contact with solvents. See gloves (3.045). When handling adhering fluids containing moderately toxic solvents, use with good dilution ventilation.

• Whenever possible, use a less toxic solvent such as mineral spirits for clean-up of film stencils instead of highly toxic commercial mixtures. If commercial stencil removers or screen cleaners are used, work in a fume hood. Small amounts of highly toxic solvents can be handled with good dilution ventilation, but for large amounts, or if local exhaust ventilation is not available, wear an approved respirator with an organic vapor cartridge. Sometimes adhering fluids can be used as stencil removers. This reduces hazards, although it may take a little longer.

• Take usual precautions for storage and handling of solvents, including precautions against fire (3.019). Do not allow smoking or open flames in the work area.

• When using PVA emulsions, avoid inhalation of resin dusts.

• Wear gloves and goggles when handling silver nitrate, and avoid inhalation of the dusts.

• Wear gloves and goggles when handling sodium hydroxide solutions. In case of spills or splashes on skin, flush affected areas immediately with water. For eye splashes, flush for at least 15 minutes and get medical attention.

• Wear gloves and goggles when handling sodium hypochlorite bleach solutions. Do not heat or add acid to sodium hypochlorite. Avoid inhalation of enzyme powders.

• Replace carbon arc lamps with other light sources (3.030).

PHOTOCERAMICS

9.033 There are many different methods of transferring a photographic image to a ceramic surface. Various silkscreening and intaglio techniques are used, while other processes involve the direct application of a light-sensitive, glaze-based pigmented colloid to the clay surface. In most photoceramic processes, the developed image is permanently bonded with the clay during kiln-firing.

Direct photoceramic techniques use an emulsion consisting of an adhesive colloid such as a polyvinyl acetate (PVA) emulsion with ammonium dichromate as the sensitizing agent. Gum dichromate emulsions can be used for porous bisque ware. Dry raw metal oxides and glaze ingredients that are finely ground may be added directly to the emulsion. Ceramic clays and glazes may contain an extraordinary variety of toxic materials. For example, compounds of lead, barium and lithium are common glaze fluxes, free silica is present is likely to be a major ingredient in most clays and glazes, and colorants and opacifiers for glazes and clay bodies can include dozens of metals from arsenic to zirconium. Certain forms of asbestos are also likely to be present in talc minerals used in some wares.

The sensitized ceramic piece is exposed in contact with a negative to a source of ultraviolet light and the image is developed in water. The image can be integrated into the piece while the clay is still moist, after bisque-firing, as an underglaze or as an overglaze.

Another direct photoceramic technique uses commercial photoresists such as Kodak Photo Resist® (KPR) which act as the light-sensitive vehicle for vitrifiable ceramic glazes (china paint). Photoresists contain toxic solvents such as the glycol ethers and related solvents. The process involves coating the ceramic surface with the resist, exposing it to a source of ultraviolet light and developing it in the KPR developer, which contains xylene. The KPR resist stripper contains butyl cellosolve, methylene chloride and benzine. China paints used as pigments for photo ceramics contain the same kinds of toxic metals and minerals as ceramic glazes, but since they fire at lower temperatures, the fluxes is more likely to be lead. Additional fluxes and glaze ingredients may be added to the china paint to lower its fusing temperature. In addition, ammonia may be used as a surface degreaser; isopropyl alcohol may be used to remove excess pigment.

See the discussion of commercial resists and resist materials under photoetching (9.018).

HAZARDS OF PHOTOCERAMICS

9.034 Photoceramic processes based on water-soluble materials are much less hazardous than techniques using commercial solvent-based photoresist materials. The main hazards of dichromated emulsions result from

exposure to the dichromates, which can be highly irritating by inhalation of the powders, and can cause skin and respiratory allergies and ulceration. Dichromates are also suspected human carcinogens. Ammonium dichromate is also flammable. PVA resins can be hazardous if the dusts are inhaled, and may cause allergies. Gum arabic resins may cause skin or respiratory allergies.

Many components of dry glazes such as lead and barium compounds are highly toxic inhalation or ingestion. In addition, inhalation of free silica dusts present in clays and glaze ingredients can cause silicosis. Lithium compounds are moderately toxic; contact with the dusts can cause irritation and possible kidney damage. Small amount of lithium compounds, however, can be extremely toxic to people taking lithium carbonate medications. Metal oxides and other metal compounds used as ceramic colorants are generally added in smaller amounts than fluxes, but some highly toxic in even these small amounts. Colorants containing uranium, arsenic, and cadmium are hazardous because they are human carcinogens. There is no known safe level of inhalation of these colorants.

Photoceramics can be extremely hazardous if commercial photoresists and related, solvent-based materials are used with ceramic pigments (china paints). The solvents methyl cellosolve acetate and butyl cellosolve used in KPR photoresist materials are highly toxic by inhalation and can be absorbed through skin to cause severe systemic effects and possible reproductive damage. These solvents are also eye irritants. The aromatic hydrocarbon xylene, used in KPR developers and resist strippers is also highly toxic. The chlorinated hydrocarbon methylene chloride, also present in KPR strippers, is highly toxic by inhalation, causing narcosis. Methylene chloride breaks down in the body to form carbon monoxide, and has caused fatal heart attacks. Naphtha (benzine) is classified as a moderately toxic solvent. Aromatic hydrocarbons and naphtha are flammable while the glycols (cellosolves and cellosolve acetates) are combustible.

Other hazards include eye and respiratory irritation that can result from handling ammonia degreasing solutions. Isopropyl alcohol is a slightly toxic solvent that is also flammable. See the hazards of other commercial resists under photoetching (8.019). Also see the bibliography for references on the hazards of standard ceramics techniques.

CHEMICAL HAZARDS

9.035 *Metal Compounds*
 ammonium dichromate (4.077)
 Oxidizing Agents
 ammonia (4.113)
 Resins
 gum arabic (4.231)

Alcohols
 isopropyl alcohol (4.240)
Aromatic Hydrocarbons
 xylene (4.247)
Chlorinated Hydrocarbons
 methylene chloride (4.251)
Glycols
 methyl cellosolve acetate (4.266)
 butyl cellosolve (4.267)
Petroleum Distillates
 benzine (naphtha) (4.274)

OTHER HAZARDS

9.036 • Methylene chloride will decompose in the presence of open flames, lighted cigarettes and ultraviolet light to release highly toxic phosgene gas (4.143).

• Kiln-firing produces highly toxic gases and fumes in addition to large amounts of heat and infrared radiation. The hazards of hot kilns include acute or chronic lung problems, thermal burns and possible eye damage (including cataracts) from infrared radiation.

PRECAUTIONS FOR PHOTOCERAMICS

9.037 • Follow all general precautions in Chapters Two and Three.

• Wear gloves and goggles when handling dichromate emulsions. Mix dichromate powders inside a fume hood or a glove box, or wear a toxic dust mask. Store ammonium dichromate separately and away from sources of heat.

• When handling PVA colloids, avoid inhalation of resin dusts.

• Use lead-free glazes instead of lead glazes in ceramics. Do not use asbestos or asbestos-contaminated talcs. Do not use uranium, arsenic, cadmium, or other colorants that are known human carcinogens.

• Wear gloves when handling glaze materials and metal colorants to avoid skin contact. Barrier creams are not satisfactory. Handle these materials inside a fume hood or a glove box, or wear an approved toxic dust respirator.

• Take careful hygiene and housekeeping precautions when handling glazes and metal powders. Clean up all spills and wipe surfaces carefully so that dusts do not accumulate. Wash hands after handling these

materials. Wear special clothing (such as an apron) for working. Do not eat, drink or smoke in the studio.

• Use photoresists only if local exhaust ventilation is adequate. Kodak recommends local exhaust ventilation for the developer and dye bath trays, and for application of the resist. Do not spray on these resists or other solvent-based materials.

• When handling solvent-based photoresists (such as KPR), their developers, thinners, dyes, strippers and related products, wear gloves and goggles. Contact your glove manufacturer for recommendations about the proper type of glove.

• Pregnant women should avoid exposure to glycol ethers and related solvents that may cause reproductive damage. See discussion of reproductive hazards (1.027).

• Take usual precautions for storage and handling of solvents, including precautions against fire (3.019). Do not allow smoking or open flames in the work area.

• Do not wash hands in solvents since this may cause dermatitis. Wash frequently in soap and water or, if necessary, use a mildly acidic hand cleanser such as pHisoderm®.

• Keep methylene chloride away from open flames, lighted cigarettes or sources of ultraviolet light. Individuals who have chronic heart disease should not work with methylene chloride.

• Wear gloves when handling isopropyl alcohol or other moderately toxic solvents. Use with good dilution ventilation.

• Wear gloves and goggles when handling ammonia solutions, and use with good dilution ventilation to remove vapors. If splashed in the eyes, flush with water for at least 15 minutes and get medical attention.

• Replace carbon arc lamps with other light sources (3.030).

• Kilns must be vented directly to the outside by a local exhaust system. Electric kilns are best vented by specially designed negative pressure ventilation systems. If possible, the kiln should be situated in a separate room, away from other activities. Wear welding goggles or hand-held welding shields to protect eyes when looking inside a kiln. The shade number should be between 2.0 and 4.0.

KWIK-PRINTING

9.038 Kwik-Printing is a simple photographic printmaking process based on "Kwik-Proof", a graphic arts material used for proofing offset negatives. Photoartist Bea Nettles first brought attention to this technique in exhibitions, workshops, media reproductions of her works, articles, and a book on the subject (see Bibliography). Kwik-Print colors consist of dichromated watercolor pigments suspended in a colloid, usually a gum arabic solution.

Kwik-Print colors can be applied to vinyl or polyester sheets, paper or fabric by wiping or brushing them on, or by airbrushing techniques. The lightsensitive emulsion is contact-printed using sunlight, sunlamps, black light, quartz lamps, photofloods or carbon arcs, and developed in water. A dilute ammonia solution or Kwik-Print Brightener (a similar oxidizing agent) may be added. Several color layers can be built up by repeating the process.

HAZARDS OF KWIK-PRINTING

9.039 The main hazards of Kwik-Printing are skin and respiratory hazards that may result from exposure to components of the colors including dichromates, gums and pigments. These are particularly hazardous if airbrushing methods are used. Dichromates are moderately irritating to skin and highly irritating by inhalation. They can cause skin and respiratory allergies and ulceration; they are also suspected human carcinogens. Gum arabic can also cause skin allergies and, if sprayed, is highly toxic by inhalation, causing a high frequency of respiratory allergies (printer's asthma). Watercolor pigments can be moderately to highly toxic, and some pigments are known or suspected carcinogens. Airbrushing methods of applying Kwik-Print colors can be more hazardous since this produces a fine mist that is easily inhaled, carrying toxic pigments and other materials deep into the lungs. The spray mist can remain suspended in the air for hours.

Ammonia solutions are highly irritating to eyes and the respiratory system. Kwik-Print Brightener is a similar irritation hazard. If carbon arc lamps are used, they add severe inhalation hazards and excessive ultraviolet light to the dangers (3.030).

CHEMICAL HAZARDS

9.040 *Metal Compounds*
 potassium dichromate (4.100)
 Oxidizing Agents
 ammonia (4.113)

Pigments and Dyes
> see specific pigments (4.155-4.223)

Resins
> gum arabic (4.231)

PRECAUTIONS FOR KWIK-PRINTING

9.041 • Follow all general precautions in Chapters Two and Three.

• Wear gloves to prevent skin contact with Kwik-Print colors.

• Use wipe-on or brush-on methods of application. Avoid airbrush sprays to reduce hazards of the process. If spraying is necessary, it should be done in a spray booth or fume hood. For small amounts, wear a respirator with cartridges approved for paint spray.

• Wear gloves and goggles when handling ammonia or Kwik-Print Brightener solutions. Small amounts can be handled with good dilution ventilation.

• Replace carbon arc with other light sources (3.030).

Conservation and Restoration

10.001 The science of photographic conservation, which has only begun to receive proper recognition, has developed rapidly in response to a growing concern for the safety and permanence of historically important photographic artifacts. The art of conservation has its roots in the very beginnings of photography, however, when Daguerre, Niépce, Talbot and others began to search for ways to fix the image. Their search, in turn, shaped the evolution of the first photographic processes. The problem of image-fading plagued these early explorations, and many of the most beautiful early processes were eventually abandoned as newer, more permanent processes evolved.

Today, photographic conservators have developed a wide range of materials and methods which protect photographs not only against possible image deterioration, but also against additional chemical contamination and physical damage. Conservators may handle most of the normal chemicals used for black and white processing, in addition to a large number of specialized conservation materials with varying levels of toxicity.

It is also important for photoconservators to know precisely what treatment chemicals have been used in the past. Ideally, treatment records should be kept with preserved photographic materials to enable conservators to evaluate the efficacy of treatments and to protect their health while handling or working around the materials.

Conservation materials used in both the past and present, include mounting adhesives and pastes that contain toxic preservatives, fungicides, insecticides and in some cases, organic solvents; buffered papers used for storage and many organic solvents used for cleaning, demounting, emulsion transfer and other procedures. Conservators may also be exposed to highly toxic fungicidal and insecticidal gases that are used for fumigation purposes.

Restoration practices vary greatly among conservators. The purpose of this chapter is not to debate which methods are best for the photographs, but to discuss the hazards of restoration materials used in the past and present.

In general, restoration involves specific procedures aimed at reversing or minimizing the deterioration of photographic works. Specialized methods include refixing or intensifying the image, removing molds or "foxing." Restoration techniques require a broad range of materials similar to those used in conservation, but they may also involve exposure to specific hazards from historical works already deteriorating. These include explosion hazards associated with nitrate films and the noxious gases emitted when these films decompose. Specific formulas have been developed to treat these and other historical photographic objects which contain a number of potentially hazardous materials such as bleaches, stain removers, lacquers, varnishes, thinners and other organic solvents, preservatives, hardeners and many chemicals used in black and white processing.

CONSERVATION METHODS AND MATERIALS

10.002 Mounting adhesives used by conservators include the basic wheatstarch or "primary" paste and methyl cellulose. Preservatives which may be added to the wheat paste include thymol and ortho-phenyl phenol.

A variety of papers and plastics may be used for archival storage purposes. These include 100 per cent rag papers, cellulose triacetate sleeves, uncoated polyester film, and films of polypropylene, polyethylene or polystyrene. Cellulose triacetate contains thermoplastic resins, is soluble in methylene chloride, and is moderately flammable. Polyester film contains synthetic resins and halogenated compounds that make it nonflammable.

Fungicides are not used as extensively today. In the past, common fungicides included phenol compounds (which also can be used as insecticides) and thymol (methyl isopropyl phenol). Thymol was added to adhesive paste in a denatured alcohol solution, applied locally or used in crystal form in a thymol cabinet for fumigation procedures. Other phenol fungicides included:

> dichlorophene (2,2-dihydroxy-5,5
> dichlorodiphenylmethane)
> ortho-phenyl phenol (o-phenyl phenol)
> sodium ortho-phenyl phenate
> pentachlorophenol
> p-nitrophenol/potassium lactate mixture

Another group of fungicidal compounds which have occasionally found use in preservation are salicylanilides. Salicylanilides have a solvent vehicle, usually a hydrocarbon, while sodium salicylanilide is

soluble in water. These compounds are effective fungicides for cloth, paper and leather, having longer lasting properties than thymol.

In some archives and museums, fumigation methods for disinfecting paper may involve the use of elaborate equipment such as vacuum chambers that introduce and exhaust fungicidal and insecticidal gases. Knowledge of fumigant hazards and increasing governmental regulation of some fumigants have caused many institutions to discontinue the practice or send materials off-site for treatment. Fumigation, however, continues to be used in some institutions in this country, Canada and abroad. Fumigant gases include carbon disulfide, methyl bromide or a mixture of gases with ethylene oxide. Ethylene oxide, a penetrating pesticidal gas, is generally combined with carbon dioxide or fluorocarbons (about 90%) as modifiers. A few institutions have used propylene oxide as a substitute for ethylene oxide to avoid meeting strict governmental rules which apply to ethylene oxide.

Smaller fumigation chambers can be made with folded cardboard troughs inside sealed containers. Naphthalene flakes (moth balls) or para-dichlorobenzene crystals may be used as fumigants in these homemade units. This practice should only be used if vapors cannot escape the chambers—polluting the air in the area.

A variety of solvents can be used for removal of old matting materials such as adhesive residues, pressure sensitive tapes and old dry mount tissues. They can also be used for surface cleaning. These may include denatured alcohol, benzine (naphtha), acetone, or the aromatic hydrocarbons toluene and xylene.

HAZARDS OF CONSERVATION

10.003 The hazards of conservation materials and procedures can vary greatly. By far, the most hazardous procedure in conservation is large-scale fumigation using fungicidal and insecticidal gases in an archival vacuum chamber or cabinet. Other significant hazards of conservation include exposure to highly toxic phenol compounds used as insecticides or fungicides for photographs on paper and to highly toxic solvents used for adhesive removal and cleaning purposes.

Fumigants vary in toxicity, but all are highly toxic as indicated by their low eight-hour Threshold Limit Values or TLV-TWAs (2.038):

SUBSTANCE	TLV-TWA (in parts per million)
ethylene oxide	1
methyl bromide	5
carbon disulfide	10
naphthalene	10
propylene oxide	20
paradichlorobenzene	75

Fumigants such as methyl bromide, ethylene oxide and carbon disulfide are extremely hazardous. Carbon disulfide and methyl bromide are highly toxic by every route of exposure and can be absorbed through skin to cause brain and nervous system damage in addition to other systemic damage. Acute or chronic exposures can be fatal.

Ethylene oxide is a highly combustible gas, and is highly corrosive to skin and eyes. Skin contact can result in severe dermatitis, allergies and blistering. Ethylene oxide is also a human carcinogen, known to cause leukemia. It is carcinogenic in animals, causing leukemia in females and mesotheliomas (malignant tumors) in males. Ethylene oxide is a suspected mutagen since it causes adverse reproductive effects in mammals. Although less data is available on propylene oxide, its hazards are suspected to be similar to those of ethylene oxide.

Homemade fumigation units also can be highly hazardous depending on the fumigants used and specific route of exposure. Naphthalene (moth ball) vapors are moderately toxic except by skin or eye contact. Naphthalene is highly irritating to skin and eyes, and may cause allergic hypersensitivity in some individuals. Individuals with a deficiency of the enzyme glucose-6-phosphate dehydrogenase are susceptible to hemolysis (intravascular bleeding) from exposure to naphthalene. The vapors of para-dichlorobenzene are moderately toxic to skin, but highly toxic by inhalation. Acute and chronic exposures can cause severe systemic damage.

Phenol compounds used as fungicides and preservatives vary in toxicity. Pure phenol is extremely toxic by every route of exposure and can be readily absorbed through skin to cause systemic damage. Absorption of small amounts can be fatal. Pentachlorophenol is also highly toxic and can readily penetrate the skin to cause systemic poisoning. Repeated skin contact with these compounds can also cause severe dermatitis. Para-nitro-phenol, used as a preservative occasionally, is a highly toxic phenol compound, with absorption causing similar symptoms of systemic poisoning.

Thymol (methyl isopropyl phenol) and dichlorophene are moderately toxic compounds used for similar purposes. Although only slightly toxic by skin contact, thymol can be absorbed through the skin. Thymol vapors produced by heating the crystals in a thymol cabinet or chamber can be highly hazardous by inhalation and irritating to the eyes. Very high levels of exposure can damage the central nervous system, although this is unlikely to happen because thymol has a pungent, irritating odor that acts as a deterrent to overexposure. 0-phenyl phenol is much less toxic than thymol but can cause eye irritation and possible corneal injury from acute exposure. Inhalation of the powder can cause upper respiratory irritation. 0-phenyl phenol is not absorbed through skin and is not a skin irritant.

Salicylanilides are moderately toxic by ingestion, and are skin ir-

ritants. These compounds are usually applied when dissolved in solvents such as hexane or heptane (4.272).

Toluene, used for adhesive removal, thinning, and general cleaning, is a highly toxic solvent, a strong narcotic by inhalation and can cause systemic effects. The hazards of xylene are similar to those of toluene. Other solvents such as benzine (naphtha) and denatured alcohol are classified as moderately toxic. Acetone is only slightly toxic, but is particularly hazardous to eyes. Most conservation solvents are flammable. Acetone is extremely flammable. Methyl ethyl ketone is also flammable and is moderately toxic by skin contact and inhalation.

Basic wheat starch paste containing a few drops of a preservative is not significantly hazardous unless accidentally ingested. Some of the preservatives are moderately irritating to skin.

Cellulose triacetate sleeves are relatively nontoxic, but may be a fire hazard since they contain no flame-resistant materials. Uncoated polyester, although it is not a fire hazard, will melt in the presence of heat or flames to cause irreversible damage to photographic negatives or prints.

CHEMICAL HAZARDS

10.004 *Phenols*
 phenol (4.027)
 thymol (4.028)
 o-phenyl phenol (4.029)
Alcohols
 denatured alcohol (4.241)
Aromatic Hydrocarbons
 toluene (4.246)
 xylene (4.247)
Ketones
 acetone (4.263)
 methyl ethyl ketone (4.262)
Petroleum Distillates
 hexane or heptane (4.272)
 benzine or naphtha (4.274)

PRECAUTIONS FOR CONSERVATION

10.005 • Follow all general precautions in Chapters Two and Three.

• Wear chemical glove appropriate for the specific solvents used in adhesive pastes. Make sure there is adequate dilution ventilation to exhaust solvent vapors.

• Use the least toxic solvents possible for adhesive removal, thinners, dry cleaning and other conservation procedures. Avoid highly toxic aromatic hydrocarbons toluene and xylene whenever possible, substituting a moderately toxic solvent such as benzine (naphtha), mineral spirits, denatured alcohol or slightly toxic acetone. If a stronger solvent is needed, use mineral spirits with 10% toluene added.

• Use moderately toxic solvents with good dilution ventilation. Highly toxic solvents such as toluene and xylene should be used in a fume hood. Small amounts can be handled with adequate dilution ventilation; but for large amounts, or if local exhaust ventilation is not available, wear an approved respirator with an organic vapor cartridge.

• Wear appropriate gloves to avoid skin contact with solvents. For most solvents (except ketones) nitrile or neoprene gloves can be worn. For handling ketones such as acetone, natural rubber gloves usually last longest. If lacquer thinner is used, consult your glove manufacturer. See gloves (3.045).

• Take usual precautions for handling and storage of solvents, including precautions against fire (3.019). Do not allow smoking or open flames in the work area.

• If the eyes are splashed with irritating chemicals, flush with water for at least 15 minutes and get medical attention.

• Do not use pure phenol or highly toxic pentachlorophenol for conservation purposes because of its high toxicity and very rapid skin absorption.

• Wear appropriate gloves (usually nitrile) if handling any product containing p-nitrophenol or salicylanilides in a hexane or heptane solution. Use with good general ventilation. Avoid repeated exposure to n-hexane.

• Wear appropriate chemical gloves (usually neoprene or butyl rubber) if handling thymol or dichlorophene. Substitute o-phenyl phenol for thymol because of its lower toxicity. A thymol fumigation cabinet should be used only if the cabinet is totally sealed to prevent the escape of thymol vapors and the cabinet is equipped with local exhaust ventilation to exhaust toxic vapors. When opening the cabinet, wear an approved respirator with organic vapor cartridges.

• Fumigation with carbon disulfide, methyl bromide, ethylene oxide or propylene oxide should never be undertaken by individual conser-

vators working with homemade units. In the past, this practice was rather common. It is not only dangerous, it is illegal.

• Vacuum chambers used by museums and archives for fumigation require elaborate equipment, local exhaust ventilation, and location in an isolated area which can be kept under negative pressure. Air sampling must be done during and following each use of the fumigation chamber to detect leakages from equipment and off-gassing from the treated materials. These measures are needed to prevent harm to fumigators and contamination of the general indoor environment. Operators of fumigation chambers must be trained and certified pest control professionals. Ethylene oxide fumigators also must institute a program to comply with many additional regulations required by the OSHA Ethylene Oxide Standard. It is preferable to send materials out to commercial fumigators. Be sure they tell you precisely what fumigants they use and how they make sure your materials are not still offgassing when they return them to you.

• Wear gloves and goggles when handling naphthalene or paradichlorobenzene. Homemade fumigation units producing naphthalene vapors require local exhaust ventilation. The cabinet should be opened only when wearing an approved respirator with an organic vapor cartridge. Locate the fumigation unit away from other activities in the workspace.

• Inert plastics such as cellulose acetate, polyester, polypropylene, polyethylene, or polystyrene are preferable to softer plastics that will emit tiny amounts of plasticizers, monomers, and other chemicals. However, when using cellulose triacetate sleeves, take normal precautions against fire. Do not allow smoking or open flames in the work area. Although the other plastics are flame-resistant, for archival purposes they should be kept away from sources of heat or flame.

RESTORATION PROCEDURES

10.006 Old formulas used to remove tarnish from daguerreotypes usually contained potassium cyanide. Another old tarnish-removing formula employed a thiourea/phosphoric acid bleach containing a wetting agent, followed by immersion in a solution of ethyl alcohol or methyl alcohol. A fairly new method involves cleaning the plate electrolytically using a direct current power source of low voltage and amperage, a silver cathode/anode, and a strong ammonium hydroxide bath.

 In some cases, a dilute wetting agent solution may be used to clean collodion (wet-plate) images. For cleaning surface dirt on the non-image side of glass plates, a range of solvents, alkaline solutions, and commercial glass cleaners have been used. However, deionized wa-

ter is probably the safest and best for this purpose. Restoration of some ambrotypes in the past was sometimes done by relacquering their backings.

Gelatin plates and films may require treatment for mold. One method which is still occasionally used, employs a thymol cabinet where thymol crystals are heated by a low wattage lightbulb until they vaporize and kill the live molds and spores. After this treatment, the plates may be cleaned with film cleaners or other solvent-containing chemicals. Most of these are chlorinated hydrocarbons such as chloroethane (ethyl chloride) and methyl chloroform (1,1,1-trichloroethane).

Faded silver prints are sometimes treated by re-fixing them in hypo. This occasionally may be followed by a hypo-eliminator containing ammonia and hydrogen peroxide. If the prints are mounted, water or sometimes denatured alcohol is used to separate the mount and adhesive residue from the print prior to chemical treatment. Treatments for some contemporary (just printed) materials may include testing for residual silver with a silver sulfide solution, intensification with a silver nitrate/sodium sulfite/hypo bleach followed by redevelopment in a black and white developer.

Other basic restoration procedures include identifying the film base with a float test employing trichloroethylene (TCE) or a mixture of TCE and methyl chloroform (1,1,1-trichloroethane), using methyl ethyl ketone (MEK or 2-butanone) for emulsion transfer and using a variety of organic solvents for general cleaning and demounting purposes. These may include denatured alcohol, acetone, methyl ethyl ketone, benzine (naphtha), mineral spirits or lacquer thinners containing a mixture of solvents including the aromatic hydrocarbons toluene and xylene. Occasionally an image can be varnished with Acryloid B-72 resin dissolved in xylene.

Cellulose nitrate film and still negatives are not treated directly since they are highly flammable and combustible in themselves. These films are not always marked, but in many cases the word nitrate is found on the edge. They require special storage in a cool, ventilated, specially fire-protected area apart from other negatives and prints.

Early safety films were made of cellulose acetate or other slow burning esters or polyesters. These also deteriorate with time and poor storage conditions, but unlike nitrate film, they do not become explosive. For conservation purposes, badly deteriorating films are duplicated and then carefully destroyed. Refer to precautions below (10.010) and to the Bibliography for references on other conservation and restoration processes that are necessarily omitted from this discussion.

HAZARDS OF RESTORATION

10.007 Restoration formulas for daguerreotypes that contain potassium cya-

nide are highly toxic by every route of exposure. Cyanides can be absorbed through skin to cause rapid systemic injury or death. Thiourea bleach solutions are only slightly toxic, but is a suspected human carcinogen. Electrolytic processes using low voltage are usually not hazardous. The ammonium hydroxide electrolytic solution releases ammonia gas which is highly irritating to the eyes and respiratory system.

Wetting agents usually include water miscible solvents of varying toxicity, a polyether alcohol that is an eye irritant, may also contain ethylene glycol, a solvent that is poisonous by ingestion (4.270).

Treatment of mold in gelatin plates or films can involve severe inhalation and eye hazards resulting from exposure to concentrated thymol vapors. Cleaning solutions for gelatin plates containing methyl chloroform (1,1,1-trichloroethane) are moderately hazardous by inhalation. Methyl chloroform, although less toxic than other chlorinated hydrocarbons, can cause mild narcosis and heart arrhythmias. Chronic exposure may cause some liver damage. Chloroethane (ethyl chloride) is the least toxic of the chlorinated hydrocarbons.

Restoration of faded silver prints involves many chemicals used in black and white processing. The silver nitrate intensifier is moderately corrosive and can be a serious eye hazard. See discussion of these standard black and white chemicals and their hazards in Chapter Five. Methyl ethyl ketone (MEK) used for emulsion transfer, is a moderately toxic solvent that is a narcotic at high concentrations. Other moderately toxic solvents used in restoration include benzine (naphtha), mineral spirits, methyl alcohol, and methyl chloroform. Acetone and ethyl alcohol are only slightly toxic. Acetone can be particularly hazardous to eyes.

Lacquers and lacquer thinners often contain a mixture of solvents including highly toxic aromatic hydrocarbons toluene and xylene. Toluene and xylene are strong narcotics by inhalation and can be absorbed through skin to cause systemic effects. Most solvents used in restoration are flammable, except mineral spirits which are classified as combustible and the non-flammable chlorinated hydrocarbons. Acetone is extremely flammable.

Cellulose nitrate attached to a flexible film base (nitrate film) is highly flammable, and can be a dangerous fire and explosion risk under certain conditions. High temperatures in the storage area can cause spontaneous combustion of nitrate films. In contact with heat or flames, as well as air, the nitrate films will decompose and release nitrogen oxide gases that are highly toxic by inhalation. Nitrate negatives that have started to decompose and are releasing powdered film base can be irritating to skin, eyes and the respiratory system. The gases released have poor odor-warning properties, and if low concentrations are repeatedly inhaled, they may result in chronic headaches, blurred vision, loss of appetite and other symptoms of systemic damage.

Acetate safety films also deteriorate with time and poor storage con-

ditions. They may give off gases including acetic acid which sometimes is noticed as a vinegar odor. Acetate films also can be damaged by heat, so special protection is needed to prevent fire. However, they do not burn any faster than ordinary thick paper and do not give off highly toxic gases.

CHEMICAL HAZARDS

10.008 *Developers*
 see black and white developers (4.002, 4.003)
Phenols
 thymol (4.028)
Acids
 acetic acid (4.035)
 phosphoric acid (4.044)
Alkalis
 sodium sulfite (4.073)
Metal Compounds
 silver nitrate (4.104)
Oxidizing Agents
 hydrogen peroxide (4.120)
 potassium cyanide (4.124)
 sodium thiosulfate (4.138)
 thiourea (4.139)
Alcohols
 denatured alcohol (4.241)
 methyl alcohol (4.239)
 polyether alcohol (4.243)
Aromatic Hydrocarbons
 toluene (4.246)
 xylene (4.247)
Chlorinated Hydrocarbons
 chloroethane (4.248)
 methyl chloroform (4.252)
 trichloroethylene (4.250)
Ketones
 acetone (4.263)
 methyl ethyl ketone (4.262)
Glycols
 ethylene glycol (4.270)
Petroleum Distillates
 benzine (naphtha) (4.274)
 mineral spirits (4.275)

OTHER HAZARDS

10.009 • Methyl chloroform, trichloroethylene, and chloroethane, decompose in the presence of flames, lighted cigarettes and ultraviolet light to produce highly toxic phosgene gas (4.143).

• The silver bleach containing sodium sulfite and hypo will decompose to produce highly toxic sulfur dioxide gas (4.141) if it is heated, if acid is added or if the solution is allowed to stand for long periods,.

• If water is added to a concentrated acid, a violent, exothermic reaction may occur. See procedures for mixing and diluting acids (4.034).

PRECAUTIONS FOR RESTORATION

10.010 • Follow all general precautions in Chapters Two and Three.

• Do not use potassium cyanide for removing tarnish from daguerreotypes. The thiourea tarnish remover and electrolytic process are much safer alternatives.

• Avoid direct, repeated contact with thiourea because of its possible carcinogenic status.

• Wear gloves and goggles when handling phosphoric acid in a concentrated form. For large amounts, ventilate locally or wear an approved respirator with an acid gas cartridge. Small amounts can be handled with good general ventilation. When mixing, always add acid to water, never the reverse. For acid splashes on the skin, flush affected areas immediately with water. For eye splashes, flush for at least 15 minutes and get medical attention.

• Avoid eye contact with wetting agent solutions, solvents and other irritating chemicals. If gotten in the eyes, flush with for at least 15 minutes and get medical attention.

• Use deionized water for cleaning whenever possible.

• Wear neoprene, latex neoprene or butyl rubber gloves and goggles when handling thymol. A thymol fumigation cabinet should be used only if the cabinet is totally sealed to prevent the escape of thymol vapors and the cabinet is equipped with local exhaust ventilation to exhaust toxic vapors. When opening the cabinet, wear an approved respirator with organic vapor cartridges.

• Wear gloves and goggles when handling formaldehyde-containing powders or solutions. For large amounts, use local exhaust ventilation or wear an approved respirator with an organic vapor cartridge.

• Wear gloves and goggles when handling ammonia solutions, and use with good dilution ventilation to remove vapors. In case of eye contact, rinse immediately with plenty of water for at least 15 minutes and get medical attention.

• Wear gloves and goggles when handling silver nitrate. Do not heat or add acid to the silver bleach solution, and do not use old solutions that have been standing for long periods.

• Do not heat or add acid to sodium thiosulfate. Discard used solutions to prevent decomposition and contamination.

• See precautions for developers and other chemicals used in black and white processing in Chapter 5.

• Wear appropriate gloves to avoid skin contact with solvents. Contact your glove manufacturer for recommendations about the particular solvents you use (see 3.045).

• Use the least toxic solvents possible for restoration purposes. Avoid lacquer thinners containing highly toxic aromatic hydrocarbons such as toluene and xylene whenever possible. Substitute moderately toxic solvents such as benzine (naphtha), mineral spirits, or denatured alcohol. If a stronger solvent is needed, try mineral spirits with 10% toluene added.

• Use moderately toxic solvents with good dilution ventilation. Highly toxic solvents such as toluene or xylene should be used in local exhaust. If local exhaust ventilation is not available, wear an approved respirator with organic vapor cartridges. Spraying of lacquers or lacquer thinners should be done in a spray booth.

• Take usual precautions for handling and storage of solvents, including precautions against fire (3.019). Do not allow smoking or open flames in the work area.

• Keep methyl chloroform, trichloroethylene, and chloroethane away from flames, lighted cigarettes or sources of ultraviolet light.

• Wash hands carefully after handling solvents, and take usual precautions for good skin care (3.047). Do not wash hands with solvents, since

this can cause dermatitis. If necessary, use an acid-type hand cleaner such as pHisoderm® to remove ink from skin.

• Wear gloves when handling intact nitrate films. If the negatives are visibly decomposing, wear gloves and goggles and handle only in well ventilated ares.

• Nitrate films should be stored apart from other negatives and prints in a cool place with sufficient ventilation to exhaust the toxic gases produced by decomposition of nitrocellulose. These and other storage requirements are detailed in the National Fire Protection Association's "NFPA 40 — Standard for the Storage and Handling of Cellulose Nitrate Motion Picture Film." Buildings for storage must be of Type 1 construction (see "NFPA 220, Standard Types of Building Construction"). Each storage room must be separated by partitions that are continuous and securely anchored. Opening through the partitions must be fire doors which meet the standard "NFPA 80". The rooms must have two exits and adequate aisle space. Inspection rooms must provide at least 35 square feet of floor area for each worker and no more than 15 people may work in rooms where nitrate film is handled. Except for projection booths or rooms (which must never contain more than 20 rolls), all rooms in which nitrate film is handled in quantities greater than 50 pounds must be protected by automatic sprinkler systems. Additional requirements can be found in the NFPA standards listed in the Bibliography.

• The proper procedure for all badly deteriorating historical nitrate film and still negatives is to duplicate them. If the emulsion has become soft and tacky, the film is deteriorating and should be copied and disposed of immediately. Disposal must be done in accordance with local fire codes and NFPA standards. Nitrate films should never be incinerated.

• Duplication can be done in two ways: 1) if the gelatin emulsion layer is intact, it can be stripped and transferred to a new support, or 2) the negative can be copied onto a duplicating film to provide negatives from which prints can be made.

• Only negatives in good condition should be kept. This film can be stored in acid free, buffered paper, in a cold, ventilated room where relative humidity is controlled at about 35 percent.

Bibliography

GENERAL REFERENCES FOR CHAPTERS 1 THROUGH 4: These references are recommended for a professional quality library for health and safety programs and Right-to-Know training materials.

PERIODICALS

ACTS FACTS, Arts, Crafts and Theater Safety, New York. A monthly newsletter updating health and safety regulations and research affecting the arts. Available from ACTS, Attn: M. Rossol, 181 Thompson St., #23, New York, NY 10012.

Art Hazards News, Center for Safety in the Arts. A newsletter published 4 times a year on various topics related to health and safety in the arts. Available from CSA, 5 Beekman St., 10th floor, New York, NY 10038.

A.M. Best Company, ***Best's Safety Directory,*** 2 Volumes, Ambest Road, Oldwick, NJ 08858. 1 (201) 439-2200. Sources safety equipment and supplies. Published yearly.

UNITED STATES GOVERNMENT RIGHT-TO-KNOW PUBLICATIONS

First determine if you are regulated under state or federal OSHA rules. State regulated people should contact their state OSHA for publications and compliance materials. Those under the federal law should have a copy of the sections of the Code of Federal Regulations (CFR) that applies to their work. These are 29 CFR 1900-1910 (General Industry Standards) and 29 CFR 1926 (Construction Standards). Call your local OSHA office for information on obtaining copies.

For extra help in complying with the Hazard Communication Standard (federal Right-to-Know) the following publications are available free from OSHA's Publications Office, Room N-3101, 200 Constitution Ave., N.W., Washington, DC 20210; (202) 523-9667:

> *"Chemical Hazard Communication"* OSHA 3084,
> a booklet describing the rule's requirements; and
> *"Hazard Communication Guidelines for Compliance"*,
> a booklet to help employers comply with the rule.

Also available for $18.00 from the Superintendent of Documents, U.S. Government Printing Office, Washington, D.C. 20210; (202) 783-3238:

"Hazard Communication—A Compliance Kit"
OSHA 3104, GPO order No. 929-022-00000-9.

"OSHA Handbook for Small Businesses" OSHA 2209.
Single free copies of this booklet which provides help meeting general OSHA regulations can be obtained by calling the OSHA Publications Office, (202) 523-9667

CANADA GOVERNMENT RIGHT-TO-KNOW PUBLICATIONS

WHMIS Core Material: *A Resource Manual for the Application and Implementation of WHMIS.*
Contact the Community Relations Department, Worker's Compensation Board of British Columbia, 6951 Westminster Highway, Richmond, BC V7C 1C6. An excellent, inexpensive, page-tabbed guide to WHMIS.

BOOKS, PAMPHLETS AND DATA SHEETS

American Conference of Governmental Industrial Hygienists, 6500 Glenway Ave., Bldg. D-7, Cincinnati, OH 45211-4438. (513) 661-7881. Publication # 1 is updated yearly, # 2 about every other year.

1. ***Threshold Limit Values and Biological Exposure Indices.***
2. ***Industrial Ventilation: A Manual of Recommended Practice.***
3. ***The Documentation of TLVs and BEIs.***

American Medical Association, ***Handbook of First Aid and Emergency Care,*** The American Medical Association, Chicago, Il, 1980.

Clark, N., Cutter, T., McGrane, J.A. ***Ventilation:*** *A Practical Guide.* Center for Safety in the Arts, New York, 1980. A guide to basic ventilation principles and step-by-step guidance for those who wish to evaluate, design and build an adequate ventilation system. Available from CSA, 5 Beekman St., New York, NY 10038.

Freeman, Victoria and Humble, Charles G. *"Prevalence of illness and chemical exposure in professional photographers."* A National Press Photographers Association (NFPA) report presented at the 1989 Annual Meeting of the American Public Health Association.

Gosselin, Robert E., Et al. ***Clinical Toxicology of Commercial Products.*** 6th Edition, Baltimore: Williams and Wilkins Co. 1987. Updated regularly. Available in the technical section of many book stores.

Haas, Ken. ***The Location Photographer's Handbook,*** The Complete Guide for the Out-of-Studio Shoot. Van Nostrand Reinhold, New York, 1989. Includes health and safety information, appropriate shots and vaccinations for various countries, etc.

Hawley, Gessner. **Hawley's Condensed Chemical Dictionary.** 11th Ed., revised by Sax, N. Irving and Lewis, Sr., Richard, Van Nostrand Reinhold Co., New York, 1987. Also available from the ACGIH. Call (513) 661-7881 for publications catalog.

Hazardous Substance Fact Sheets, New Jersey Department of Health, Trenton, NJ 08625. (609) 984-2202. These are excellent fact sheets on individual chemicals. Around 900 chemicals are covered.

"How to Read a Material Safety Data Sheet," The American Lung Association, 1988. A five page data sheet which defines MSDS terms. Contact your local American Lung Association for information on obtaining it.

International Labour Organization. **Encyclopaedia of Occupational Health and Safety.** 3rd Revised Edition, 2 vols. New York: McGraw-Hill, 1983. Also available from the ACGIH. Call (513) 661-7881 for publications catalog.

Klaassen, Curtis D., Ambdur Mary O., and Doull, John, eds. **Casarett and Doull's Toxicology.** 3rd ed. New York: MacMillan Publishing Co., Inc., 1986.

Kodak's list of publications may be obtained by writing Eastman Kodak Company, Photographic Products Group, Dept. 412-L Rochester, NY 14650-0532. Send $ 1.00 for KODAK Publication L-1, Kodak Index to Photographic Information. Relevant publications include:

- *"Safe Handling of Photographic Chemicals,"*
 Kodak Publications No. J-4.
- *"Disposal and Treatment of Photographic Effluent,"*
 Kodak Publication No. J-55.
- *"Disposing of Minilab Effluent,"*
 Kodak Publication No. J-20.
- *"Disposal of Small Volumes of Photographic-Processing Solutions,"*
 Kodak Publication No. J-52.
- *"Photolab Design,"*
 Kodak Publication No. K-13

Lefevre, M.J. **First Aid Manual for Chemical Accidents.** Dowden, Hutchinson and Ross, Stroudsburg, PA, 1980.

National Fire Protection Association, Batterymarch Park, Quincy, MA 02169. 1-800-344-3555. Obtain catalog of the 270 codes. Choose pertinent codes such as *NFPA #30. Flammable and Combustible Liquids Code,* and *NFPA 491M. Manual of Hazardous Chemical Reactions.*

National Institute of Occupational Safety and Health. **Registry of Toxic Effects of Chemical Substances.** US Department of Health and Human Services, 1981-2 Edition plus yearly supplements. Reproduced by the National Technical Information Services, Port Royal Road, Springfield, VA 22161.

Patty, Frank, ed. **Industrial Hygiene and Toxicology.** Vol. II, 3rd edition, Part A, (1980), Part B, (1981), Part C, (1982), Interscience Publishers, New York. Also available from the ACGIH. Call 1-513-661-7881 for publications catalog.

Ramazzini, Bernardini. *De Morbis Artificum (Diseases of Workers)*. 2nd ed., 1713. Translated by W. C. Wright. Chicago: University of Chicago Press, 1940. Ramazzini, called the "Father of Occupational Health and Safety," discusses hazards of many occupations including art and craft workers in the 1700's.

Rossol, Monona. *The Artist's Complete Health and Safety Guide*, Allworth Press, New York, 1990. A guide to safety and OSHA compliance for those using paints, pigments, dyes, metals, solvents, photochemicals, and other art and craft materials. Available from Allworth Press, 10 East 23rd St., New York, NY 10010.

Sax, N. Irving and Lewis, Richard J. Sr. *Dangerous Properties of Industrial Materials*, 7th Edition. Van Nostrand-Reinhold Co., New York, 1988. Also available from the ACGIH. Call 1-513-661-7881 for publications catalog.

Shaw, Susan D. *"In Process: Reproductive Hazards in Photography." Photomethods.* Vol. 28, No. 6, June 1985. A discussion of specific chemicals used in photography that can damage the reproductive systems of both men and women. Available from ACTS, Attn: M. Rossol, 181 Thompson Street, New York, NY 10018.

Shaw, Susan D. and Rossol, Monona. *"Warning: Photography May Be Dangerous to Your Health." ASMP Bulletin,* Vol. 8, No. 6, June 1989. An entire issue of the American Society of Magazine Photographer's Bulletin devoted to the hazards of photochemicals with a special section describing the new Hazard Communication Law as it pertains to photographers. Available from ACTS, Attn: M.Rossol, 181 Thompson St., # 23, New York, NY 10012.

Tell, Judy (ed). *Making Darkrooms Saferooms.* A National Report on Occupational Health and Safety, Durham, NC: National Press Photographers Association, 1988. An excellent summary publication containing case histories, hazards assessments and practical safety measures for professional photographers. Available from Charles Cooper, Exec. Dir., NPPA, 3200 Croasdaile Dr., Suite 306, Durham, NC 27705.

The MSDS Pocket Dictionary. Genium Publishing Corporation. They have a variety of small dictionaries of terms used on Material Safety Data Sheets for the U.S. and Canada, in English, Spanish and French. Contact Genium Publishing at 1145 Catalyn Street, Schenectady, NY 12303-1836. 1-518-377-8854.

The WHMIS Handbook. Corpus Information Services, 1450 Don Mills Road, Don Mills, Ontario M3B 2X7. 1-416-445-6641. A well-written, costly, page-tabbed guide to WHMIS.

U.S. Department of Health, Education, and Welfare. *Occupational Diseases: A Guide to Their Recognition.* Revised ed. DHEW (NIOSH) Publication No. 77-181. Washington, D.C.: U.S. Government Printing Office, 1977.

SCIENTIFIC JOURNAL PAPERS (obtainable from medical libraries):

Choudat D, Neukirch F, Brochard P, et al. *"Allergy and Occupational Exposure to Hydroquinone and to Methionine"*, **Br.J.Indust.Med.**, 1988; 45:376-380.

Hodgson, M.J. and Parkinson, D.K. *"Respiratory Disease in a Photographer."* **Am.J.Indust.Med.** 9:349-354, 1986.

Kipen H.M. and Lerman, Y. *"Respiratory Abnormalities Among Photographic Developers: a Report of Three Cases."* **Am.J.Indust.Med**. 9:341-347, 1986.

Liden C. "Occupational Dermatoses at a Film Laboratory." Contact Dermatitis, 1984; 10:77-87.

Mandel EH. *"Lichen Planus-like Eruptions Caused by a Color-film Developer."* **Arch. Dermatol.,** 1960; 81:516-519.

Miller, Barry A. and Blair, A. *"Mortality Patterns Among Press Photographers (letter)."* **J.Occup.Med.** 25:439-440, 1983.

GENERAL REFERENCES FOR CHAPTERS 5 AND 6

Davidson, Jerry. **Light Up Your Darkroom:** *How to Tone, Tint and Retouch Black-and-White Prints.* Pembroke Publishers Limited, Markham, Ontario Canada, 1986.

ILFORD Technical Data Sheets on individual chemicals and processes can be obtained by writing ILFORD Photo Corporation, West 70 Century Road, Paramus, NJ 07653. Useful titles include:

- *"Disposal of Process P-30 Solution Waste,"*
- *"Procedure for Neutralizing Ilford Cibachrome and Cibacopy Bleach Solution,"*
- *"Disposal of Photoprocessing wastes,"*
- *"Silver Recovery from Cibachrome, Cibacopy and Monochrome Fixers."*

Kodak's list of publications may be obtained by writing Eastman Kodak Company, Photographic Products Group, Dept. 412-L Rochester, NY 14650-0532. Send $ 1.00 for KODAK Publication L-1, "Kodak Index to Photographic Information." Relevant publications include:

- *"CHOICES—Choosing the Right Chemicals for Photofinishing Labs,"* Kodak Publication J-35. Gives methods for reducing effluent discharge by using developer and bleach-fix regener-ation, and separate bleach and fixer for Process RA-4, and Developer bleach, and fixer regeneration with Process C-41.

- *"CHOICES—Choosing the Right Chemicals for Minilabs,"* Kodak Publication J-36. Describes the various process options available for using KODAK EKTACOLOR RA and FLEXICOLOR chemicals in minilabs.

- Individual data sheets discussing *"Safe Handling Considerations"* for various Kodak processes such as Ektrachrome E-6 Process, and individual chemicals such as developers and stop baths (see L-1 index).

Eaton, George T. *Photographic Chemistry*. 3rd ed. Dobbs Ferry, New York: Morgan & Morgan Inc., Publishers, 1980.

Land, Edwin H. *"Absolute One-Step Photography."* The Photographic Journal, Vol. 114, No. 7, July 1974.

Land, Edwin H. *"An Introduction to Polavision."* **Photographic Science and Engineering,** Vol. 21, No. 5, September/October 1977.

Marshall, Lucille Robertson. *Photo-Oil Coloring for Fun or Profit.* Larum Publishing Co., Washington, DC 1944.

REFERENCES FOR CHAPTERS 7 and 8:

Blacklow, Laura. *New Dimensions in Photo Imaging.* Focal Press, Boston, 1989. Step-by-step manual on solvent transfers and magazine lifts, hand coloring, toning, cyanotypes, Van Dyke Brown Prints, Gum Bichromate Prints, Casein Pigment Prints, and Kwik Prints with safety notes.

Bostick, M.S., and Sullivan, R. *"A Descriptive Catalog of Platinum and Palladium Photographic Chemistry."* Bostick and Sullivan, P.O. Box 2155, Van Nuys, CA 91404. Very informative catalog, updated regularly.

Bunnell, Peter. *Non Silver Photographic Processes: Four Selections, 1886-1927.* New York: Arno Press, A New York Times Company, 1973. Reprint of an original manuscript on photogravure, gum bichromate, oil and bromoil processes, platinum print.

Crawford, William. *The Keepers of the Light.* Dobbs Ferry, New York: Morgan & Morgan, Inc., Publishers, 1979.

Daguerre, Louis Jacques Mande'. *An Historical And Descriptive Account of the Various Processes of the Daguerreotype and the Diorama*. New York: Winter House Ltd., 1971.

Flynn, Deborah. *Imaging With Light Sensitive Materials.* Rochester, New York: Visual Studies Workshop Press, 1978.

Gernsheim, Helmut. *The Origins of Photography.* Revised 3rd ed. New York: Thames and Hudson, Inc., 1982.

Gilbert, George. *Photography:* The Early Years. New York: Harper & Row Publishers, Inc., 1980.

Hill, Levi L. *A Treatise on Heliochromy.* New York: Robinson & Caswell, 1856.

Humphrey, Samuel Dwight. *Humphrey's (Daguerrean) Journal*, IV, 1852.
Kodak, *A Sensitizer for Paper, Cloth and Similar Materials.* Eastman Kodak, Publication AJ-5, Rochester, NY 14650.

Nadeau, Luis. *History and Practice of Oil and Bromoil Printing.* Atelier Luis Nadeau, Fredericton, New Brunswick, Canada, 1985.

Nadeau, Luis. *Modern Carbon Printing.* Atelier Luis Nadeau, Fredericton, New Brunswick, Canada, 1986.

Nadeau, Luis. *The History and Practice of Platinum Printing.* Atelier Luis Nadeau, Fredericton, New Brunswick, Canada, 1984.

Newhall, Beaumont. *The Daguerreotype in America.* 3rd revised ed. New York: Dover Publications, Inc., 1976.

Newhall, Beaumont. *The History of Photography.* 5th revised ed. New York: The Museum of Modem Art, 1982.

Rinhart, Floyd, and Marion Rinhart. *The American Daguerreotype.* Athens, Georgia: The University of Georgia Press, 1981.

Romer, Grant B. *"Daguerreotype."* The Camera Handbook of Antiquated Techniques Used by Contemporary Photographers. Lucerne, Switzerland: Camera 2/79.

Taft, Robert. *Photography and The American Scene.* New York: Dover Publications, Inc., 1964.

REFERENCES FOR CHAPTERS 9 and 10:

Antreasian, Garo Z., and Clinton Adams. *Tamarind Book of Lithography:* Art and Techniques. New York: Abrams Co., 1971.

Arnow, Jan. *Handbook of Alternative Photographic Processes.* New York: Van Nostrand-Reinhold Co., 1982.

Center for Safety in the Arts, 5 Beekman Street, Suite 1030, New York, NY 10038. Data Sheets on art and conservation including:

- *Celluloid Film Hazards in Conservation*
- *Emergency Plans for Museum Conservation Labs*
- *Hazards of Dyes and Pigments for Museum Personnel*
- *Health and Safety Programs for Conservation Laboratories*
- *Health and Safety Resources for the Arts*
- *Organic Pigments*
- *Photographic Processing Hazards in Schools*
- *Storage and Disposal of Conservation Chemicals*
- *Thymol and O-Phenyl Phenol: Safe Work Practices*
- *Ventilation for Conservation Laboratories*

Clapp, Anne R. *Curatorial Care of Works of Art on Paper.* 3rd revised ed. Oberlin,

Ohio: Intermuseum Conservation Association, 1978.

Edwards, Stephen R.; Bruce M. Bell and Mary Elizabeth King, eds. **Pest Control in Museums: A Status Report (1980).** Association of Systematics Collections, 1981.

Health, Safety and Human Factors Laboratory. *"Safe Practices for Kodak Photosensitive Resists."* Data Sheet. Rochester, New York: Eastman Kodak Company, June 1980.

John Michael Kohler Arts Center. **The Alternative Image. An Aesthetic and Technical Exploration of Non-Conventional Photographic Printing Processes.** Kohler Arts Center, Sheboygan, WI, 1984.

Johnson, Lois M., and Stinnett, Hester. **Water-based Inks:** *A Screenprinting Manual for Studio and Classroom.* Philadelphia College of Arts, Printmaking workshop, Philadelphia, PA, 1990.

McCabe, Constance. *"Preservation of 19th-Century Negatives in the Ntional Archives."* Journal of the American Institute for Conservation, Vol. 30, No. 1, Spring 1991.

Moses, Cherie; James Purdham; Dwight Bohay and Roland Hoslin. **Health and Safety in Printmaking, A Manual for Printmakers.** Occupational Hygiene Branch, Alberta Labor, Edmonton, Alberta, Canada, 1978.

National Fire Protection Association, Batterymarch Park, Quincy, MA 02169. 1-800-344-3555. Obtain catalog of the 270 codes. Choose pertinent codes such as **NFPA 40. Storage and Handling of Cellulose Nitrate Motion Picture Film, NFPA 911. Protection of Museums and Museum Collections, NFPA 220. Types of Building Construction,** and **NFPA 80. Fire Doors and Windows.**

Nettles, Bea. **Breaking the Rules.** 2nd edition, Inky Press Productions, Urbana, IL, 1987.

Nadeau, Luis. **Gum Bichromate and Other Direct Carbon Processes.** Atelier Luis Nadeau, Fredericton, New Brunswick, Canada, 1987.

Scopick, David. **The Gum Bichromate Book: Contemporary Methods for Photographic Printmaking.** Light Impressions Corporation, Rochester, NY 1987.

Siedlicki, Jerome. *"Occupational Health Hazards of Painters and Sculptors."* Journal of the American Medical Association 204:1176, 1968.

Siedlicki, Jerome. **The Silent Enemy**. 2nd ed. Washington, D.C.: Artists' Equity Association, 1975.

Swedlund, Charles, and Elizabeth Swedlund. **Kwik Print.** Light Impressions Corporation, Rochester, NY 1987.

Wade, Kent E. **Alternative Photographic Processes.** Dobbs Ferry, New York: Morgan & Morgan, Inc., Publishers, 1978.

Wehlte, Kurt. **The Materials & Techniques of Painting.** Translated by Ursus Dix. New York: Von Nostrand-Reinhold Company, 1982.

310

Index

A

Accident prevention, 3.027
Accidents, 3.025-3.027
Acetic acid, 4.035
Acetone, 4.263
Acids, 4.033-4.052
Acute health effects, 1.011
Adhesives, 10.002, 10.006
Aerosol sprays, 4.283-4.285
Air conditioners, 3.032
Albumen, 7.017-7.021
Albumen printing, 7.017-7.021
Alcohols, 4.238-4.243
Aldehydes, 4.022-4.025
Aliphatic amines, 4.016-4.021
Alizarine crimson, 4.155
Alkalis, 4.053-4.073
Alumina, 4.156
Ambrotype printing, 7.007-7.011
Amidol, 4.004
Aminophenol, 4.003
Ammonia, 4.055, 4.113, 4.141-4.142
Ammonium alum, 4.076
Ammonium bromide, 4.114
Ammonium dichromate, 4.077
Ammonium EDTA, 4.078
Ammonium persulfate, 4.115
Ammonium thiocyanate, 4.116
Ammonium thiosulfate, 4.117
Antimony white, 4.157
Aromatic Hydrocarbons, 4.244-4.247

B

Barium white, 4.158
Barium yellow, 4.159
Barrier creams, 3.046

Becquerel daguerreotype method, 7.002
Benzene, 4.245
Benzine, 4.274
Benzotriazole, 4.031
Benzyl alcohol, 4.242
Bleaching, color, 6.007-6.011
Blood diseases, 1.022-1.023
Bone black, 4.160 Borax, 4.056
Boric acid, 4.036 Bromine, 4.118
Bromoil printing, 8.033-8.037
Buffered papers, 10.002, 10.006
Burnt sienna, 4.161
Burnt umber, 4.162
Butyl acetate, 4.258
Butyl cellosolve 4.267
Butylene glycol, 4.270

C

Cadmium barium orange, 4.163
Cadmium barium red, 4.164
Cadmium barium yellow, 4.165
Cadmium orange, 4.166
Cadmium red, 4.167
Cadmium vermilion red, 4.168
Cadmium yellow, 4.169
Canadian OHSA, 2.002
Cancer, 1.012
Carbitol, 4.264
Carbolic acid, 4.027
Carbon arc lamps, 3.030-3.031
Carbon black, 4.170
Carbon disulfide, 4.277
Carbon monoxide, 4.149
Carbon printing, 8.017-8.021
Carbon tetrachloride, 4.249

About the Authors

Susan D. Shaw, is an environmental scientist, author and photographer. She holds a Master of Fine Arts degree in Film and Photography and a Masters degree in Public Health, Environmental Science and Nutrition, both from Columbia University. This dual training in photography and public health and environmental toxicology culminated in her critically acclaimed first edition of OVEREXPOSURE in 1983. She has lectured and written extensively about health hazards in photography and other environmental health issues. Shaw is Founder and Executive Director of the Marine Environmental Research Institute (MERI), an international non-profit research corporation based in New York and Maine.

Monona Rossol, M.S., M.F.A., is an industrial hygienist, chemist, artist, and internationally recognized authority on the hazards of art and theatrical materials and processes. She lectures and consults extensively in the United States, Canada, Australia and England. She is the founder and President of Arts, Crafts and Theater Safety (ACTS), a New York-based non-profit organization which provides health and safety services to the arts. She writes a monthly newsletter, ACTS FACTS, and has written over 60 articles and four books on this subject, including *Stage Fright: Health and Safety in the Theater* and *The Artist's Complete Health and Safety Guide,* both published by Allworth Press.

Allworth Press publishes quality books for artists, authors, graphic designers, illustrators, photographers, and small businesses. Titles include:

ASMP Professional Business Practices in Photography
Fifth Edition *by American Society of Media Photographers*
(softcover, 6 3/4 x 10, 416 pages, $24.95)

Pricing Photography
Revised Edition *by Michal Heron and David MacTavish*
(softcover, 11 x 8 1/2 , 144 pages, $24.95)

The Business of Studio Photography
by Edward R. Lilley
 (softcover, 6 3/4 x 10, 304 pages, $19.95)

The Photographer's Guide to Marketing and Self-Promotion
Second Edition *by Maria Piscopo*
(softcover, 6 3/4 x 10, 176 pages, $18.95)

How to Shoot Stock Photos That Sell
Revised Edition *by Michal Heron*
(softcover, 8 x 10, 208 pages, $19.95)

Stock Photography Business Forms
by Michal Heron
(softcover, 8 1/2 x 11, 144 pages, $18.95)

Business and Legal Forms for Photographers
by Tad Crawford
(softcover, 8 1/2 x 11, 192 pages, $18.95)

Legal Guide for the Visual Artist
Third Edition *by Tad Crawford*
(softcover, 8 1/2 x 11, 256 pages, $19.95)

The Law (in Plain English) for Photographers
by Leonard DuBoff
(softcover, 6 x 9, 208 pages, $18.95)

The Copyright Guide
by Lee Wilson
(softcover, 6 x 9, 192 pages, $18.95)

Mastering Black-and-White Photography
by Bernhard J Suess
(softcover, 6 3/4 x 10, 240 pages, $18.95)

The Digital Imaging Dictionary
by Joe Farace
(softcover, 6 x 9, 256 pages, $19.95)

The Photographer's Internet Handbook
by Joe Farace
(softcover, 6 x 9, 224 pages, $18.95)

The Artist's Complete Health and Safety Guide
by Monona Rossol
(softcover, 6 X 9, 328 pages, $16.95)

Travel Photography: A Complete Guide to How to Shoot and Sell
by Susan McCartney
(softcover, 6 3/4 X 10, 384 pages, $22.95)

Nature and Wildlife Photography: A Practical Guide to How to Shoot and Sell
by Susan McCartney
(softcover, 6 3/4 X 10, 256 pages, $18.95)

The Photographer's Assistant
by John Kieffer
(softcover, 6 3/4 X 10, 208 pages, $16.95)

Please write to request our free catalog. To order by credit card, call **1-800-491-2808** or send a check or money order to Allworth Press, 10 East 23rd Street, Suite 210, New York, NY 10010. Include $5 for shipping and handling for the first book ordered and $1 for each additional book. Ten dollars plus $1 for each additional book if ordering from Canada. New York State residents must add sales tax.

To see our online catalog, go to **www.allworth.com**